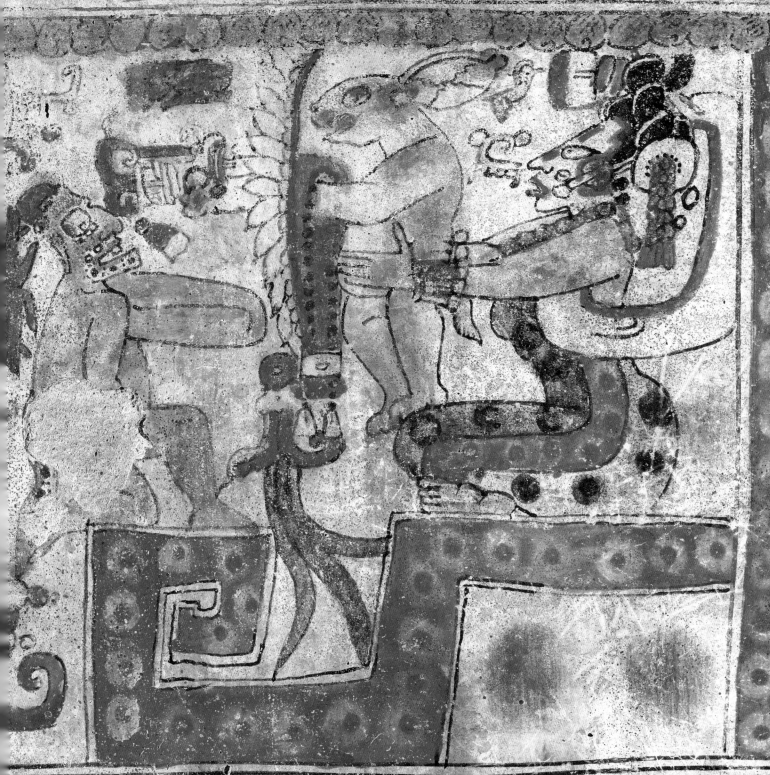

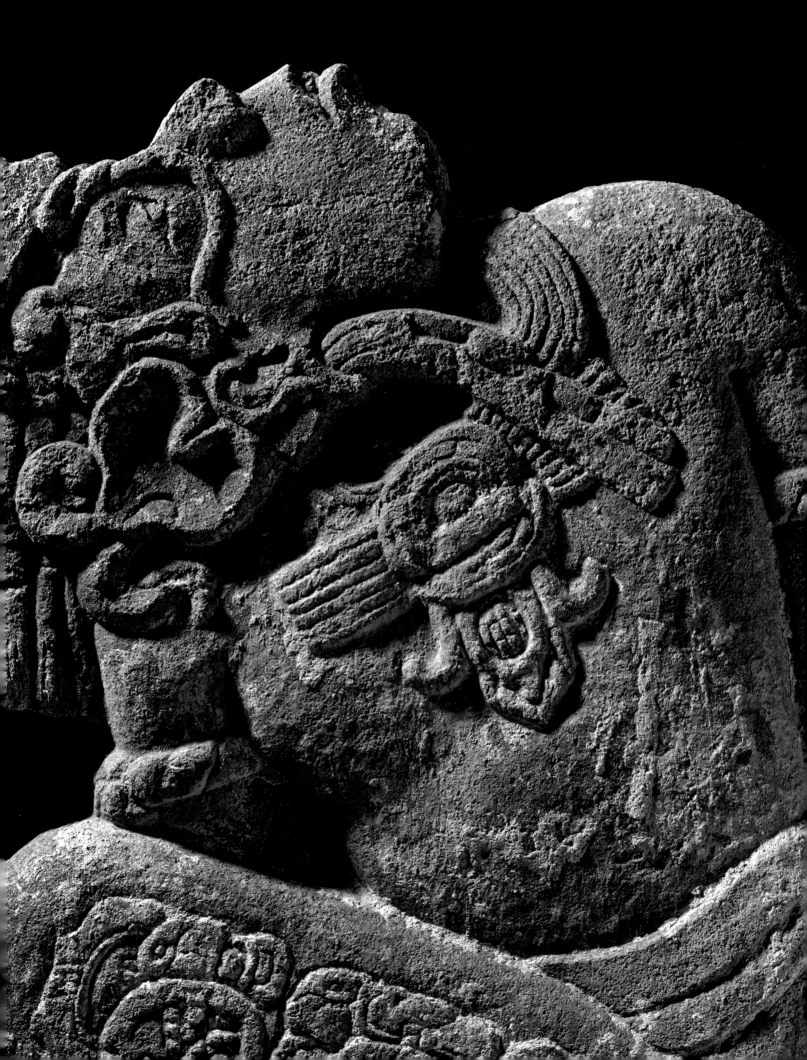

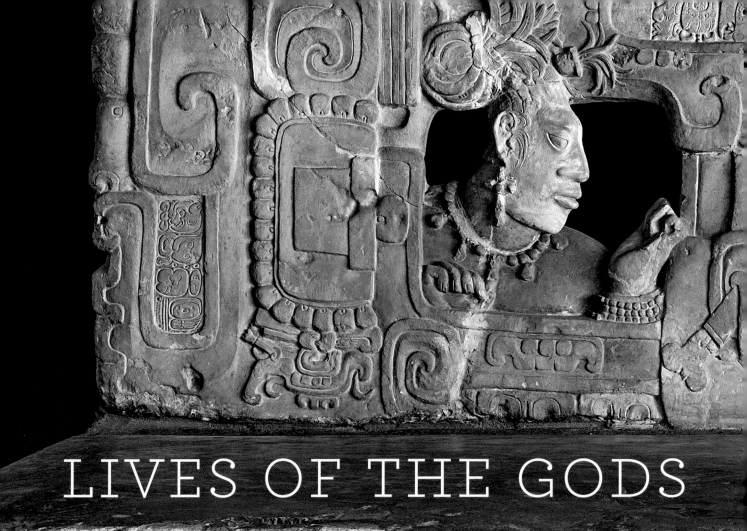

LIVES OF THE GODS

THE
MET

The Metropolitan Museum of Art, New York

DISTRIBUTED BY YALE UNIVERSITY PRESS,

NEW HAVEN AND LONDON

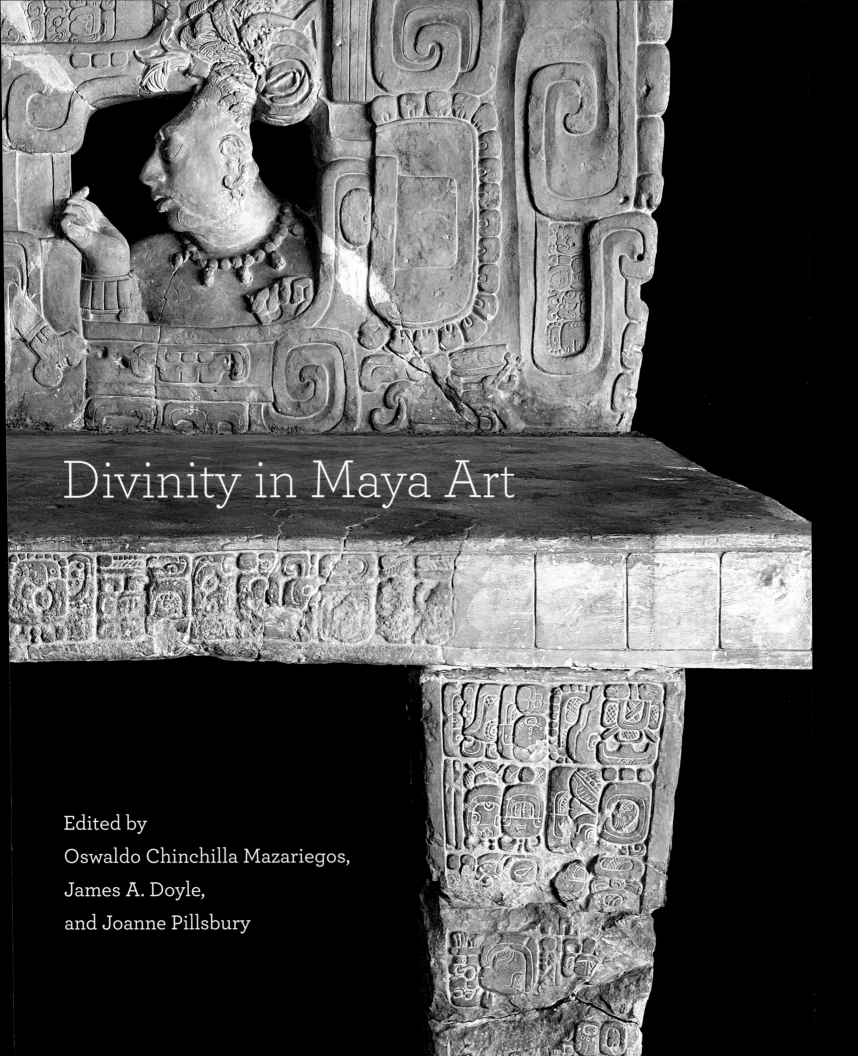

Divinity in Maya Art

Edited by
Oswaldo Chinchilla Mazariegos,
James A. Doyle,
and Joanne Pillsbury

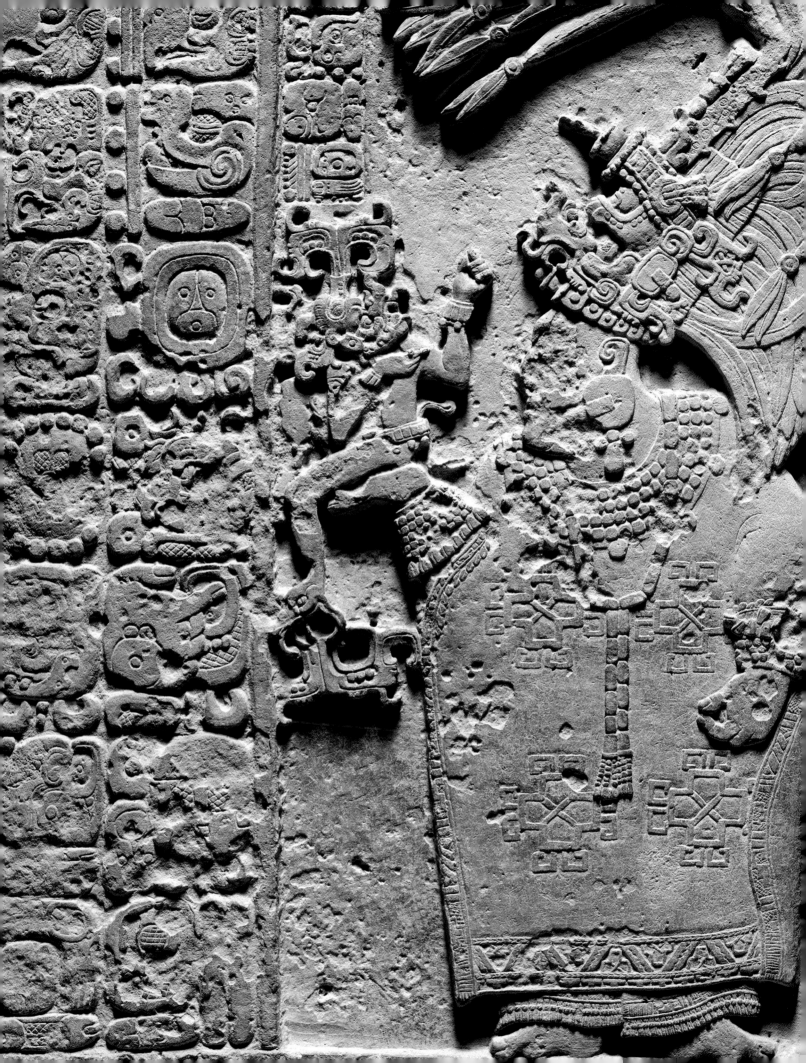

Contents

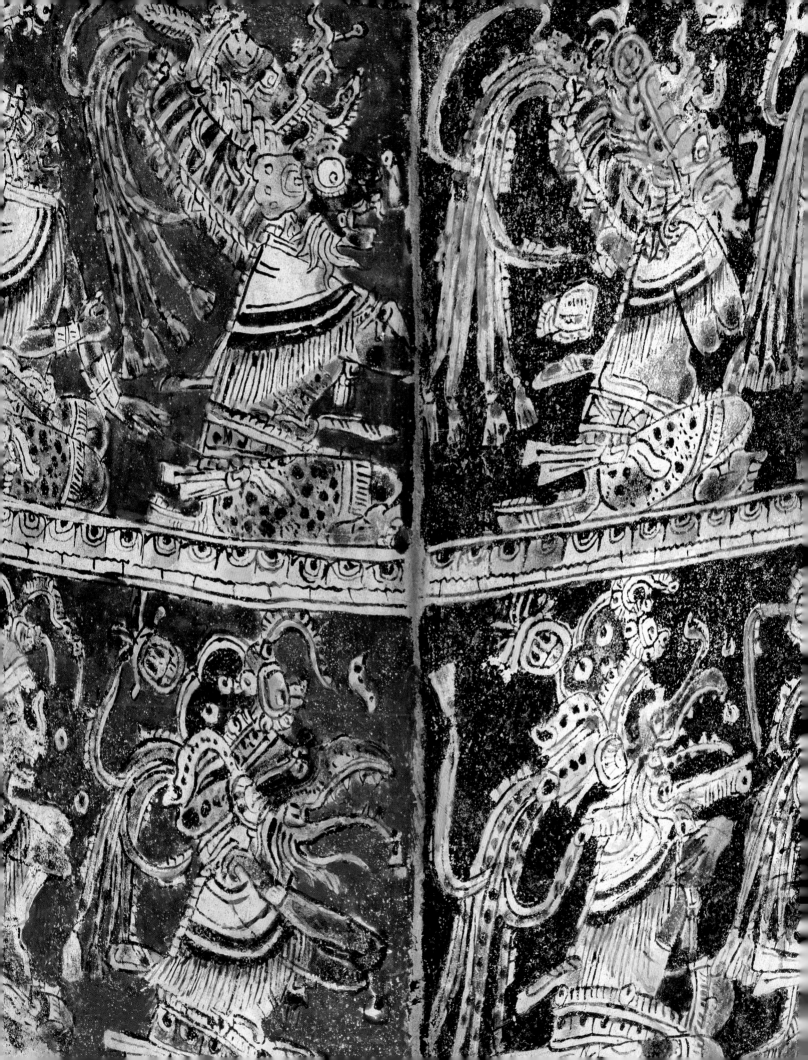

Directors' Foreword

Lives of the Gods: Divinity in Maya Art addresses a fundamental question that artists in all times and all places have faced: How do you give shape to divine power? In Maya belief, gods follow a life cycle similar to that of humans: they are begotten, they are born, and they die. Some are depicted as infants, others as mature adults, and still others as aged beings. The Maize God, for example, a powerful deity recognized across the Maya region, is shown as a resplendent young man, full of youth and vitality; he is also represented in his transit to death and in the process of being born again, echoing the staple crop's agricultural cycle. As a metaphor, the Maize God is a paradigm of rebirth and regeneration, a powerful reminder of resilience in the face of existential challenges.

This volume accompanies the first major exhibition of Maya art in the United States in a decade. It features more than one hundred works by masters of the Classic period (A.D. 250–900). These landmark artworks — in various media and ranging from the monumental to the miniature — adorned the spectacular royal cities in the tropical forests of what are now Guatemala, Honduras, and Mexico. They evoke a world in which the divine, human, and natural realms are interrelated and intertwined.

One of the themes of the exhibition is the importance of ancestral knowledge, passed down from generation to generation. Although the Maya had a profound literary tradition, most of their books were destroyed in colonial-era campaigns to stamp out idolatry. That makes the monuments with extant texts featured in these pages all the more precious; they are rare, direct sources of Maya history and belief. Moreover, this volume presents new discoveries and insights drawn from the study of Classic-period hieroglyphs. Among the exciting recent developments in Maya art history and epigraphy (the study of glyphs) is the identification of artists, whose signatures are exceedingly rare in ancient American art — remarkably, for a scant couple of centuries in a limited area, Maya sculptors and painters signed their works. Their signatures are occasionally prominent and often beautifully carved on the backgrounds of stone monuments. Only now are we beginning to understand Maya artistic practices and the artist's role in court society.

We are grateful to the institutions that have so generously lent works to *Lives of the Gods*, especially the governments of Guatemala, Honduras, and Mexico, as well as major museum collections in Europe, Latin America, and the United States. We thank Joanne Pillsbury, Andrall E. Pearson Curator of Art of the Ancient Americas in the Michael C. Rockefeller Wing at The Met, for bringing this project to fruition. She was joined by cocurators Oswaldo Chinchilla Mazariegos, Associate Professor of Anthropology at Yale University, Laura Filloy Nadal, Associate Curator in the Michael C. Rockefeller Wing at The Met, and Jennifer Casler Price, Curator of Asian, African, and Ancient American Art at the Kimbell Art Museum. We are also grateful to James A. Doyle, formerly Assistant Curator at The Met and now Director of the Matson Museum of Anthropology at Pennsylvania State University, for initiating this project in 2018, and to George T. M. Shackelford, Deputy Director of the Kimbell Art Museum, for his enthusiastic support. Our appreciation goes to the scholars Iyaxel Cotjí Ren, Caitlin C. Earley, Stephen D. Houston, and Daniel Salazar Lama for the insightful essays they contributed to this publication.

The *Lives of the Gods* exhibition was made possible at The Met by the William Randolph Hearst Foundation, the Placido Arango Fund, the Diane W. and James E. Burke Fund, the Gail and Parker Gilbert Fund, the Mellon Foundation, and The International Council of The Metropolitan Museum of Art, with additional support from Stephanie Bernheim. In Fort Worth, the exhibition was made possible by the Kimbell Art Foundation. This publication was made possible by the Samuel I. Newhouse Foundation, Inc., the Mellon Foundation, and the Doris Duke Fund for Publications.

MAX HOLLEIN
Marina Kellen French Director
The Metropolitan Museum of Art, New York

ERIC M. LEE
Director
Kimbell Art Museum, Fort Worth, Texas

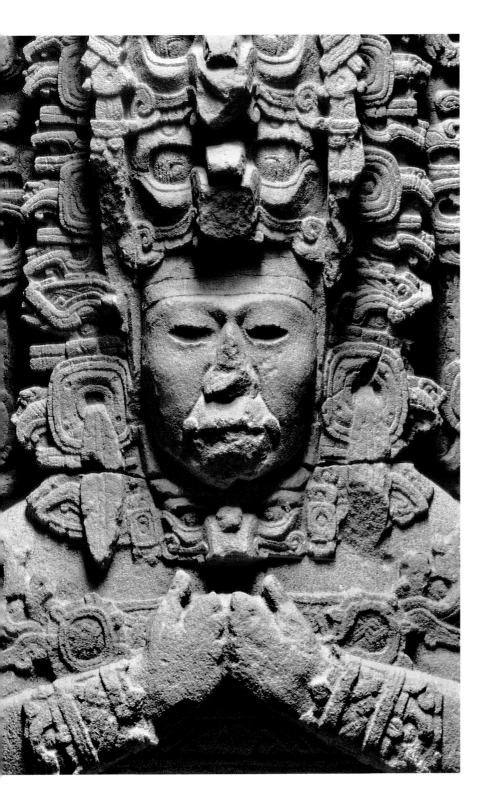

Contributors to the Catalogue

OSWALDO CHINCHILLA MAZARIEGOS
Associate Professor of Anthropology,
Yale University, New Haven, and Curator,
Yale Peabody Museum of Natural History,
New Haven

IYAXEL COJTÍ REN
Assistant Professor, Department of Anthro-
pology, The University of Texas at Austin

JAMES A. DOYLE
Director, Matson Museum of Anthropology,
and Associate Research Professor of Anthro-
pology, Pennsylvania State University,
State College

CAITLIN C. EARLEY
Assistant Professor, Department of Art,
Art History, and Design, University of
Washington, Seattle

STEPHEN D. HOUSTON
Dupee Family Professor of Social Science,
Professor of Anthropology, and Professor
of History of Art and Architecture, Brown
University, Providence, Rhode Island

JOANNE PILLSBURY
Andrall E. Pearson Curator, Art of the Ancient
Americas, The Michael C. Rockefeller Wing,
The Metropolitan Museum of Art, New York

DANIEL SALAZAR LAMA
Associate Researcher, Centro de Estudios
Mexicanos y Centroamericanos, Mexico City,
and Postdoctoral Researcher, Archéologie
des Amériques, Paris

Lenders to the Exhibition

British Museum, London

Brooklyn Museum

Chrysler Museum of Art, Norfolk, Virginia

Cleveland Museum of Art

Dallas Museum of Art

Detroit Institute of Arts

Dumbarton Oaks Research Library and Collection, Pre-Columbian Collection, Washington, D.C.

Instituto Hondureño de Antropología e Historia (IHAH), Sitio Maya de Copán, Honduras

Kimbell Art Museum, Fort Worth, Texas

Library of Congress, Washington, D.C.

Los Angeles County Museum of Art

The Metropolitan Museum of Art, New York

Ministerio de Cultura y Deportes de Guatemala, Museo Nacional de Arqueología y Etnología, Guatemala City

Museo Amparo, Puebla, Mexico

Museum of Fine Arts, Boston

Museum of Fine Arts, Houston

Museum der Kulturen Basel

Secretaría de Cultura del Estado de Tabasco, Mexico, Museo Regional de Antropología Carlos Pellicer Cámara, Villahermosa

SECRETARÍA DE CULTURA – INSTITUTO NACIONAL DE ANTROPOLOGÍA E HISTORIA (INAH), MEXICO

• Museo Arqueológico de Soconusco, Tapachula, Chiapas

• Museo Maya de Cancún, Quintana Roo

• Museo Nacional de Antropología, Mexico City

• Museo de Sitio de Palenque Alberto Ruz L'Huillier, Chiapas

• Museo de Sitio de Toniná, Chiapas

Virginia Museum of Fine Arts, Richmond

Yale University Art Gallery, New Haven

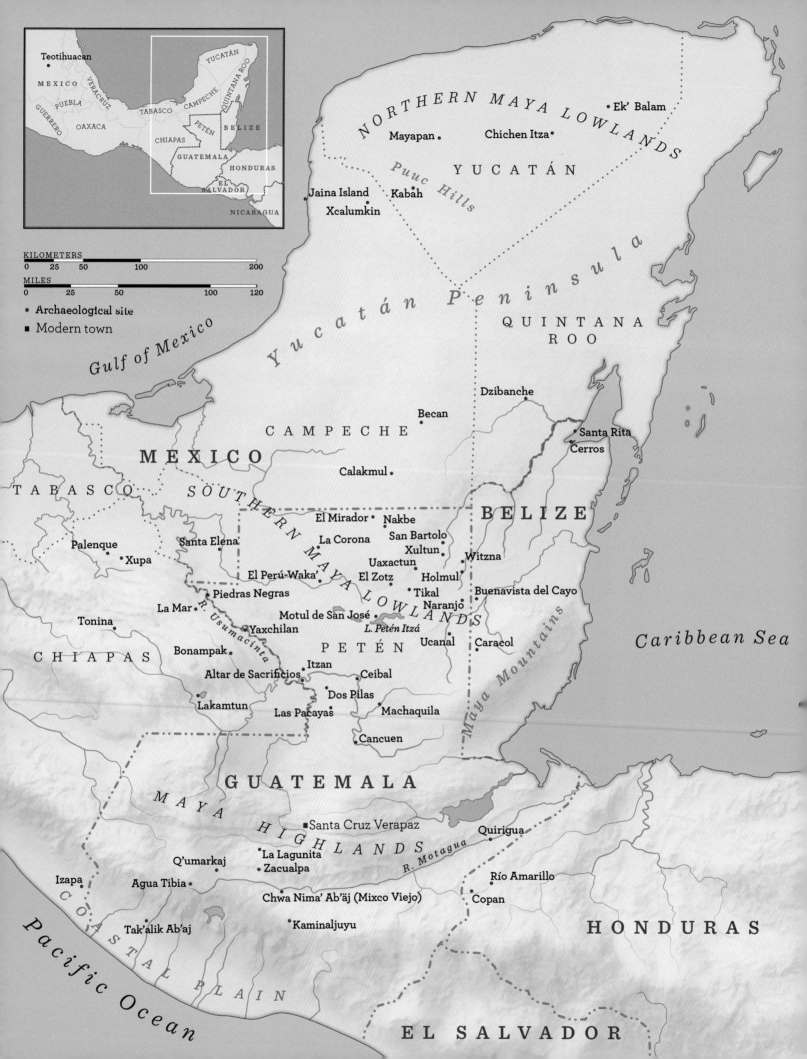

NORTHERN MAYA LOWLANDS

• Ek' Balam

Mayapan • • Chichen Itza •

YUCATÁN

Puuc Hills

Jaina Island • • Kabah

Xcalumkin •

Yucatán Peninsula

QUINTANA ROO

Gulf of Mexico

• Dzibanche

Becan •

CAMPECHE

MEXICO

• Santa Rita
Cerros •

Calakmul •

TABASCO SOUTHERN MAYA LOWLANDS

El Mirador • • Nakbe

BELIZE

La Corona • • San Bartolo

Palenque • Santa Elena • Xultun •

• Xupa El Perú-Waka' • Uaxactun •

El Zotz • Holmul • • Witzna

Piedras Negras • Tikal •

La Mar • *R. Usumacinta* • Naranjo Buenavista del Cayo •

Tonina • Motul de San José •

Yaxchilan • *L. Petén Itzá*

CHIAPAS

Bonampak • PETÉN Ucanal • Caracol •

Altar de Sacrificios • Itzan •

Lakamtun • Ceibal •

Las Pacayas • Dos Pilas •

Machaquila •

Cancuen •

Maya Mountains

Caribbean Sea

GUATEMALA

MAYA

■ Santa Cruz Verapaz

Quirigua •

HIGHLANDS

R. Motagua

Q'umarkaj • La Lagunita •

Agua Tibia • Zacualpa •

Río Amarillo •

Izapa • Chwa Nima' Ab'äj (Mixco Viejo) • Copan •

Tak'alik Ab'aj • Kaminaljuyu •

HONDURAS

Pacific Ocean

COASTAL PLAIN

EL SALVADOR

Inset map:

Teotihuacan •

MEXICO

VERACRUZ YUCATÁN

PUEBLA

TABASCO CAMPECHE QUINTANA ROO

GUERRERO OAXACA

PETÉN BELIZE

CHIAPAS

GUATEMALA HONDURAS

EL SALVADOR

NICARAGUA

KILOMETERS
0 25 50 100 200

MILES
0 25 50 100 120

• Archaeological site
■ Modern town

Note to the Reader

The Mayan linguistic family comprises more than thirty languages that are spoken today, several extinct languages that were documented in colonial times, and Classic Mayan, the language recorded in logo-syllabic script. In that writing system, words are represented by logograms (signs that correspond to morphemes), combinations of syllabic signs, and combinations of logograms and syllables.

This publication includes terms and names in Classic Mayan and several modern languages, primarily K'iche' and Kaqchikel. The transcription of terms in Mayan languages follows the orthographic conventions of the Academia de las Lenguas Mayas de Guatemala and presents phonetic readings in italics. Sign-by-sign transliterations of logograms and syllables in the Mayan script are provided in selected cases. In accordance with linguistic conventions, they appear in boldface, with logograms uppercase and syllables lowercase: **ma-ta-K'UH**. Apostrophes correspond to glottal stops. In contemporary usage, Mayan proper names generally do not carry accents. However, institutional names and modern place-names sometimes use accents for Mayan terms to reflect their pronunciation by Spanish speakers; in such cases, accents appear here in accordance with that preference.

The decipherment of Mayan writing is an ongoing scholarly endeavor, and many signs remain unread; other signs cannot be read owing to the texts' physical deterioration. Those uncertainties are conveyed by ellipsis in square brackets: [...]. Tentative readings are indicated by question marks in parenthesis: (?).

Throughout these pages, photographs of cylindrical ceramics are complemented by rollout photographs, which offer a seamless view of the images depicted around each vessel. Most were made by Justin Kerr, who developed the rollout-view technique by exposing film in small intervals as the object rotates on a turntable. The "K numbers" that identify Kerr's photographs, and that scholars widely use to designate the vessels themselves, appear in the endnotes.

The captions include the largest of each object's dimensions, to offer a sense of scale. Geographic information is included only if the work's precise place of origin is known or its general location within the Maya region can be assumed. All dates are A.D. unless otherwise indicated. Some sculptures are inscribed with dedicatory dates, for which we have provided the equivalent year in the Gregorian calendar. Undated objects are ascribed to chronological ranges based on archaeological and stylistic data.

An extraordinary feature in Maya art during the Late Classic period is the presence of clauses that contain the names of sculptors or scribes. While not common, such "signatures" attest to artists' social standing and the appreciation of their works. Their names are included here when the clauses are at least partly legible, in some cases on collaborative works that bear two or more signatures.

Map of the sites mentioned in this volume

11

LIVES OF THE GODS

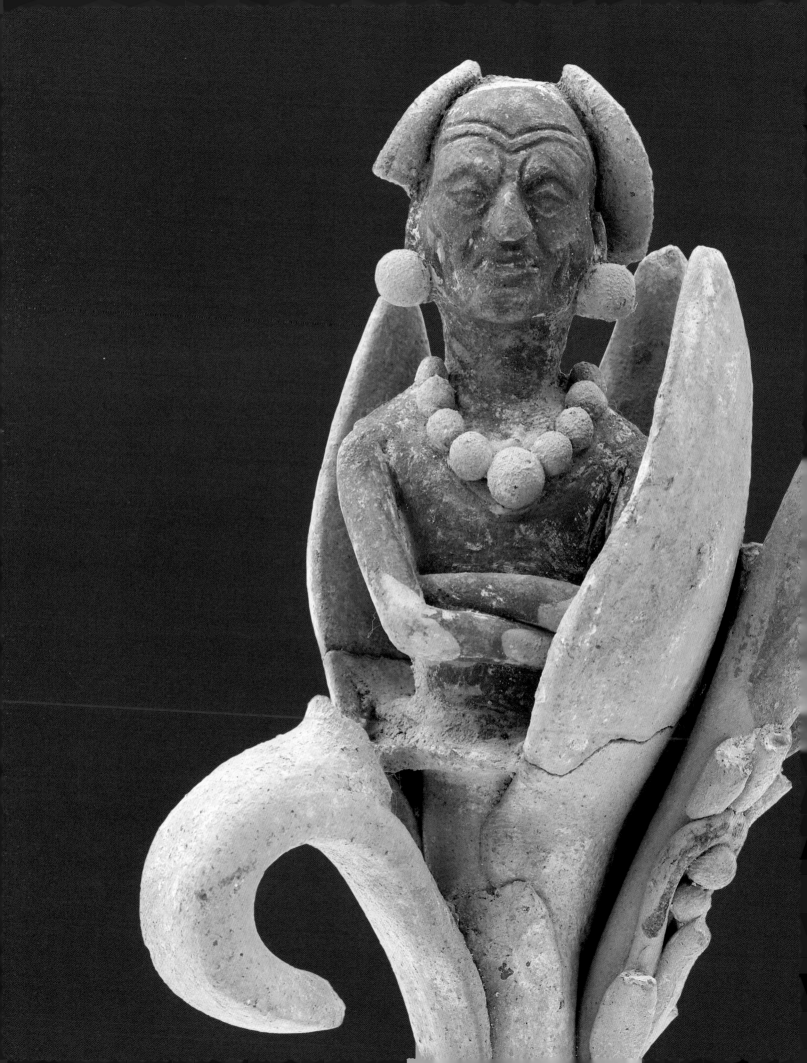

Introduction

OSWALDO CHINCHILLA MAZARIEGOS

A MAN IN A FLOWER. Young or old, arms crossed over the chest. Ancient Maya artists created many such delicate ceramic objects, which doubled as whistles (figs. 1–4). X-ray imaging reveals the carefully built vent that drives air blown through the long stem to a small concealed chamber formed by the figure's head (figs. 5a, b).[1] The blue pigments — variations of Maya blue, a luxurious color — were obtained by mixing indigo with palygorskite clay through an intricate technological process that produced a stable chemical complex.[2] But who are the characters emerging like stigmas from the center of these flowers? Are they men or gods? How did they relate to the objects' function as whistles? Were these merely fanciful objects or were they endowed with religious meanings? Did they serve special roles in ceremonial occasions? Although some of the whistles still sound, the objects are mute about

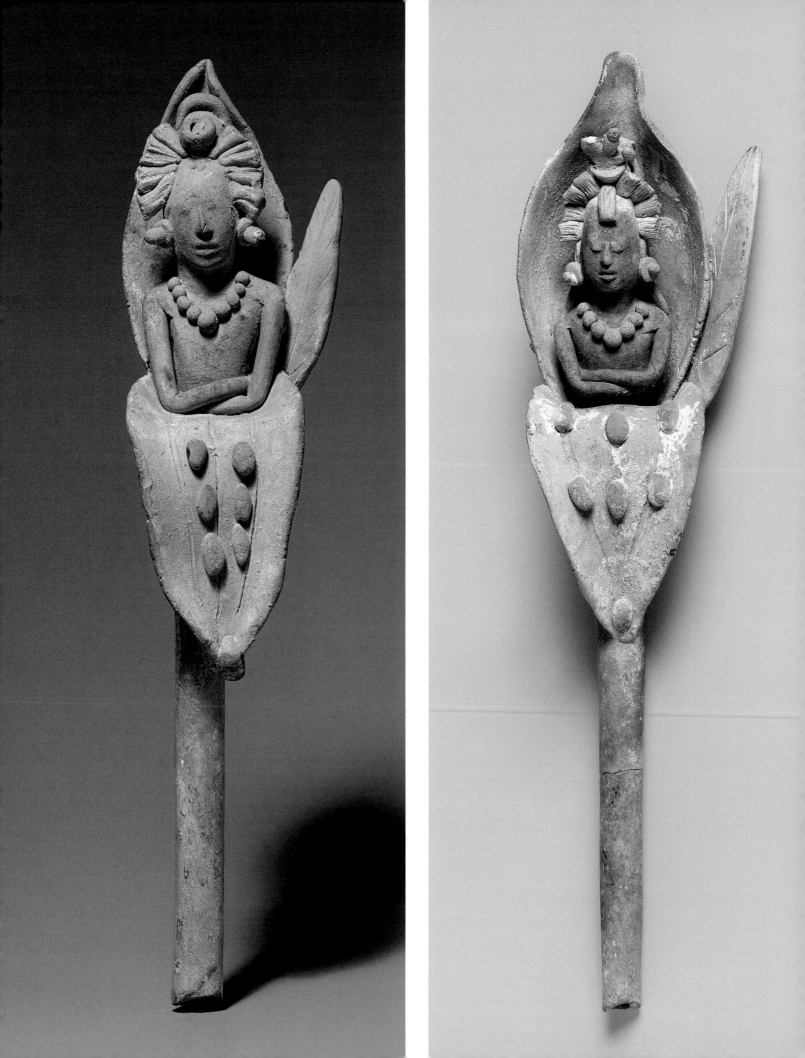

1
Whistle with the Maize
God emerging from a
flower. Mexico, Late
Classic period (600–900).
Ceramic, pigment,
H. 8⅛ in. (20.7 cm). The
Metropolitan Museum of
Art, New York, The Michael
C. Rockefeller Memorial
Collection, Bequest of
Nelson A. Rockefeller, 1979
(1979.206.728)

2
Whistle with the Maize
God emerging from a
flower. Mexico, Late Classic
period (600–900). Ceramic,
pigment, H. 8¼ in. (21 cm).
Brooklyn Museum, Dick S.
Ramsay Fund

3
Whistle with an old man
emerging from a flower.
Mexico, Late Classic period
(600–900). Ceramic,
pigment, H. 6¾ in. (17.1 cm).
Dumbarton Oaks Research
Library and Collection,
Pre-Columbian Collection,
Washington, D.C.

4
Whistle with an old man
emerging from a flower.
Jaina Island, Campeche,
Mexico, Late Classic period
(600–900). Ceramic,
pigment, H. 4⅞ in.
(12.3 cm). Museo Nacional
de Antropología, Mexico
City, Secretaría de
Cultura–INAH

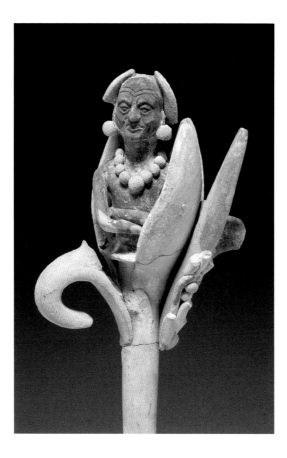

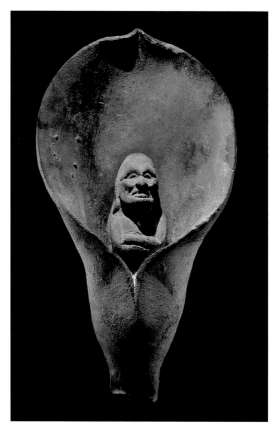

their meaning and use. Only by combining the disciplines of archaeology, art history, ethnography, and linguistics can they be discerned.

Lives of the Gods focuses on ancient Maya concepts and representations of divinity. This project is a testament to the aesthetic qualities of Maya artistic creations and an exploration of the profound religious meanings that they condensed. While informed by scholarship that began in the nineteenth century, much of its contents derives from research conducted in the last few decades. We examine recent finds from a royal tomb from the site of El Zotz and the extraordinary mural paintings of San Bartolo. We pursue new interpretations of the sixteenth-century highland Maya book known as the *Popol Wuj* and other texts produced by Maya writers in the early colonial period. We probe the deep wisdom contained in the traditional religion of modern Maya peoples. And we delve into the great advances

made possible by the decipherment of Maya hieroglyphic writing.

The Maya

In early colonial times, the name "Maya" designated the language spoken in Yucatán. It has since extended to designate an entire linguistic family, comprising more than thirty languages, currently spoken by no fewer than six million people. Today, Maya peoples live in Guatemala, Belize, parts of Honduras and El Salvador, the southern Mexican states of Chiapas and Tabasco, and the Yucatán Peninsula (encompassing the modern states of Campeche, Quintana Roo, and Yucatán). In addition, there are Maya diaspora communities in the United States.[3]

The forebears of the modern Maya thrived in highland and lowland landscapes throughout an expansive territory, adapting to cope

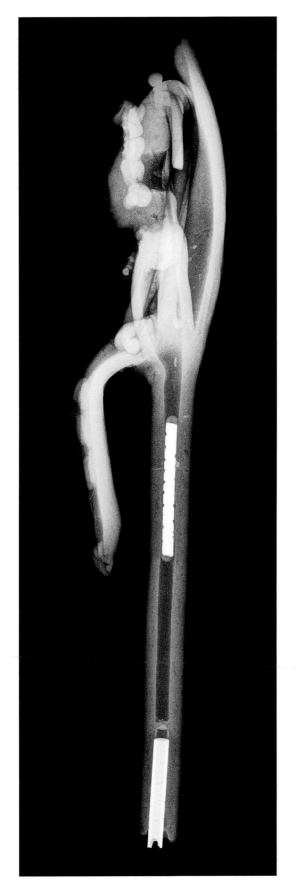
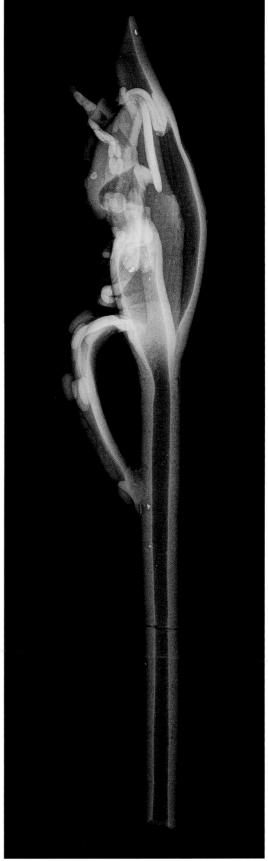

5A,B
X-ray images of ceramic
whistles in figures 1 (left)
and 2 (right)

with diverse, and often challenging, environments. In the south, the Guatemalan volcanic chain, with active cones rising more than four thousand meters above sea level, divides the extraordinarily fertile slopes of the Pacific coast from the cool and rugged valleys of the highlands. In eastern Guatemala, the thorn scrub valley of the Motagua River — the source of highly valued jade — runs along a tectonic fault that makes the highlands especially prone to earthquakes. Partly navigable by canoe, this river was a major trading route connecting the highlands with the Caribbean Sea and the tranquil waters of the Belize coastline, protected by an extensive coral-reef system. Tall limestone ranges in the northern highlands drain through the tributaries of the Usumacinta River, the longest waterway in the Maya area, which flows down to the lowlands and the Gulf of Mexico.

Indigenous writers in colonial Yucatán called the land they inhabited "Peten" (territory or island). The word relates to *pet*, a term that qualifies things that are flat and circular.[4] Indeed, the Maya Lowlands consist of an extensive limestone plateau, relatively flat except for low hills and ridges. Only in the southern part of the lowlands do the northeastern ranges of the Chiapas Highlands create rugged terrain along the Usumacinta River basin, while the Maya Mountains rise more than 1,100 meters in Belize. A dominant feature of the landscape in the lowlands is the paucity of permanent sources of water. Beyond the edges of the Usumacinta tributaries and shorter rivers that drain toward the Caribbean across Belize, the sole water sources are the lakes of central Petén (nowadays the name of an administrative unit comprising much of northern Guatemala). Elsewhere in the lowlands, ancient and modern populations depended on rainwater, collected in carefully engineered reservoirs that supplied entire cities through the

prolonged dry season. In the northern lowlands, sinkholes known as cenotes — from the Yukatek Mayan word *ts'onot* (well) — provided access to the underground water table.

Maya peoples have inhabited those territories for millennia. Recent underwater explorations in the caves and cenotes of eastern Yucatán revealed human remains dating to more than eleven thousand years ago — when the water level was much lower and the caves were dry, offering shelter to early migrants who foraged for wild resources. By 6000 B.C., the Maya were experimenting with cultigens, and maize cultivation gradually became prevalent by 2000 B.C.[5] Small permanent communities appeared along the Pacific coastal rim about 1500 B.C. and across the Maya area after 1000 B.C.

Far from isolated, these early peoples traded and interacted with members of other communities, who spoke Mayan and non-Mayan languages. Networks of interaction extended into Central America and, especially, to the Gulf Coast and highlands of Mexico. People traded valuable goods, such as jade, obsidian (a volcanic glass used to manufacture cutting implements and weapons), colorful feathers, woven fabrics and sewn garments, bark paper, salt, cacao (the seeds that produce modern chocolate), bouncing rubber balls, and probably slaves obtained in warfare. Intensive and sustained interaction among the Maya and neighboring peoples for millennia resulted in the widespread adoption of related technologies, social and political mores, and cultural patterns across a broad geographic area known as Mesoamerica, which includes much of western and central Mexico, the Maya area, and parts of the Central American isthmus. Mesoamerican peoples shared a substrate of cosmology, myths, and religious beliefs, together with ritual practices that ordained the proper ways to honor and sustain the gods and goddesses.

These beliefs and practices were fluid, manifesting in multiple ways through time and across widely distant geographic spaces, but nevertheless generally had recognizable links with common core tenets.[6]

Twentieth-century archaeologists coined the terms "Preclassic," "Classic," and "Postclassic" to designate major periods of Precolumbian Maya history. Decades of subsequent research show that the cycle of rise and decline suggested by those terms is unwarranted. The building efforts of the Maya in the Preclassic period (1500 B.C.–A.D. 250) overshadow those of later periods. Classic Maya metropolises were often built over enormous platforms created by their Preclassic forebears. Conversely, Postclassic societies (A.D. 900–1524) were not simply toned-down sequels of their Classic-period precedents but innovators who reinvigorated Maya culture in thriving cities and kingdoms. Yet there are reasons for maintaining the designation of the Classic period (A.D. 250–900), which is the focus of this project.[7]

The Classic period was a time of intense growth across the Maya Lowlands. Maya ruling dynasties claimed deep roots going back to Preclassic times, but it was only after A.D. 250 that they adopted stone sculptures as vehicles for dynastic commemoration. Initially this occurred at Tikal and other cities in northeastern Petén. Concomitantly, scribes composed progressively longer and more detailed texts using the technology of writing (which the Preclassic Maya probably adapted from an earlier script invented in the Gulf Coast of Mexico).[8] During the Early Classic period (A.D. 250–600), the custom of erecting carved stelae with inscriptions that recorded the names of rulers, key events in their lives, and the calendrical and religious celebrations over which they presided spread across the southern Maya Lowlands and into selected cities in Yucatán. The finery of a deceased

Early Classic ruler at the site of El Zotz, Guatemala, conveys the wealth and splendor of Maya royalty. A jade-and-shell mosaic mask covered his face (fig. 6); he also wore large earspools and three celts hanging from a belt composed of rectangular plaques, all made from jade — the most valuable mineral known to the ancient Maya.

Throughout the Late Classic period (A.D. 600–900), the rulers of numerous cities, together with prominent members of their royal courts, were patrons to communities of scribes and artists, who produced texts and artistic records of outstanding quality; in these commissions, Maya kings and queens sought to highlight their close connections with deities and their performance of religious rituals dedicated to gods and goddesses. The inscriptions also reveal a political landscape of cities ruled by ambitious dynasts who built regional hegemonies through marital alliances, tributary relations, and warfare. At the same time, they built a sacred landscape, with cities dominated by temples that rose on tall pyramidal platforms, which were conceived as houses for the gods. This was a time of prosperity and demographic growth; a recent estimate suggests that seven million to eleven million people inhabited the central lowlands.[9]

This extraordinary boom came to a halt during the ninth century. The population plummeted, and numerous cities were abandoned. A growing body of paleoclimatic data suggests that environmental stress played a role in this radical transformation, but many questions remain about the ways in which lowland communities and their leaders responded to droughts, and about how the interplay of social and environmental factors led to dwindling populations and the abandonment of many cities.[10] The central lowlands were never completely deserted, though. Important settlements remained

6
Mask. Structure F8-1, Burial 9, El Zotz, Guatemala, 4th century. Jade, shell, approx. H. 7⅞ in. (20 cm). Museo Nacional de Arqueología y Etnología, Guatemala City, Ministerio de Cultura y Deportes de Guatemala

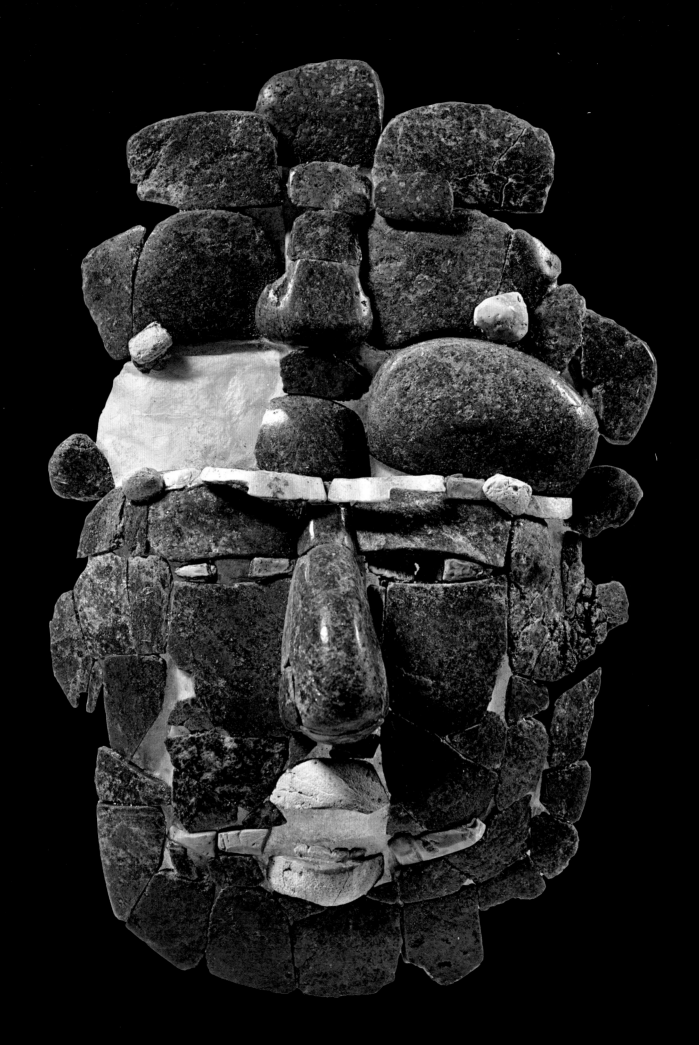

7

Lidded vessel with peccary. Structure F8-1, Burial 9, El Zotz, Guatemala, 4th century. Ceramic, Diam. 12⅜ in. (31.5 cm). Museo Nacional de Arqueología y Etnología, Guatemala City, Ministerio de Cultura y Deportes de Guatemala

in the lake region of central Petén, where the island city of Noh Peten ("great island," now Flores) persisted as the capital of a Maya kingdom until 1697, long after most Maya areas had become possessions of the Spanish kings.[11]

Maya peoples in the highlands and the drier regions of northern Yucatán flourished through the Postclassic period. Both regions were incorporated into the Spanish Empire in the sixteenth century. Colonization and Christianization transformed Maya communities, which experienced repeated cycles of disruption caused by war, political violence and repression, epidemic disease, forced cultural change, and interaction with European and African peoples.[12] Nevertheless, today Maya peoples retain much of their traditional lifeway, despite prevalent conditions of poverty and marginalization. Growing awareness

of the value of preserving their languages and cultures helps Maya peoples confront the challenges that result from increased participation in national politics and world economies.

Reading the Classic Maya Gods

Paul Schellhas's 1892 study of deities in Postclassic Maya codices inaugurated the systematic study of ancient Maya religion. The German scholar isolated representations of individual gods and goddesses, identified their name glyphs, and sought correlates among the deities that were mentioned in colonial texts. Unable to read the glyphic names, Schellhas introduced alphabetical designations that are still used today (for example, God A, God B, and so on).[13] Schellhas and other early observers also traced the basic conventions

that Maya artists employed to portray animals, plants, and humans. By the turn of the twentieth century, these researchers had published systematic works that allowed readers to identify, for example, the flat nose, hoofs, and hairy skin of a peccary (fig. 7) or the broad, downcurved mouth of a turtle (fig. 8).[14]

In subsequent decades, scholars gradually identified representations and names of deities in Classic Maya art and inscriptions. Eric Thompson's 1970 study *Maya History and Religion* synthesized a century of previous research. The noted archaeologist and epigrapher expertly surveyed the still barely readable hieroglyphic sources together with works by Spanish writers, such as the sixteenth-century friar Diego de Landa, and by Yukatek Maya authors who in the seventeenth and eighteenth centuries compiled prophetic and mythological texts in the Books

of Chilam Balam.[15] Thompson also drew from research conducted by ethnographers working in Maya communities, who recognized deeply rooted beliefs of Mesoamerican origin that had been merged with aspects of Christianity in the religious practices of modern Maya peoples. In addition, Thompson provided an important summary of Maya mythology that compared colonial sources with narratives compiled in twentieth-century Maya communities.[16]

Beginning in the 1970s, influential scholarly contributions came from Michael D. Coe. A towering figure in Olmec and Maya archaeology, Coe realized that there was a trove of imagery and textual data related to the Maya gods and goddesses on ceramic vessels from the Classic period — many coming to light owing to the accelerated looting of archaeological sites. In his 1973 catalogue *The Maya*

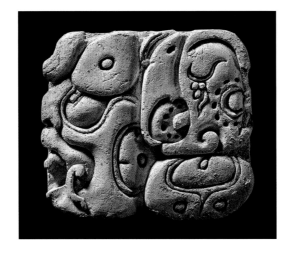

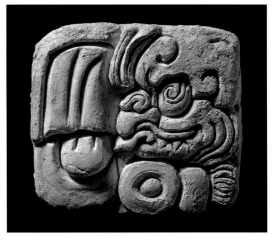

9

Glyph block, probably part
of the name of K'inich
Ahkal Mo' Nahb, ruler of
Palenque. Temple XVIII,
Palenque, Chiapas, Mexico,
600–800. Stucco, W. 6 in.
(15 cm). Museo Regional de
Antropología Carlos Pellicer
Cámara, Villahermosa,
Secretaría de Cultura del
Estado de Tabasco, Mexico

10

Glyph block. Temple
XVIII, Palenque, Chiapas,
Mexico, 600–800. Stucco,
W. 5¾ in. (14.5 cm). Museo
Regional de Antropología
Carlos Pellicer Cámara,
Villahermosa, Secretaría
de Cultura del Estado de
Tabasco, Mexico

Scribe and His World, and in subsequent
works, he demonstrated that these vessels
depicted mythical episodes involving the
deities on Schellhas's list as well as a host of
previously unknown characters.[17] He also
suggested that these representations could
be interpreted by comparing them with the
mythical narratives of the *Popol Wuj*.

Widely regarded as a literary master-
piece, the *Popol Wuj* (also spelled *Popol Vuh*)
was written in the mid-sixteenth century in
K'iche', a highland Mayan language spoken
by more than one million people today.[18]
The unnamed authors were members of
high-ranking families in the K'iche' kingdom,
which held sway over a large region of west-
ern Guatemala before the Spanish invasion.
The authors of the *Popol Wuj* lived in the
early decades of Spanish colonization and
interacted closely with Dominican friars who
introduced Christianity to their communi-
ties;[19] however, they centered their work on
recovering the *ojer tz'ij* (ancient word) — that
is, the stories that were known before the
arrival of the Spaniards. Although these writ-
ers focused on explaining the origin of the
K'iche' kingdom, the mythical narratives that
they collected in the *Popol Wuj* are compa-
rable to versions known from other colonial
and modern sources compiled in the Maya
area and elsewhere in Mesoamerica. Mythical

representations that relate to the *Popol Wuj*
appear in artworks created as early as the
Preclassic period, a testimony to the extraor-
dinary resilience of Maya religious beliefs.[20]

Major breakthroughs in the study of Maya
culture occurred in the decades that followed,
thanks to the decipherment of ancient Maya
writing. The aesthetic qualities of Maya
hieroglyphs had attracted the attention of
observers since colonial times (figs. 9–11).[21]
Nineteenth-century scholars unraveled the
mathematical structures and astronomical
significance of the Maya calendar, but it was
not until the mid-twentieth century that new
inroads in the phonetic decipherment of the
inscriptions enabled the texts to once again be
read in the language in which they were writ-
ten. While initial examinations indicated that
Classic Maya texts recorded history, further
research showed that information about the
lives and dynastic origins of kings, queens, and
noble people was invariably linked to their
performance of religious rituals, in which they
highlighted their relations with the gods. By
the late twentieth century, epigraphers were
able to read both the names of deities and
phrases that referred to their primeval deeds
and the cults that they received; this allowed
researchers to delve into the religious con-
notations of places, buildings, and objects
as well as concepts of divinity, personhood,

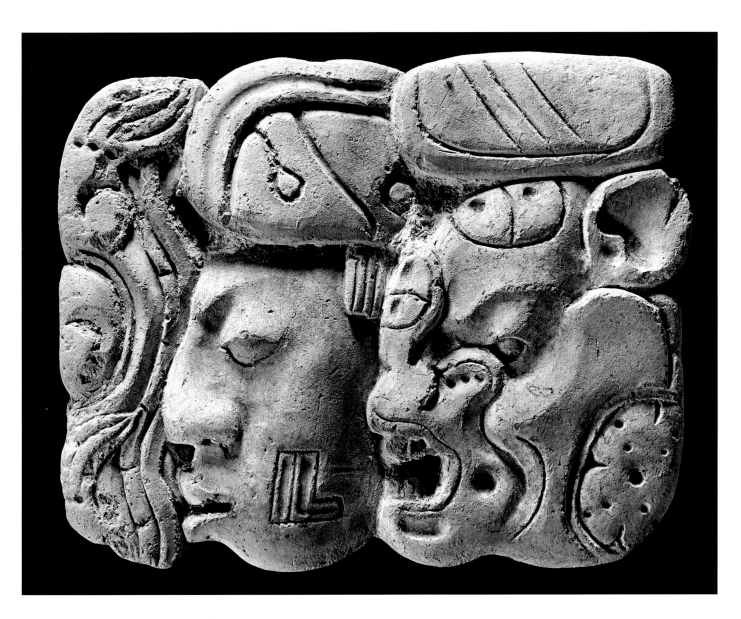

11

Glyph block. Temple XVIII, Palenque, Chiapas, Mexico, 600–800. Stucco, W. 8 ¼ in. (21 cm). Museo de Sitio de Palenque Alberto Ruz L'Huillier, Secretaría de Cultura–INAH

souls, and afterlife destinies without depending entirely on analogies with the religion of later and better-documented Maya communities. Hieroglyphic decipherment resulted in refined understandings of ancient Maya artistic and iconographic conventions.[22] Current approaches to the study of Maya religion involve nuanced interpretations of hieroglyphic texts together with careful comparisons with the *Popol Wuj*, other early colonial sources, and the traditional religion of modern Maya peoples.

Hieroglyphic readings and ethnographic parallels provide clues about how to interpret the ceramic flowers that initially sparked our curiosity. Two of them form a nearly identical pair and portray a deity, the Maize God (see figs. 1, 2). A defining attribute on each figure is the jewel that projects from the forehead. Equally distinctive is the elongated head, which is bald except for a band of hair across the brow. The leaf that extends upward on the right side of each whistle suggests that a flower and not a maize cob enshrines the youthful god. Ethnographic analogies come to mind: in mythical narratives from the modern Lacandon Maya people of northeastern Chiapas, the gods were born from

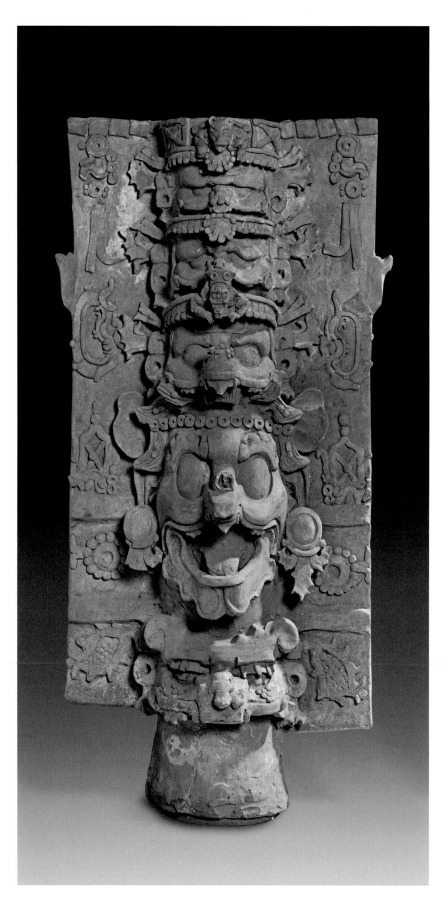

flowers; colonial texts from Yucatán describe a paradisiacal place of female flowers, where a god descended, taking the shape of a hummingbird to impregnate them; and Early Postclassic relief carvings from Chichen Itza show women emerging from large flowers as hummingbirds bite their breasts.[23]

By contrast, the other two whistles show old men emerging from the flowers (see figs. 3, 4). These old men may correspond not to deities but to ancestors, portrayed as flowers that grow in the world of the dead. Similarly, on the pillars of the largely unin vestigated Castillo Viejo at Chichen Itza, hieroglyphic captions associated with bas-relief depictions of flowering plants refer to the plants as *mam* (grandfather), suggesting that they are metaphorical representations of ancestors.[24] This is consistent with widespread beliefs shared by the Maya and other peoples of Mesoamerica about mythical places of beauty, abundant in flowers and precious objects, that were destinations in the afterlife. The deceased ancestors who resided there were sometimes portrayed as flowers themselves, blooming in those wondrous places.[25] Reverence for deceased forebears is an important component of Maya religion.

These four ceramic objects may have stood for something more than flowery portraits. Traditional Lacandon ritual life — which has endured significant change in recent decades — centers on a cult of clay censers, bowls with the face of a god on one side. These vessels are portraits of deities, but they are also conceived as seats where the gods rest during religious rituals. The censers themselves are believed to possess spiritual qualities and autonomy: "apart from being the

12
Censer stand. Probably Palenque, Chiapas, Mexico, 690–720. Ceramic, pigment, H. 44 in. (111.8 cm). Kimbell Art Museum, Fort Worth, Texas

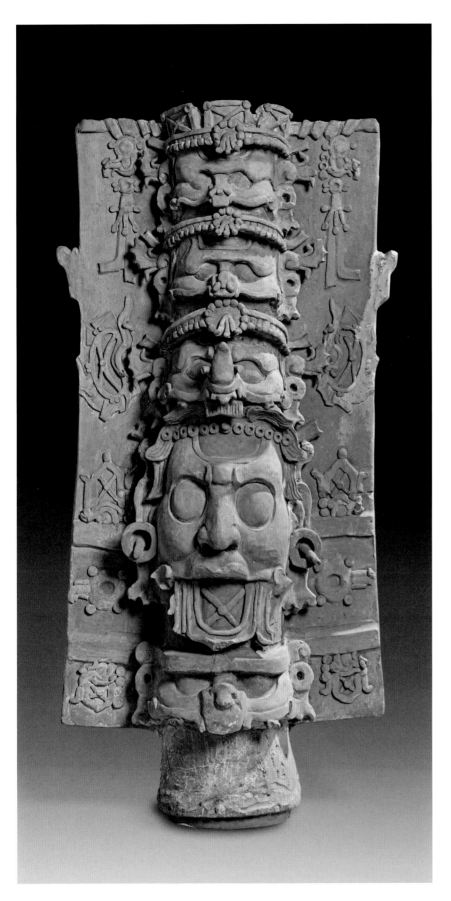

image of a particular deity, each censer also was a mystical entity in itself, in the sense that it had volition and power of its own."[26] Making censers is comparable to giving birth, and newly made censers must be cared for like children. Small stones placed inside the censers are regarded as their souls and the embodiments of the gods. People provide food and drink for the censers, which age and eventually die. Special ceremonies mark the death of old censers and their renewal with freshly made ones. Similarly, Lacandon ceramic drums have the face of K'ayom, the god of music, and are considered to be animated beings, engendered by the women who make them and educated by the men who add the membranes and play them.[27]

There are indications that ancient Maya ritual objects — such as the flowers that occupy our attention — were conceived as living creatures, like the modern Lacandon censers. The life cycle of Lacandon censers also provides a model to explain the ceremonial interment of censer stands at the Classic Maya city of Palenque. These ceramic cylinders were elaborately modeled with the faces of gods. Their features are partly human or animal-like, but some aspects, such as the large, oval eyes, are unnatural. One god, rising over a personified mountain, has jaguar ears and a skeletal mandible (fig. 12). Another, humanlike, has a pointed barbel marked with crossed bands in a mouth that has no mandible (fig. 13). Both wear headdresses consisting of three avian beings, one atop the other.

There is a smack of the grotesque in these masterful clay sculptures. In fact, that is a tendency in much of Maya art. In parallel with true-to-life depictions, Maya artists

13
Censer stand. Probably Palenque, Chiapas, Mexico, 690–720. Ceramic, pigment, H. 44 ⅞ in. (114 cm). Kimbell Art Museum, Fort Worth, Texas

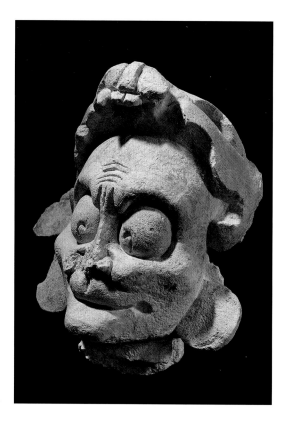

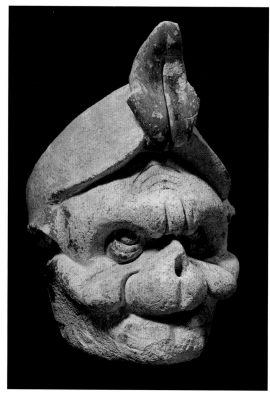

relished combining animal and human features in fanciful ways. Large eyes, frowning gazes, skeletal attributes, and menacing fangs are common. Examples include a series of fantastic stucco heads depicting mythical characters that were part of the reliefs on the exterior of the Casa del Coral, an architectural group built by Late Classic peoples near the gigantic pyramids of the Late Preclassic city of El Mirador (figs. 14–16).[28] The heads of deities and mythical characters sometimes had human appearances, but many were decidedly bizarre, even frightful. Their visages provided ample opportunities for the artistic imaginations of the ancient Maya.

This Volume

Lives of the Gods explores the transcendent concepts of ancient Maya divinity and the astonishing ways in which deities were rendered by the sculptors, ceramists, painters, scribes, lapidaries, and flintknappers active in the Classic period. In the opening chapter, James A. Doyle compares Maya ideas about divinity with those of other peoples in the Americas and elsewhere. Doyle brings attention to the landscape that the Maya conceive as animated, living, and inhabited by divine beings. The second chapter delves into Maya cosmogony (the explanation of world origins), envisioned as a series of struggles among the gods. Mythical episodes depicted in ceramics highlight the divine transgressions that set in motion creative processes that eventually resulted in the rise of the sun and the moon, the discovery of sustenance, and the life of people on earth.

In the third chapter, Stephen D. Houston looks at the regular cycle of day and night, and at the deities that presided over the sky, the sun, and the moon. Findings from a royal burial in the El Diablo pyramid at the site of El Zotz illustrate these aspects of Maya cosmology and religion. The following chapter by Doyle examines the gods of rain and lightning,

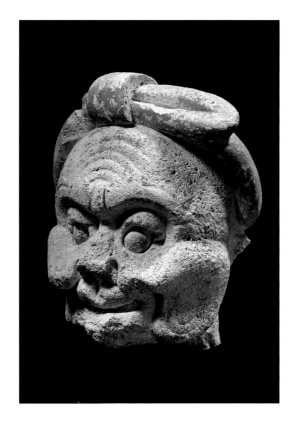

Chahk and K'awiil. For millennia, the successful management of water was key for Maya agriculture, and the gods who controlled such limited resources were paramount. Maya peoples depended on multiple crops for subsistence, chief among them maize. In his chapter, Daniel Salazar Lama reconstructs the mythology of the revered Maize God, a subject cherished by ancient Maya artists.

Since Schellhas's seminal work, scholars have concentrated their attention on the major deities. Yet refined readings of hieroglyphic texts show that, to a large extent, Maya peoples during the Classic period focused their religious cults on local deities that belonged to particular cities and their ruling dynasties. Caitlin Earley offers a survey of the patron gods of lowland cities, situating these deities amid a landscape of political contests revealed by the decipherment of inscriptions. Iyaxel Cojtí Ren harnesses the *Popol Wuj* and other early colonial texts to explore the cult of patron deities among the K'iche' and Kaqchikel. She relates her insights from colonial sources to aspects of the religious life of the modern Maya of highland Guatemala.

In traditional Maya religion, men and women conceive of their lives as perpetual negotiations with divine beings who control the cycles of day and night and own the resources of the earth, the production of rain, and agricultural bounty, sharing them sparingly with people. They demand constant attention and readily rescind their gifts if slighted.[29] They range from powerful overarching deities to a host of local patrons, ancestors, and owners of land features such as hills or springs (nowadays often named after Catholic saints and angels). The ancient Maya likewise conceived of innumerable deities, sometimes categorized in hieroglyphic texts as "the multitude of heavenly gods and the multitude of earthly gods."[30] While the complexity of their beliefs can be baffling, more than a century of research, boosted in recent decades by the decipherment of the Mayan script, has produced a substantial body of knowledge and a foundation for robust debates. *Lives of the Gods* distills recent scholarship on Maya deities and presents a wondrous corpus of representations from the masterly hands of the ancient Maya artists and scribes these divine beings inspired.

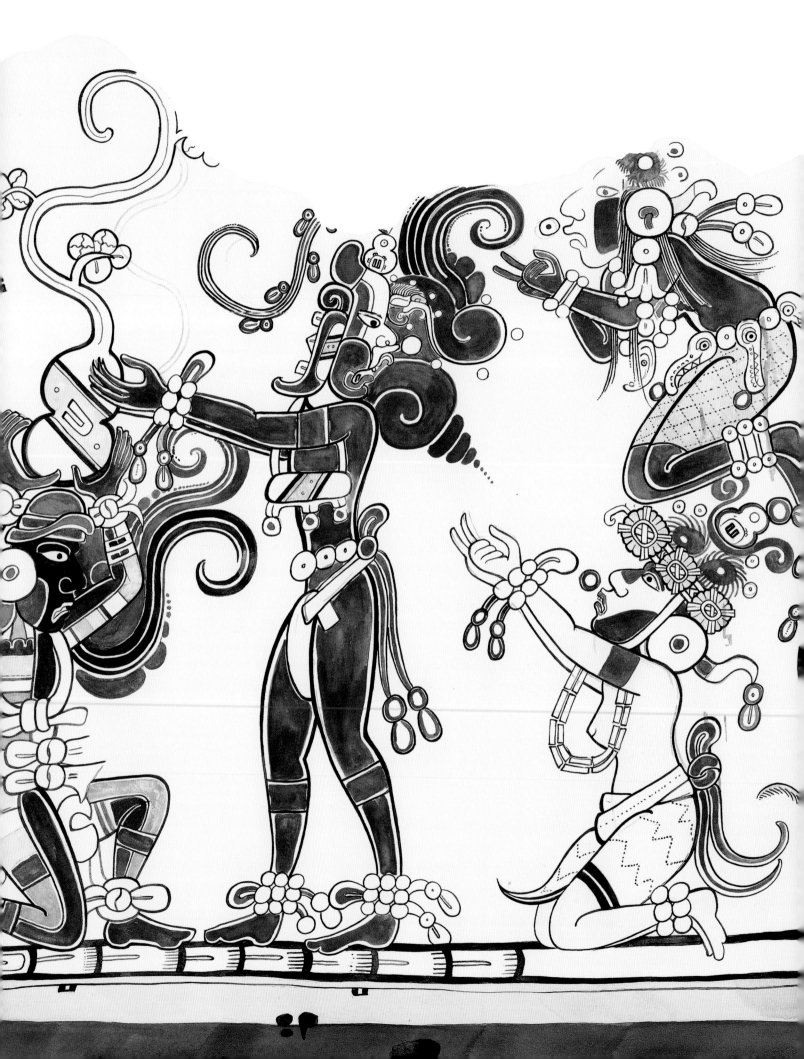

Lively Gods, Godly Lives

JAMES A. DOYLE

These were great temples wherein were the stone gods.
There all the lords of the Quichés [K'iche'] worshiped.
All the nations worshiped there as well....

There was an ilb'al — *there was a book.*
Popol Vuh [Popol Wuj] *was their name for it....*

The original book exists that was written anciently,
but its witnesses and those who ponder it hide their faces.

— POPOL WUJ

THE DETAILED FEATURES of a painted dancer — from the nail of the big toe, to the protruding ankle bone, to the fold of the skin in the twisting torso, to the lone unruly strand of hair — indicate that the artist aimed to inject the figure with humanity (figs. 17a, b). He has a graceful profile with a stoic expression that contrasts with his frenetic motion. Balancing on the ball of his left foot, he raises his right leg as he throws his right arm behind him, grasping a large axe, and holds aloft a stone implement with his left hand. The figure's muscular arms and legs, with defined curves and proportions, suggest a humanlike sketch. Upon closer inspection, however, the dancing figure transcends the merely mortal. Fishlike details emerge: a barbel sprouts from the face to frame the chin; scales glimmer on the rear of the legs; watery vegetation grows from the crown of the elongated head. The earflares, bracelets, anklets,

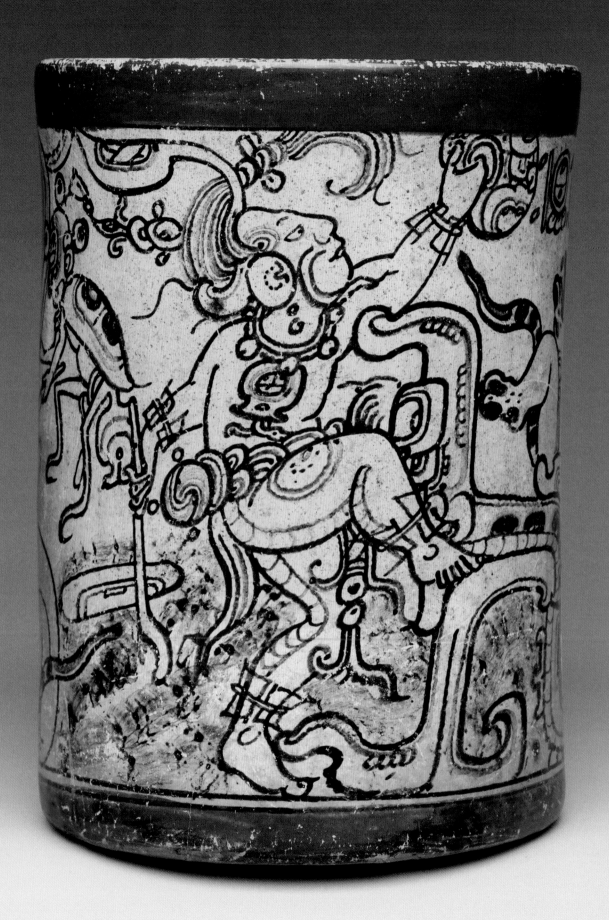

and pectoral are the trappings of a supernatural entity. He wields his shiny axe with other nonhuman characters in front of a mountain spirit in this vignette of a long-lost origin narrative.

This dancer on a drinking cup is likely Chahk, a god associated with rainstorms and rulership among the ancient Maya. Diverse Maya peoples built extraordinary cities in southern Mexico and northern Central America between about 250 and 900, a span known as the Classic period (see map on p. 10). Maya capitals, set atop the legacies of centuries of prior constructions, were built upon primordial places where maize farmers had settled long before, amid a powerful, tropical rainforest. The ruling families who controlled these royal courts were united by a lingua franca reflected in a complex hieroglyphic script, in which syllables and whole words took form as images. Their capitals boasted bustling marketplaces, ballcourts, and performance spaces, as well as plazas and buildings ornamented with sculptures and paintings that conveyed sacred symbols of foundational creation stories.

The visual culture recognized today as Maya coalesced in the first millennium B.C. The earliest major constructions, erected after about 700 B.C., were wide plazas and arrangements of buildings aligned with solar movements.[1] Dispersed settlers came together to create gathering spaces, perhaps united in a desire to materialize a big idea collectively or under the direction of a certain powerful individual or group. These early centuries are striking for their lack of explicitly royal or religious imagery on ceramics, on architecture, or in burials. The near absence of texts, too, underscores the aporia of interpreting early Maya monumentality: was it because of community cooperation or coercive service to powerful rulers — or a little bit of both?

By the Late Preclassic period (ca. 300 B.C.– A.D. 250), clearer evidence exists of royal families, hieroglyphic writing, and a shared iconography. The primary sources are few. But some, such as the extensive murals dating to 100 B.C. discovered at San Bartolo, Guatemala, are extraordinary.[2] Their complex facture, subject matter, architectural context, and artistry hint at a painterly tradition

17A
Attributed to the Metropolitan Painter (Maya, active 7th–8th century). Vessel with mythological scene. Guatemala or Mexico, 7th–8th century. Ceramic, pigment, H. 5½ in. (14 cm). The Metropolitan Museum of Art, New York, The Michael C. Rockefeller Memorial Collection, Purchase, Nelson A. Rockefeller Gift, 1968 (1978.412.206)

17B
Rollout view

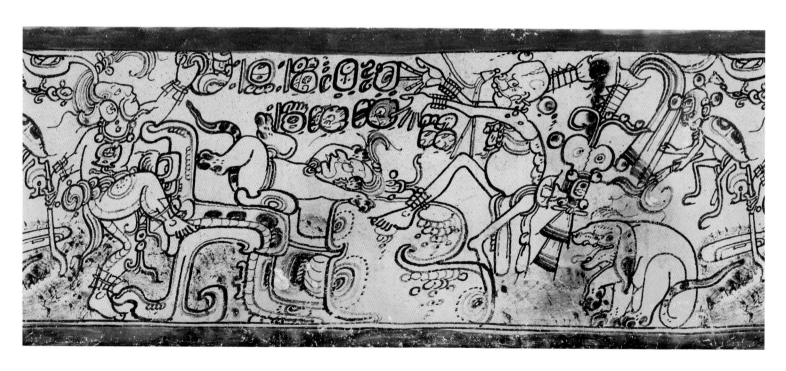

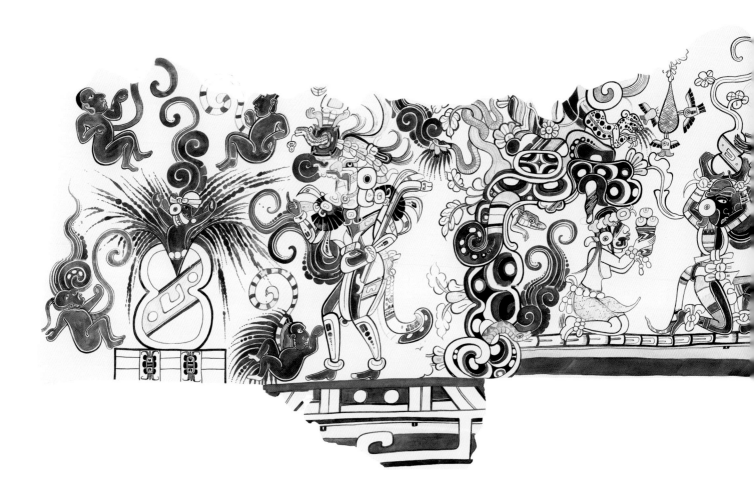

18
Reconstruction of the north
wall mural, Las Pinturas
Sub-1A, San Bartolo,
Guatemala. Watercolor by
Heather Hurst

that had a long germination. The presence of what is likely the hieroglyph (word sign) for lord (*ajaw*) also suggests that this political institution known from later times was well established by at least 100 B.C. The mural texts are not yet fully deciphered, but a scene that shows the presentation of a headdress to an individual supports the argument that those in charge held early claim to the *ajaw* title.[3] They may have achieved this leadership role through success during life or through inheritance, as part of a prominent family.

On multiple levels, the San Bartolo murals clearly illustrate the complexity of Maya religious thought as expressed by master artists. The colorful scene on the north wall shows a sacred landscape (fig. 18). Here, a mountain — an imposing, living being — is depicted with elliptic motifs (a third of the way from the

left, above), with a cave for a mouth and a stalactite tooth. This animate mountain rises above the feathered-serpent surface of the ground, supporting trees, mammals, reptiles, birds, and flowers. A procession of humanlike and divine individuals, differentiated by their physical traits, comes together in ceremony before the cave, from which emerges a woman holding a basket of holy food — in fact, the earliest known depiction of tamales. Behind the mountain, a winged individual observes a creation event, in which five infants, some with candy-striped umbilical cords, spew forth from an exploding monumental bloody gourd. The different self-contained tableaux suggest discrete events, snapshots in a grand origin narrative, the meanings of which are opaque to modern viewers. To the residents of San Bartolo, however, these stories were

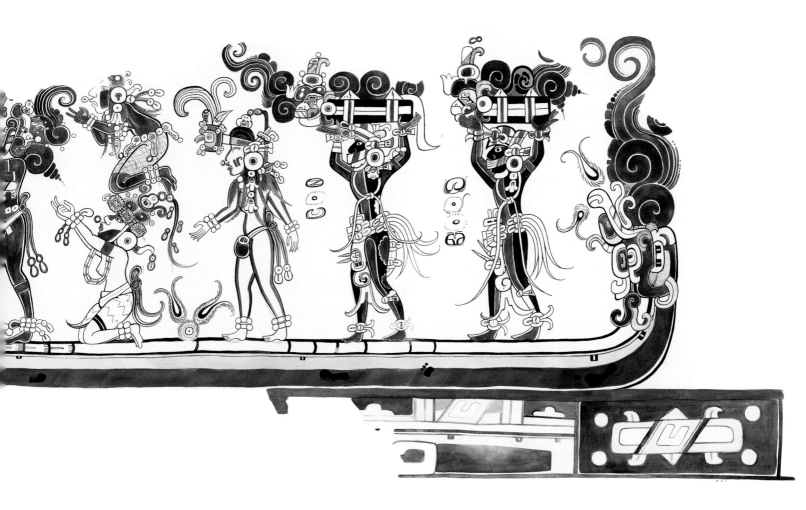

foundational to who they were, how they got there, and how they lived their lives.

Moreover, the San Bartolo murals reveal that, by 100 B.C., Maya religious thinkers and artists collaborated to depict natural forces as distinct personified characters. Graceful figures interpreted as male and female maize deities include, in one scene from the west wall, a male that dances and plays a tortoise-shell drum while wise water deities address him from seated positions (fig. 19). In another scene, four giant avian deities alight in front of four archetypal young lords, who burn offerings and draw blood from their foreskins with stingray spines. This quadripartite structure refers to the cardinal directions created by the sun's movement. Diving and singing figures, including a diminutive wind deity, perform their parts in this epic story.

Maya environmental philosophy and aesthetics, building on precedent from long-standing traditions in the region, were thus based around a cast of sacred beings that were the personifications of environmental features.[4] Falling rain, still water, lightning, the sun (both daytime and nighttime), the moon, and maize (and other staple crops) grew heads, arms, and legs. Artists bound the divine powers within humanlike bodies that experienced the mortal stages of youth and old age. The development of recognizable deities in the art of the Preclassic period set the stage for the Classic-period florescence of painting and sculpture, from the monumental to the miniature.

Across the global past, people gave human-like qualities to natural phenomena in order to make them tangible, understandable, and teachable. The material expressions of beliefs

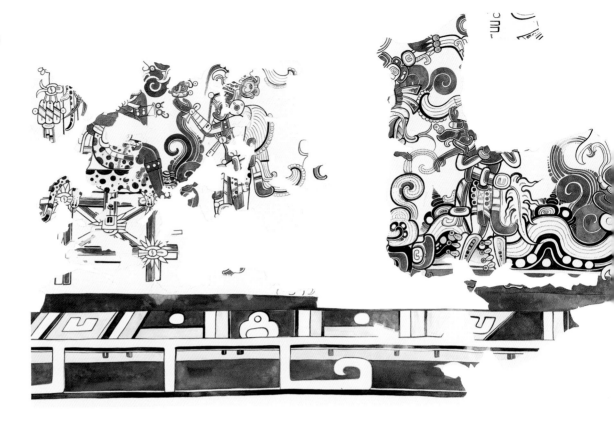

and creativity often provide only glimpses into the grand origin stories or morality tales that passed down orally from generation to generation, but they still preserve the power of the divine made visible. By understanding such historic examples, we ultimately learn about ourselves: how do we make sense of the divine, and how do we continue to personify and even deify the beliefs that we inherit from our parents and grandparents?

Divine Bodies in the Global Context

Deities are the personified manifestations of time, fears, natural phenomena, aspirations, and many more ephemera.[5] They are generally nonhuman agents that are considered sacred and powerful in absentia or present in rituals by inhabiting or being embodied by human-made images. They often existed in a time before humans. Origin stories tell of their creations and deeds, which take place in divine settings that sometimes mirror the earthly realm. Because deities often created humans or gave them the knowledge and tools to prosper, they issue further directives outlining the devotional practices that mortals owe them and engage in supernatural supervision, playing a role in social morality.

In the imaginations of human thinkers, and subsequently in artistic representations, deities take the forms of different components of physical reality: people, geology, flora or fauna, celestial bodies, or ephemeral phenomena, such as precipitation, light, or darkness. Many can also be intangible or amorphous, completely invisible, or impossible to describe. Several societies in the global past and present, however, ascribe humanlike forms to deities that embody or control natural forces.[6] They give them names, classifications, and attributes in addition to particular histories. Sometimes, sacred texts specify that humans themselves were created in the image of the

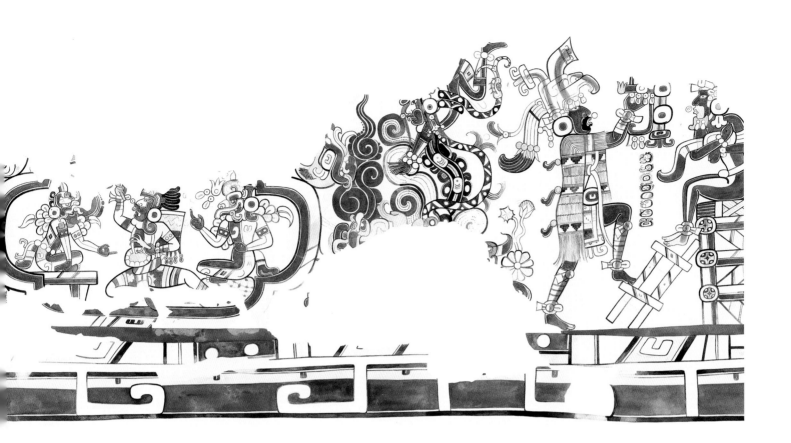

gods. As in the case of the Classic Maya, universal deities can be replicated on a local scale by individual rulers or dynasties.

There are countless religious models. Animism, for example, purports that divinity takes physical form in nature, while pantheism centers on an all-encompassing, indistinct divinity that permeates all physical and supernatural reality. The belief in divinity in distinct supernatural forms, theism, is understood as a spectrum between monotheism, belief in one supreme being, and polytheism, belief in many gods. Religions, however, are always in flux. Differing theologies at one time, or changing ideas over time, are often present in the same religious tradition. This leads to competing or parallel traditions emerging under the same model of the divine, which can be difficult to parse in the ancient world.[7]

The definition of a god varies greatly across the gamut of religious thought. In theistic religions, there are different levels of divinities governed by their own hierarchies, with varying degrees of godliness.[8] Pantheons, the groups of gods in particular religions, thus may grow over time as an exclusive definition of godliness expands to include other forces or concepts. Gods can be discrete or fluid personalities. There can even be semidivine characters, sometimes the offspring of gods with mortals, or mortals that attain divine status through their deeds in life or through their bloodlines. Ancestors, pharaohs, or emperors whose physical bodies are no longer animated with mortal life force can take on divine status as they cross over to afterlives or another world.

In ancient Egypt, for example, gods were described as *ntr* or *ntrt*, meaning they existed outside tangible, everyday human life in a divine realm.[9] They were understood as mythic personalities and were worshiped through sculpted statues and

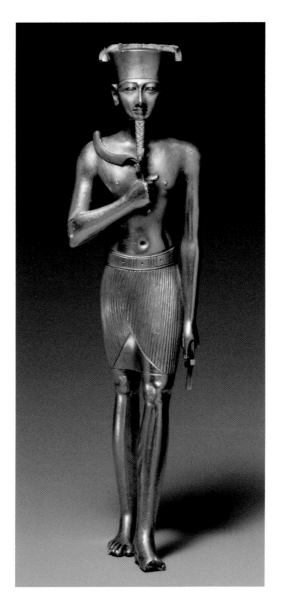

reliefs in temples and shrines. Cult statues
thus conveyed multiple levels of meaning
in addition to community or political affili-
ation. Representations of Egyptian deities,
and the hieroglyphic for *ntr*, initially took the
shape of inanimate objects, transitioned into
zoomorphic forms, and eventually assumed
anthropomorphic forms, such as a gold figure
of Amun (fig. 20). In this sculpture, he is a
bearded individual, striding forward, carrying
a weapon and an ankh emblem, and wearing a
crown (missing its plumes) and braided beard.
Inhabiting its statue, a deity could reside in
the temples that provide its earthly home,
thereby allowing the god's being to be present
during the ceremonies needed to help main-
tain or even encourage cosmic order.

Later, human leaders were identified
with gods, such as the falcon deity Horus,
the divine model for the ideal king.[10] Deities
carried with them superhuman abilities, and
their roles seem to vary depending on context.
The development of imagery and hieroglyphic
names for a divinity over time often signaled
such a conceptual change as well. Some exam-
ples of Egyptian deities conflated human and
animal forms to merge different divine identi-
ties, suggesting that one god inhabits the body
of another.[11] A single divine force, Amun
(Hidden), merged with the sun (Re) each day,
and artists represented the combined being
as Amun-Re.[12]

As religions circulated in the global past,
styles of representing the divine traveled and
morphed into new traditions. For example, as
Buddhism spread in the early first millennium
through regional trade from the Indian sub-
continent to Southeast Asia, artists created
monumental representations of deities in new
places regarded as sacred.[13] One illustrative
case is the Bodhisattva Maitreya, the Buddha
of the Future, which was portrayed through-
out South Asia in myriad media, scales, and
styles. Sculptors in this region excelled at lay-
ering multiple divine identities in one bodily
form, such as the Hindu deity Harihara, who
combined aspects of both Vishnu (Hari) and
Shiva (Hara) (fig. 21).[14] The subtle division
down the center line of the body emphasizes
the contrasting divine attributes on either
side, such as the curled locks of Shiva's hair
opposite Vishnu's smooth, tall headdress.
Artists also gave visual expression to certain
aspects or powers of creator deities, such as
omnipresence, by depicting multiple faces
or limbs.[15] In images of Brahma, a Hindu
creator ancestor, one serene body adorned
with a detailed, pleated skirt supports the

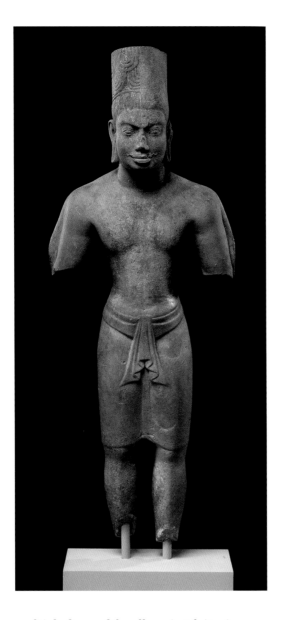

multiple faces of the all-seeing deity. Across South Asia, sculptures are activated during special ceremonies with perishable clothing, metal jewelry, and offerings of substances and prayers.

In ancient Greco-Roman traditions, the divine could be experienced and made present through sculpture and the subsequent activation of images in ceremony. Aesthetic choices were thus theological ones, and sculptors navigated the constant tension between deity and representation. Epiphanies, the manifestation of deities to human believers, became durable in painted or modeled form.[16] Mediterranean

polytheism traveled far and wide through oral traditions, along with naturalistic representations of deities within humanlike bodies. Subtle details and differences in narrative and visual presentations allowed performance attendees and devotional viewers to distinguish the divine beings in Greco-Roman art's rich pantheon. Sculptors transformed materials like bronze into the soft fleshiness of divine bodies, cloaking the mythic beings in humanity. For example, Eros, a god of love, is often depicted napping peacefully in a childlike guise. Hellenistic poets reference the Sleeping Eros statues, with warnings not to wake the sleeping god.[17] The sweet curls and plump body read as human, while the wings gently folded along his back signal that this deity is ready to spring into flight. Adult Olympians and semidivine individuals alike were depicted with idealized athletic bodies with naturalistic musculature and bodily positions. Other forces from the pantheon manifest in images of humans blended with domesticated or wild animals, sea creatures, or fanciful beasts.

Christian religious art addresses the mediation of the divine — centered around an omnipotent, tripartite creator god — and the mortal. This is especially evident in the events surrounding the birth of Jesus Christ, the instantiation of the supreme deity in human flesh. Mary, the human mother of Jesus, has been venerated and represented in multiple ways that allow Christians to visualize the corporeal being whom the Holy Spirit visited. Artists in the Rhine valley in Germany made shrines of the Virgin Mary in which her body was a holy vessel for the Trinity, allowing the miracle of Incarnation to be revealed and reenacted in moments of personal devotion (fig. 22). Later Renaissance depictions of Christ and Mary emphasize their fleshy bodies and liturgical vestments, while portraying divinity through attributes such as halos to

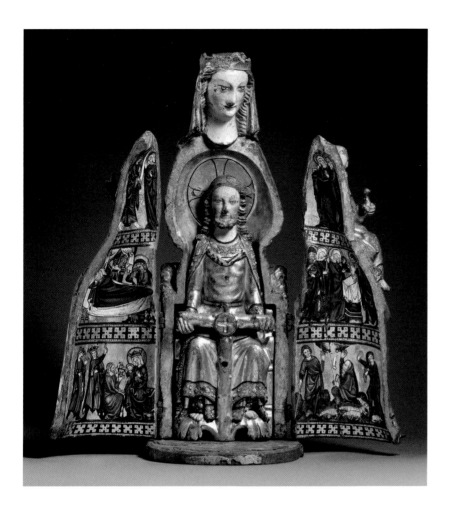

22
Shrine of the Virgin.
Germany, Rhine valley,
ca. 1300. Oak, linen
covering, polychromy,
gilding, gesso, H. 14 ½ in.
(36.8 cm). The Metropolitan
Museum of Art, New York,
Gift of J. Pierpont Morgan,
1917 (17.190.185a, b)

create a visual tension between the human and the holy.

Creation narratives and genesis events have played important roles in inspiring artistic representations into the early modern period and the present. Sculptors have shaped divine creator couples who were model ancestors, as well as culture heroes who were originators of life-giving forces, such as agriculture. Bamana artists in what is now Mali, for example, made sculpted headdresses as part of ritual assemblages worn and performed in dances as a male-female pair of antelopes.[18] The female antelope, carrying her offspring on her back, was positioned atop the head of the performer, who also donned a full-length raffia costume that covered the body and undulated with the dance movements. These works and events celebrated Ci Wara, a

legendary, semidivine figure who introduced farming to mortals.

In Polynesia, the divine power of the universe was entangled with human genealogy and the sacred spaces and objects that mortals created.[19] The gods (*atua*) could be encouraged to travel to the human realm (*te ao*) of brightness and clarity (*atea*) from the place of darkness (*te po*) through the dynamic activation of ritual objects, some of which were known as *to'o*, or god images. *To'o* were wrapped in special materials and housed in separate dwellings, then removed and deployed periodically. The physical motion and aesthetic presence required to welcome the gods in ceremony is embodied in works such as the scepters from the Austral Islands. Ritual practitioners spun or twirled these composite sculptures during ceremonial protocol. Made from sacred materials, they often featured diminutive god images, such as a single figure in motion. The angular, abstracted figure on top of one example transforms when viewed from different angles, appearing at times as a single being or as multiple overlapping beings (fig. 23). The movement of such images thus created a constantly shifting godly body who calls to his peers to join them in the bright place.

Whether abstracted or stylized, naturalistic or idealized, some common visual characteristics emerge when investigating how artists chose to make the divine incarnate throughout history. Some deities were depicted, while others, such as the Allah of Islam, were explicitly forbidden to be represented. Gods could be portrayed as smooth, perfect beings in testament to their qualities of immortality or eternal youth. They could be animals or part animals, powerful wild or domesticated creatures that walked among people. Superhuman powers of all-seeing, flight, reincarnation, or galactic speed could be captured in still images or in performances.

Detail of a scepter (*tahiri*).
Austral Islands, Rurutu
or Tupua'i Island, early
to mid-19th century.
Wood, coconut fiber,
human hair, H. 30 ¼ in.
(76.8 cm). The Metropolitan
Museum of Art, New
York, The Michael C.
Rockefeller Memorial
Collection, Bequest of
Nelson A. Rockefeller, 1979
(1979.206.1487)

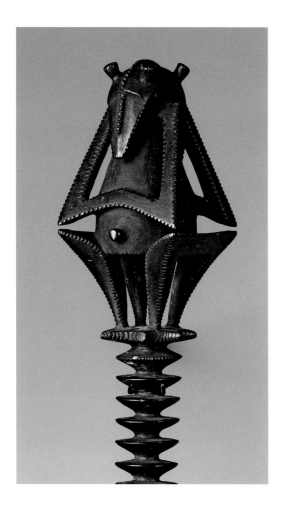

In many traditions, artists made the divine relatable by including markers of humanity in the details.

At times, the act of creating a transcendent image from one's imagination using mundane materials was itself considered divine. The Italian Renaissance artist Michelangelo, for example, acquired the nickname Il Divino (the divine one) for his mastery of sculpting, painting, and *disegno* (drawing and design).[20] Painted or sculpted forms such as those created by Michelangelo revealed divine energies to human devotees, allowing patrons, specialists, and common folk alike to access the secrets of the holy. Such godly images were so powerful that they also became dangerous for those with opposing views; iconoclasts in some regions aim their malice at the visages of gods to deactivate their divine supervision.

Similarly, ritual practices among different societies past and present amplified the godly aesthetic through sacred architecture, texts, and kinetic performances. Artistic innovations thus infuse daily lives with divine motivations and outcomes.

Divine Landscapes of the Americas

The arts in the ancient Americas, and the intellectual trajectories that accompanied them, grew in splendid isolation. When European colonizers arrived in the New World, they encountered a universe with sophisticated but totally distinct traditions related to divinity and image. Yet common threads united the Americas, just as the connectedness of other ancient societies — in Egypt, Turkey, Mongolia, India, China, the Mediterranean, and sub-Saharan Africa — allowed technological and artistic innovation to spread from one culture to another. Thriving trade routes — in gold, silver, turquoise, marine shells, textiles, and even tropical bird feathers — connected artistic communities throughout the modern nations of the Western Hemisphere.[21] These routes, trampled only by human or llama feet, crisscrossed mountains and connected to seagoing routes along the coasts of the Atlantic, Pacific, and Caribbean.

Mountains were, in a sense, the anchors of art in the ancient Americas. The continuous mountain chain stretching from the Arctic to Patagonia provided shelter and sustenance, while its jagged peaks and tumultuous rock forms inspired awe with their outsize scale. Mountains were at once comforting as natural defensive vantage points and threatening as shaking, shifting, erupting forces. They touched the sun, moon, rivers, and seas. Their fertile soil — the pulverized stones of the crags — nourished plants and animals, and their caves sheltered dark echoes in the recesses of the netherworld. For these

reasons, mountains were vital agents in the environmental philosophy of early Americans.

Peoples who lived in the shadow of mountains recreated them in paintings, sculptures, and other forms of representation. From these divine mountains sprang creator couples, the sun, the rain, and other foci of religious beliefs. Those who lived far away deified the peaks and mythologized them as distant powers. Volcanoes, mountains that rumbled alive periodically to spew forth ash or lava, inspired architectural and sculptural creativity.[22] Mountains also provided raw material for artworks. The human-made products that were derived from mountains' veins reminded the individuals who produced and used them about the natural order of things. Pilgrimages allowed people to collect such resources and simultaneously honor the mountains as primordial ancestors.

Mountains were, and in many places still are, the conceptual center of communities, whether physical or spiritual. In the Andes, for example, the centrality of mountains is well documented.[23] The snowcapped peaks were thought of as ancestral beings who watched over their realms. Sacredness in the environment and in relation to other things or people was expressed by Quechua speakers as *wak'a*, a word that also refers to mountains or even special individual stones.[24] Places, ritual objects, or people could all be *wak'a*.

Concepts similar to *wak'a* seem to have existed in the northern Andes and societies in the Caribbean region. Late fifteenth-century accounts in the Antilles, for example, describe *zemí*, a force pertaining to deities and ancestors in the environment — trees, stones, or other parts of the landscape — that inspired painted and sculpted images.[25] Artists in the Antilles sought out veins of special greenstones to create tangible ritual objects that took abstract mountainous forms. Oral traditions known as *areitos*, passed down from generation to generation through celebrations and communal feasting, were the performed histories of gods and humans on the islands. On the mainland, in Colombia, Panama, and Costa Rica, gold, silver, and copper mining allowed metalworking to flourish. The extraordinary objects that captured the divinity of the sun and moon in gold or silver served as transcultural power symbols, connecting leadership in the Caribbean and Pacific regions to the bounty of the mountains.

The Mesoamerican Divine

The Maya visual world grew from thousands of years of oral histories and expressive culture in the broader region. The aforementioned San Bartolo murals exhibit features that permeate earlier visual traditions in Mesoamerica. The first material forms given to concepts from the natural world come from artists of the Olmec civilization, dating to about 1600–400 B.C.[26] One aspect of Olmec art is an emphasis on four corners and a center. That quincunx shape is a symbolic representation of the four cardinal directions and the axis mundi, the central line that connected the layers of the world. This spatial orientation was foundational for successor cultures, including the Maya.

The distinctive Olmec iconography includes both a cleft mountain as a primordial creation place and a divine personification of the maize plant, especially after 800 B.C.[27] Maize sprouts, the green shoots of corn that signify the beginning of a propitious growing season, accompany the deity, who seems to have several different aspects. On a jadeite axe, itself symbolic of a sprout of maize, an artist incised a supernatural figure in profile, wearing an elaborate headdress, facing the viewer's left (fig. 24). The snarling, downturned mouth with prominent upper lip and protruding sharp incisor, L-shaped eye, and

earflare assemblage are indicative of a super-natural being. The headdress itself is crowned by a V-shaped cleft, from which a cross shaped maize sprout emerges, identifying this figure as the Olmec Maize God. Olmec artists also depicted a god of storms, personified as a fanged supernatural being with cloudy swirls on its enlarged head, in greenstone and relief sculpture. Other fantastic creatures with feline, avian, and reptilian attributes populate the rich religious and visual worlds of the Olmec.

After the decline of Olmec-style artis-tic production and about the same time as painters were putting the finishing touches on the murals at San Bartolo, farming villages around the Basin of Mexico began to invest in a colossal urban-planning project known today by the later Nahuatl name Teotihua-can, roughly the "place where man met the gods." Teotihuacan was truly a painted city. It is estimated that millions of square feet of the city's walls were covered in fresco paint-ings (fig. 25).[28] For centuries, the residents of Teotihuacan commissioned for their homes and ceremonial spaces bright murals featur-ing human characters, deities, fanciful beasts such as feathered serpents, and processional and narrative scenes with chaotic activities reminiscent of those found in the paintings of the fifteenth-century Netherlandish artist Hieronymus Bosch.

Much of the surviving information on Mesoamerican religions and depictions of deities comes from the few surviving Mexica and Mixtec books, dating from the fourteenth to the sixteenth century, from central and southern Mexico.[29] The great city of Tenoch-titlan, the forebear of modern Mexico City, was the capital of the empire of the Mexica (also known as the Aztec Empire). The city grew from the widely held concept of the *alte-petl* (water-mountain) as the center of a polity whose residents self-identified as a loosely

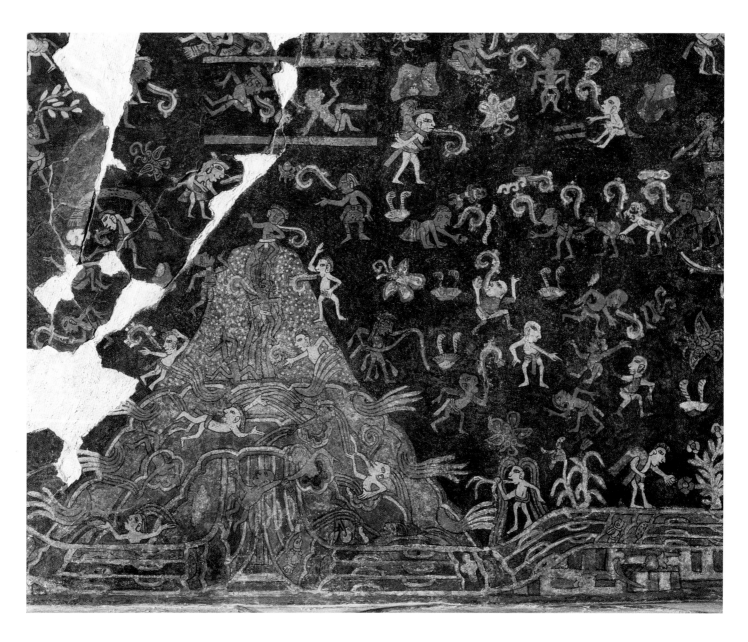

Mural with mountain
scene (detail). Tepantitla,
Teotihuacan, Mexico,
350–550. Secretaría de
Cultura–INAH

held unit, distinct from their neighbors.
Altepetl came to mean "city-state." Bringing
this powerful landscape metaphor to life, the
imperial *altepetl* of Tenochtitlan rose from
the center of Lake Texcoco as a human-made
mountain.[30]

At the heart of Tenochtitlan was the
Templo Mayor, the main temple of the Mexica,
which took the form of a large pyramidal plat-
form with two temples on its summit. This
arrangement represented another powerful
concept: Coatepec (Serpent Mountain). The
temple to the north was dedicated to the earth

and rain god Tlaloc, and the southern temple
was dedicated to Huitzilopochtli, the deity of
the sun and patron of the Mexica. The earli-
est version of the Templo Mayor was erected
in the fourteenth century; it was renovated in
subsequent generations at least six times.[31]
This was a legendary place where Huitzilo-
pochtli dismembered Coyolxauhqui (She
with Copper Bells on Her Cheeks), his sister
and the moon goddess, as punishment for her
conspiracy with their siblings to murder their
mother, Coatlicue (She of the Serpent Skirt).
Artists represented the doomed Coyolxauhqui

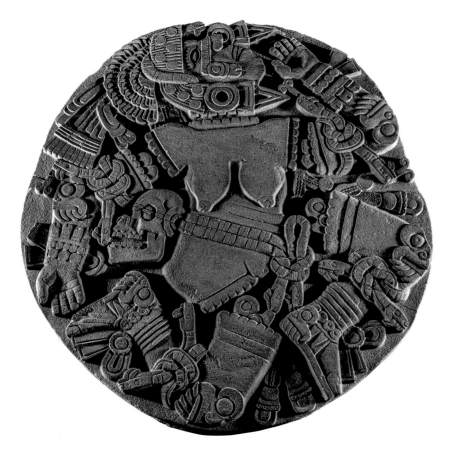

word *teotl* as a conceptual and linguistic equivalent to the Spanish *dios* (god), but the current scholarly consensus is that it has a more layered meaning that includes sacredness in things, deities, and images.[33] Other Nahuatl words convey the rich nuances in godly identities, such as *ixiptla* (impersonator or image) or *ixiptlahuan* (god surrogates).[34]

Images and names of Nahua deities from painted books that predate European colonization show that artists also used visual clues, such as specific regalia, to distinguish or combine deities (fig. 27).[35] After obtaining different attributes, individual gods could perform multiple functions as split or aggregate personalities, acquire the powers of other beings, or even impersonate other divine beings. This fluid quality of godly representations, as well as the concept of a mountain as a place of origin, predates the Postclassic Nahua by centuries, as is clearly visible throughout Classic-period Maya art.

26
Coyolxauhqui. Templo Mayor, Tenochtitlan, Mexico, 1469. Stone, Diam. approx. 10 ft. 8 3/8 in. (3.26 m). Secretaría de Cultura–INAH

27
Spider monkey with Wind God regalia. Mexico, 13th–16th century. Stone, H. 15 5/8 in. (39.7 cm). The Metropolitan Museum of Art, New York, Gift of Brian and Florence Mahony, in celebration of the Museum's 150th Anniversary, 2017 (2017.393)

and her mother in some of the most iconic megalithic sculpture from the ancient world (fig. 26). Coyolxauhqui's stony visage emerging from the lunar disk gazed up at her brother's temple from the foot of the southern stairway of the human-made Coatepec, recreating her divine anguish for devotees of the Templo Mayor passing by her dismembered body.

Sixteenth-century European accounts, such as the Florentine Codex, equated the deities of the Nahua — a term that refers to speakers of the Nahuatl language, including the Mexica — with their ancient Roman counterparts. The Franciscan priest Bernardino de Sahagún and his Nahua coauthors connected Huitzilopochtli to the semidivine hero Hercules; the sower of discord Tezcatlipoca to the sky god Jupiter; the maize deity Chicomecoatl to the goddess of agriculture and fertility Ceres; and so on.[32] Religious authorities in the colonial period identified the Nahuatl

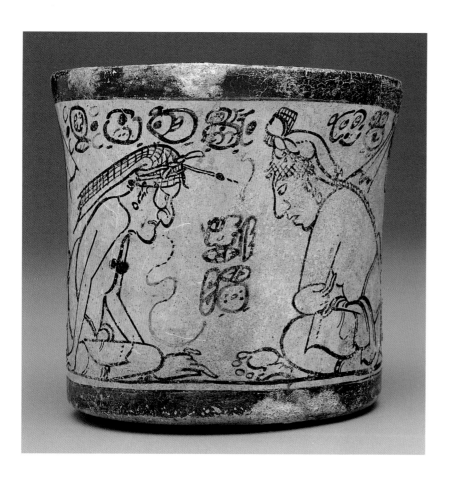

28
Codex-style vessel.
Guatemala or Mexico,
700–750. Ceramic, pigment,
Diam. 4⅛ in. (10.5 cm).
Kimbell Art Museum, Fort
Worth, Texas

kept vital wisdom, and goddesses in turn played crucial roles as midwives, ensuring the continuation of the generations.

Rich ethnohistoric accounts from across Mesoamerica inform the study of ancient traditions. Certain subjects of religious stories seem to have endured from precolonization periods, many of which — sun, moon, corn, elders — are still relevant to contemporary societies. The stable parts of stories can be considered nodal subjects, the structures that underlie narratives that take on local or time-specific idiosyncrasies.[36] Specific deep-held beliefs are evident in ritual performances and other parts of everyday community life. The variations among them underscore that ancient representations of deities and their associated stories were adapted in different places and across time.[37]

Recent advances in hieroglyphic decipherment have opened a window onto the diverse religious narratives of the Classic period. We now know how the artists themselves described sculpture and painting and have gained a fuller understanding of their complex visual parables. The newly unlocked script has also revealed the long-lost identities of many ancient Maya artists (see figs. 57, 94), as well as the names of various origin mountains and the gods that were born there (discussed below).

**Born from Mountains:
Gods of the Classic Maya**

Gods, for the Classic Maya, were born from mountains, the place of emergence of the three forces vital for life in the region: sun, rain, and maize. Artists personified the sun's intense power, which produces the colors of the visible spectrum of light, causes plants to lean toward it, and even makes midday intolerable without shade. The sun, after sunset, begins its nighttime journey under

Scribes, artists, and elders preserved and passed on deity stories across Mesoamerica. This tradition appears on the side of Maya codex-style drinking cups from the Classic period. On one of these cups, a lively conversation takes place between a pair of elderly deities instructing four younger pupils (fig. 28). The deity on the left is speaking words, and his bearded counterpart on the opposite side is speaking of numbers. Such aged spirits were the keepers of knowledge, the banks of intergenerational healing, oral histories, and hope. They, along with the younger scribes who told the vital stories of communities and gods, kept the cycles of time moving. Scribes could be supernatural as well, as seen on a codex-style vessel found at Nakbe, Guatemala. Here an elaborately dressed individual with deer ears and marked with "night" glyphs references a codex bound in jaguar skin (fig. 29). Elderly women also

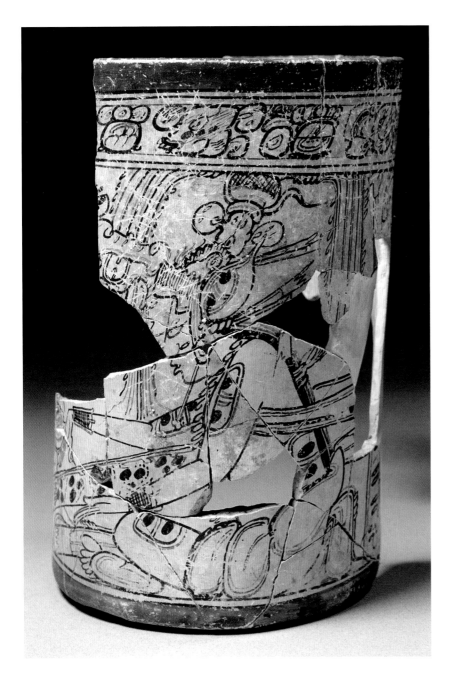

crop. Maya artists created visual similes between the life cycle of corn and the lives of maize deities. Maize, in its infancy, sprouts as a blue-green shoot and matures into a wispy stalk with undulating leaves crowned with a fluffy tassel. As the ears grow, the stalk widens to support the weight of the seed-bearing ovules, and wind transforms the maize field into a crowd of dancers as the plants strain against their bracing roots. As the rains dwindle, harvesting begins, separating and retrieving the ears from the yellowing plants, so that the dried bones of the cob can be stored and used to seed the next year's crop.

The solar and agricultural cycles served as building blocks for scribes to construct dynastic histories in which Maya rulers were protagonists in the divine landscape. Royal genealogies could be expressed as natural phenomena; ancestors peered down from the clouds to bless their descendants. Artists frequently focused on the daily lives of rulers, reflecting the courtly actions of self-proclaimed divine leaders.[38] Artists represented human performances that channeled godly identities with mythic glosses, such the imagined epic flight of a monstrous avian being. Celebrations lasted as long as the reign of the daytime or nighttime sun, and special moments in rulers' lives were equated to liminal blazes at dawn and dusk as solar entities collided with the earthly plane. More rapid phenomena, such as the sudden appearance of a violent thunderstorm heralded by split-second flashes of lightning, also became important beings based on human forms.

These grand and small cycles centered on the concept of an otherworldly, floral mountain, home to ancestors and gods.[39] From this mountain they were born and ascended into the sky. The eastern horizon, where the sun first appears, was a place of honor and a contact zone between the earth and the sky, where moisture accumulates and transforms

29
Codex-style vessel with scribe. Grupo Códice, Nakbe, Guatemala, 8th century. Ceramic, pigment, approx. H. 15 ¾ in. (40 cm). Museo Nacional de Arqueología y Etnología, Guatemala City, Ministerio de Cultura y Deportes de Guatemala

the dark earthly realm, while its counterpart, the moon, reigns over the night, along with planets such as Venus and the infinite stars. Keen astronomers, Maya observers charted phenomena such as eclipses, when the moon crosses the sun, representing a conflict between light and darkness. Cycles of planetary bodies or alternating wet and dry seasons dictated the verdant crescendo and subsequent dessication of maize, the staple

30
Mosaic facade. Río
Amarillo, Honduras,
8th century. Stone,
W. 9 ft. 10 ⅛ in. (3 m).
Sitio Maya de Copán,
IHAH

into life-giving rain. Artists referenced the divine realm in Maya art through flowers, jade, and images of song and sacred breath. Pyramidal platforms were thus human-made versions of the mountain, known in the texts as *witz* (fig. 30). Stone and stucco portraits adorning the platforms represented these mountain deities with gaping, cavelike mouths and rocky outcrop foreheads. Rulers thus transformed architectural spaces into a paradise for residents to behold, one that contrasted sharply with a dark nether-world accessed by caves, the nature of which remains little understood.

Images of divine birth survive on drinking vessels, the most widely used canvases of Maya painters. In the kingdoms near Lake Petén Itzá, Guatemala, artists achieved unparalleled success in polychrome scenes of momentous otherworldly events.[40] Two vessels that might have been created by some of the same hands stand out for their virtuoso technique. On one, the scribe set the scene and described the action: *sihyaj k'uh uhtiiy jo'chan naah witz xaman*, or "[a] god was born; it happened [at] Jo'Chan Naah Mountain in the north" (fig. 31).[41] The mountain is depicted as five anthropomorphic

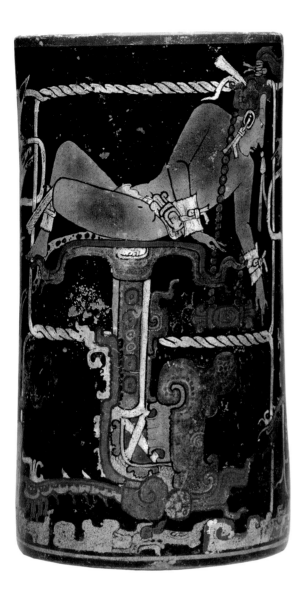

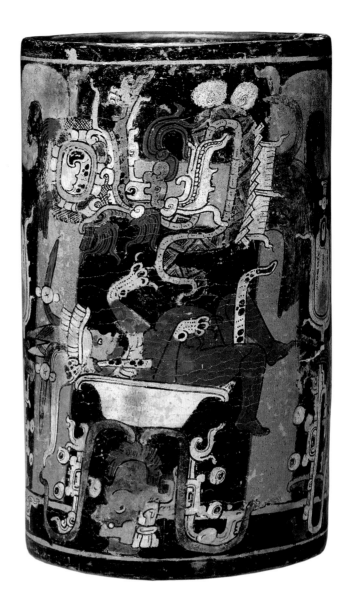

31
Cylinder vessel. Motul de San José area, Guatemala, 755–80. Earthenware, pigment, H. 8⅞ in. (22.5 cm). Museum of Fine Arts, Boston, Gift of Landon T. Clay

32
Cylinder vessel. Motul de San José area, Guatemala, 740–80. Earthenware, pigment, H. 9 in. (22.7 cm). Museum of Fine Arts, Boston, Gift of Landon T. Clay

mountain-deity (*witz*) forms in profile along the ground line; one large head in profile with a gaping mouth represents the stony earth crocodile with cross-banded eyes. At center, a resplendent, reclining deity, presumably the one who was born, is identified by name, though it is difficult to decipher. He shares formal attributes with the Maize God, including an elongated skull and tasseled hair. Jaguar ears and a jaguar tail suggest he is a specific nighttime deity. Though largely unclothed, he wears earflares, a nose bead representing sacred breath, bracelets, anklets, and a beaded necklace with a ponderous pendant.

On the second vessel, on a different date, another god, Wuk Ye Took', was born on a "white" mountain: *sihyaj k'uh wuk ye took' utiihy sak witz* (fig. 32). Wuk Ye Took' takes the form of a corpulent infant with a human-like face but jaguar paws, ears, and tail. He wears an elaborate headdress with flint blades (*took'*) that might be specific to his identity. From his umbilicus emerges an elaborate diamondback, feathered, and fiery serpent. The serpent grasps an elaborate shield in its mouth, suggesting that the newborn deity might convey martial power onto the recipient of its patronage. The Maya frequently placed

such supernatural events and the wisdom of the elders in the center of epic histories that played out thousands of years earlier.[42]

Crucial to the understanding of all these sacred aspects of Maya life in the Classic period is the word recorded in the hieroglyphic script as *k'uh*. Similar to the Nahuatl *teotl*, *k'uh* encompasses a multivalent conceptual role as "god" or "sacred thing,"[43] and it seems to have been understood as a concentrated force rather than an omnipresent, diffuse one. *K'uh* resonates with other ancestral American terms, such as *wak'a* and *zemí*, and with related words in modern Mayan languages, such as the Tzotzil or Tzeltal *ch'ulel* (soul, or spirit), which applies to living beings and objects in the landscape.[44] In fact, related terms appear in at least sixteen colonial and modern Mayan languages, with meanings varying from gods, saints, and shrines to droplets and more.[45] There are more than 1,400 identified instances of *k'uh* in the hieroglyphs, dating from approximately 445 to 906, connoting divinity or divine essence, god, and physical god images.[46]

The hieroglyph for *k'uh* takes many forms, but it generally appears as a nonhuman head in profile (fig. 33). Artists displayed a high degree of creativity when innovating new variants, often tied to specific rulers or dynastic tastes. The scribes at Palenque in Mexico, for example, developed a version featuring a face in profile with an axe as an eye, used only there from 690 to 783.[47] Sometimes other motifs were added to the **K'UH** hieroglyph, such as a flow of droplets that seems to emerge from the left of the godly face, in what is known as a glyphic "prefix" (suffixes are added to the right; infixes are superimposed within the glyph block). The droplets may reference divine exhalations. Artists depicted the concept of holy breath flowing from deities as early as the murals at San Bartolo, where painters illustrated such emanations from the Maize God and his companions as scrolls and volutes. Scribes could also abbreviate **K'UH** by showing just the droplets as part of complex hieroglyphic phrases. In rare instances, the **K'UH** designation was also applied to entities that were specifically marked as female.[48]

K'uh could be scattered (*chok*), as seen on a codex-style vessel with a seated lord appearing to bestow the hieroglyph upon his visitors (fig. 34). The gesture of an open hand streaming droplets, which is encapsulated in the hieroglyph *chok*, is an artistic convention used throughout Classic Maya art to depict rituals involving incense or blood. The polysemy of blood, incense, and divine essence was sometimes emphasized by artists who added luxury and prestige imagery such as jade, obsidian, or flowers to the **K'UH** glyph.[49] The material aspects of *k'uh* are also hinted at in phrases that suggest it could be lifted (*k'al*), which is the same verb used to describe the installation of such works as a stone lintel above a doorway.[50] The physicality of the concept of god or sacred things probably extended to other materials beside stone, such as ceramic, wood, bone, shell, and fiber. Thus, *k'uh* could be wielded, harnessed, and expressed by men and women sculptors, painters, potters, carvers, or weavers.

Hieroglyphic captions accompanying images aid in understanding varying depictions of *k'uh*, from the anthropomorphic (humanlike) to the zoomorphic (animallike) to the therianthropic (a combination of the two). Interpretation is often difficult, as many of these divine forms feature overlapping traits of mortal beings.[51] Sometimes monkeys, dogs, vultures, rabbits, or opossums sit as humanlike members of divine courts in creation scenes. Gods have square eyes with elliptical or spiral pupils, often crossed, which might underscore a widespread belief in supernatural or cosmic vision.[52] Their eyes also bear the glyphic signs for "shine" (*lem*).

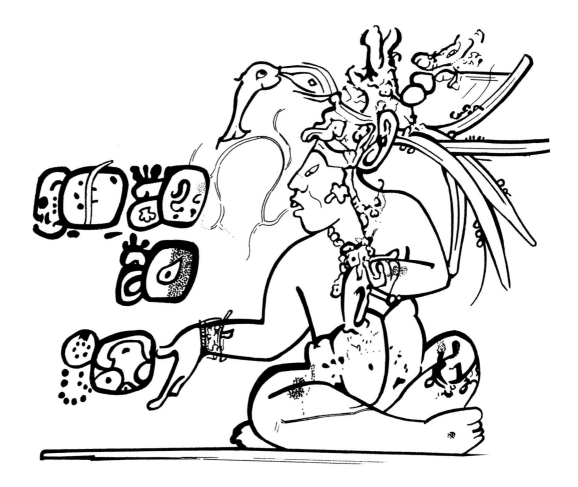

33
Hieroglyph for **K'UH**.
Drawing by Christian
Prager

34
Detail of cylinder vessel
showing a seated lord
appearing to scatter the
hieroglyph **K'UH** to his
visitors. Drawing by
Diane Griffiths Peck

They often have reptilian or piscine lips, sometimes with shark teeth. Feline ears and paws merge with humanlike limbs and visages. Large markings cover the godly bodies. These "shining" signs — sometimes merging with the hieroglyphs for day or night — are stony or obsidian markings that designate the bodies as reflective or luminous surfaces.[53]

Maya artists often layered the shifting attributes of deities into composite images, creating marvelously complex and multifaceted divine representations through "theosynthesis."[54] Artists merged various features into the body of one supernatural entity, which often had a specific proper name, producing a divinity that was always in flux and context-dependent. The Rain God could carry features of the Lightning God that would have been understood as a fusion of the two bodies, just as sometimes the hieroglyphic names themselves are infixed, prefixed, or suffixed. Certain features that denote age, distinctive garments, the lack of a lower jaw, winged arms, or even monkey ears could all be used to layer stories on top of a primary deity image.

Artists and their patrons embraced theosynthesis as a way to create localized deities, specialized versions of the universal god identities of rain, sun, and other phenomena (see fig. 131).[55] Dynasty founders often introduced specific gods to a place, or sometimes the gods themselves were thought to have founded the royal court in very ancient times. Patron gods, also referred to as *k'uh*, were not to be confused with ancestors (*mam*) who had reached their apotheosis or with any living or deceased human rulers.[56] Patron gods often came in pairs, trios, or quartets, signifying their complementary powers and multiple associations with the cardinal directions.[57] Some

texts refer to the effigy images of patron gods either as *winbaah* (image, figure, or portrait) or *baah* (image) in Yukatek Mayan. These images could be displayed or presented after being gifted to allies in diplomatic events.[58] As such, the gods could share the visual plane with mortals.

Gods and their representations were crucial to the political power of Maya kings and queens. Glyphs tell us that the Maya summoned gods (*tzak k'uh*) often in association with the accession of kings. Gods were said to have supervised (*yichonal*) certain royal events. Throughout Maya art, kings and queens were shown to channel gods through human impersonations (*ubaah a'n k'uh*) in which the royal body was understood to be fused with the body of the supernatural being through headdresses and other regalia (fig. 35). A human ruler who donned a solar deity headdress induced a copresence of the divine; deity eyes outshine the mortal gaze. Moreover, the prefix for royal titles, *k'uhul*, incorporates the glyph for *k'uh*. These emblem glyphs essentially read as *k'uhul X ajaw* (holy/ divine X lord) in which *k'uhul* is a stream of drops falling from another glyphic sign for preciousness. Yet this does not mean that the Maya rulers were asserting that they *were* gods. In these instances of impersonation, the rulers don masks to assume the features of particular gods and often reference the gods in their chosen regnal names, but their hands, feet, limbs, faces, and eyes retain their humanity. *K'uhul* is more rhetorical than transformational, although rulers were said to have supernatural qualities, such as *ch'ahb ahk'ab* (genesis and darkness).[59]

Between about 800 and 900, the political system in the Maya Lowlands changed drastically, one city-state at a time. The self-proclaimed divine kings and queens who had ruled for centuries ceased to hold their claims on territory and tribute, and governance recombined in different places as people migrated away from the royal courts. Though many artist workshops disbanded and talented hands took to farming maize, painting and sculpture did not disappear. Instead, art took new forms and addressed new subjects. The grandiose Classic-period deities endured in oral histories, and people adopted new divine beings in the northern regions, at places such as Chichen Itza and Mayapan.

Crucial sources that informed early studies of Maya gods in the nineteenth century are the four extant religious books from the twelfth to the sixteenth century from the northern Yucatán (fig. 36). These screenfold almanacs, known as codices (sing. codex), are the scant survivors of the innumerable literary sources burned by the Spanish invaders in the sixteenth century. The hieroglyphic term *k'uh* appears many times in the codices as part of or conflated with god names, as well as in full-bodied form, though only in specific contexts.[60] Scholars have drawn from these codices and the rich ethnohistory of the Yucatán Peninsula compiled by Spanish colonizers in the sixteenth, seventeenth, and eighteenth centuries to produce a clearer understanding of Maya gods before and after colonization. In the *Relación de las cosas de Yucatán* (ca. 1566), Friar Diego de Landa — a Franciscan bishop in Yucatán who destroyed ancestral Maya books in the sixteenth century — refers to various Maya deities using Spanish terms, including *dios* (god), *ídolo* (idol), and *ángel* (angel). *Dios* is used primarily for the four Bakabs, who held up the sky; Chahk, the rain god; and the Yucatán version of an avian deity named Yax Kok Ah Mut. The nineteenth- and early twentieth-century study of these pivotal primary-source codices identified the gods pictured along with calendrical texts that laid out various events in the cosmological lives of the Maya after about 1000. These studies revealed the complex godly world of Mesoamerica, such

35
Ruler with deity head-dress. Temple 22, Copan, Honduras, 8th century. Stone, approx. H. 26 3/4 in. (68 cm). Sitio Maya de Copán, IHAH

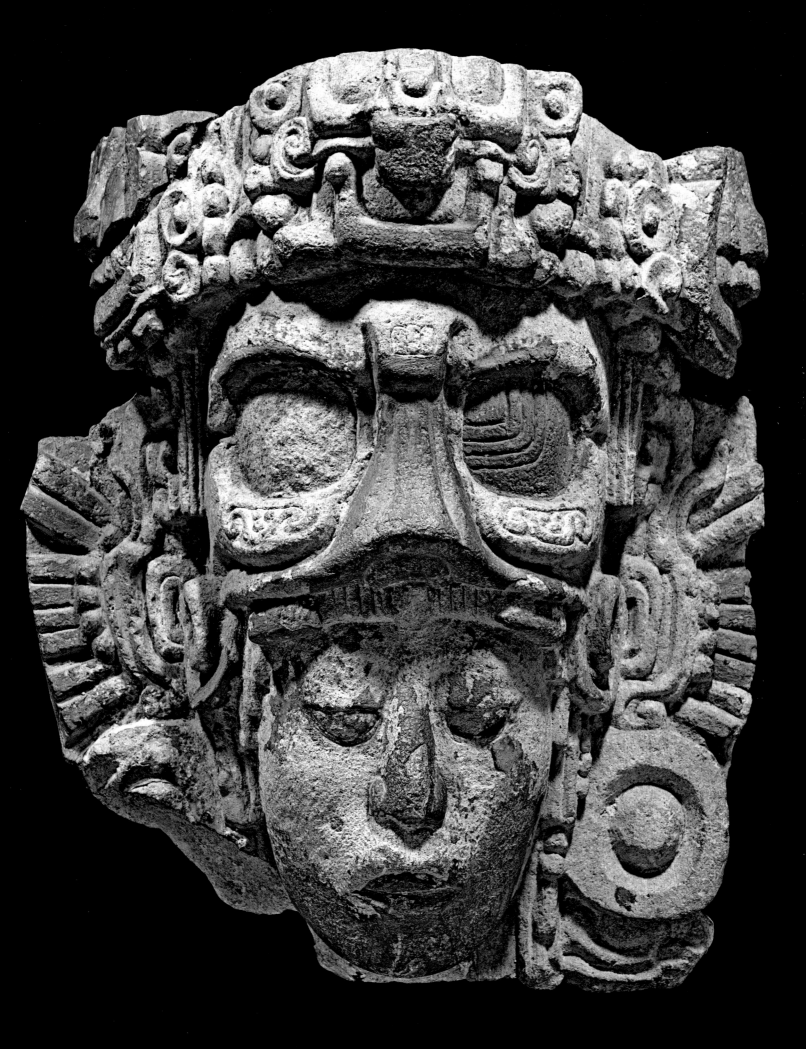

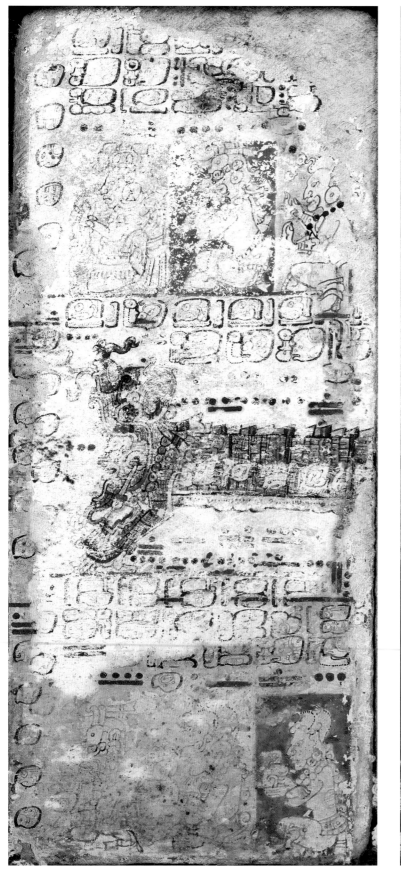
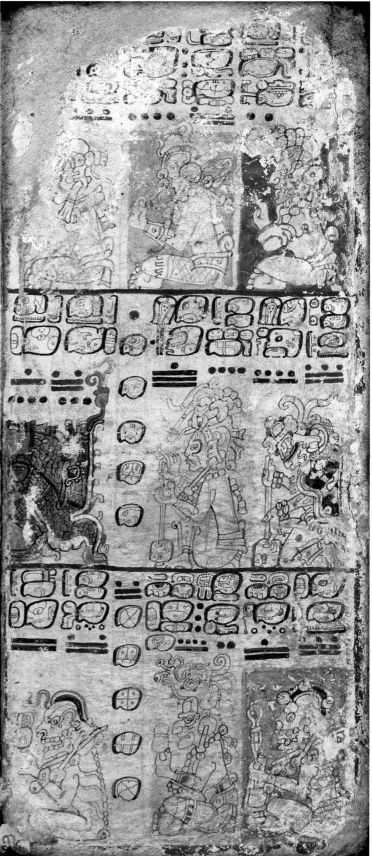

as the finding that some gods had four different forms, corresponding to the cardinal directions, as well as specific colors and close associations with other deities.

One of the other key sources in interpreting the spiritual worldview of the Classic-period Maya has been the *Popol Wuj*, the K'iche' manuscript collectively authored and compiled in the mid-sixteenth century, which represents creation narratives and historical events that likely derive from a preconquest illuminated manuscript.[61] The document clearly establishes the Indigenous narratives about the relationship between the supernatural and the mortal. Further, the authors confirmed the visual analogies between the lives of humans and the life cycle of maize. The figures in Classic Maya painted and sculpted scenes have been compared since the 1970s to the epic heroes in the *Popol Wuj*, though debate about these interpretations continues.[62]

In the contemporary world, the *Popol Wuj* itself forms a crucial component of highland Maya identity for many and, more broadly, of Indigenous activism. Despite orchestrated idolatry campaigns and forced conversions, many ancestral Maya gods endure in contemporary communities throughout Mexico, Guatemala, Belize, Honduras, and El Salvador, as well as in diaspora communities. Modern ethnographic and linguistic studies offer important tools for interpreting Classic Maya art.[63] For example, among present-day speakers of Ch'orti', a language closely related to the language of the hieroglyphs, the sun is a major deity; his consort is the moon. Celestial bodies are associated with personified deities who play a role in weather, agriculture, and luck.[64] Another example is the divine figure Maximon, represented in composite sculptures as having both Indigenous and Catholic roots,

who plays an important role in contemporary highland Tz'utujil communities. His origins have been traced back to the old gods of the Classic period.[65]

The Classic Maya depictions of gods and goddesses challenge modern viewers and defy familiar models for interpreting religious images. The nature of Maya religion — specifically, whether the deities represent individual gods arranged in a pantheon (animistic) or personify natural forces related to a general environmental energy (animatistic) — has thus been a subject of much scholarly debate and will likely continue to be so.[66] The current consensus is that Classic Maya gods are both specific, named entities *and* the personifications of natural forces at different times in their histories, as attested by the hieroglyphs. They had discrete identities but could sometimes be grouped into categories in texts, such as "sky gods" or "earth gods," and could even be referred to as a multitude (*hun-pik-k'uh*).[67]

The "multitude" of Classic Maya deities embodies a core group of divine concepts from different parts of the natural, human, and agricultural world. The rich histories from hieroglyphic texts, archaeological excavations, and ethnographic investigations allow a fresh examination of how artists imagined fleshy beings, mapped them onto narrative scenes, and contributed to religio-politics by manifesting the divine in the human realm, making the gods present in the daily lives of kings and queens. The Classic Maya gods thus serve as a pivotal case study in giving form to elusive spiritual forces in the past and present. The gods created by Classic Maya artists lived beyond the royal courts, as scribes and elders transmitted generational knowledge throughout centuries, and they are still very much alive in Indigenous communities today.

Cosmic Struggles, Primeval Transgressions

OSWALDO CHINCHILLA MAZARIEGOS

W HISTLING VESSELS are curious objects. Composed of two separate chambers — one open, the other sealed and with a whistle attached to the top — they are joined at the base by a conduit that allows water poured into the open chamber to push up the air trapped inside the sealed chamber, generating subtle sounds through the vents of the whistle. The whistling chamber can take the shape of a person or an animal (birds, monkeys, and dogs are frequent subjects), so that the sounds emanating from the whistle seem to come from a mouth or beak. The ingenuity of this device has led scholars to think that, though it can be found in two far-flung locations, it was not invented twice. Researchers surmise that examples from Mesoamerica imitated earlier models from the Andean area, probably Ecuador, a tantalizing indication of long-distance contact as early as 1000 B.C., when whistling vessels appeared in both regions.[1]

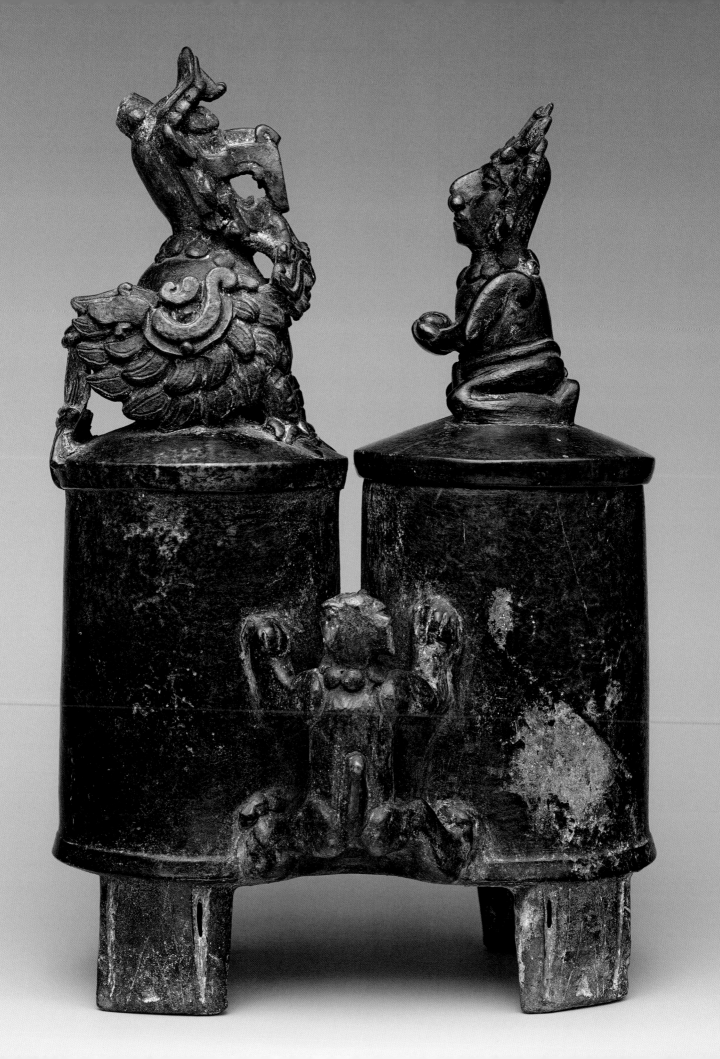

37A
Whistling vessel.
Guatemala or Mexico, 5th
century. Ceramic, H. 11⅞ in.
(30.2 cm). The Metropolitan
Museum of Art, New York,
The Michael C. Rockefeller
Memorial Collection, Gift of
Nelson A. Rockefeller, 1963
(1978.412.90a, b)

37B
X-ray image revealing a
spherical whistle inside
the bird's head

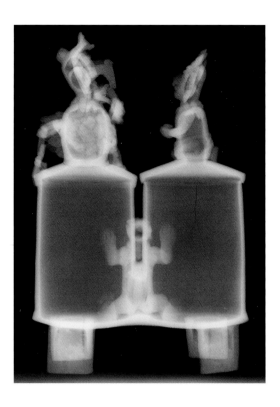

During the Early Classic period, lowland Maya potters produced magnificent examples in highly polished blackware based on the shape of cylinder tripod vessels with lids (fig. 37a). The models possibly originated in the Mexican Highlands, but Maya potters turned them into elaborate figural objects.[2] A favored theme was a great avian being with serpentine wings (depicted as flattened serpent heads with feathers growing from their jawless mouths), who stands proudly, wearing a lordly crown. X-ray imaging of one of these vessels reveals the spherical chamber of a whistle, hidden inside the head of the bird (fig. 37b). Here, the sounds of the whistle doubled as the bird's calls directed toward a simply clad young man who kneels on the opposite chamber's lid, which could be lifted to pour water inside.[3]

There is marked asymmetry in the scale and elaboration of the figures but no hint of antagonism between them. The bird is larger and imposing, with a curved beak that bites into the twisted body of a double-headed serpent. The man is smaller and obsequious, seemingly presenting a loaf-shaped object to the bird — possibly a fruit or a tamale. A third participant is a quadruped that seems to be climbing the walls of the vessel. It takes comparisons with other representations and recourse to passages from colonial and modern mythical narratives to realize that the scene is ripe with tension. The confrontation between the two main characters is explicit in another blackware whistling vessel, which shows a young man shooting at the great bird with a blowgun.[4] The encounter signaled the momentous transition between two cosmic eras and the downfall of the monstrous bird, a being that pretended to shine like the sun or opposed the rise of the sun. Colonial and modern narratives explain how that bird — sometimes joined by other fearsome denizens of the previous era — was brought down by the humble, unpretentious youngsters who were destined to become the sun and the moon.

For the ancient Maya and other peoples of Mesoamerica, the world as they knew it originated from a series of struggles that transpired in primeval times. The protagonists were gods and goddesses who sometimes worked together but frequently opposed one another, and whose attempts at creation were often met with unexpected results and failures. Eventually, their protracted efforts resulted in the formation of the earth, the rise of the sun and the moon, the discovery of maize — the staple crop that would provide sustenance for people — and the creation of men and women. But these ends were not met at once, nor did they result from the will of omniscient deities. While the gods were satisfied with the results, their achievements were transactional and fragile, subject to potential failure and destruction. The task of ensuring the permanence of the world fell on the shoulders of people, who were charged with the duty of providing for the gods through the

offerings of prayer, song, and dance; the smoke of burned resins; food and drink; blood shed from their own genitals, ears, and other body parts; and the blood and flesh of animal and human victims.

We can reasonably assume that ancient Maya scribes wrote about the primeval struggles of the gods in hieroglyphic books that are now lost.[5] Fortunately for us, artists also depicted favored episodes in paintings and carvings on durable media, which ranged from small, private objects to monumental sculptures, mural paintings, and entire building programs. Early colonial authors wrote a renowned version of these sagas in the mid-sixteenth-century highland Maya text known as the *Popol Wuj*, and modern storytellers still recount related stories. Ancient performers also reenacted them in ritual dances; to this day, traditional dances and religious rituals performed in Maya communities evoke the gods' primeval quests.

The Eras

According to the myths of the modern Lacandon Maya, the primordial god Ka'koch created the first earth and sun. But the earth was swampy, and the light of the sun was inconstant, disturbed by frequent eclipses. It took the efforts of one of his children, Hach Äk Yum, to form the present sun, dry the surface of the earth, and fashion rocks and cliffs. That creation did not last; Lacandon narrators describe how the world was subsequently destroyed by a flood and by the sun, which descended and burned the entire forest. The gods have threatened to destroy the world at other times, and some say that it will come to an end with the death of the last Lacandon, when no one remains to make offerings to the gods.[6]

Beliefs about the multiple creations and destructions of the world, as well as the rise

and fall of successive suns, are widespread in modern Maya communities. Variants diverge on the number of eras or the reasons for their destruction but broadly agree that former suns were weak or unsteady, and that the inhabitants of former eras had physical and moral failures that brought about their demise. The narratives generally cast the present world as morally superior to earlier ones. It is properly illuminated in regular cycles by the sun and the moon and inhabited by people who accept the duty of sustaining the deities and the world itself through prayers, offerings, and sacrifices.[7]

Did the ancient Maya share similar notions about successive cosmic eras? The hieroglyphic inscriptions contain only isolated hints. The most explicit is a passage from the panel of Temple XIX at Palenque that refers to a flood — not of water, but of blood that was spilled when the head of the Starry Deer Crocodile was chopped off (fig. 38). According to the inscription, this happened in primeval times, almost two centuries before the mythical date 4 Ajaw 8 Kumk'u, which, for the Classic-period Maya, marked the institution of period-ending celebrations at the end of a count of thirteen b'aktuns and the beginning of a new count in 3114 B.C.[8] The Starry Deer Crocodile was a mighty reptile that embodied the sky or perhaps the Milky Way. It had the front legs and ears of a deer, stars in the eyes, and more stars strung along the body. Many centuries later, Maya scribes depicted the same creature in the Madrid and Dresden codices (see fig. 63), spilling torrents of water from its body and mouth. Maya writers in Yucatán recorded versions of the episode in colonial times, using the alphabetic script introduced by Spanish friars. In all these accounts, the killing of a mythical crocodile marks the destruction of a former world.[9]

The Palenque hieroglyphic text attests to the antiquity of beliefs, among people of the

Maya Lowlands, in world destruction by flood. But rather than narrating the end of an era, the intent of the Temple XIX text was to highlight the role of a deity known as GI. The text recounts how GI was enthroned like a king eleven years before the killing of the Starry Deer Crocodile. An obscure passage describes a fire-drilling ritual, followed by a phrase that refers to GI's enactment of building or settling down. This phrase may allude to the re-creation of the world after the debacle. The narrative then moves on to recount the births of GI, GII, and GIII, the triadic patron gods of the Palenque royal dynasty.[10] The entire section can be understood as a mythical preamble for the subsequent commemoration of royal rituals conducted by Ahkal Mo' Nahb III, the Palenque king who dedicated this inscription in 736.

The rhetoric of the mid-sixteenth-century authors of the *Popol Wuj* was not dissimilar. They wrote a detailed account of the previous eras and their demise, the struggles of the gods who would become the sun and the moon, and the discovery of maize. All were requisite to the creation of the first four men and four women, who were the forebears of the K'iche' ruling houses. The cosmogony of the *Popol Wuj* served as a preamble to the history of the K'iche' kings, their difficult journey to the Guatemalan Highlands, their ascent to lordship, and the foundation of their city

and kingdom, followed by their genealogies, up to the later holders of K'iche' royal titles living under the Spanish colonial system. The primeval deeds of the gods offered paradigms for the political and ritual actions of the K'iche' rulers.

In the *Popol Wuj*, the gods voiced the questions that would guide their efforts: "How should the sowing be, and the dawning? Who is to be the provider, nurturer?"[11] The first question referred to the search for sustenance (which, in Mesoamerica, was maize) and to the rise of the sun and the moon. The second question was about the creation of people who would take care of the gods. The answers to those questions were not readily available, and their solution involved a series of trials and errors. The account of earlier eras focused on their inhabitants. Animals were created first, but the gods — displeased by their inability to speak and pronounce their names — condemned them to live in forests and be hunted. In a second attempt, the gods formed effigies of mud, but they were dissatisfied with their loose bodies that disintegrated easily. In the third attempt, they attempted to carve people of wood. These were able to multiply and populate the earth, but they were dry and ill-formed, had no sensibility, and, most important, failed to remember their creators. They were destroyed by a flood and by fiery resin, and they suffered punishment inflicted by their own grinding stones, cooking pots, and water jars, which turned against them, as did the dogs and turkeys they consumed.[12]

The gods finally succeeded at creating well-shaped, intelligent people who would recognize and worship them in the fourth attempt, when they employed maize as the raw material to compose people. There is evidence that Mesoamerican peoples deified the staple crop even before it became the mainstay of everyday diet.[13] The Maize God was portrayed frequently in Maya art as far back as the Preclassic period, and the myths about that deity were favorite subjects for Classic Maya pottery painters. But some of them knew versions in which the first people were fashioned from clay instead of maize, as suggested by hieroglyphic captions on vessels that describe the gods modeling human faces with the verb *pak'* (to shape by hand), a term generally referring to things made from clay. Modern Maya narratives recorded in Tzotzil, Mopan, and Lacandon communities agree that the first people were formed from clay. This explanation probably coexisted since ancient times with the one that identified maize as the substance used to create people, which is known only from the sixteenth-century highland Maya versions of the story.[14]

The Downfall of the False Sun

In the *Popol Wuj*, the creation of people from maize solved one of the questions posed by the gods in the beginning: "Who is to be the provider, nurturer?"[15] Before arriving at a solution, the K'iche' writers recounted the expansive story of the heroes Hunahpu and Xbalanque, who were destined to become the sun and the moon and were also identified with maize. The young brothers employed their magical powers and their wits to overcome formidable opponents who were older, stronger, and wealthier. They won a crucial contest against Seven Macaw, an avian being who pretended to shine like the sun and the moon but shed only a dim light over the wooden people of the previous era. To bring him down, they stalked the proud bird while he perched on a tree to eat its fruit. Hunahpu hit the bird with a blowgun shot to the jaw, then tried to grab him, when Seven Macaw tore off Hunahpu's arm. The heroes then tricked the bird into believing that they would cure the unbearable toothache that he suffered after receiving the blowgun shot;

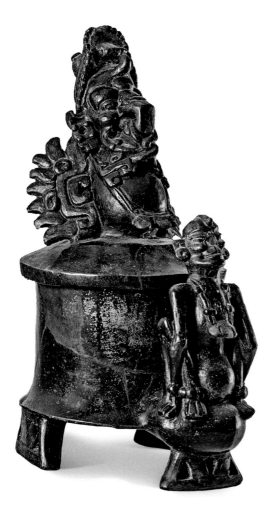

39
Whistling vessel. Structure
IVB, Tomb 2, Calakmul,
Campeche, Mexico,
5th–7th century. Ceramic,
H. 12 ⅝ in. (32.1 cm).
Museo Arqueológico de
Campeche, Fuerte de San
Miguel, Secretaría de
Cultura–INAH

instead, they extracted his teeth and eyes, killing him.[16]

Scholars have long debated the links between Seven Macaw in the *Popol Wuj* and ancient Maya representations of the Principal Bird Deity, the large raptorial bird that was a favorite theme in Early Classic blackware whistling vessels (see fig. 37a).[17] In one example, the bird embraces the vessel with its wings, and its body forms the whistling chamber.[18] In another, recovered from a rich burial at Calakmul, the bird occupies the removable lid, and the whistling chamber takes the shape of an elegantly seated monkey, with the sounds doubling as the monkey's gibber (fig. 39). Did the monkey play a role in an ancient version of the bird's myth? No monkey is mentioned in connection with

Seven Macaw in the *Popol Wuj*, but the text does affirm that survivors from the former era became monkeys.[19] The monkey on this vessel may be a survivor of the former era, sitting before the great bird who pretended to shine like the sun over his people, but that interpretation remains tenuous; we do not know whether the Classic Maya of Calakmul conceived of the transformation of the inhabitants of the former era in the same terms as did the K'iche' authors of the *Popol Wuj*.

Rather than forcing interpretations molded on the *Popol Wuj*, it is more productive to trace the variability of ancient Maya representations, their changes through time, and the ways in which they approximate and depart from colonial and modern myths, including but not limited to the mid-sixteenth-century K'iche' version of the *Popol Wuj*. An early depiction of the story of the mighty bird appears on Stela 25 from Izapa, which dates to the Late Preclassic period (fig. 40). At left is a crocodilian tree. The reptile's head is in the ground and its tail rises like a trunk with leafy branches, upon which a small bird rests. Mesoamerican peoples envisioned mighty trees rising on the four sides of the world, oriented in accordance with the daily course of the sun from east to west and its yearly movements from north to south. The tree on Izapa Stela 25 is likely a cosmic tree marking one of the four directions.[20]

On the stela, a short man (possibly a child) steps on the snout of the crocodile, perhaps emphasizing his dominance over this tremendous creature, and holds a pole with his right hand. Perched on the horizontal beams atop the pole is a large bird, whose portentous nature is indicated by the human face emerging from its beak, the skeletal head forming its chest, and the small bird heads that peek from its outstretched wing. The stela portrays the mythic episode in which a monstrous bird tears off the arm of a young hero; here,

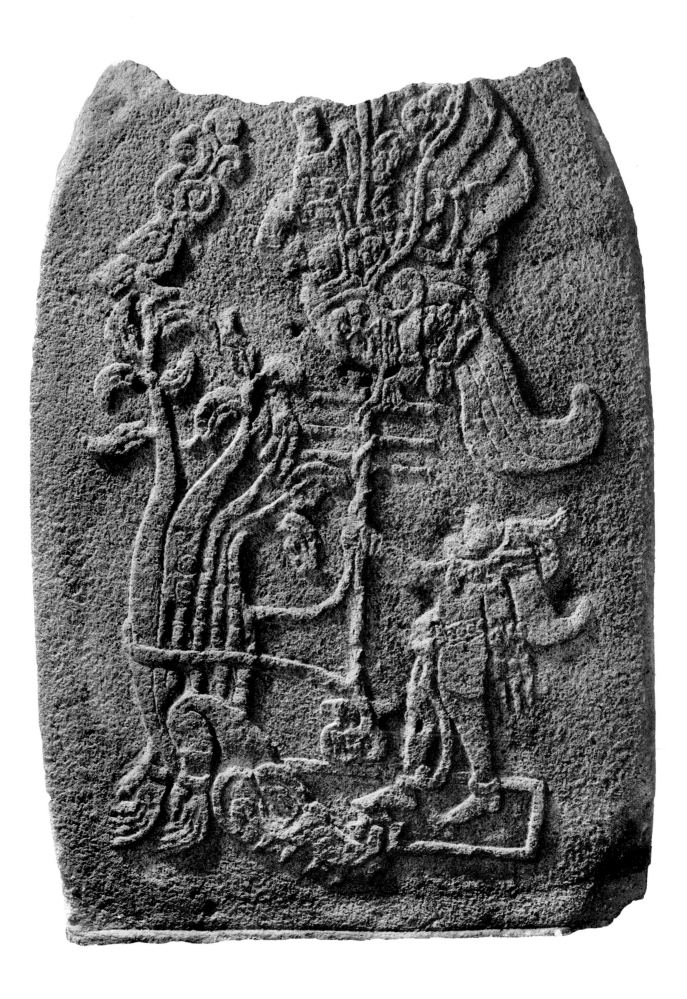

however, the bird employs its toothed vagina, shaped as a serpentine head, instead of its beak. The severed limb hangs loosely from the maw in the bird's abdomen, while thick spurts of blood flow from the hero's handless left arm.[21]

Beliefs in primeval beings who had a toothed vagina — sometimes shaped as a serpent mouth — are widespread in Meso-america.[22] While normally female, these characters sometimes merge masculine and feminine qualities. In mythical narratives, they are among the monstrous beings who prevailed in former eras and who opposed the rise of the sun and the advent of the present era. Defeating these monsters was a primary task of the heroes who would become the sun, moon, and maize, because, as the *Popol Wuj* recounts, "people will never be able to live here on the face of the earth" while such intimi-dating creatures reigned.[23] In the *Popol Wuj*,

Seven Macaw is not endowed with a toothed vagina, yet the formidable maw is evident both on the bird on Izapa Stela 25 and on the Early Classic macaws modeled in stucco as part of the first building stage of the ballcourt at Copan, Honduras. In the latter representa-tions, the toothed vagina takes the shape of a feathered serpent projecting from the bird's abdomen and biting a severed arm (fig. 41).[24]

There are other departures. The avian monster in the *Popol Wuj* is a macaw, which coincides with the anatomy of the birds from the Copan ballcourt and other depictions, such as a Late Classic plate recovered at the site of Las Pacayas that shows the very moment the macaw bites off its opponent's hand (fig. 42). The blowgun resting behind the maimed hunter suggests that the painter of this plate knew a variant of the story similar to the version in the *Popol Wuj*.[25] The ques-tion is, how do the macaws in these depictions relate to the Principal Bird Deity, which invariably takes the appearance of a raptor (such as an eagle or a hawk), often biting a double-headed serpent with its downcurved beak? More than prey, the serpent seems to be an inherent attribute of the monstrous bird (see figs. 37a, 39). Interestingly, in Late Preclassic murals at the site of San Bartolo, cutting off one of the serpent's heads seems to mark a stage in the defeat of the great bird.[26]

On the stucco macaws from the Copan ballcourt, the severed arm bears a large oval spot. This mark indicates that the arm belonged to a young god who was often portrayed as a hunter, wearing a straw hat, and shooting at birds with a blowgun. Hiero-glyphic name tags associated with this god on Classic Maya vessels identify him as Juun Ajaw (One Lord) (see fig. 112) and, in one revealing case, Juun Pu'w (One Pus).[27] The latter alludes to the black spots that blight the young god's skin, denoting sores or pustules, which are sometimes surrounded by red halos

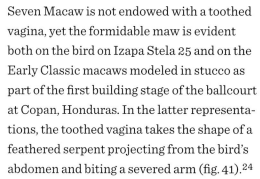

40
Stela 25. Izapa, Chiapas, Mexico, Late Preclassic period (ca. 300 B.C.–A.D. 250). Stone, H. 61⅞ in. (157 cm). Museo Arqueológico del Soconusco, Tapachula, Chiapas, Secretaría de Cultura–INAH

41
Reconstruction of an Early Classic–period stucco macaw from the first construction stage of the ballcourt at Copan, Honduras. Sitio Maya de Copán, IHAH

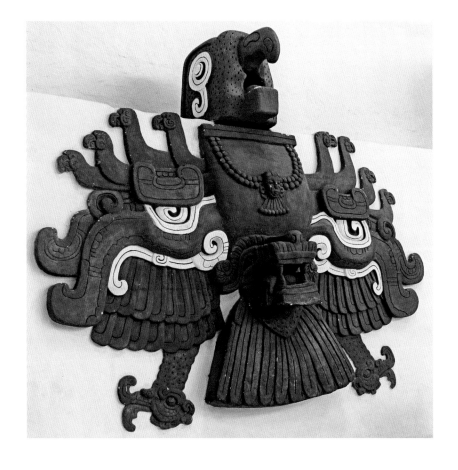

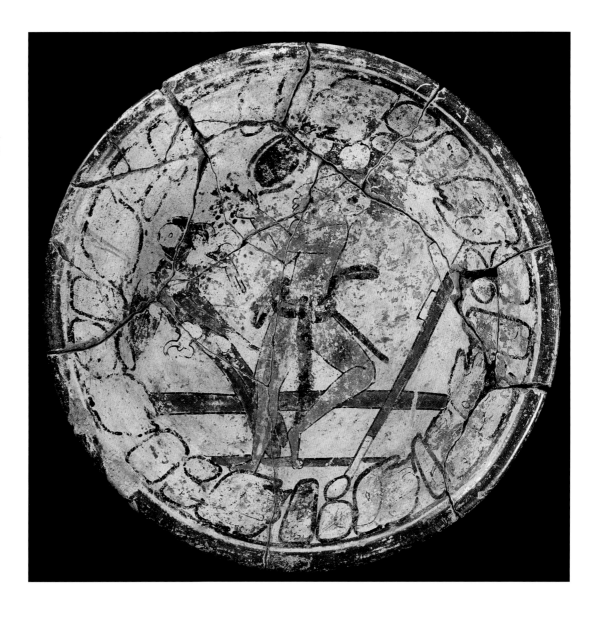

that accentuate the swelling. Skin ailments —
such as pimples, buboes, and pustules — are
common attributes of Mesoamerican solar
heroes, who are normally portrayed as sickly
and destitute but nevertheless destined to
become the sun.[28] The pustules of Juun Pu'w
in Maya art are thus consistent with his defeat
of the monstrous bird that pretended to shine
like the sun in a former era, signifying the
hero who would eventually take his rightful
place as luminary and shine over the people
of the present era.

On occasion, artists depicted two identi-
cal spotted gods together, suggesting that

some Classic Maya versions of the myth
featured twin blowgun hunters, in parallel
with the *Popol Wuj*. On the renowned Blom
Plate — named after the pioneering Mayanist
Frans Blom — they aim their blowguns at a
great bird, from whose head grows a second
avian head attached by a string of large beads
(fig. 43). Juun Pu'w was the bird's opponent in
the Classic Maya myth and, in some inter-
pretations, suffered the loss of an arm, as did
Hunahpu in the *Popol Wuj*.[29] Yet the authors
of the *Popol Wuj* did not describe Hunahpu as
having spots on his skin, and the bird on the
Blom Plate is not a macaw but the Principal

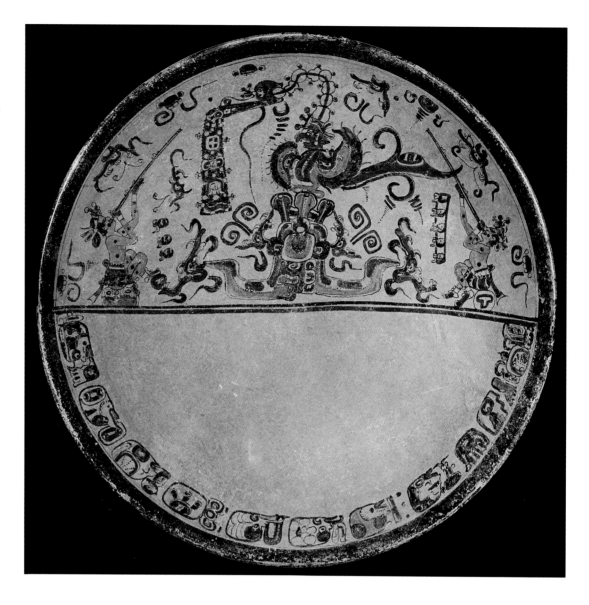

43
Plate. Mexico, Late Classic
period (600–900). Ceramic,
Diam. 17½ in. (44.5 cm).
Museo Maya de Cancún,
Quintana Roo, Secretaría de
Cultura–INAH

Bird Deity. The variations show that there was no unified version of the myth in Classic times; instead, an array of overlapping accounts related in complex ways with one another and with the one that was written down, centuries later, in the *Popol Wuj*.

The Itzamnaaj Bird

A full-figure hieroglyph from Tonina conflates the avian body of the Principal Bird Deity with the head of the paramount god Itzamnaaj, who is always depicted as an old man, conveying a probable reading of

Itzamnaaj Muut (Itzamnaaj Bird) (fig. 44).[30] The elderly god wears a diadem with a frontal medallion marked with the *ahk'ab* sign of darkness. This attribute appears in portraits of the mythical bird from as far back as the Preclassic period and later became a constant in representations of Itzamnaaj. Indeed, the bird and the god are so closely related that they can be regarded as embodiments of the same deity. Both are celestial beings; the Principal Bird Deity perches on elevated positions, often above sky bands (conventional representations of heaven and heavenly beings in Maya art), while Itzamnaaj

44
Full-figure hieroglyphic
block. Tonina, Chiapas,
Mexico, 7th–8th century.
Sandstone, H. 12 ½ in.
(32 cm). Museo de Sitio
de Toniná, Secretaría de
Cultura–INAH

frequently sits on a sky-band throne, like a heavenly lord. They are sometimes shown as a pair, and they are designated by variants of the same glyphic name.[31]

The overlap poses a paradox that is not easily resolved. Itzamnaaj is generally considered to be a paramount god in Maya religion, but the Principal Bird Deity is often depicted in circumstances that imply defeat. In Preclassic sculptures, the bird falls headfirst from the sky; on painted ceramics from the Classic period, it endures the beating of blowgun pellets shot by a spotted god (see fig. 43).[32] This raises the question: Was Itzamnaaj identified with the fallen sun of a former era in his avian manifestation as the Principal Bird Deity? Itzamnaaj and the Itzamnaaj Bird have squint eyes, which are related to brightness and light and are a distinctive attribute of the Sun God.[33] The *ahk'ab* medallion that they wear in the forehead links them to the night and darkness. In Preclassic and Early Classic representations, the wings of the Principal Bird Deity were marked with the signs *k'in* (sun or day) and *ahk'ab* (night or darkness). This blend of attributes conveying both daylight and darkness may indeed suggest the opaque sun of a former era.

Other explanations are possible. In the *Popol Wuj*, the encounter with Seven Macaw was not the sole episode in which Hunahpu and Xbalanque shot a bird. In another, they shoot a falcon that their grandmother had sent as a messenger.[34] This was a turning point in their story, marking the beginning of their journey to the realm of the lords of death. Similarly, the Principal Bird Deity plays the role of a messenger from Itzamnaaj in several representations, including one of the best-known depictions of Juun Pu'w shooting at the Principal Bird Deity (fig. 45). While often regarded as analogous to the shooting of Seven Macaw in the *Popol Wuj*, the scene on this finely painted vessel more likely shows the bird coming down from the sky as a messenger. That is the sense of the glyphic phrase written on this vessel, below the blowgun, which tells that the god descended from the sky (*ehmi chan*). It finds parallel in a different episode of the *Popol Wuj* in which the heroes shoot at a falcon that is bringing them a crucial message.[35]

There is another dimension to the paradox. The Principal Bird Deity was closely tied to royalty. The bird was portrayed in monumental stucco masks on the facades of Preclassic buildings at Cerros, Uaxactun, Tikal, Nakbe, and other sites. In some of the earliest royal portraits on stelae, at the sites of Izapa and Kaminaljuyu, the kings themselves personify the bird, thus embodying the sun of a former era.[36] In Classic-period stelae from Piedras Negras, the bird is perched on sky bands above the scaffolds upon which newly enthroned lords sit. The arrangement reappears on an incised bone that shows, on the upper right, perched on a sky band, the bird witnessing the accession ceremony of a lord (fig. 46). The young incumbent — his arms and back marked with shining symbols that normally denote the luxuriant skin of the Maize God — is ready to receive a headdress with the figure of the avian god. By donning it, the new lord will embody that deity, thus acquiring the mythical bird's powers and status. But the question remains: Did taking on the Principal Bird Deity's attributes also bring about the inexorable destiny of a former sun — that is, to be defeated and fall?

The authors of the *Popol Wuj* described Seven Macaw as a boastful character whose

45
Rollout view of cylinder vessel. Guatemala, 680–750. Ceramic, H. 4½ in. (11.4 cm). Museum of Fine Arts, Boston, Gift of Landon T. Clay

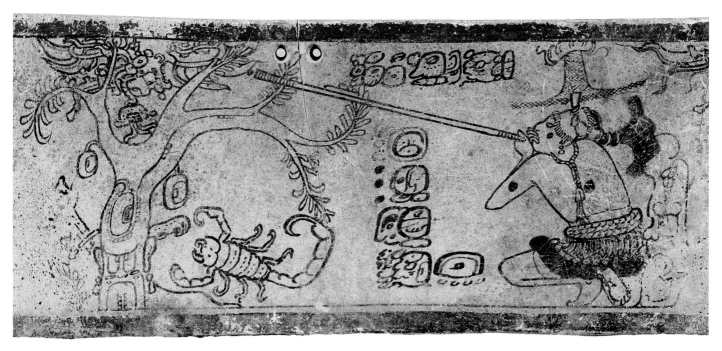

46
Incised bone. Guatemala,
Mexico, or Belize, Late
Classic period (600–900).
Bone, H. 3 in. (7.6 cm).
Dallas Museum of Art,
The Otis and Velma Davis
Dozier Fund

47
Scene from the Dance of
the Macaws, Santa Cruz
Verapaz, Guatemala.
Photograph by Ricky López
Bruni and Haniel López,
2022

Mythical narratives recounted how they fell
from the sky and were substituted by another
deity, who became the sun of a newer era. Yet
they continued to be regarded as powerful dei-
ties, were revered in religious feasts, and were
linked to political power.[37]

The Old God's Daughter

In the modern town of Santa Cruz Verapaz,
Guatemala, young men perform the Dance
of the Macaws, which evokes the abduction
of the maiden Warchaj and her rescue by her
affronted father, Ma'muun. The plot is decep-
tively simple: The old lord Ma'muun and
his wife zealously guard their daughter and
caution her to admit no strangers while they
leave her home alone. Despite their admoni-
tions — conveyed through dramatic speeches
in the Poqomchi' language — the maiden
is unable to resist the entreaties of K'iche'
Winaq, a warrior from the neighboring town
of Rab'inal, and the couple elope. Realizing
that his daughter is gone, Ma'muun enlists
the help of two giant macaws — performed
by dancers with broad-beaked masks and
feathered costumes — who search the moun-
tains, find the fleeing couple, and seize the
K'iche' warrior (fig. 47). The macaws oversee
an uneven fight in which the old man kills his
younger and stronger opponent and recovers
his daughter.[38]

The dance evokes the warlike contests for
territory that were frequent in ancient times,
and the K'iche' warrior's quest for the girl
equates to a quest for land. Although he failed,
his death was not insignificant. In a culmi-
nating episode of the dance, the triumphant
lord Ma'muun hacks the dead warrior's body
and feeds the blood to his own wife and to
the macaws, in return for their help. Feeding
the macaws the warrior's blood amounts to
sharing food with the trees in the mountains,
thus ensuring abundance and fertility. It is

dubious shine was not the true radiance of
the sun but only the luster of the jewels that
he wore. Seven Macaw's eventual defeat
resulted from his moral failures as much as
from the onslaught by the heroes who would
become luminaries. The available evidence is
not enough to conclude that the Classic and
Preclassic Maya conceived of the Principal
Bird Deity in a similar way, but that is a cogent
possibility. Explaining the links of Maya
rulers with the Principal Bird Deity as the
sun of a former era is a challenge for future
researchers, but it should be noted that, in
Mesoamerican religion, defeated gods were
nevertheless revered and commemorated
in elaborate artworks. In sixteenth-century
Nahua myths, the suns of former eras were
identified with major gods, such as the god-
dess of carnal love Xochiquetzal, the wind
god Quetzalcoatl, and the fire god Xiuhteuctli.

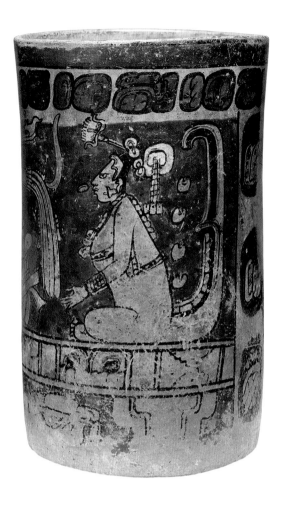

comparable to the ritual killing of a turkey during the traditional blessing ceremonies for a new house.[39] The killing of the K'iche' warrior evokes human sacrifice, and the fertilizing qualities of his blood can be interpreted as tantamount to the impregnation of the girl, although this is not made explicit in the modern dance. The cosmogonic connotations are also evident in a variant narrative from the same town, featuring two hawks instead of macaws. In that version, the invader escapes and becomes the sun, while the maiden becomes maize.[40]

The modern performers are aware of the dance's ancient roots. Classic Maya texts refer to macaw dances; one is the dance of the "descending macaw" that a king from Piedras Negras performed during a great meeting in 749, commemorated in Panel 3 from that site (see fig. 141).[41] But we know little about the contents of that dance. The macaw dance of Santa Cruz Verapaz more closely relates to mythical narratives, recorded in

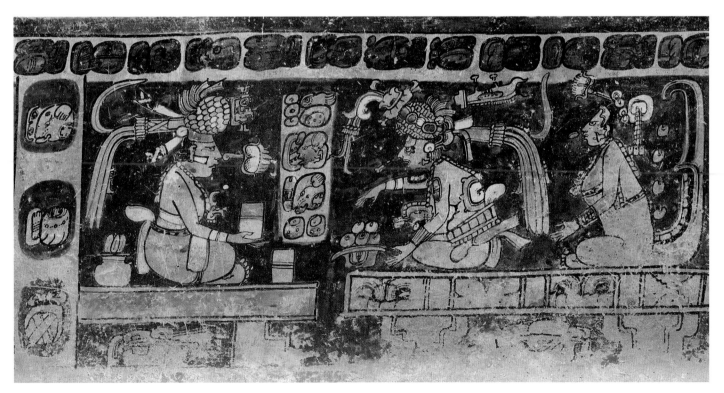

sixteenth-century texts and still circulating in numerous variants across Mesoamerica, about the abduction of a young goddess.[42] This transgression disrupted the gods' placid existence, setting in motion struggles that led to the origin of the sun and the moon, maize and other cultigens, and the present world at large.[43] In the *Popol Wuj*, this episode concerned Xk'ik, the daughter of one of the lords of the deathly realm of Xib'alba. She felt an irresistible attraction to the skull of Hun Hunahpu, one of two brothers who were summoned to play ball by the lords of death, only to be treacherously killed. The skull, hanging like a fruit from a prodigious tree, spoke to Xk'ik and impregnated her by spitting on her hand. Her magical powers allowed her to escape punishment from her infuriated father, and she gave birth to the heroes who would later take revenge against the lords of death, defeat the monstrous beings that prevailed in the previous era, and rise to the sky as luminaries.[44]

In modern variants of the myth, compiled across the Guatemalan Highlands, the suitor was not dead. After the coveted maiden rejected his advances, he opted for a magical transformation, taking the appearance of a hummingbird. Upon sight of the beautiful bird, the girl fell for him.[45] This scene was depicted by a Classic Maya painter on a vessel that is likely related to an ancient version of the myth (figs. 48a, b). To the observer's left in the rollout view of the vessel, a young man impersonates a hummingbird. The long, curved beak that pierces a flower in front of his nose is a conventional attribute of hummingbirds in ancient Maya art. He sits on an undecorated throne, presenting food and drink to the old god Itzamnaaj, who sits on a taller, celestial throne with the young Moon Goddess behind him. While the vessel does not duplicate exactly the characters of any modern story, it reflects patterns that are present in every variant of the myth. The Moon Goddess

is likely the old god's daughter and the young hummingbird-man is her suitor. The painting is close to modern Q'eqchi' narratives, in which the girl became the moon, and to modern Ixil versions involving negotiations between the girl's father and her suitor.[46]

A different version of the myth is likely portrayed on a finely carved vessel in the Chocholá style from Yucatán (figs. 49a, b). Here, an old god watches a young woman who cuddles a small animal, posed as a baby in her arms. It is not easy to characterize the old god. The large jewel on his head is common to portraits of Itzamnaaj, but the almond-shaped eye and the jaguar ear — projecting above his human ear — are unusual. Intriguingly, the woman is seated inside a large conch shell. In some narratives, the overzealous parents locked their daughter inside an enclosure — a box, a jar, a windowless room — to keep her from potential suitors. This was to no avail, as the suitors employed magic to come inside, tantamount to penetrating the young woman's intimacy. The enclosures in these stories explicitly stand for the maiden's womb and her reproductive potential. Conch shells served that very function in Classic Maya art, symbolizing female genitals. It is no accident that the head of the god K'awiil — associated with abundance and fecundity, among other things — is depicted emerging from the conch shell spirals, to the observer's right in the rollout image of the vessel.[47]

The scene on the Chocholá-style vessel is reminiscent of modern Lacandon narratives in which the suitor was a hunter who had killed all the gophers in the forest. Attracted by the young daughter of the death god Kisin, he followed her to her family's underground residence, eventually transforming into a hummingbird and seducing the girl. Realizing the deceit, Kisin demanded his new son-in-law do bridal service for him, and the couple's main task was to repopulate the forest

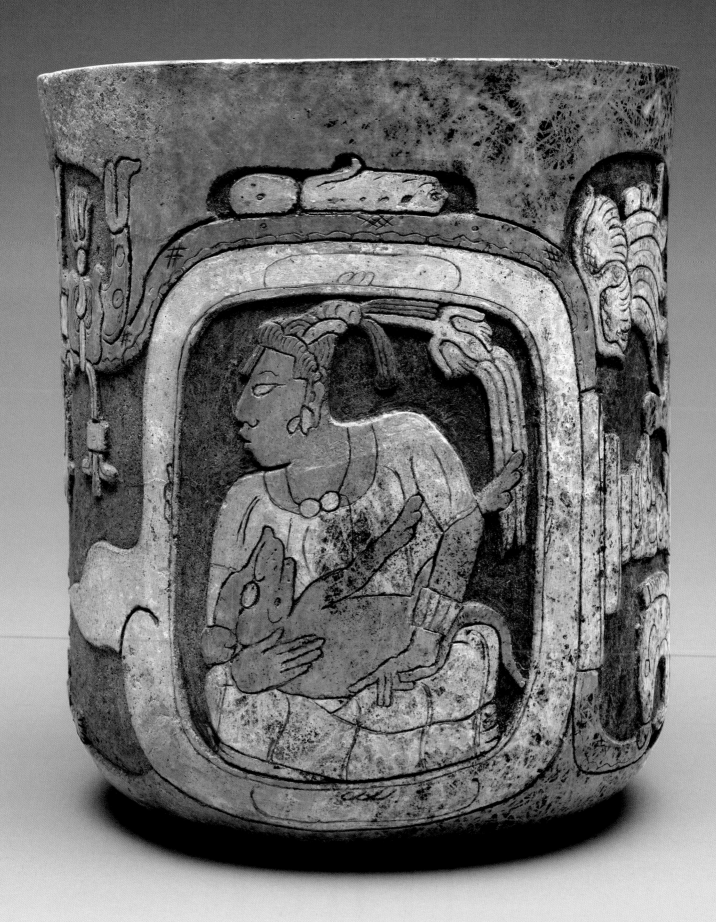

with all the gophers that he had killed — their offspring.[48] On the Chocholá vessel, the father is not a death god, and the creature in the young woman's arms does not seem to be a gopher — it may be a squirrel, a mouse, a tayra, or another long-tailed quadruped.[49] But the woman's role as a mother of animals aligns her with Kisin's daughter in the Lacandon myth. Furthermore, her concealment inside a conch shell recalls the modern stories of maidens being locked up by their parents. Despite such vigilance, neither those parents nor the old god of the Chocholá vessel could prevent their daughters' seduction and pregnancy.

Comic Struggles

The primeval struggles of the gods are often told and depicted in humorous ways. In the *Popol Wuj*, the heroes overcame powerful foes not by force or martial prowess but by outwitting them and performing magical feats. In some passages, the K'iche' writers expressed the victories with metaphors and double entendres that cast the heroes' actions as sexual assaults. Modern Maya ritual performances are no less mischievous, often involving lewd language and sexual innuendo. Their humorous edge does not detract from the deep meanings that they transmit, related to the origin of social institutions and the evocation of the primeval feats of the gods.[50] In the modern Dance of the Macaws, Ma'muun is a dramatic hero who suffers for the loss of his daughter and bravely engages the unwanted suitor. But he is also a comic figure, stopping often to imbibe alcohol from a flask. The old man's awkwardness as he struggles to pursue the young couple is intended to stir laughter. Terse fragments of Classic Maya mythical narratives preserved on ceramic vessels exhibit a similarly blithe mood. With some frequency, they portrayed old, powerful gods in circumstances that were likely amusing to their contemporary viewers.

The ancient Maya knew no mounts; there were no equines, camelids, or other potential domesticates that could be harnessed as such in Mesoamerica. Yet there are representations of young mythical characters sitting gracefully on cervid mounts. They contrast sharply with others that show Itzamnaaj riding deer or peccaries. The image of the powerful celestial god awkwardly astride such beasts was preposterous. One vessel shows Itzamnaaj riding a peccary on one side of the vessel and a deer on the other (figs. 50a, b). As in a modern comic strip, the vessel features a short

49 A
Cylinder vessel. Yucatán, Mexico, Late Classic period (600–900). Ceramic, slip, H. 7 1/4 in. (18.4 cm). Museum of Fine Arts, Houston, Gift of Frank Carroll in memory of Frank and Eleanor Carroll

49 B
Rollout view

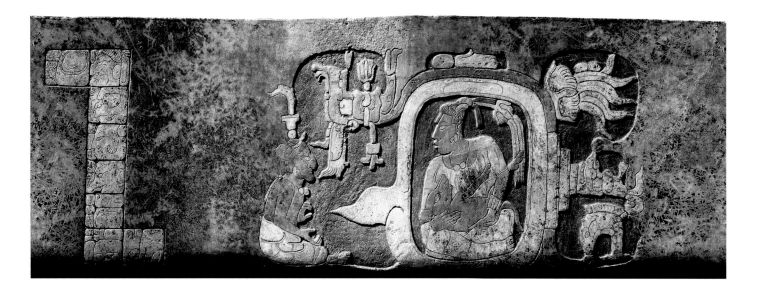

50A
Vessel with mythological frieze. Belize or Guatemala, 7th–8th century. Ceramic, pigment, H. 10⅞ in. (27.5 cm). Kimbell Art Museum, Fort Worth, Texas

50B
Rollout view

51 (opposite)
Whistle figurine. Mexico, 700–900. Terracotta, pigment, H. 9⅞ in. (25.1 cm). Detroit Institute of Arts, Founders Society Purchase, Katherine Margaret Kay Bequest Fund and New Endowment Fund

hieroglyphic caption that conveys the god's words, linked to his lips by a fine, undulating line. Addressing a standing old man, he asks, "b'ay b'ih lok'ooy [...] mam?" (where is the road [where] [...] fled, grandfather?).[51] The caption suggests that he is pursuing someone, whose name is only partly readable. Conceivably, these representations relate to mythical narratives that were not dissimilar from that of the modern Dance of the Macaws, in which Itzamnaaj pursued his missing daughter with the help of animals.

Classic Maya artists relished depicting dubious amorous dealings between old men and young women (or gods and goddesses). An old man embracing a young woman is a common theme in figurine whistles attributed to Jaina Island, Campeche. He is sometimes lifting her skirt or making other erotic gestures (fig. 51). The old men are often smaller than the women, making such amorous approaches appear pathetic and humorous.

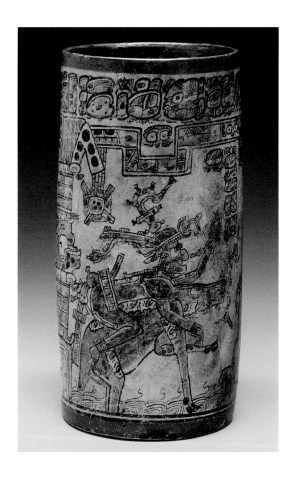

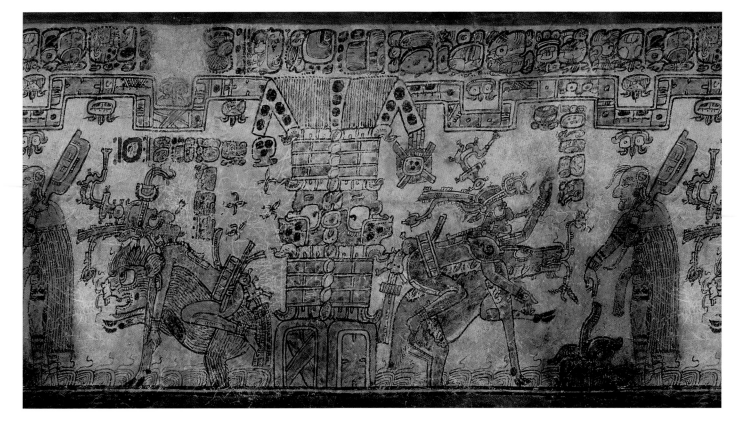

While occasionally interpreted as moon goddesses, the young women have no distinctive lunar attributes, and it is equally hard to characterize the old men in these figurines as representations of gods.[52]

Mythical models for these incongruous relations appear on codex-style vessels that show an old god emerging from the gaping mouth of a serpent that grows from the extended serpentine foot of K'awiil and coils around a young woman, toward whom the old god reaches lustfully (see fig. 78). The hieroglyphic captions refer to the apparent result of the encounter: the birth of deities who are portrayed on some of the vessels as swaddled babies.[53] These encounters conceivably share the crucial theme of the hummingbird myths: the transgression committed by a young couple, which resulted in the birth of gods, the generation of useful plants and animals, and the onset of the struggles that would bring about the present world.

The Moon and the Rabbit

In the *Popol Wuj*, the ordeals of Hunahpu and Xbalanque culminated with their rise to the sky as the sun and the moon. Only after this transition were the gods able to create people, whose lives would be ordered by the regular cycles of day and night.[54] But the authors of the *Popol Wuj* did not explain why the moon is dimmer than the sun, why it has dark spots, and why it waxes and wanes. The omissions are hard to explain because these questions received much attention in other mythical narratives from across Mesoamerica.

Perhaps the mutable appearance of the moon explains why the ancient Maya conceived a host of lunar deities, who were named in the elaborate phrases known as the Lunar Series in Classic Maya inscriptions on monuments across the lowlands. A cylinder vessel shows four gods standing taut before

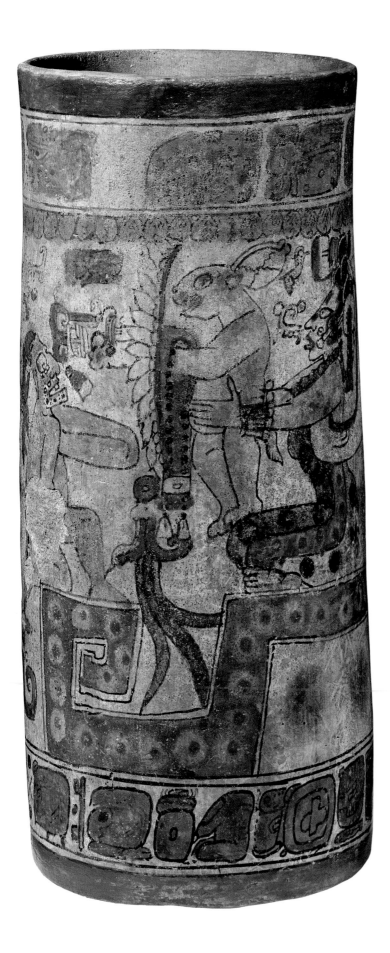

the enthroned Moon Goddess, like courtiers attending a queen (figs. 52a, b). All have growing from their armpits crescent-shaped signs that denote their lunar quality. From right to left are the Maize God, the Water-lily Serpent, a black-eyed jaguar god — his feline nature revealed by the jaguar ear — and a skeletal death god. Except for the Water-lily Serpent, the figures correspond to the three gods that alternate in Glyph C of the Lunar Series, where they are said to arrive on specific days of the ongoing lunation (a lunar month of twenty-nine or thirty days).[55]

The second of the four lunar gods standing on the vessel is a curious being with a human-shaped body and mythical reptile head. It is dubbed the Water-lily Serpent, although its name in the hieroglyphic texts was read differently.[56] On the Chocholá vessel discussed above, the Water-lily Serpent winding around the conch shell where the young woman is confined indicates that the scene unfolds in an aquatic setting (see fig. 49b). The downturned snout, jawless mouth with pointed barbels, and water-lily pad and flower tied to the forehead are the being's distinctive features. An aquatic plant is attached to its serpentine body, and a fish nibbles at its tail.

But why is the Water-lily Serpent standing among the three Glyph C gods on this vessel? A possible explanation relates to the lunar aspect of the Maize God. This was one of the young deity's multiple manifestations, along with stellar and arboreal forms, including one as a god of cacao. (See "Maize, Rebirth," in this volume, and figs. 124a, b.) When portrayed as a lunar deity, the Maize God often carried the head of the Water-lily Serpent as a headdress, with the water-lily pad and flower on his head and the reptile's downturned snout forming a mask piece that attached to his ear and projected in front of his nose. The reasons for this association are not entirely clear, although Mesoamerican myths often ascribe aquatic

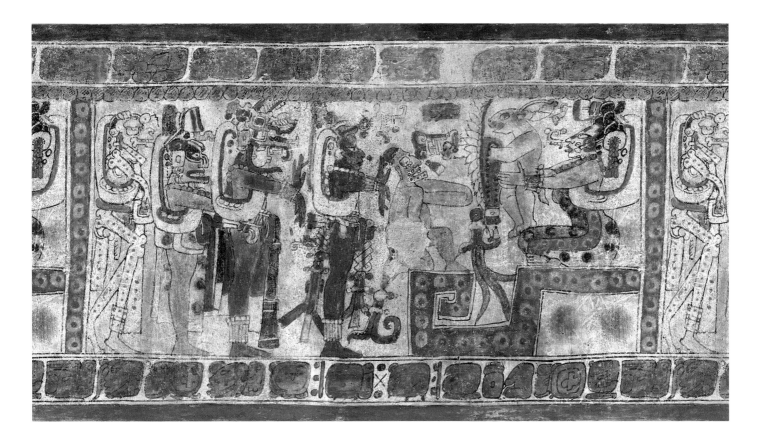

52A (opposite)
Cylinder vessel with
Moon Goddess and other
celestial beings. Mexico or
Guatemala, Late Classic
period (600–900). Ceramic,
H. 10 in. (25.4 cm). Los
Angeles County Museum
of Art, Purchased with
funds provided by Camilla
Chandler Frost

52B
Rollout view

attributes to lunar deities.[57] Arguably, the human-bodied Water-lily Serpent shown here is but the headdress of the lunar Maize God, walking behind its wearer.

While normally worn by the lunar Maize God, the Water-lily Serpent head is also the headdress of a royal lady who sits inside an oversized moon sign on a relief from the Usumacinta River region (fig. 53). In death, the souls of Maya kings and queens were thought to reach celestial destinies and were likened to luminaries. Deceased kings were portrayed with the appearance of the Sun God himself. Queens were similarly depicted as moon goddesses. This panel was likely one of a pair that portrayed the deceased parents of a living king, apotheosized as the sun and the moon.[58]

The lunar Maize God was sometimes paired with the spotted god Juun Pu'w. Both appear on a finely incised conch-shell trumpet dating to the Early Classic period (fig. 54). The designs on this complex object condense

multiple facets of Maya religious thought. The trumpet itself was likely considered to be animated by the living essence of a deity, whose face was incised on the spires, and whose name glyph spells the name of the trumpet itself in the hieroglyphic inscription. A hole drilled through the end of the shell's outer lip suggests that it was hung vertically so that the deity's face would be correctly oriented. But in this position, the portraits of the Maize God and Juun Pu'w would be upside down, as was the inscription that named the trumpet and its owner. The moon sign behind the Maize God denotes his lunar quality; he also wears a Water-lily Serpent headdress, although it does not have a water-lily pad or flower. Juun Pu'w hugs the undulating body of a serpent; the small creature crawling on his head may be a mollusk or a fish.

The Maize God and Juun Pu'w's relationship with this trumpet deity is unclear, but whatever the rationale for their portraits on

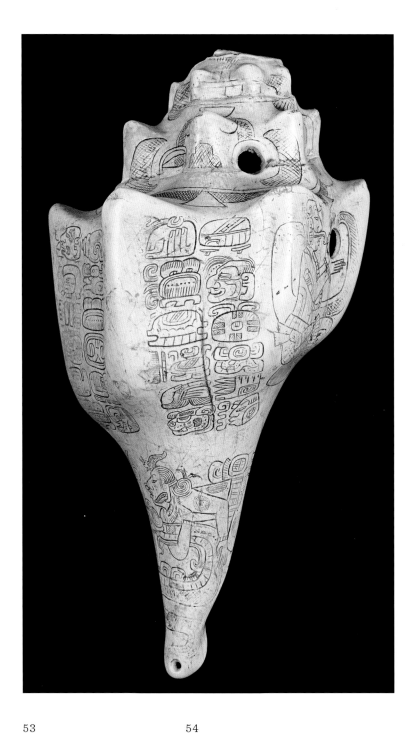

53
Lintel. Usumacinta
River region, Guatemala
or Mexico, 750–850.
Limestone, pigment,
H. 27½ in. (69.8 cm). Los
Angeles County Museum
of Art, Purchased with
funds provided by the Shinji
Shumekai Ancient Art Fund
and Joan Palevsky

54
Conch-shell trumpet.
Petén, Guatemala, 300–550.
Conch shell, hematite,
L. 9 in. (22.9 cm). Chrysler
Museum of Art, Norfolk,
Virginia, Gift of Edwin
Pearlman and Museum
purchase

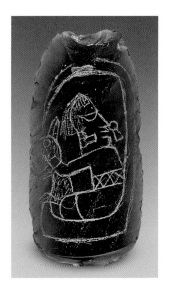
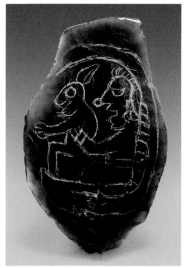
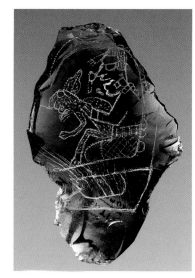

55A–C. Incised flakes. (A) Cache 42, associated with Stela P20, Great Plaza, Tikal, Guatemala; (B) Cache A26, Structure L, Group A, Uaxactun, Guatemala; (c) Cache 45, associated with Stela P29, Great Plaza, Tikal, Guatemala, 4th–8th century. Obsidian, each approx. H. 3⅛ in. (8 cm). Museo Nacional de Arqueología y Etnología, Guatemala City, Ministerio de Cultura y Deportes de Guatemala

the conch-shell trumpet, the two young gods were closely linked in Maya myths, forming a contrasting pair. The Maize God was a handsome dancer with unblemished skin, associated with all forms of wealth — cacao, jade, elaborate costumes — while Juun Pu'w was a stark hunter who wore simple clothing and whose blotched skin denoted sickness. Their opposing qualities find strong parallels in the heroes who became the sun and the moon in Mesoamerican mythical narratives.[59]

The lunar Maize God was among a select group of deities who were consistently depicted on incised obsidian flakes placed in caches (ritual deposits hidden beneath floors), particularly at Tikal and Uaxactun (figs. 55a–c). While sometimes described as a moon goddess, the young deity who holds a rabbit while sitting inside a lunar crescent on these flakes is clad in a simple belt and short skirt, most likely a male outfit, implying that the figure instead represents the lunar Maize God. Although his nosepiece is often a simple bead on these flakes, some examples show the downturned snout of the Water-lily Serpent attached as a mask to the god's face.[60]

Holding a rabbit is an attribute that the lunar Maize God shared with the Moon Goddess. Ancient Maya artists depicted rabbits as furry, bearded animals with long pointed ears marked with crossed, undulating lines (fig. 56). In mythical narratives, these little creatures are often tricksters. A series of Classic Maya vessels represents episodes from an amusing story in which a rabbit made off with the clothes, hat, and regalia of the powerful God L. This revered, aged deity with jaguar attributes was a patron of merchants and commerce and a master of tobacco smoking — important for its recreational, ritualistic, and medicinal properties. Two of these vessels show God L presiding over an assembly of gods on the primeval date 4 Ajaw 8 Kumk'u (see fig. 57).[61]

Classic Maya vessel painters delighted in showing God L being ridiculed by a rabbit despite, or perhaps because of, his grandeur. The textual annotations on one vessel provide details, including the rabbit's salacious words for the naked and humiliated god, who is begging for the return of his clothes. In another piquant detail, the rabbit is hiding behind the leg of the Sun God, who tells God L that the thief has been caught. These are among the few extant fragments that allow us to savor the informal and humorous tone of Classic Maya mythical narratives.[62] The story of the little rabbit beating God L has the flavor of

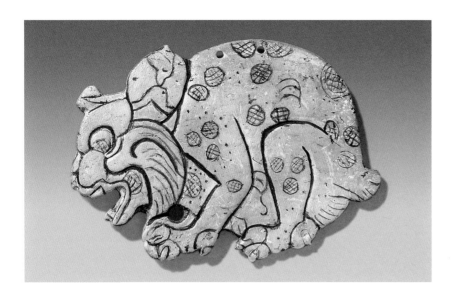

56

Rabbit pendant. Guatemala or Mexico, Late Classic period (600–900). Shell, W. 3 in. (7.6 cm). Museum of Fine Arts, Houston, Gift of Frank Carroll in memory of Clytie Allen

trickster tales that recount the victories of the weak over the powerful using wit rather than brute force.

On the cylinder vessel discussed above, the naked God L appears kneeling before the enthroned Moon Goddess, while the imposing rabbit in her arms holds the god's hat and cape (see fig. 52a). Another vessel shows several deities, including God L himself, throwing the clothes and regalia to the moon, from behind which peek the rabbit and the Moon Goddess.[63] The story likely offered an underpinning for the legend of the rabbit in the moon. How the rabbit came to be there is an important question in Mesoamerican myths, and the solutions are often amusing: storytellers variously describe how a lunar deity got a pet rabbit or swallowed a rabbit, how the rabbit was punished for misdeeds by being thrown to the moon, and how a god slapped the rabbit on the face of the moon, among other explanations. One way or another, the rabbit found its destiny in the moon.

MAYA MYTHS ABOUT THE ORIGIN of the world — whether the defeat of a great bird, the abduction of an old god's daughter, or the theft of God L's clothes — involve trials and errors,

transgressions that led to protracted struggles and eventual successes, however fragile. In the traditional religion of the modern Maya, it is people's responsibility to prevent the world from ending by providing for the gods through properly conducted prayers and offerings. In rituals, they evoke the chaos that prevailed in primeval times and the gods' efforts to shape the present world and its inhabitants.[64] Classic Maya rituals were imbued with similar meanings. In the rhetoric of the hieroglyphic texts, the kings were responsible for sustaining the gods and performing the rituals that would ensure the renewal of the world.[65] The archaeological remains of household rituals show that commoners likewise propitiated the gods, though on a smaller scale and with different practices.[66]

The extraordinary artistic and written records of the Maya allow us to trace cosmogonic myths back to Preclassic times. The mural paintings of San Bartolo and the stelae of Izapa and other sites contain early representations of mythical episodes that can be recognized in variant versions on painted vessels from the Classic period, the pages of the Postclassic codices, and the expansive textual narratives by Indigenous writers in early colonial Guatemala and Yucatán. Hieroglyphic texts preserve terse but important passages that hint at the wealth and diversity of written and oral narratives that circulated in Classic and Postclassic Maya cities. Despite centuries of colonization and cultural change, modern Maya peoples preserve versions of ancient myths that explain the origins of the world and of human communities. Transmitting those narratives from one generation to the next, they continue to evoke them in religious rituals and to perform them in dramatic representations such as the Dance of the Macaws, fulfilling an age-old responsibility to propitiate the gods.

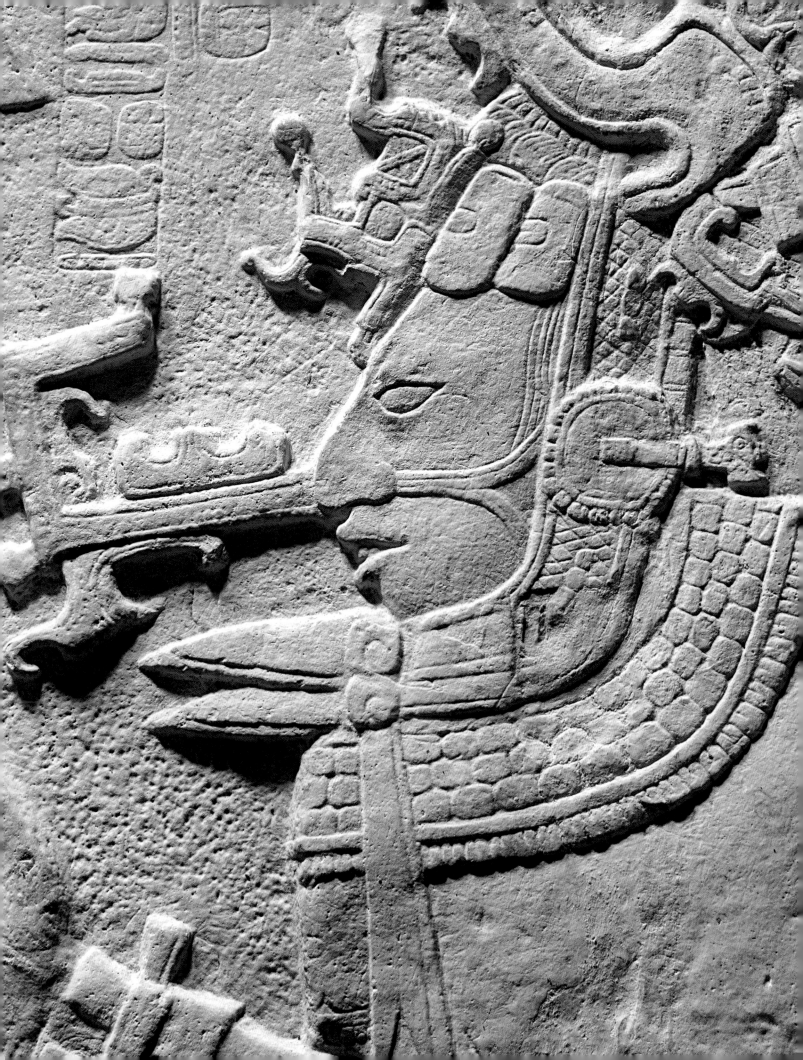

Day, Night

STEPHEN D. HOUSTON

THE ROARS BEGIN before dawn. There is a rumble, then a bellow, as howler monkeys call from their perches in the Maya rainforest. Bats return to their caves, bellies full of insects, or, if vampires, gorged on animal blood. A glow strengthens in the sky, birds chirp and squawk. Weather permitting, the sun then glints through the leaves. By midafternoon, the rays beat hard enough to crack any exposed earth; at dusk, as the day draws to a close, birds begin to fight over roosts. Parrots fly in agitated pairs on their way to favorite branches, and howlers resume their doleful calls. Sometimes the monkeys will settle down, but more often than not they vocalize into the night, calling and responding to other howlers near and far. By now, the sun has ceded its position to the moon or, if the moon has disappeared, to numerous stars and a luminous, meandering Milky Way. Leaving their dens, jaguars, kinkajous, raccoons, tapirs,

anteaters, pacas, vipers, and other creatures seek food and mates. Yet conditions change completely with the arrival of seasonal rains. Scents intensify, either from floral aromas or the stench of decay, and there is a rich, almost overwhelming bounty of smells. Field and forest drip with moisture; clouds obscure the sun, moon, and stars; and mosquitoes bite, breed, and bite again. They are not alone. After the first heavy rainfall, termites venture forth. Dropping their wings, they seem to alight everywhere, as do other insects of the season. Yet such changes have their own, larger kinds of continuity: barring drought, fire, or damage by humans, the cycles of the jungle will repeat year in, year out, as they did in the past, as they will in the future.

Light and Dark

The ancient Maya thought deeply about the daily and seasonal dramas of their world. In fact, the course of the day — *k'in* in most Mayan languages — corresponded to the most basic ordering of time itself. In the Classic period and later, a calendar specialist, known as an *aj k'in* (person of the day), attended to the sequence of days and the meaning and effects of time on human action. Lower-ranking Maya even went by the numbered day name of their birth, at least according to a small number of glyphic references. Although the title *aj k'in* is quite rare in hieroglyphic texts, day keepers must have been common. They are frequently mentioned in later colonial or more recent sources, but, as with so many nonroyal individuals, they received little more than a nod in dynastic texts. Perhaps the duties of the calendar specialist were bundled with other duties or expertise, without any need to specify that function. In one glyphic text from the Classic period, a related word, *k'inil*, appears with *cha'nil*

(festival), suggesting that timed celebrations must have been determined by someone with knowledge of calendars.[1] The hieroglyph for *k'in* has proved to be both ancient in date and enigmatic in form. Some scholars claim that it depicts an open flower, perhaps based on the fact that many such plants bloom during the day. But there is another nuance as well. An early Mayan text on a jade ear ornament hints that, when found with day names and a distinctive cartouche (bordering element), the *k'in* sign implied sacrificial blood. According to several ancient sources, offerings of blood helped to create and sustain time, and, graphically, the three lobes under most day names appear to show gouts of blood in coagulated swirls.[2] In later periods, the lobes had become so schematic as to be unrecognizable, yet, in a few painted examples, red pigment discloses their bloody essence.

Darkness, the absence of the sun, had its own glyph. Comprising a bony element and cross-hatched semicircles, it read *ahk'ab* (night), or, in extended form, *ahk'bal* (darkness), a word applying to its use as a day name in the sequence studied by calendar priests. A feature of ancient calendars in Mexico and Central America is that the names of the days may have varied, but their ordering or fundamental import did not; often, the day signs show telling visual details. In Nahuatl, for example, the language of the Aztecs, the counterpart of *ahk'bal* was *calli* (house), perhaps in allusion to dim interiors or underground, myth-shrouded buildings. Maya imagery communicated other subtleties. When marking the bodies of nocturnal beasts and gods or certain materials, *ahk'bal* identified their habitual time of activity (jaguars) or light-absorbing surface (obsidian).[3] Its opacity and innate darkness contrasted with another sign imbued with the reflective sheen and hardness of polished celts, or axes. At times,

looking out from a stone object marked with *ahk'bal* is a face resembling the Maya glyph for "god," pointing to the existence of vital and enduring forces within.

Maya cities played with light and dark. The moldings of buildings left strongly defined shadows and zones of sunlight that shifted by the hour. Temples at the top of pyramids had curtains to cover their entrances, and the murky labyrinths at a few Maya palaces were illuminated only by torches of resinous *taj* (pine), which were sometimes also used as tools for "painting" designs with sooty smoke. Amusingly, fireflies in Classic-period imagery are often shown holding small torches as the source of their light.

Humans performed certain rites after sunset. One inscription records the occurrence of royal funeral ceremonies in the "black of day," or night (*yik'in*).[4] The timing probably had two aims. One was to enact a metaphor between the burial of kings and the disappearance of the sun; the other was to take full theatrical advantage of the dark setting. A performance in broad daylight did not have the intensifying conditions of flickering light, partly seen shapes, and disembodied sound. An early historical account from highland Guatemala describes one royal interment at night during which "in the great silence of the darkness they walked with the corpse to the place of burial, attended by a royalty and lords, followed by a large concourse of people."[5]

The Classic Maya also had a distinct class of priests — *yajaw k'ahk'* (fire lords, or fire vassals) — tied to the tending of sacred fires, a ritual task that was probably taken in part from the city of Teotihuacan in central Mexico.[6] This might have been a continuous activity, to judge from practices among the much later Aztecs, but it carried an enhanced visual impact at night.

Creation and Cataclysm

For the Classic Maya, darkness was associated with mythic periods, possibly when the sun came into existence or when it first spread its warming light. On pots created in the late eighth century, two calligraphers from the kingdom of Naranjo, Guatemala, who surely knew each other, painted images of an elderly but robust deity. This god assembled and presided over an array of sinister, nighttime beings. The vessel by Lo' Took' Akan(?) Xok has the more detailed scene and longer text (fig. 57).[7] The surfaces of this box- or house-shaped ceramic alternate from black to red in the background, as though capturing the wavering light of dawn. The pot by Aj Maxam, whose career lasted a bit longer, into the next reign, commits to an all-black background.[8] Perhaps this indicated an earlier, darker time of the same day or was simply a design choice. The event on both pots took place, their texts claim, in 3114 B.C., long before the advent of the Classic period and the existence of the Maya as identifiable peoples.

Seated within a stony, cavelike building, the aged deity on both vessels projects an image of tight control. His right hand, the body part regarded favorably by later Maya (lefties attracted disdain or suspicion), extends in a commanding gesture. In front of him, rapt subordinates grip their upper arms and shoulders in a standard pose for obeisance. The thin cigar in the god's lips is one of his traits, as are his ties to trading, riches, and the night. Perhaps the dark was thought expedient for merchants passing through unfriendly foreign lands; there would be fewer opportunities to see and seize valuable goods. Despite its gloom, the vessel by Lo' Took' Akan(?) Xok may show the god at a place of the dawning sun, *k'inchil*, thus accounting for the intense red in the background. The texts on the two

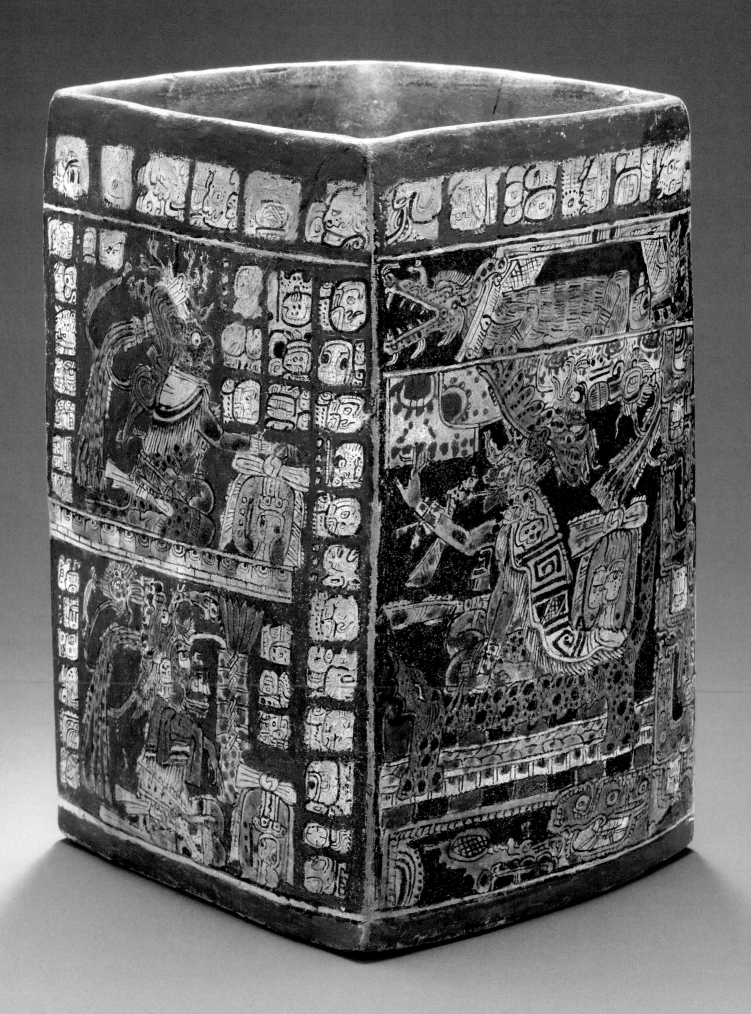

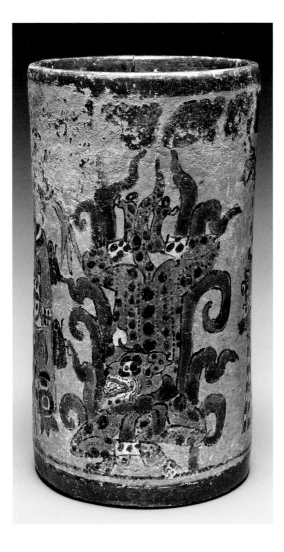

ceramics refer to their respective ownership by a *chak ch'ok keleem* (great, strong youth) and a *keleem* (strong youth), individuals likely to be in later adolescence. On the pot illustrated here, the owner is said explicitly to be impersonating the Sun God. Did dawn and the inception of a bright sun offer suitable models for a young ruler at the beginning of his career at court?

The command over baleful spirits implies another attribute of lords, that they had the power to subdue or harness malignant or dangerous forces, namely those inclined to trouble dreams or roam in forests away from human settlement. Among the most unsettling creatures on Maya vessels are beings known as *way*, whose glyphic label comes from a word for "dream" in many Mayan languages (figs. 58–60).[9] Often shown in attitudes of dance or in violent, undignified movement, *way* appear to explain the nature of dreams, indeed, nightmares. In Western thought, such visions are commonly understood as insubstantial figments that construct and retain memories; they may also convey yearning, worry, and frustration, or replay past events, but they offer no injury beyond a restless night. For the Maya, past and present, dreams represent a spiritual domain; they are aspects of human souls that flit outside the body. In fact, they are so closely linked that, according to some ethnographic accounts, damage to one would affect the other. Active at night, when dreams visualize them, the *way* have other traits too. They do not overlap with other Maya gods or behave like known birds or beasts. They are surreal or horrific. Often noisy and hybridized — a dog merged with a jaguar, or a monkey with a deer — their mouths agape, they may wear clothing, sit or walk upright, or locomote on their hands like the most agile acrobats. Others casually hack off their own heads or dance partly fleshed. Generally they display none of the crouching, bent-over habits of animals, a posture known as *kot* in many Mayan languages. One *way* is even a whirlwind, a great storm with gusts in four directions, spouting clouds, sparks, or flames. Their physical liberation in imagery tends to synch with the uneasy ruptures, unpredictability, and errant motions of dream states. They also fold the wild and the savage into an understanding of the human soul.

As with all religious concepts, the *way* have a history. The earliest known examples date to about 600 in the Classic kingdom of El Zotz, Guatemala, where, with few exceptions, they cavort on red backgrounds that are much like the dawning place on the vessel from Naranjo. Each king, often named generically as the ruler of such-and-such a place, seems

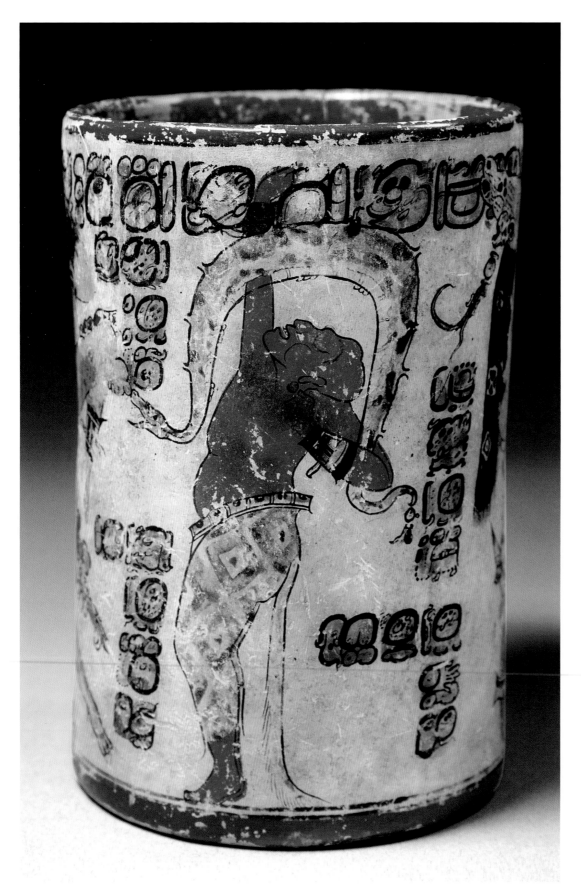

59
Cylinder vessel. Burial 96,
Structure A-III, Altar de
Sacrificios, Guatemala, 8th
century. Ceramic, pigment,
H. 8 in. (20.3 cm). Museo
Nacional de Arqueología y
Etnología, Guatemala City,
Ministerio de Cultura y
Deportes de Guatemala

60
Cylinder vessel. Naranjo,
Petén, Guatemala, Late
Classic period (600–900).
Ceramic, pigment, H. 12 in.
(30.5 cm). Chrysler Museum
of Art, Norfolk, Virginia,
Gift of Edwin Pearlman and
Museum purchase

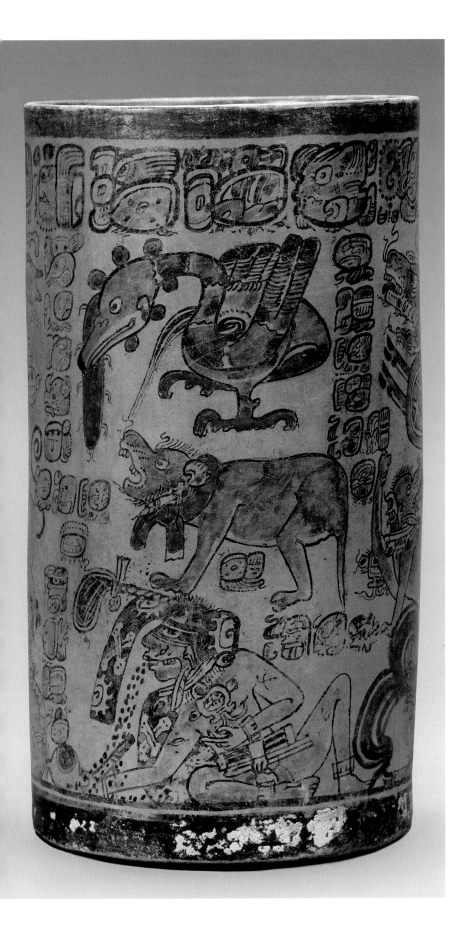

to have had his own *way* (fig. 61). A century later, in areas to the north, near Calakmul, Mexico, the *way* prance on a groundline in a manner that suggests social dominance: they often face to the left, as do the most important figures in Maya scenes, although this orientation could also follow the flow of Maya writing, which passes from left to right (fig. 62). Curiously, the *way*, rather like figures in dreams, do not seem to pay much heed to one another. They appear in various groupings, their images a kind of inventory or subset of *way* characters, often on containers for highly valued drinks such as chocolate or atole. This remains a puzzle. Why did scribes paint a throng of unpleasant beings on objects intended for pleasure?

As a term for "dream," *way* is widespread across time, yet the patterns from the Classic period are far more restricted. Mention of *way* concentrates in a period of less than two centuries, from 600 to 800 at most, clustering in the central part of the southern Maya Lowlands. This was where dynasties, despite their hostility, maintained strong aesthetic contact in interactions that must have had an undercurrent of copying and competition. But here is another mystery. One scholarly interpretation is that the *way* served in Classic times as the weapons and alter egos of "sorcerer-kings." These were rulers who summoned these spirits — some diseaselike, resembling later names for maladies — to target and afflict enemies. Witchcraft became, in a sense, an affair of state, perhaps a linchpin of royal power. However, two features suggest an alternative. The *way* belonged to people holding general titles, not to specific individuals, and the backgrounds on the pots tended to be red or orange in the earliest examples. Perhaps the *way* disported in some remote past; the lack of clearly specified dates or ties to particular rulers in these depictions suggests the *way* were spirits from long ago.

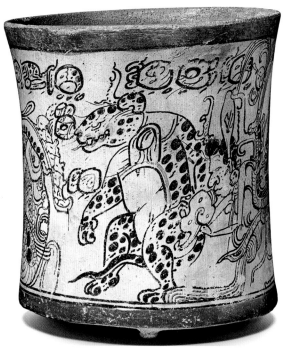

This debate is not yet settled, although, in one context from the Classic era, *way* as "dream" does imply that they were often dormant. The abodes of deities, ranging from house models in stone to pyramids of immense size, corresponded to "places of dreaming" or slumber (*wayib*).[10] If gods slept there or reposed in dormant states, they might also be awakened and put to royal use.

An inky or a dark red background could also point to the future. This may be the case in a tableau of world destruction in the Postclassic Dresden Codex, one of four surviving books from the ancient Maya (fig. 63). Under a "black sky," over a "black earth," Chel, an aged and taloned creator goddess, pours torrents of water onto the same trading god featured on the ceramics from Naranjo. He is depicted here not as a wealthy merchant but as a warrior who lunges forward in attack, with his spearthrower held up and darts in his hands: the belligerence is palpable. Evidently, the red glow of dawn was thought a befitting

backdrop for death and cosmic destruction. Above them is a schematic emblem for the sky (discussed below), rimmed with watery blue; rain disgorges from signs for the solar and lunar eclipses. The end of the sky morphs into a celestial crocodile with deer hooves, vomiting forth unruly flows of water.[11] In many images of this creature, the body exhibits the form and markings of a long snake. This may be a direct reference to the reptilian crocodile or a linguistic witticism in visual form. During Classic times, the term for "snake" was a homophone or near-homophone of the word for "sky," although their free alternation as written signs was a relatively late phenomenon, suggesting earlier avoidance of these substitutions; whether the sky was literally likened to a serpent remains unclear.

The dark background and the linkage of cosmic destruction to a water-soaked field of battle may also account for an unusually elaborate image of Classic Maya conflict in Room 2 of the Bonampak murals in Chiapas,

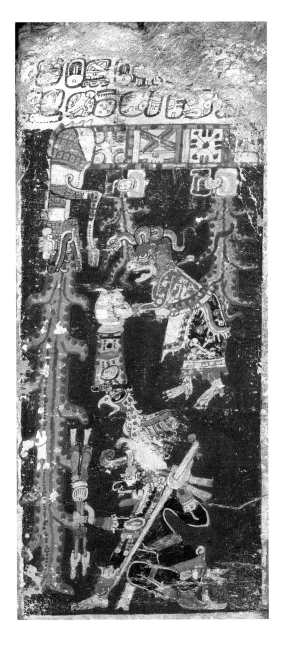

contemporary time, is a well-known trope
for impactful war in Classic Maya texts. By
bringing the cosmic down to human scale, the
darkness of the battle scene may fuse dynastic
conflicts with the end of the world, leading to
other cycles of creation and destruction.

Sky Bands and Crocodiles

The ancient Maya paid close attention to
other polarities: not just day and night but also
contrasts between the sun and the moon, or
a star (or planet) and the moon. When juxta-
posed in glyphic texts these signs spelled the
word *tz'ak*, a term having to do with ordering
or placing things in proper sequence. The first
sign was an element that presaged or led to the
second, and the pairings themselves evoked
the reliance on couplets or parallel phrasings
in the formal speech and poetry of the Maya.[13]
Sun gave way to night or moon, and, depend-
ing on the phase of lunation, stars glimmered
before moonrise. Two hammered, cut, and
embossed metal disks from the Cenote of
Sacrifice at Chichen Itza, Yucatán, Mexico,
exemplify the pairing of sun and moon. One
disk, the sun, is gilt copper, while the other,
the moon, is tin on a wood support.[14] The
material qualities of the metals were doubt-
less relevant. Golden copper was logical for
the sun, here possibly in a state of eclipse, and
argent tin served well for the moon. The disks
were likely a set, and the slightly smaller size
of the moon (6.5 cm in diameter versus 8.1 cm
for the sun) recalled their relative magnitude
in the sky.

Such pairings help to explain a Late Clas-
sic throne, parts of which are painted red,
found at Structure 66C in Group 8N-11 at
Copan, Honduras, and dated to about 780–90
(fig. 64).[15] Underneath its main bench are
four Atlantean figures, two of them aged but
potent beings called Itzam, who supported
heavy burdens like the surface of the world or

Mexico.[12] In the late eighth century, some-
where in the nearby forests, a bloody melee
took place in the dark of night. Above the
scene, at the summit of the vault, courses a
thin, horizontal band of sky; just below sit
bound captives and figures in dark disks with
centipede mandibles. As will be discussed,
these disks resemble stylized versions of blaz-
ing suns, but perhaps they are presented here
as nocturnal or eclipsed versions. The stormy,
torrential nature of dire events, whether
in the distant past or, for the Classic Maya,

64
Sky-band throne. Structure
66C, Group 8N-11, Copan,
Honduras, ca. 780–90. Tuff,
L. 17 ft. 1½ in. (5.22 m).
Sitio Maya de Copán, IHAH

the sky itself. In Maya belief, which delighted in paradox and the uncanny, the old were not necessarily weak. Based on their looped and copious hair, the other two figures are the boisterous rain god Chahk. The throne has two eagle heads on either end and three frontal faces used by the Maya to convey the sheen of polished adzes. Between these faces, from the left, are a moon deity clutching its rabbit (an emblem of fertility, linked to human menstrual cycles); a dark, jaguar-eared embodiment of night with *ahk'ab* markings; the embodied sun; and a planet or star deity that sprouts a scorpion tail, perhaps a reference to a specific planet (maybe Venus) or to the zodiacal sector of the sky associated with it. The symmetrical pairings with respect to the center line of the bench highlight oppositions, with night poised against day and the moon against a planet or star. To underscore this theme, the building housing the throne was adorned with a large solar cartouche. The Sun God gazed out from it, but with unusual attributes: at the four corners of the cartouche are not the expected beams of light but handled rattles or maracas. Perhaps, as

in other known images, the Sun God faced outward as an elegant dancer, moving forward to the cadences of celestial music. The building also contained the tenoned head of what may be a more youthful Sun God, a being discussed below.

The arrangement of signs on the Copan throne is what scholars call a "sky band," a sequence of celestial elements that embody the sky.[16] With the sky band, a limitless, overarching space could be reduced to a single graphic emblem. Sky bands are common in Maya imagery of all periods. At about A.D. 1, Altar 12 from the city of Tak'alik Ab'aj on the Pacific piedmont of Guatemala displayed a sky band above a standing figure. *K'in*, Venus, and signs for luminosity (the emblems for polished adzes of hard stone) run along its band. Depictions of hot solar breath bend down at right angles on either end. That hard angling of the sky band, a surpassing stiffness, is one of its frequent attributes, in both texts and imagery. Yet the reasons for the various uses of sky bands are unexplained. When present, was the sky band emphasizing an outdoor locale or a specific episode of celestial contact

Chahk seated on a sky
band, Dresden Codex,
p. 40c. Yucatán, Mexico,
Late Postclassic period
(1250–1524). Amate paper,
pigment, folio H. 9 ⅞ in.
(25 cm). Sächsische
Landesbibliothek – Staats-
und Universitätsbibliothek
Dresden, Codex Dresdensis

or intervention? Or was the sky merely
assumed to be present in all other images?
Most sky bands occur as iconography, but a
few, in what are termed "full-figure glyphs,"
spell out the word for "sky"— *ka'n, cha'n, kan,*
or *chan,* depending on the stage of sound
shifts in Mayan writing.[17] The sky band has
great resilience and cross-cultural reach. As
David Stuart and other colleagues have noted,
by the time of the Aztecs and the peoples of
early colonial Mexico, this Maya emblem had
metamorphosed into the Mexican depiction
of a sacred book.[18] This was heavenly writing
indeed, and a later echo of Maya prestige.

An example from the Dresden Codex
displays many constituents of the sky band
(fig. 65). These include a *k'in* sign; a cross-
band that is thought by some, on weak evi-
dence, to represent the ecliptic (the yearly
path of the sun as obscured by the occasional
eclipse); an *ahk'ab* glyph; and the more con-
ventional sign for "sky." In other versions, the
sky band contains a luminous celt, much like
on the throne at Copan, sometimes equipped
with a face to imbue it with animacy. At
Tak'alik Ab'aj, there is a glyph for Venus, and

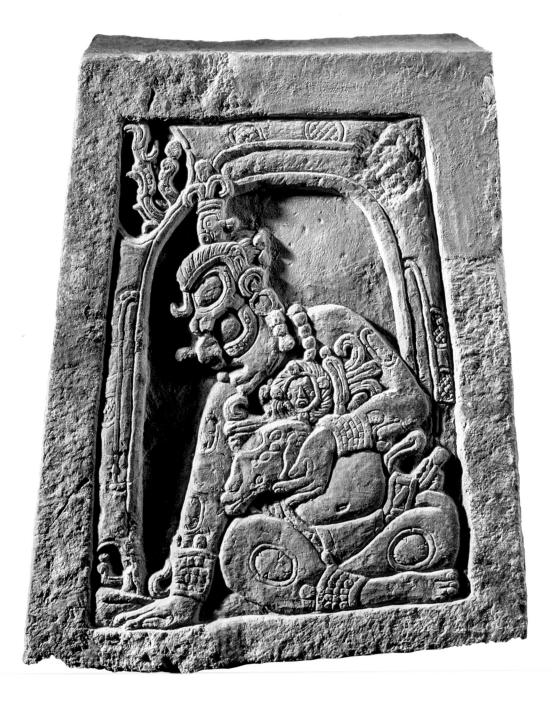

66
Throne armrest with Sun
God. Structure N5-1, Dos
Pilas, Guatemala, ca. 750.
Limestone, H. 24 ¼ in.
(61.8 cm). Museo Nacional
de Arqueología y Etnología,
Guatemala City, Ministerio
de Cultura y Deportes de
Guatemala

on Stela 10 at Piedras Negras, Guatemala, what might be a shooting star spouting flames to advertise the sky band's fiery nature is accompanied by a moon sign and a blast of solar energy represented as a creature with a square snout. Some of these glyphs slant or tilt to one side, perhaps to reflect their celestial instability. Yet there is little patterning to the elements, no hidden code to be deciphered — some researchers have sought in vain for

occult readings. The basic construction of the sky band is an edged panel that sometimes ends in eagle heads, incense burners, or vessels for cached ritual items. Several sky bands are also depicted within a reptilian body, with clear ventral scales and other epidermal patterning.[19] This is doubtless a reference to the celestial crocodile, that chimera with deer hooves, polished adzes in place of toes, and cross-bands or Venus signs that flash in

67

Deity mask. Northwest
Court of the Palace,
Palenque, Chiapas, Mexico,
7th–8th century. Stucco,
H. 8¾ in. (22.3 cm). Museo
Regional de Antropología
Carlos Pellicer Cámara,
Villahermosa, Secretaría
de Cultura del Estado de
Tabasco, Mexico

its eyes or on its ears. A number of examples display the lashed headband usually worn by the Itzam. From many lines of evidence, this crocodile was linked to sorcery, creation, the division of earth from sky, and perhaps the Milky Way.[20]

Sun Gods and Howler Monkeys

The dominant figure in determining what was light or dark was the Maya Sun God (fig. 66). He had a consistent set of features that included a robust body, the fierce eyes of a raptor — perhaps an eagle (a bird tied closely to the sun in Mesoamerican belief) — the prominent nose of older gods, *k'in* markings on his body, and sometimes three small dots under his eye. A stucco head from Palenque depicts him frontally, with filed and notched central incisors and a forehead marked with the sign for a polished adze: his flesh was clearly thought to be shiny and hard as stone (fig. 67). Occasionally his headdress showed, in symbolic form, a beam of light in the shape of a centipede, as on the headdress of a historical figure described as the Ajaw K'in (Lord Sun) on a looted stela, the origins of which are unknown (fig. 68).[21] The presence of centipedes is surprising, as these insects ordinarily live in the very opposite of sunny places, being scavengers of the moist jungle floor, cave entrances, and holes.[22] By Postclassic times, just prior to the Spanish conquest, the Sun God tended to sprout a light beard, and a surviving carving of wood, covered by tesserae, reveals wisps of golden-brown hair.[23] Surrounding his visage in many examples is his solar disk or cartouche. Yet the disk pertains not to a daily refulgence but to one event in particular. Marked with the Maya *yax* sign for "first" or "new," the cartouche seemingly refers to the very first sun, either at creation or at the start of the dry season. There are clues that, in these images, the solar disk was

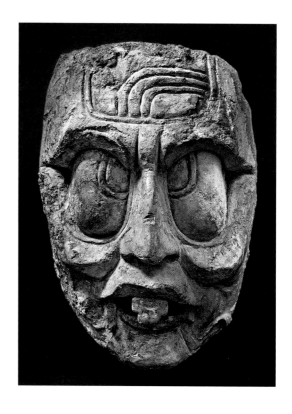

understood not so much as an ethereal glow but as a hard material. Equipped with the sharp breaks and curves of knapped flint or other stone, these disks can shine with indices of luminosity or the polished reflectance of stone; that flint emits sparks for kindling fires could not have escaped the Maya. This connection of lithics with deities may account for the caches of incised obsidian objects found in several parts of Tikal, Guatemala (fig. 69).[24] Typically discovered under or near a stela, in groups of nine, they crystallize the Sun God, the Moon Goddess, and a variety of beings associated with lightning and sacred paper regalia into obsidian artworks capable of slicing flesh. According to a glyphic tag, one set indicates that these objects were labeled as "lords" (*ajaw*) of this or that celestial body or of darkness itself, perhaps in relation to eagles, which the Classic Maya associated with the world directions — east, west, north, south, and the center between them.[25] The caches further attest to the connections among the Sun God, however he might appear,

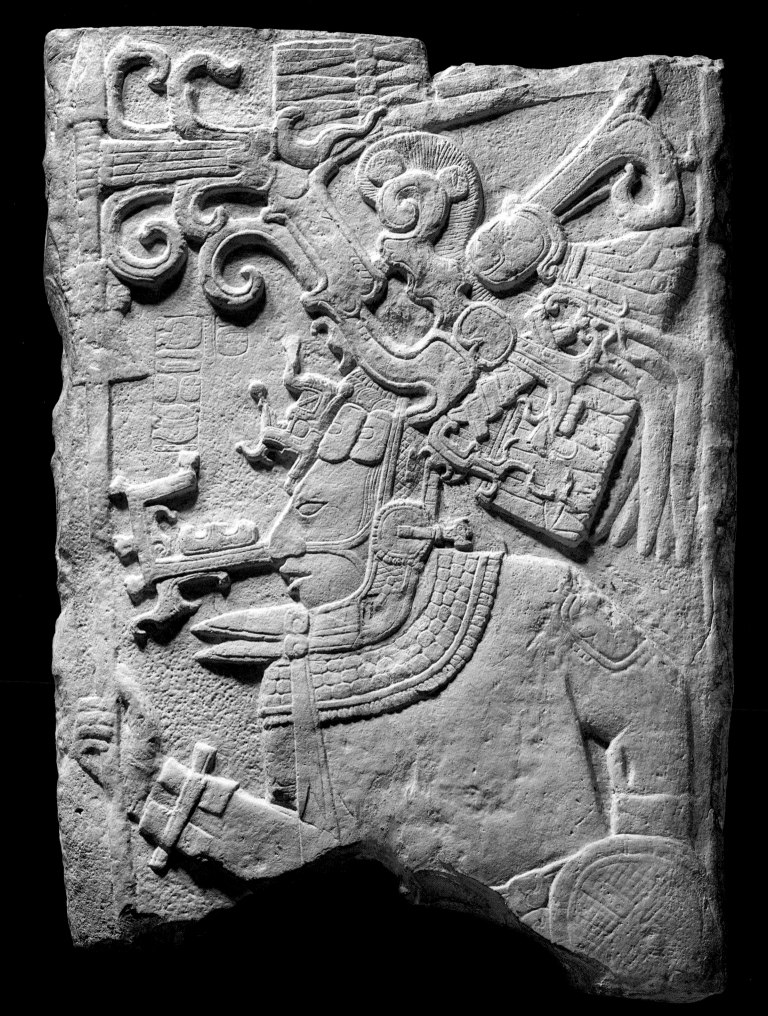

68
Panel fragment. Palenque region, Chiapas, Mexico, 7th–8th century. Stone, H. 39¾ in. (101 cm). Museo de Sitio de Palenque Alberto Ruz L'Huillier, Secretaría de Cultura–INAH

69
Incised images of the Sun God and the Moon Goddess. Cache 56, Great Plaza, Tikal, Guatemala, ca. 700. Obsidian, each approx. H. 5 in. (13 cm). Tikal National Park

and other beings, who must have figured as a collective within the cosmic orderings.

At Tonina, Chiapas, Mexico, a broken ballcourt ring switches out, in a sense, the central image of the Sun God or *k'in* sign with the hole through which a rubber ball would pass.[26] The other key elements are centipede maxillae (upper jaws), probably arranged at one time into the expected series of four on the sides of the ring. The equivalence between the ball and the sun must have resonated here, as did the presence of two nocturnal Sun God heads. These exhibit the upper part of jaguar heads and a ropy feature called a cruller, which passes from the ears, under the eyes, and then twists over the nose. The consensus is that this being, the so-called Jaguar God of the Underworld, is the nighttime aspect of the sun; at the very least, the cruller functions as a marker of nocturnal things and refers to a being tied to rites of fire, perhaps at night. For example, a censer stand from Palenque displays the Jaguar God of the Underworld in a regal pose, with attributes of a Mexican deity associated with fire rites in his headdress; below is an Atlantean figure supporting him with upraised arms (fig. 70). But unlike the daytime Sun God — with one exception from the Postclassic murals of Santa Rita, Corozal,

Belize — the Jaguar God of the Underworld suffers at the hands of others, as a mythic captive to be burned by young lords, in a few scenes and texts.[27] At Tonina, historical captives perform that role of the sun's nighttime aspect (see figs. 148, 149): consigned by myth to be perennial losers, they presumably await fiery torture at the hands of their captors. Few other supernatural beings in Maya imagery demonstrate this degree of shifting appearance by time of day or arc of celestial transit.

The focus on the sun and diurnal passage may also elucidate an unusual stela erected at the city of Machaquila, Guatemala.[28] Placed on the eastern side of the royal plaza, it would have worked as a gnomon, a sundial casting a shadow that varied by time of year. At the bottom is a *witz*, or "hill" element; just above floats the local king as the embodiment of lordly time at the close of an important calendar, called a "period ending" by scholars. The glyphs frame that day-sign portrait of the ruler with a relatively unembellished, angular sky band that once contained glyphs. Just above, extending from the top of the stela, is the head of the Sun God. At dawn, the sun would rise between the buildings behind the stela (Structures 16 and 17), and the shadow of his carved image would fall toward a central feature of the plaza, a masonry quatrefoil to designate a watery, symbolic space underground; Chahk looks up from it in one depiction. In a straight line from there to the other side of the plaza was a stone model of a cosmic turtle, a conventional representation of the terrestrial world. The carvings and plaza are unlikely to have been randomly arranged. As a sequence of carvings and hollows, they must have represented some enchained link between sun, time, water, and the earth's surface.

The Sun God has, much like the *way*, his own history and varied avatars. Later versions in the Postclassic period or immediately

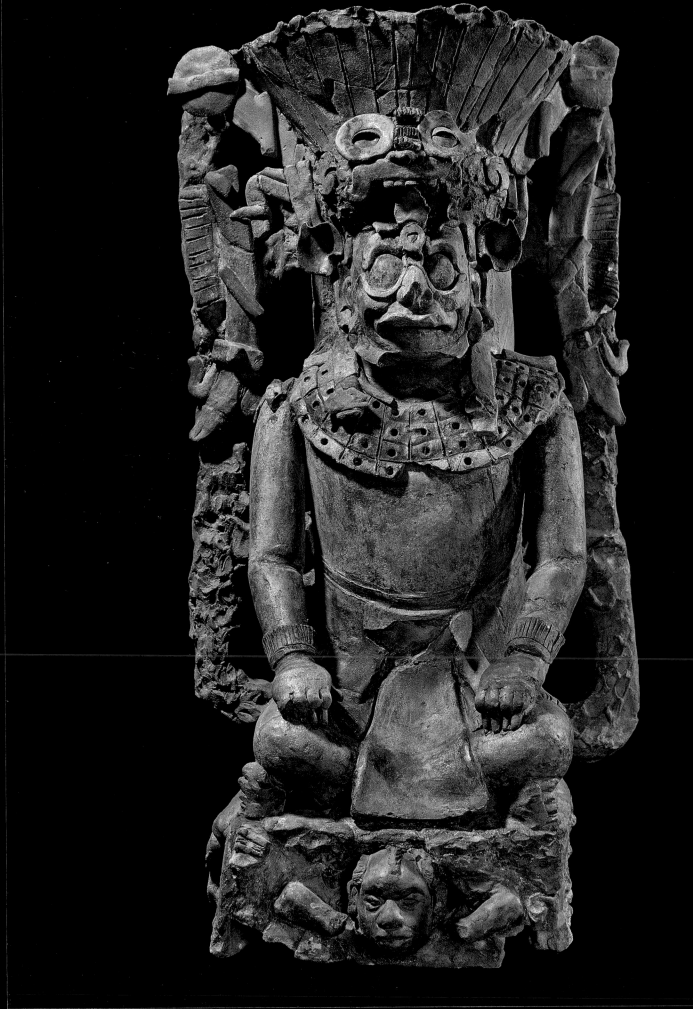

before tend to add a radiant, bejeweled, multipronged disk that finds its final expression in the celebrated Calendar Stone of the Aztecs. A capstone from the Temple of the Owls, Chichen Itza, shows it edging a sky band as part of a resplendent scene of K'awiil, a deity of lightning and growth, rising from a cavity: jewels float in the air and cacao pods (tokens of wealth) grow from sky and cavity.[29] Like similar disks, the capstone from Chichen Itza has two layers. One pulses slightly in the background, perhaps to denote the expansive reach of the sun's rays. The presence of a similar, slightly earlier disk around a deity in the tomb of San Juan Ixcaquixtla, Puebla, Mexico, confirms its origins away from the Maya region.[30] The Classic-period tomb highlights, on its painted back wall, a probable Sun God with gold disks, quetzal-plume headdress, two wavy-edged obsidian objects in hand, and a hexagonal frame with triangular designs around its edge. This final feature prefigures the solar disks known from later images, but the murals also station a set of seated figures, in two files, to address the deity: anyone moving to the back of the tomb would replicate their interaction. The scene promises festivities to come, with headdresses on stands, ready for use, and, on the opposite wall, figures holding up dance masks and a musical conch.

An important innovation of the final years of the Classic period was a younger version of the Sun God. Identified by the anthropologist Karl Taube, he presents arresting contrasts with the older deity found on Maya images as far back as the Late Preclassic period.[31] The youthful god begins to appear at a time when new waves of foreigners are depicted in Maya imagery. The older Maya deity, known as K'inich or K'inich Ajaw, embodies wise and muscular rule. Indeed, many kings attached his name as a title once they ascended to the throne.[32] The young Sun God has comparable features of high rank, such as a *sak hu'n* (jewel

of rule) affixed to a diadem of shell or jade plaques on his forehead and a quetzal-plume headdress. A carving at Ceibal, Guatemala, shows him plainly, with one knee up in a pose associated with foreigners (fig. 71). A vibrant warrior, he clutches a spearthrower, darts, and possibly a stick for fending off an opponent's darts.[33] Underneath is a probable centipede jaw, likely to affirm that he rises as a beam of light; below may be a centipede maw, doubled by Maya convention to show both front and side, with wind signs in its eyes. No text seems necessary to label this god other than a single date in 889: 1 Ajaw 3 Yaxk'in. The use of this time in the calendar may have had intended nuances: 1 Ajaw is the name of an important deity, a young lord associated with rule, and the month 3 Yaxk'in (*yaxk'in* means "new," "first sun," or "day") tips us to the arrival of the

70
Censer stand. Building 3, Group B, Palenque, Chiapas, Mexico, 7th–8th century. Ceramic, H. 26 in. (66 cm). Museo de Sitio de Palenque Alberto Ruz L'Huillier, Secretaría de Cultura–INAH

71
Ceibal Stela 18, showing the young Sun God atop an open centipede jaw, with the date 1 Ajaw 3 Yaxk'in (889). Drawing by Nicholas Carter, after James Porter

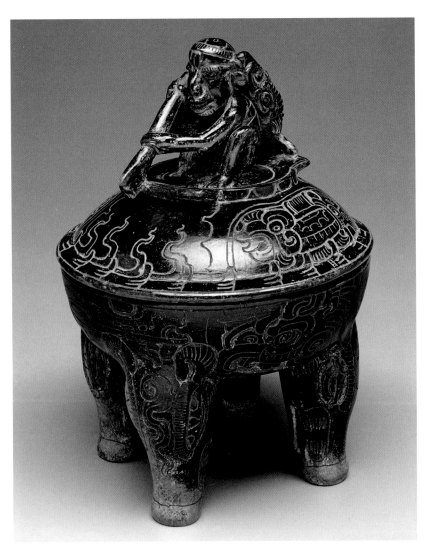

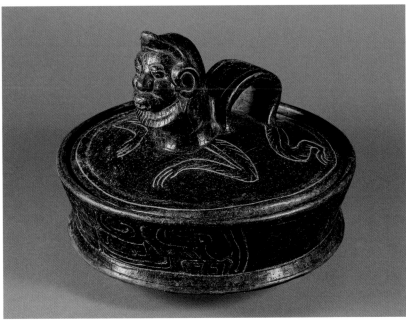

fierce sun at the onset of the dry season.[34] The stela was found at Ceibal in the eastern base of Structure A-20, a building connected with ancient solar ceremonies as part of a complex scholars call an "E-Group." Another example of the god, on Ucanal Stela 4, dated to 849 and also from Guatemala, has him floating above a local Maya ruler. But this deity is both ready for battle and, in a relevant detail, wrapped in a sinuous cloud marked with the glyphic syllable **mi**. This makes little sense with common terms for "cloud" in Mayan languages — *tokal* or *muyal* — but it does fit with the Nahuatl word *mix-tli*. Nahuatl was used extensively, by Postclassic times, in the coastal area of Tabasco, Mexico, from where this god may have come. Perhaps this representation of the deity was less about the dominant, even oppressive midday sun than about the rays of sun being the warrior Sun God's lancing darts at the first break of dawn.

There were other beings tied to the dawn or daybreak. The twitter of birds and the roars of howler monkeys are natural complements to the sun's arrival. Not surprisingly, those creatures appear in Maya imagery and text in ways that show a clear tie to the onset of days. A rather human-looking howler monkey — the fringed hair and beard, snub nose, and furrowed brow give away his simian nature — paddles his canoe among darting fish on the lid of an Early Classic bowl (fig. 72). On his head is a clear *k'in* sign, and another fish is cinched to his back by a band around his torso. The suggestion of movement is obvious, as is fishing, a task appropriate to the early hours of day when fish rise to the surface. But the *k'in* monkey becomes even clearer in bowl lids from the tomb of a dynastic founder at the Diablo pyramid of El Zotz.[35] One is a smelly monkey, a malodor signaled by a musk or excrement curl on his forehead; in a witty contrivance, his very body is the handle of the bowl, the creature being lifted to expose a presumably

Lidded tetrapod bowl with
paddling monkey. Mexico
or Guatemala, 250–450.
Ceramic, cinnabar, H. 12 in.
(30.5 cm). Dallas Museum
of Art, The Roberta Coke
Camp Fund

73
Lidded vessel with monkey.
Structure F8-1, Burial 9,
El Zotz, Guatemala, 4th
century. Ceramic, Diam.
8¾ in. (22 cm). Museo
Nacional de Arqueología y
Etnología, Guatemala City,
Ministerio de Cultura y
Deportes de Guatemala

more fragrant meal below (fig. 73). The other
two lids, however, show more of the monkey's
essence, going beyond natural referents to the
animal world (figs. 74, 75). Both have distinc-
tive, flowery rosettes as their brows, and they
rear their heads back to roar in throaty bel-
lows. The canines of monkeys are there, along
with the snub nose and fringed beard. The
incised bowl, among the masterpieces of Early
Classic civilization, incorporates the body of
the ceramic into the monkey's own form (see
fig. 74): his arms are on either side of the lid, a
collar pectoral is on the front; his legs appear
on the bowl below, as does, on its back, his
signature tail. Instead of fur, that tail consists
of a centipede or beam of light connected
to his body by the head of a mythic bird, the

muwaan owl. Such beings are also portrayed
on a bowl from Holmul, Guatemala, and, with
jawless, yawning maws, on a vessel excavated
at Becan, Campeche, Mexico. The monkey on
the incised bowl from El Zotz has four ban-
ners suspended from his neck. These show
the head of the Sun God, two possible Maize
Gods, and the Jaguar God of the Underworld,
hinting at a four-part division of the day, with
the Sun God at the acme and the Jaguar God
at the nadir. The use of this creature as a sign
for *k'in* is overt on glyphic texts at Quirigua,
Guatemala, and Yaxchilan, Mexico. These
inscriptions confirm that the mythic howler,
a noisy harbinger of dawn, equipped with his
writhing centipede tail, also functioned as an
unequivocal glyph for "day."

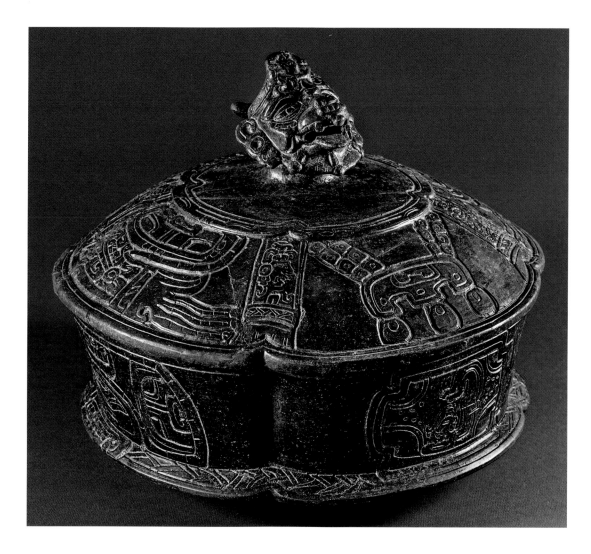

74
Lidded vessel with
howler monkey. Structure
F8-1, Burial 9, El Zotz,
Guatemala, 4th century.
Ceramic, Diam. 10¼ in.
(26 cm). Museo Nacional
de Arqueología y Etnología,
Guatemala City, Ministerio
de Cultura y Deportes de
Guatemala

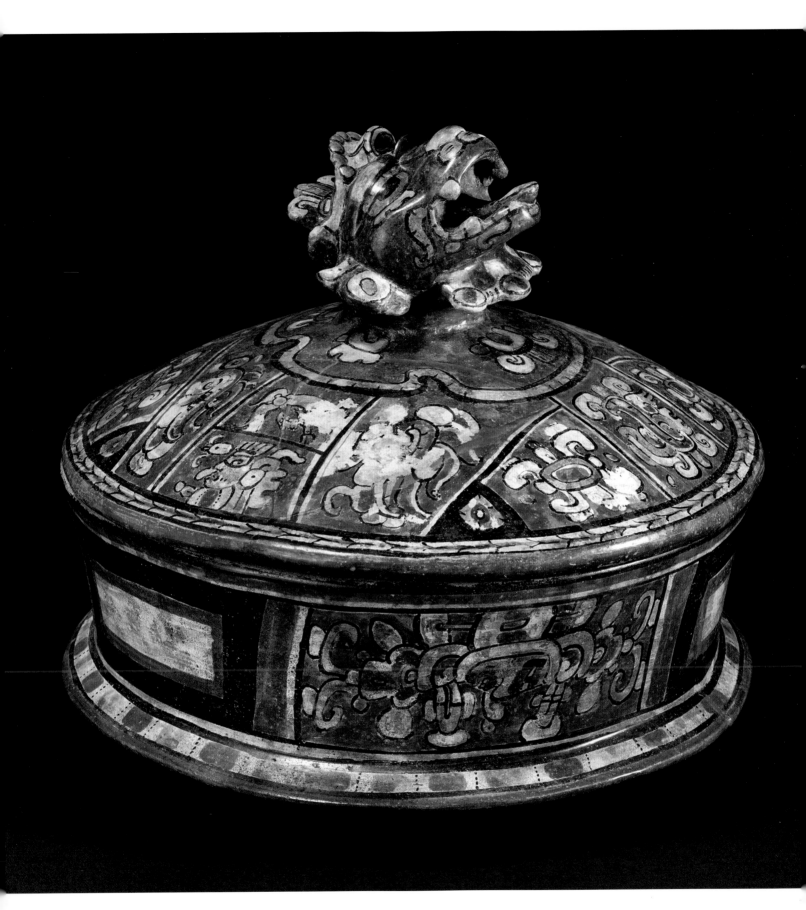

Another feature of the Sun God is his martial nature, a desirable trait of kings. Stela 1 at Ek' Balam positions him within his cartouche at the top of the carving, shield and weaponry in hand, sky band just below. But a second matter also comes to the fore: the blurring of royal and divine identities. It was important for rulers, as well as some queens and noblemen, to be able to impersonate deities, usually in the context of dance. Divine spirits appear to have inhabited human bodies. Those impersonating the Sun God tend to carry as their regalia the implements of battle — a *took'* (flint) and a *pakal* (shield). These two elements are tied glyphically to a dance celebrated in Room 3 of the Bonampak mural building.[36] The culmination of spaces dedicated to distinct episodes of rule, Room 3 takes the world of the Bonampak court back into full sunlight. The three princes who dominate the murals, along with courtiers of lower rank, dance beneath a bright vault with images of the Sun God, deities whose mouths gush with blood, and a red sky band at the level of the capstones. Centipedes shoot from most of the dancers' headdresses, and a small figure is sacrificed directly across from where a visitor might enter. Over to the side, the women of the royal house let blood from their tongues with spines or blades in the company of a possible eunuch (he is grouped twice with royal ladies and has the heavy build of castrated men). Other than a few captions, some blank, the scene is relatively textless, in part because the events are probably communicated by a long text in Room 1, which clarifies that an impersonation is taking place, involving a flint and shield. The scene on the square vessel from Naranjo is also concerned with Sun God impersonation. The overall focus on night followed by day, and with sacrifice at Bonampak, can hardly be a coincidence. If the Sun God desires blood, Room 3 represents a clear exposition of such offerings and the political and martial maneuvers behind them.

Moons and Rabbits

The Sun God is undeniably male: in Maya depiction, he is a solid figure at the height of middle age. That also holds true for his more youthful aspect. But his counterpart at night, the moon, takes on a female shading, with exceptions. In many appearances, this figure is a young woman, but a few examples are indisputably androgynous, without distinct breasts, and some representations are fused with the Maize God, who had similar properties of indistinct gender.[37] Some moon gods must have existed as well, possibly affected by the conventional division scribes made between lunations of 29 and 30 days respectively. Was that division thought to be gendered? There is also a vessel that exhibits many deities with lunar crescents, clear references to the lunar months enumerated in Maya dates (see fig. 52b).[38] Nonetheless, most often the moon is depicted as a young woman who exemplifies standards of Maya beauty, with a full body and, at times, bare breasts.

The Dresden Codex provides a name glyph for this goddess, Ixik (Lady) or Sak Ixik (White Lady). In that book she is not equipped with the crescent associated with the moon, but there is broad agreement among scholars about the identification. There are also connections between the moon and menstruation because of the similarity between the length of lunation and that of a menstrual cycle. The Mayan glyph *hul* (arrival), for example, refers to the first sighting of the crescent moon — the eye that appears within the glyph is probably the orb of the Moon Goddess — and a likely cognate word, *hula* in colonial Yukatek Mayan, means "menstrual cycle."[39] Moreover, the section of the Dresden Codex on the Moon Goddess focuses on her espousal and coupling with other deities; indeed, her frequent companion is that most famously procreative of animals, the rabbit. Reproduction is alluded

75
Lidded vessel with howler monkey. Structure F8-1, Burial 9, El Zotz, Guatemala, 4th century. Ceramic, Diam. 13 in. (33 cm). Museo Nacional de Arqueología y Etnología, Guatemala City, Ministerio de Cultura y Deportes de Guatemala

to here, and more subtly the identification of attributes or essences assigned to males and females.

The pairing of sun and moon affirms and develops this theme. An Early Classic vessel in the Ethnologisches Museum, Berlin, features an image of the deceased Maize God; as in some other scenes, he may also blur with a historical figure who has, in the Mayan expression, "entered the road" (see fig. 126).[40] Wrapped in a knotted funerary shroud, he lies on a bier, a watery register coursing underneath; shin high in that liquid stand six mourners, almost certainly his grieving consorts, an array of rather androgynous corn maidens (secondary sexual characteristics become more pronounced in the imagery of a century or so later). A mountain behind them supports a monkey and a jaguar that stare brashly at the viewer. At top center is a *yaxk'in* (new sun) disk rising upward. Inside is a sign

joining the image of a seed with, perhaps, an emblem of legitimate sons. Just to the right appears the lunar crescent. This complex, combinatory symbol promises the renewal of the deceased but also, in referring to the dyad of sun and moon, is a possible portrayal of what composed the human spirit.

The juxtaposition of deceased parents is a particular emphasis at Yaxchilan. On Stela 1, two such figures appear, impersonating deities: the father, predictably, as the sun and the mother as a figure deciphered by David Stuart as K'in Bahal(?) Ixik K'uh, perhaps the Sun Pouring Goddess (fig. 76). Stuart proposes that a woman has *babal* (poured out) a future ruler (possibly the *k'in* or "sun" here) from an implied vessel that could involve a uterine metaphor. The importance of women who bore kings is a consistent theme across world cultures. The gaudy mausoleum of Spanish kings in the Escorial palace and monastery includes queens who had done this duty, while Queen Jane Seymour, the third spouse of King Henry VIII of England and mother to his heir, Edward VI, is the only one of his six immiserated wives to be buried beside him. Similarly, in imperial China, the concubine who bore the imperial heir could vault to prominence and controlling influence.[41] The role of parent, an everyday matter if personally consequential, intensifies when a child becomes a ruler. For Classic Maya rulers, the absorption of father and mother into the sun and moon asserts the fixity of legitimate descent — the sun will always rise, the moon as well, if with occasional, predictable absences. But there is another claim too, that, for the Classic Maya, royal ancestors acquired an essential, life-giving radiance.

Scattered evidence indicates that, in rare circumstances, higher nobles might also have declared ancestral fusions with the sun and moon. Two sets of lintels from the small settlement of Chicozapote, Mexico, not far

76

Detail of Stela 1, Yaxchilan, Mexico. Photograph by Teobert Maler, 1898–1900

from Yaxchilan, show their main figures in what might be described as a pose of "gracious condescension." [42] They are attentive to underlings but, as hinted by their inclined heads, project a certain amour propre. Built in two phases, the structure with the lintels had one set with legible texts, albeit with one caption of slovenly execution. The addition to this building was completed, its lintels carved, yet its glyphic captions were left blank. The earlier building had two doorways with parental portraits: the father, to the left, in his solar disk, the mother, to the right, with her lunar crescent and rabbit. It is tempting to think that the figure passing under these lintels would have been none other than the local lord. He (or any visitor) would have looked up to scan a continuous text that began with the mother's caption and concluded with that of the father, who therein proclaimed his vassalage to Shield Jaguar III of Yaxchilan (Itzam Kokaaj Bahlam III). The lintels in the addition probably show him in sequence, first enthroned, then, in the final lintel, in conversation with another, slightly older figure.

All ancestral figures at Yaxchilan are shown seated. Yet most images go further by equipping and gendering deceased parents with solar and lunar disks, as on Stelae 1, 4, 8, and 10. [43] The couples appear only at the tops of stelae, often over a living ruler bloodletting below. For example, on one of its faces, Stela 11 elevates the pair above a ritual celebrating a solstice; on its other face is the king impersonating the rain god Chahk (see fig. 90). That the parents occur closer to the sky, above dynastic rites, accords with their notional and literal identity as ancestral and celestial bodies. Nonetheless, one ballcourt marker, near Structure 14, presents what is probably a deceased ruler, Shield Jaguar III, within a flinty solar disk. Not far from Yaxchilan, the ballcourt marker Lacanjá Tzeltal Altar 11 extends that usage by depicting two captives within a "new sun" disk conflated with a lunar disk. [44] These carvings may indicate that ballcourts were the places where such figures and their celestial counterparts rose or sank beneath the ground, a passage that might also extend to captives who, as sacrifices, conceivably fed such beings. If the sun and moon might rise and fall, so too would the parents associated with them, through supernatural apertures in ballcourts.

Humans not only observe cycles but also endow them with logic, feeling, purpose, and personalities, such as the deities who embodied the polarities of day and night and other beings reflecting the times in between. A natural pattern is never entirely so when permeated by meaning. The Maya embraced such nuances and their representational challenges. Through graphic ingenuity, they captured the immensities around them or the figments of disturbed dreams. They converted the arching sky, orbs that shone, beams of light, inky night, and wild phantasms into reproducible, concrete shapes, infusing them in the process with movement, motive, and stories. Some narratives related to times in the distant past; others might be reenacted on a daily basis. But, as largely royal commissions, the texts and images of the Maya were attached to the few, not the many. The kings, queens, courtiers, and high magnates set the visual agenda of their time, and, in final analysis, they were the ones who subsidized public depictions of day and night. For all that self-focus, however, they left us with an interpretable record of the bright and dark spaces of their world, and the place of gods and people within it.

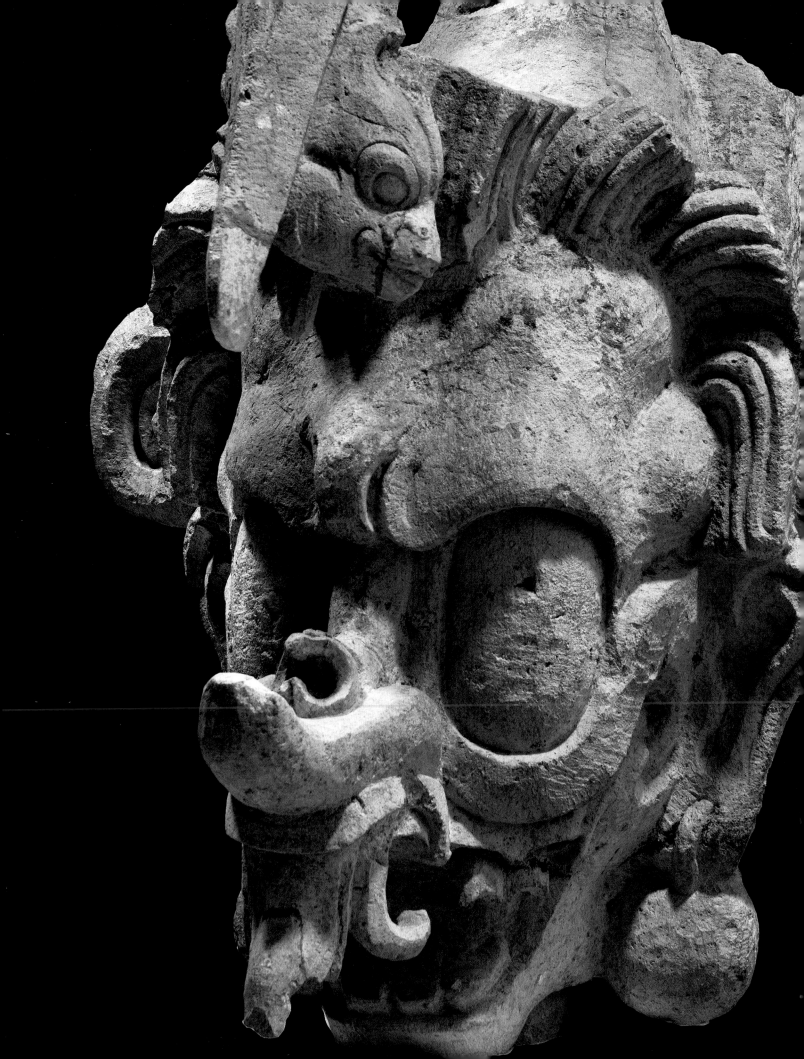

Rain, Lightning

JAMES A. DOYLE

A SUDDEN, RAPID BREEZE cuts through the heaviness of the humid Maya Lowlands air and signals that a major storm might be coming. Even if no dark clouds are visible through the trees, thunder can be heard from far away. In the gloom of the stormy skies, lightning rivals the sun in its ability to light up the landscape, if only fleetingly. Tension charges the atmosphere as the first large drops fall on the high jungle canopy. As the downpour intensifies, waterfalls appear across the terrain, creating a deafening roar. Afterward, the booming sound of rain gives way to an impossibly loud chorus of amphibians awakened by the deluge. During the rainy season, from June to October, each afternoon sees this drama unfold; during the dry season, many creatures are dormant, and only memories of rain — and the promise of more to come — survive.

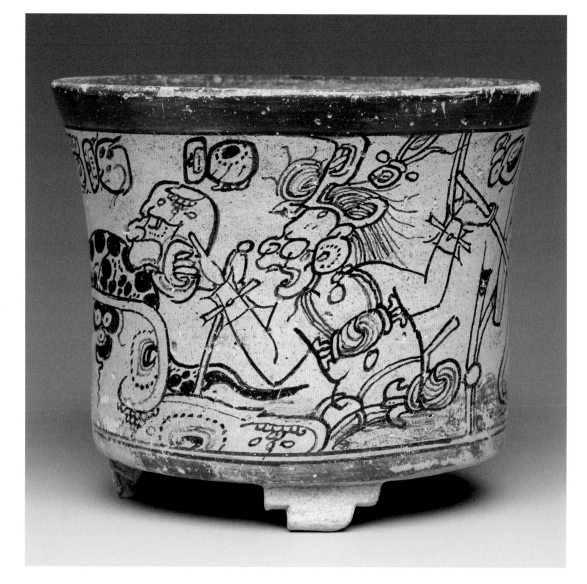

77A
Attributed to the
Metropolitan Painter
(Maya, active 7th–8th
century). Vessel with myth-
ological scene. Guatemala
or Mexico, 7th–8th century.
Ceramic, H. 4½ in.
(11.4 cm). The Metropolitan
Museum of Art, New York,
Purchase, The Michael C.
Rockefeller Memorial
Collection, Bequest of
Nelson A. Rockefeller
and Gifts of Nelson A.
Rockefeller, Nathan
Cummings, S.L.M. Barlow,
Meredith Howland, and
Captain Henry Erben,
by exchange; and funds
from various donors, 1980
(1980.213)

77B
Rollout view, detail

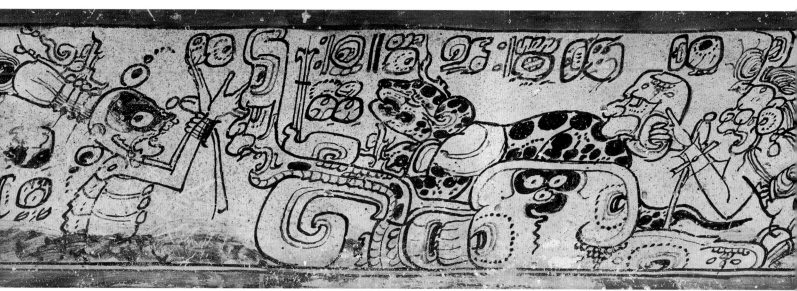

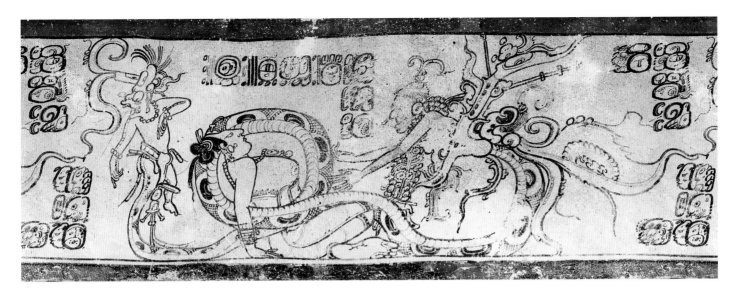

78
Rollout view of vessel
with snake-lady scene.
Guatemala or Mexico,
650–800. Ceramic, slip,
H. 6 1/2 in. (16.5 cm).
Los Angeles County
Museum of Art,
Anonymous gift

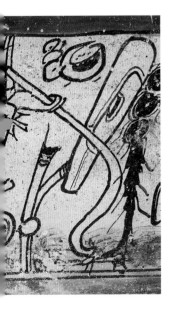

Maya artists beginning in the late first millennium B.C. depicted the kinetic and electric energy of tropical rainstorms as a fearsome, axe-wielding Rain God, known in many instances by the name Chahk (figs. 77a, b). Chahk's axe and boxing stone — a rainmaking tool sometimes called a *manopla*[1] — were thought to be the sources of the crashes heard during tempests, and the effects of his violent force were seen in the forest and the cities. The Maya recognized multiple versions of Chahk, presented in sculpture and painting as a divine being ranging from humanlike to supernatural and from young to aged. The most important characteristics of Chahk are his associations with water and the hydrological cycle as expressed by his accoutrements and body markings.[2] Maya artists often depicted his body with fish scales, gill slits, a shark tooth, or barbels similar to those found on catfish. His unruly hair is a key attribute, and he often wears a headdress or diadem resembling vegetation or aquatic flowers with a crossed-bands motif. He is most often adorned with earflares made of spondylus shells, signaling a deep connection with the sea and the richness of its products.

The divine nature of lightning itself also captured the imaginations of Maya artists of the Classic period, who personified the fractal flashes as a living, reptilian being symbolic of Chahk's axe (fig. 78, at far left).[3] Known in the corpus of hieroglyphic inscriptions as K'awiil, this important lightning deity is generally depicted with large eyes with spiral pupils, a serpentlike face, and a smoking or flaming element emerging from the forehead. This protrusion was the hallmark of K'awiil, and its appearance on depictions of other deities or rulers signals an element of lightning fused with other identities. One of K'awiil's legs is often a serpent, a visual metaphor for lightning, which was commonly symbolized by fire serpents in Mesoamerica. K'awiil was a vital part of Classic-period Maya rulership — conceptually, as a reinforcer of ultimate authority, and physically, as a scepter grasped by kings and queens. Further, many rulers took the names of Chahk and K'awiil in their royal monikers to channel the power of the skies.

Chahk as Creator

Some compositions celebrated rain as a generative force by portraying Chahk either as an active agent in creation scenes or as a creator himself. The virile deity on the vessel

attributed to the Metropolitan Painter stars in one such visual narrative (see figs. 17a, b), versions of which appear on several works by different hands.[4] The details of his regalia here point to a specific identity or episode. For example, Chahk's necklace is distinct: the collar consists of pendant eyeballs, and the pectoral is in the shape of an upside-down water jar marked with the hieroglyph for darkness, with what looks like a small serpent emerging from its mouth. The overall setting of this scene suggests a theme of creation or origin; the shining Rain God steps in front of a large *witz*, a living mountain represented here as a jawless head that seems to spring forth from the ground, breathing out a foggy mist that surrounds the dancing deity.[5]

The chain of events depicted on this vessel begins on the top of this *witz*, above which hovers a hieroglyphic caption. The text names the owner of the vessel as a *"k'uhul chatahn winik,"* a royal title in use during the Classic period in certain places, but its cryptic phrasing makes the actions in the image difficult to identify. The other characters help build out a fuller story. On the nose of this zoomorphic incarnation of a mountain spirit balances a flailing baby deity with a jaguar tail, paws, and ears. This character has large eyes, an aquiline nose, and a shark tooth; it's a supernatural face that contrasts with the more humanlike visage of Chahk, though the infant has a similar knotted hairstyle and vegetal headdress. This reclining character is the deified Baby Jaguar, depicted elsewhere and mentioned as a hieroglyphic logogram in royal names at places like Tikal.[6]

Almost touching the Baby Jaguar is a frightening creature identified as an embodiment of death by its skeletal head, distended belly, and bony appendages. He dances in a gesture mirroring that of the Rain God, rising off his left foot and lifting the right. His tense hands seem to reach for the Baby Jaguar or

the hieroglyphics above him. This death god wears an elaborate backrack composed of textiles, bone elements, and extruded eyeballs. His pectoral is similar to Chahk's, but its vessel replaces the *ahk'bal* glyph for "night" with a percent-sign motif, the meaning of which is not clear. This death god has two creepy companions, a firefly and a dog, and they also gaze in the direction of the Baby Jaguar at the center of the tableau. In scenes like this Chahk could be interpreted as dancing the Baby Jaguar into being, creating new life in the face of the throat of rotting death, represented by this death god and his friends.

This dancing Chahk contrasts with other artists' portrayal of the god in an act of creation in an aquatic setting. One of the most accomplished Maya painters fashioned such a scene on a large tripod plate (figs. 79a, b), a surface that allows for a close viewing of the entire vista, unlike the turning required to view cylindrical vessels.[7] The scene begins on the outer walls and feet of the vessel, which are painted with watery motifs in black, including swirls, registers of droplets, and water lilies. On the plate's inner surface the artist fused the mythic and the historical to form a microcosm. The delicate main scene features Chahk, named in the hieroglyphic text on the plate, waist-deep in a register of aquatic motifs and hieroglyphs for "sea" (*nahb*). Three symbols, representing stars or the planet Venus as well as the front and rear parts of the body of the celestial Starry Deer Crocodile, appear on either side of the upper scene, denoting that part of the composition as the sky.[8] A celestial bird at the top of the scene carries what appears to be the glyph for the name of a month — 4 Keh — on its head as it seems to survey the action below. The text just below the bird begins with the fictive date of 13 Ok 8 Zotz, indicating when an event involving the four gods of Matwiil "happened" (*uhtiiy*) "at the black cenote, at the black

79A
Tripod plate with mythological scene. Guatemala or Mexico, 7th–8th century. Ceramic, slip, Diam. 16 ½ in. (41.9 cm). The Metropolitan Museum of Art, New York, Gift of the Mol Collection, 2021 (2021.320)

79B
Side view

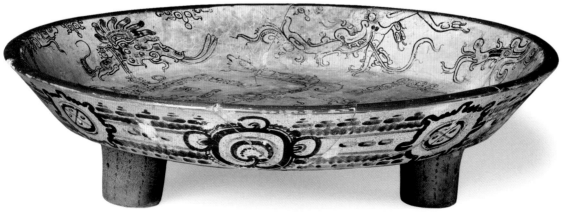

water, at the five-flower house," which could be a reference to a watery paradise.[9] One god is identified as a feline or jaguar, which appears just below the text, roaring, head back; the names of two other gods are, unfortunately, partially eroded.[10]

Below, Chahk rises from the black water with his axe. From his head and left arm grow three vegetal branches that morph into deities and other beings. These include a large serpent to the left, the jaguar mentioned above, and a large jester god in the upper right that is recognizable by its crossed bands motif; these figures could correspond to the gods of Matwiil (a mythical place) mentioned in the text. Chahk's left hand morphs into a personified version of obsidian at the lower right, which could be a reference to this representation of the branched rain deity as a living version of an eccentric scepter (discussed below).[11]

Here, Chahk is presented as the progenitor of agricultural deities, such as the Maize God, the personification of staple crops. Sprouting from a zoomorphic head painted on the sidewall of the vessel is the Maize God, recognizable by his characteristic elongated cranium and sporting in front of his nose an elliptical bead, which symbolizes divine breath. He emerges from a water-lily rhizome that spreads its tendrils to either side toward the jaws of a centipede symbolizing the cenote mentioned in the text.[12] The Maize God gestures in dance as he rises from the aquatic plant, which presumably was generated by the actions of Chahk above. Though the work is slightly eroded, the artist's talent is evident in the confident delineation of the Maize God's graceful profile through to the left hand caught in a gesture of performance.

Growing down from the black water to the right of the Maize God is the torso of a figure with tobacco leaves sprouting from its head. Tobacco was an important ritual plant for the Maya of the Classic period, used as a stimulant in cigar or snuff form, and many images of rulers incorporate tobacco leaves into regalia, signifying their access to the substance.[13] The relationship of Chahk to tobacco is not made explicit in visual depictions, but other deities smoke cigars presumably made from the plant. The smoking element that protrudes from the Lightning God is also often depicted as a cigar. Accompanying the tobacco entity and to the left of the Maize God is another figure growing downward out of the black water; this being could be the spiritual embodiment of a root crop. Thus, the artist here creates an agricultural paradise: the rain brings maize, tobacco, and sweet potato or manioc, represented as four beings who appeared at creation and set the stage for the dawn of people.

Works painted in the codex style — that is, painted in a fine line with a restrained palette resembling ancient Maya codices — increasingly featured Chahk as creator in the second half of the eighth century, and their activation in courtly life connected royal actions to deep time. Those drinking from the Metropolitan Painter's vessel or consuming maize tamales served from the tripod plate would reenact and harken to the emergence of Chahk from a primordial sea or the naissance of the Baby Jaguar at the dancing god's hands. These objects signaled a ruler's access to sacred knowledge, which may have been kept secret and shared only on special occasions. Such fine serving vessels also would have been gifted among Maya rulers as part of an ongoing diplomacy. The codex style is a hallmark of the royal courts and loyal local palaces around the great city of Calakmul, straddling the border between southern Campeche and northern Guatemala.[14] A large volume of broken vessels at Calakmul itself signals that these were vital components of commensal gatherings there, raised in annual celebrations of the genesis of the rain.

Chahk the Fisherman, Chahk of the First Rain

Chahk has long been portrayed as the creator of water, memorialized as a purveyor of aquatic bounty in some of the earliest monumental sculpture from southern Mesoamerica. In one Preclassic work, sculptors along the Pacific coast of Chiapas depicted an early version of the Rain God as a piscatorial character with human features, stooping over a basket of fish, with another woven container on his back, presumably to carry his catch (fig. 80). Here, the Rain God, whose feet morph into fish, stands atop a watery register under a sky band that frames the scene, fluid issuing from his mouth and falling from both baskets.[15]

80
Stela 1. Izapa, Chiapas, Mexico, 300 B.C.–A.D. 100. Stone, H. 82 ¼ in. (209 cm). Museo Nacional de Antropología, Mexico City, Secretaría de Cultura–INAH

Contemporaneous Preclassic friezes at sites such as Calakmul and El Mirador show widespread artistic conventions for depicting personified rain. The forehead or hair of the deity always takes the form of a prominent curl or volute, which may be a reference to clouds. The protruding tooth and piscine jaw also feature in Preclassic visions of Chahk, yet, curiously, the ears are most often adorned with circular ornaments rather than the spondylus shells that later artists depicted. One scene with the dancing Maize God inside a mythic turtle from murals at San Bartolo demonstrates the artistic license taken in these early imaginative interpretations of a unique, important creation event involving Chahk (see central scene in fig. 19). Chahk impersonations also seem to have been performed in the late first millennium B.C.: on the El Mirador frieze, an individual wears a headdress of the Preclassic Rain God as he swims with a water bird among symbols of mountains and clouds.[16]

Centuries later, in the early eighth-century sculpture workshop of the royal court of Waxaklajuun Ubaah K'awiil at Copan, artists fashioning a program of architectural sculpture created some of the most extraordinary surviving depictions of the Rain God producing water. From single enormous stones, the carvers extracted multiple dynamic versions of Chahk's face with a monstrous water bird emerging from his head amid tumbling cascades (fig. 81).[17] The Rain God opens his mouth as if to bellow; his upturned nose and upper jaw extend forward, and a jagged trilobed tooth projects. Large elliptical eyes with spiral pupils lie beneath a furrowed, bulging brow. A mop of unruly hair atop the forehead droops above an earflare assemblage. Arising from the rear of the head is a striking, long-necked bird with wild eyes, perhaps a heron or an egret; its snarling, pointed beak grasps a distressed fish. The conflation of divine beings

81

Rain God and cascades.
Híjole Structure, Temple
26, Copan, Honduras,
7th century. Stone; Rain
God: approx. D. 34 ½ in.
(87.5 cm); cascades: approx.
D. 40 ½ in. (103 cm). Sitio
Maya de Copán, IHAH

and birds of prey extends to representations in other media, such as a large bowl whose lid is modeled as a supernatural bird, its hooked beak poised to snap down on an unlucky fish (fig. 82).

The varied Chahk heads and gushing cascades of water that vivified the facade at Copan were dismantled by ancient residents of the site, who ritually buried them out of reverence for their subject matter and quality. Indeed, the three-dimensionality and movement captured in the grouping are the marks of a virtuoso hand (or hands). The quality is so astonishing that, upon discovering the sculptures, Honduran excavators exclaimed, "¡Híjole!" (Son of a . . . !). Though reconstructions of the original arrangement remain speculative, it is possible that the heads were flanked by the waterfalls, or the water may have gushed forth below the projecting visages. Regardless, the message is clear: Chahk brings flowing water and fishy abundance.

Chahk as a fisherman also appears in a set of delicately incised images on bones from

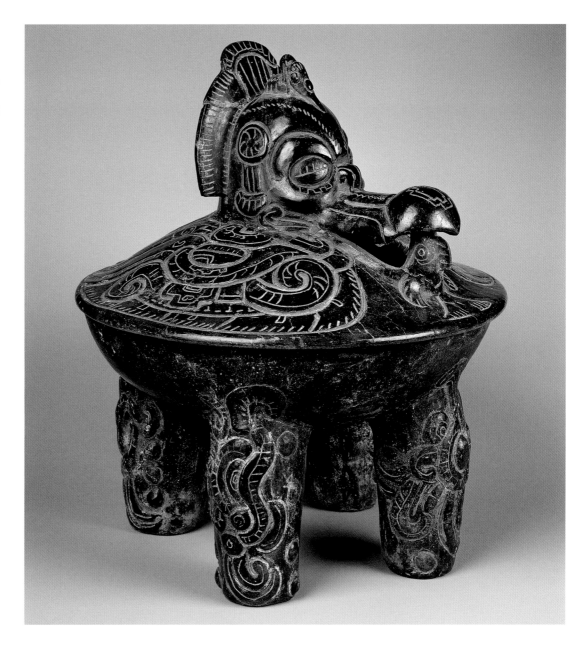

Tikal Burial 116, roughly contemporaneous with the Copan sculptures (fig. 83). Two of the bones feature scenes of three Rain Gods, two in a canoe and one wading waist-deep in a bubbly body of water. A text accompanying the canoeing Chahks states that "it is his bone, Jasaw Chan K'awiil, the holy lord of Tikal," indicating the deceased's ownership of the objects. The wading deity clutches a large fish and wears a bundle or basket on his back, which holds another fish. One Chahk seems to steer the canoe with an oar; the other leans over the prow to grasp a striped fish. This action is a metaphor for summoning, as the glyph for the invocation of a deity is a hand grasping a fish. The presence of Chahk on the Tikal bones underscores this deity's primary role in the Classic-period pantheon; the same set includes bones featuring the Maize God, the Jaguar Paddlers, and other divine beings. While here Chahk steadily fishes by hand to procure sustenance, other images depict chaos and deities in a sinking canoe. Rain is the constant and foundational substance that

83

Chahk scenes incised on
bones, Burial 116, Temple I,
Tikal, Guatemala. Drawing
by Andy Seuffert

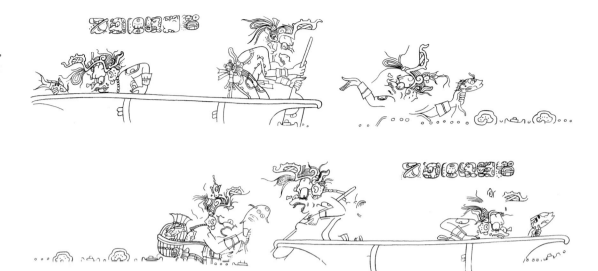

84

Rollout view of cylinder
vessel. Petén, Guatemala,
600–700. Earthenware,
slip, H. 8¾ in. (22.1 cm).
Museum of Fine
Arts, Boston, Gift of
Landon T. Clay

85

Rollout view of cylinder
vessel. Petén, Guatemala,
650–800. Earthenware,
slip, H. 8⅝ in. (21.7 cm).
Museum of Fine
Arts, Boston, Gift of
Landon T. Clay

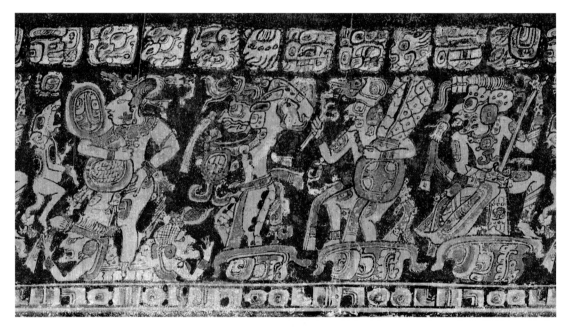

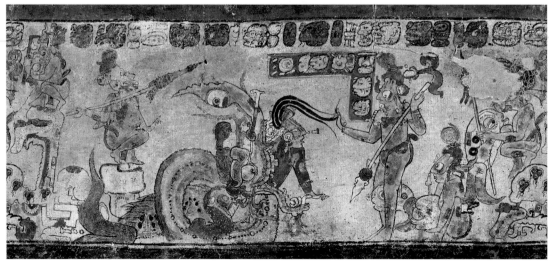

creates bodies of water in the human realm and in the unpredictable godly universe.

Painters depicted Chahk in a canoe on several polychrome drinking vessels. On one, the canoeing Chahk and two other deities (one perhaps a different Chahk) observe the emergence of the Maize God from a cracked turtle shell, from each end of which emerges an old god (fig. 84). This scene echoes that of the Rain God and Maize God's watery encounter from the murals at San Bartolo painted centuries prior. Chahk also appears as a spear hunter in a series of polychrome depictions. In one, the standing Rain God seizes the Wind God by the hair and pulls him from the mouth of a monstrous shark (fig. 85).[18] Chahk is attended by four other deities — two atop a *witz* — and by fish, signaling a fusion of the mountainous upper world and the watery underworld. The Rain God here has knotted hair and a pectoral, spondylus earflares, a loincloth, a spiral eye, and a protruding tooth. These attributes are shared with some of the other deities in the scene, suggesting that other rain or water deities have come together to bring forth the wind. Artists created visual parables that placed the personification of rain and storms as a principal protagonist in important divine moments.

Chahk's connection to the primordial sea is borne out in sculpted works at Tikal. For example, a pair of small earflare frontals made from spondylus shell features the deity's head (fig. 86). The artist created a metarepresentation of Chahk's spondylus earflares on these shell ornaments, which were meant to imbue the wearer with the Rain God's power. Chahk also appears in the corpus of monuments at Tikal from the Early Classic period, such as the fifth-century Stela 1, in which he emerges with a boxing stone from one end of a double-headed serpent bar. The Rain God's eminence as a subject at Tikal seemed to diminish throughout the seventh and eighth centuries, a trend paralleled in the hieroglyphic histories: only one documented ruler, Nuun Ujol Chahk, who reigned from about 657 to 697, took the name of the Rain God, suggesting that K'awiil, used in at least seven regnal names, superseded him as a patron in the religious life of the Tikal dynasty.

Chahk as a local patron played an important creation role in the narratives and art of the city of Palenque. One relief panel underscores the interconnectedness of rulership at Palenque with the Rain God and other deities (fig. 87). In the image, K'inich K'an Joy Chitam II dances while impersonating Chahk; he is

to K'awiil. The infant deity held by Queen Ix Tz'akbu Ajaw, on the scene's left, is also K'awiil. Chahk as a metaphorical scaffolding for rulership at Palenque takes physical form on a throne from a few decades later. The throne's leg depicts the deity's disembodied head (in profile, facing left) modified with elements that blend the Rain God with other supernatural beings (fig. 88). The diadem with crossed bands, water-lily motifs, spiraled pupils, and furrowed brow all allude to Chahk, though other distinctive attributes, such as the spondylus earflares, are absent. This floating, aquatic image, marked with the hieroglyph for "stone," may represent a place-name; rulers seated upon the throne might have enacted an episode set in that mythical place related to Chahk. On the throne's sculpted back, Chahk appears with his ear ornaments and knotted pectoral, seated in a quatrefoil cartouche along with a text referencing fishermen.[20]

The artistic programs of other Late Classic kingdoms feature a version of Chahk named First-Rain Chahk. One such image appears on a small codex-style vessel, perhaps depicting events at the start of the tropical rainy season (see figs. 77a, b). The scene centers on a water-lily jaguar who crouches on a large *witz*, hinting that this full-grown feline might be related to the Baby Jaguar seen on other vessels. Over the jaguar's hindquarters, Chahk brandishes a boxing stone in his right hand. In his left, he holds a shiny axe with a whiplash form. He is shown with his typical wild hair and vegetal headdress, marine-shell earrings, and a pectoral seemingly made of knotted cords. As in the colossal versions from Copan, a single tooth projects from his fishlike mouth. The smudgy border at the bottom of the scene may denote that the action takes place in a misty or watery location, similar to the codex-style scenes described above. The hieroglyphic text above the boxing stone

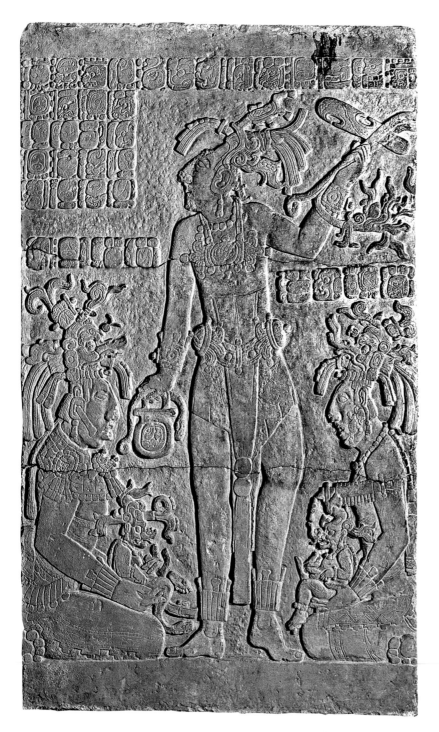

87
Panel. Palenque area, Mexico, 702–11. Limestone, H. 65¾ in. (167 cm). Dumbarton Oaks Research Library and Collection, Pre-Columbian Collection, Washington, D.C.

flanked by his mother and father, who hold small lively deities in infant form. The text mentions the dedication of a dwelling place for a specific version of Chahk (known as Hux Bolon Chahk, or 3 9 Chahk), which the god subsequently entered.[19] The ruler embodying Chahk holds an axe, the handle of which transforms into a serpent in a reference

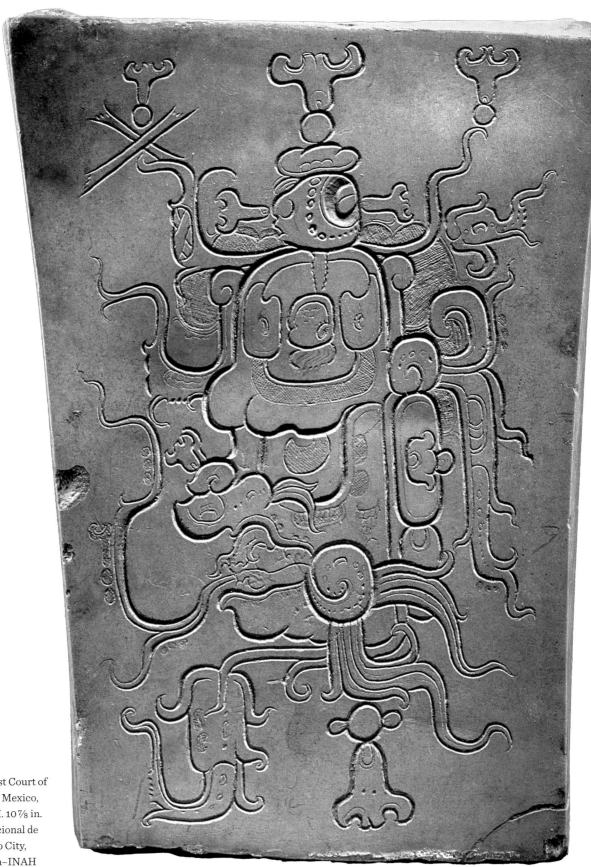

88
Throne leg. Southwest Court of
the Palace, Palenque, Mexico,
ca. 784. Limestone, H. 10⅞ in.
(27.5 cm). Museo Nacional de
Antropología, Mexico City,
Secretaría de Cultura–INAH

specifies that this is First-Rain Chahk (Yax Ha'al Chahk). The artist elided the text with the portrait of the deity, who faces off with a death god to the left of the water-lily jaguar, this time specified as the *way* (creature) who is said to be "whitening," as his bones would be bleached by the sun's power.[21]

Other depictions of Yax Ha'al Chahk in the codex style relate directly to the Baby Jaguar scene described above, complete with *witz*, fireflies, and death gods. Most references to First-Rain Chahk come from the Late Classic period, signifying an increasing preoccupation with the first rains of each year's rainy season.[22] Scribes referred on the Hieroglyphic Stairway at Copan to the birth of First-Rain Chahk on a day in May, corresponding to the beginning of the rainy season in the region. Even in the absence of explicit hieroglyphic titles, perhaps other versions of axe-wielding rain gods would have been inferred as the harbingers of the first rains by those viewing these images or texts.

Chahk as Striker, Yopaat

Artists also depicted Chahk as an older, though no less powerful, rainmaker. One codex-style scene features an aging rain god wielding a ceremonial axe in his left hand while placing his right hand on a stone temple that he has presumably split open (figs. 89a, b).[23] Chahk is shown with features that appear in other depictions: a watery vegetal headdress, spondylus earspools, and fishlike barbels. The wisps on the knob of his head, however, are nothing like the bushy, unruly tangle of knotted hair seen in other portrayals. The torso of the god is also uncharacteristically saggy, accented with skin rolls — a convention in Maya depictions of geriatric bodies. Most peculiar here is the volute the god vomits out, which recalls the sculpted fluid on the Preclassic stela

representing the Rain God (see fig. 80). The spewed matter flows between his legs and upward, so that he appears to be seated in the crook of the watery emanation. Rather than dancing, he crouches as if ready to spring into action.

Though Chahk is the largest character in this scene, it centers on the two figures in front of the cracking temple. On the left, a youthful Maize God — identified by a cob-shaped head with a wispy tassel of hair and the shining hieroglyphs on his arms — poses as if in mid-dance. By him sits a forlorn captive with black face paint and arms bound behind his back. The text to the left of the captive may identify him, perhaps as a nighttime version of the same Maize God, but the phrasing is difficult to interpret. A serpent slithers from one of the quatrefoil voids in the temple, and an aged god emerges from the serpent's mouth. The direction of the figures' gazes reveals the sequence of events. The old god emerging from the serpent stares at the back of the aggressive Rain God, who in turn focuses intently on the building he is destroying. In contrast, both the Maize God and the captive look upward. Scattered about the scene are circles and teardrop shapes aligned vertically in twos and threes; these likely represent raindrops falling as a result of Chahk's ritual actions. The Maize God and captive are awaiting the first rains, blessed for their life-giving powers but cursed for their destructive capacity. By breaking open the building's roof, Chahk could be bringing the Maize God back to life.

Is this the First-Rain Chahk at a different point in his godly life cycle? The text, which runs beneath the entire length of the upper band, refers to "raising the drinking cup" in an act of dedication. The vessel's owner is noted as "striker," a name perhaps relating him to the axe-wielding figure of Chahk.[24] The designation could also indicate the owner's earthly role in the perpetuation of agricultural

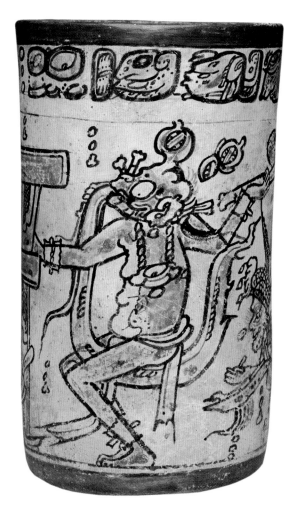

89A
Codex-style vessel with mythological scene. Guatemala or Mexico, ca. 7th–8th century. Ceramic, H. 7½ in. (19 cm). The Metropolitan Museum of Art, New York, Gift of Justin Kerr, in memory of Barbara Kerr, 2014 (2014.632.1)

89B
Rollout view

cycles — that of breaking open the soil to sow maize. The contrasts between good and evil, growth and decay, and the shine of youth versus the sagging of old age converge in this mythic scene encapsulating the relationship between rain and maize. In the mortal realm, the act of Chahk striking with an axe may have been associated with sculpting itself, as some artists' signatures contain the god's name.[25]

A bellicose Chahk starred in many narrative scenes in the later part of the Classic period, when many leaders took aspects of the Rain God as part of their regnal names.[26] Though the warlike aspect of the Rain God in the Maya realm may be connected to similar storm deities in the central Mexican metropolis of Teotihuacan, iconographic elements of the Mexican deity do not appear to fuse with Chahk during the Classic period. Even in places where Maya sculptors referenced the motifs of the central Mexican deity, they portrayed rulers in full Chahk headdresses or even impersonation masks with no foreign images.[27] For example, on Yaxchilan Stela 11 the ruler Bird Jaguar IV stands, dressed as

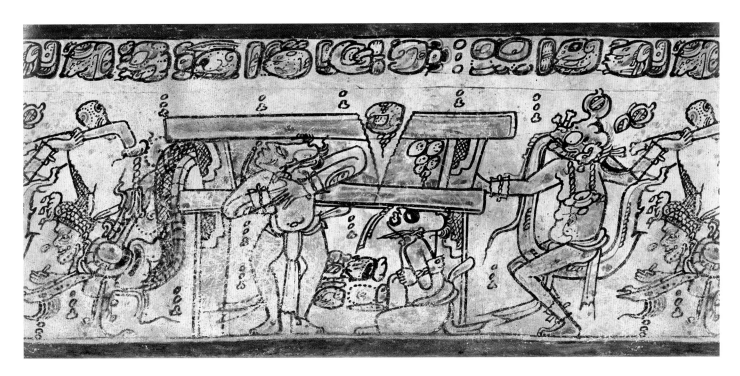

90

Stela 11, Yaxchilan, Chiapas,
Mexico. Drawing by
Alexandre Tokovinine

91

Monumental figure
(Chahk). Mexico, 9th
century. Limestone,
H. 84 ½ in. (214.6 cm).
The Metropolitan Museum
of Art, New York, Harris
Brisbane Dick Fund, 1966
(66.181)

92

Detail of Altar of Zoomorph
O, Quirigua, Guatemala.
Drawing by Matthew
Looper

Chahk, above three subordinate lords (fig. 90).
The sculptors made special effort to empha-
size that this event was not a god's appearance
but an impersonation. The mask seems to
float in front of the ruler in an X-ray–type
view, revealing his human earflares just below
the godly spondylus versions attached to the
Chahk diadem. He holds forth an axe shaped
as an effigy of K'awiil, the lightning god. By
donning this regalia these rulers took on the
primordial role of Chahk the Striker; they
conquered captives and ruled over subordi-
nates just as Chahk took down massive fish or
destroyed buildings.

Sculptures and mural programs in the
northern lowlands emphasize the warlike
aspect of Chahk as well (fig. 91). Clutching the
handle of a large axe, Chahk is shown with
an open mouth and pronounced cheeks, as
if shouting or threatening. The two holes in
the axe would have been filled with blades
of stone; this double-bladed Chahk axe is
also seen in the Temple of the Chacmool at
Chichen Itza and in a doorjamb at Kabah.
Ruler impersonations in the Puuc region and
the Yucatán Peninsula also include other
attributes of Chahk seen in earlier represen-
tations, such as the knotted pectoral. This
violent iconography of Chahk may have origi-
nated in codex-style ceramics from the area of
Calakmul and been distributed to other parts
of that city's sphere of influence and then
further northward over time.[28]

One attribute of Chahk that Late Clas-
sic artists emphasized was a boxing stone,
which, along with other implements such
as conch shells or clubs, was associated
with rainmaking.[29] In fact, the stones are
intimately associated with a related deity
known by the hieroglyphic name Yopaat,
who is depicted similarly to Chahk but with
sparks emanating from his head.[30] Yopaat
appears as a lively subject on the masterful
colossal sculptures known as the Altars of

Zoomorph O and Zoomorph P from Quirigua
as well as in full-figure hieroglyphs in the
regnal names of several Late Classic rul-
ers. Yopaat became an especially important
patron of the dynasty at Quirigua. He appears
as an anthropomorphic deity with the spotted
snout of a feline, often portrayed in mid-
bellow with a furrowed brow, dancing with
handfuls of stones among a violent swirl of
clouds (fig. 92). In rare instances, it seems
that artists fused the identities of Chahk and
Yopaat, though Yopaat does not carry his
counterpart's long-bladed axe.[31]

The diversity of traits in depictions of
the deities suggests that ideas about Chahk
and related rainy divinities shifted during
the Classic period. Different rulers commis-
sioned artists to portray various versions of
Chahk, perhaps at specific moments that were
mentioned in oral traditions of the time. The
introduction of images of Yopaat as a related
but distinct deity raises questions about the
theological or ecological philosophies of Late
Classic royal courts. Furthermore, the sparks
of Yopaat's crown recall the aftereffects of a
lightning strike, which also appear in depic-
tions of the Lightning God himself, K'awiil.
A tripartite division of storm gods — Chahk,
Yopaat, and K'awiil — echoes the K'iche *Popol
Wuj*, in which Thunderbolt Huracan, Youngest
Thunderbolt, and Sudden Thunderbolt are the
three tempest deities in the sky.[32]

K'awiil

Lightning as a personified force intimately
related with Chahk appeared in Maya art in
the Early Classic period. One such portrayal
occurs on Tikal Stela 4, dated to 396, in which
the seated ruler Yax Nuun Ahiin I faces out
toward the viewer in regalia associated with
Teotihuacan. Above the ruler's head floats a
disembodied god head, with a high forehead
pierced with a smoking element, possibly

lightning flashing over the scene. Another Early Classic depiction of K'awiil appears incised on a round ceramic vessel modeled as a snail shell, from which an old god emerges (figs. 93a, b). On the side of the vessel the creator outlined an early version of the Rain God seated within a crenulated cartouche, a motif that references the word *yax* (new or first). This elaborate image of Chahk includes the spiral pupil, piscine tooth, knotted pectoral, tousled hair, and the hieroglyph for *yax* marking his body, perhaps signaling a specific primordial version of this deity.[33] This "first" Chahk clutches an axe in the form of a living, smoking being. This is an abbreviation of K'awiil—the artist depicted only the head and serpent foot—in which the smoking blade protrudes from the mouth of the Lightning God rather than emerging from the forehead. Smoke emanates from the top and bottom of the animate scepter, portraying the moment after a lightning strike has singed the immediate environs. This complex image perhaps reflects contemporaneous oral traditions that gave an identity to lightning distinct from that of rain. K'awiil had become a powerful force in

his own right, wielded by the Rain God to chop at the landscape and incinerate wherever his serpent foot landed.

Over time, sculptors and painters gave a humanlike body to the serpentine Lightning God. By at least the sixth century, K'awiil had a complex set of distinguishing traits, including an elongated upper lip and reptilian snout; large eyes with spiral pupils; a prominent shark tooth or fangs; a high, tapered forehead pierced by either a celt (a stone axe blade) or a torch; and body ornamentation like pectorals, bracelets, and anklets. Four K'awiil figures, originally sculpted from wood, shed light on his role at that time. They are known today only because archaeologists at Tikal recognized the significance of hollows left in mud centuries ago when the wood effigies disintegrated after a flood; miraculously, they were able to recover their thin decorative shells of painted stucco. Four versions of the sculpture, perhaps a reference to the cardinal directions, depict a seated Lightning God holding a square plaque with dangling ornaments. These could represent mirrors, reflective surfaces made of obsidian or pyrite, that formed

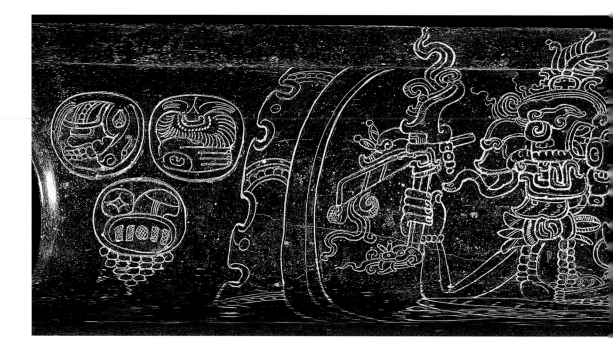

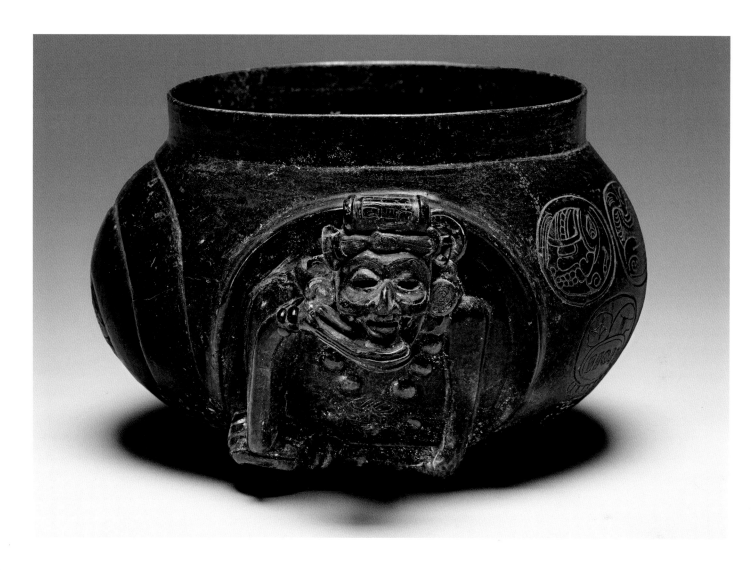

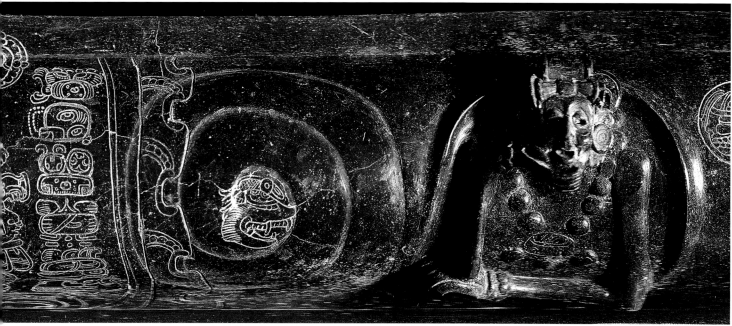

94
K'in Lakam Chahk and
Jun Nat Omootz (Maya
sculptors, active late 8th
century). Panel with royal
woman. Usumacinta
River region, Mexico or
Guatemala, 795. Limestone,
W. 27½ in. (69.8 cm).
Cleveland Museum of
Art, Purchase from the
J. H. Wade Fund

part of ritual assemblages for Maya rulers. These K'awiil figures, poised for the afterlife, hold potential energy — seated, primed for action with their divinatory objects — while their smoky, scepterlike counterparts perform a lively dance, as shown in ritual.

Maya scribes used the phrases *ch'am k'awiil* or *tzak k'awiil* — deciphered as grasping or summoning K'awiil — to record the actions of a ruler on his or her day of accession. K'awiil was thus a deity to be seized figuratively and,

in sculptural form, literally by Maya kings and queens. The grasping action refers to a scepter, but conceptually the rulers must have believed they were actually wrangling and wielding the fractal lightning god himself.[34] This vital conceit appears in multiple depictions of K'awiil scepters in the Late Classic period, including the one on a late eighth-century panel from an ancient site affiliated with Piedras Negras, then known as Yo'kib (fig. 94). The regal woman in the center of the composition stands

in profile, facing the viewer's left and extending her right hand from her elaborately embroidered tunic. In her hand writhes K'awiil. The sculptor framed the reduced-scale deity with smoky volutes, one pair emitting downward from the serpent foot and the other from the smoking celt pointing skyward from the shiny forehead. K'awiil twists his torso toward the face of the queen and raises his arms to her, as if in lively conversation. The sculptors — K'in Lakam Chahk and Jun Nat Omootz signed the work — created the two hands of K'awiil, complete with gesturing fingers and delicate fingernails, with impressive dexterity.[35] Both sculptors also worked on a team with their peers to produce the monumental Stela 12 from Piedras Negras, one of the most formally inventive stelae in the entire corpus, dedicated on the same date as the panel in 795. The two works amply demonstrate their creators' exceptional skill in relief carving.

The many depictions of Lightning God scepters in relief sculpture raise a question: From what materials were K'awiil effigy scepters actually made? None in the round has been discovered archaeologically, suggesting that, if we accept the visual evidence that such objects once existed, they were likely made of perishable materials. A class of K'awiil sculptures that has been recovered in tombs and dedicatory offerings across Mesoamerica may, however, represent versions of these objects. The works were chipped from sedimentary rocks such as chert or flint or shaped from obsidian, producing sharp blades that were once hafted to wooden handles. They are known as "eccentrics" for their idiosyncratic forms; in the Maya region they often take shapes related to K'awiil.[36]

One important cache of eccentric flints comes from an Early Classic–period building at Copan, where the flints were deposited during the building's interment, in perhaps the seventh or eighth century.[37] The structure,

nicknamed Rosalila, was at that time carefully encased and buried by residents to preserve the polychrome stucco facade, commissioned by the eighth ruler of the city, Wi' Yohl K'inich.[38] The program of modeled stucco contains monumental deity portraits, including *witz* figures and monstrous avian creatures with faces of solar deities; these serve as full-figured hieroglyphs for the name of Copan's founder, K'inich Yax K'uk' Mo'. With this construction, Wi' Yohl K'inich memorialized his ancestor's tomb, which lay meters below Rosalila, by creating a technicolor sacred mountain emblazoned with his name and patron deity. Excavators found the offering of eccentrics beneath a threshold between the west room and the south room of the temple, along a spiraled path that ritual practitioners used to access the innermost chamber. The flints were painted and wrapped in fabric or barkcloth before being buried.

The Rosalila flints may have been scepter finials that depict in profile humanlike beings with elongated foreheads wearing feathered headdress and other regalia, sometimes seemingly seated on benches. Many of the heads bear the smoking celt attribute of K'awiil, and one example depicts a seated ruler holding a K'awiil scepter or effigy (figs. 95a–f). The examples of eccentrics with multiple heads facing different directions may reference the omnipresent supernatural vision of K'awiil. Three eccentrics from Temple 26, excavated at the base of the Copan Hieroglyphic Stairway, feature a humanlike figure at the center of the composition (figs. 96a–c). From the figure's limbs and headdress radiate multiple heads with the forehead element of K'awiil. Another example from an unknown context depicts multiple versions of K'awiil in a single scene (fig. 97). Here, the Lightning God with his smoking forehead element sits in the center of a canoe-shaped form, flanked by two humanlike beings facing inward, also bearing

95A–F
Eccentric flints. Rosalila
Temple, Copan, Honduras,
600–800. Flint, each
approx. H. 15¾ in. (40 cm).
Sitio Maya de Copán, IHAH

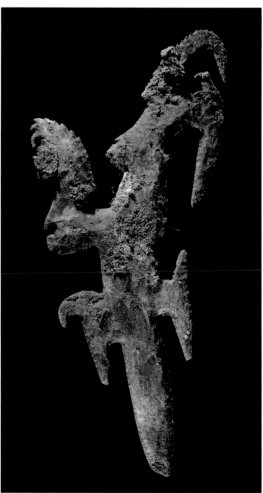

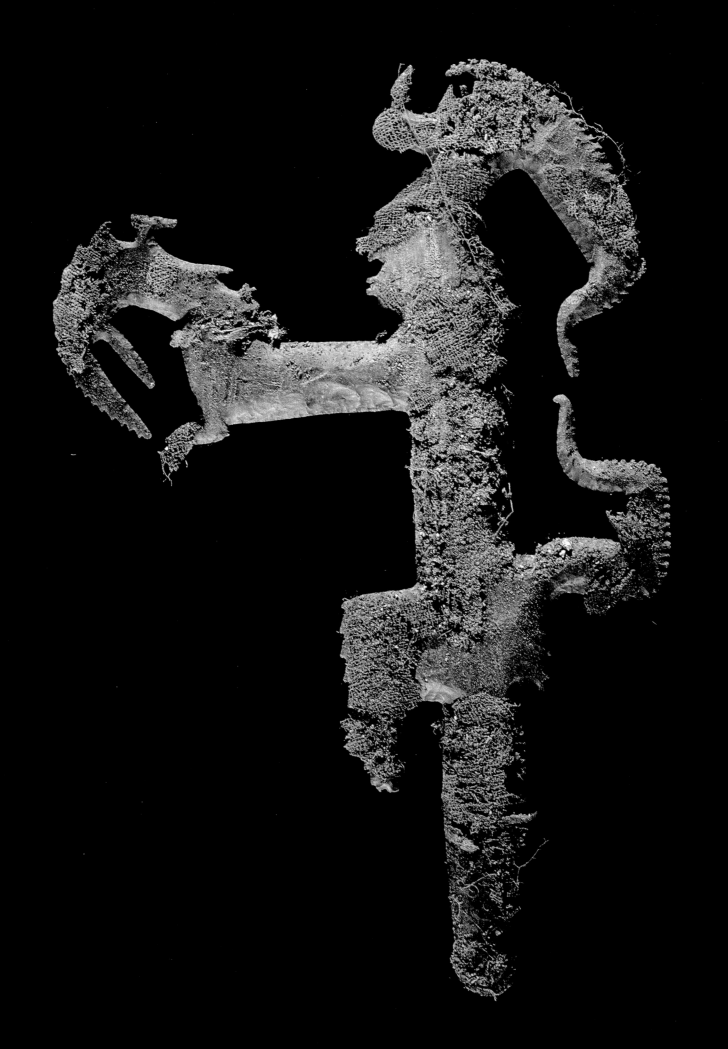

96A–C
Eccentric flints. Temple
26, Copan, Honduras,
8th century. Flint, each
approx. H. 13⅛ in.
(33.5 cm). Sitio Maya de
Copán, IHAH

97
Eccentric flint depicting a
canoe with passengers. Late
Classic period (600–900).
Chert, W. 12⅝ in. (32.1 cm).
Museum of Fine Arts,
Houston, Museum purchase
funded by the Alice Pratt
Brown Museum Fund

the forehead ornament. The three passengers are framed by two outward-facing heads of K'awiil, presumably the prows of the great supernatural canoe.

Since few depictions in flint feature the zoomorphic features of K'awiil seen in painted or sculpted examples, it is possible that these figures with the torch element represent either impersonations of the Lightning God or other deities with the K'awiil attribute.[39] For example, some versions of the Maize God feature the smoking cranial element. Artists fused the identities of the two deities to convey the relationship between lightning

98A–C
Three views of Stela
11. Copan, Honduras,
early 9th century.
Stone, approx. H. 67 in.
(170 cm). Sitio Maya de
Copán, IHAH

99
Incised flake with deity
image. Cache 131, Temple II,
Tikal, Guatemala, ca. 700.
Obsidian, approx. H. 3 1/8 in.
(8 cm). Museo Nacional de
Arqueología y Etnología,
Guatemala City, Ministerio
de Cultura y Deportes de
Guatemala

strikes on the ground and agricultural fertility, as seen on Copan Stela 11 (figs. 98a–c). There, the ruler impersonating the Maize God standing atop the jaws of a cenote has a large fiery protrusion from his high forehead, connecting lightning to an opening of the earth from which corn grows (see fig. 98a). Examples of obsidian flakes incised with the head of K'awiil confirm the intimate association of this special material from the earth with the power of lightning (fig. 99).

The connection between lightning and maize is borne out also with ethnohistoric and ethnographic evidence from the Maya Highlands and beyond. Tz'utujil ritual practitioners and healers in Santiago Atitlán refer to ancient objects in their bundles — including obsidian blades and stone axes — as tangible lightning.[40] This direct correlation of obsidian or flint with lightning could indicate that earlier eccentric scepters were conceived of as lightning weapons. Ancestors of the Tzotzil were thought to mete out thunderbolts as punishment for wrongdoing in Zinacantán.[41] Among the Mopan and Yukatek Maya, for example, ancient stone axes were believed to

be connected to Chahk and to represent the material correlates of thunderbolts.[42] This would be in line with findings from across Mesoamerica and other parts of the Americas, where lightning and associated objects and places were linked with agriculture.[43] The implantation of eccentrics bearing images of K'awiil into buried offerings could be likened to both a manmade lightning strike and the sowing of a seed, intended to generate the growth of maize and people.

Beyond his ability to strike the earth and engender maize, K'awiil played a symbolic role for Maya kings and queens. The conjuring of K'awiil and physical objects such as scepters or other effigies embodied a wider concept, written in the script as *k'awiilil* — or "K'awiil-ness" — that could refer to the idea of "power" among ancient Maya rulers.[44] A specific context in which *k'awiilil* is mentioned is the removal of power from one place and its installation at another (see "Divine Humans, Patron Deities" and "Wood, Stone," in this volume). This metaphor equates royal power with a charge of energy that arrives at new locations with the force of a lightning strike. K'awiil as an instrument of Chahk was thus inherent in the installation of rulers throughout the Classic period, whether or not he was explicitly grasped at the moment of accession.

Stormy Legacies

The eco-aesthetics around rain and lightning had an enduring presence in Maya visual arts after the Classic period. The anxieties about appeasing the Rain God that led patrons to commission codex-style painters or Copan sculptors to make elaborate scenes may have been well founded: people migrated away from places like Copan, Palenque, Calakmul, and Tikal by the beginning of the ninth century, and a prolonged drought may have been a major factor in the political changes at the end of the Classic period. Future refinements of archaeological and paleoclimate data, in tandem with testing environmental conditions for possible visual correlations, can help us begin to piece together the chronology of deity images.

The importance of personified rain and lightning in the Postclassic period across Mesoamerica is underscored by the prominence of the central Mexican deities known to the Mexica as Tlaloc, the Storm God, and Tezcatlipoca (Smoking Mirror), who is depicted with a serpent foot.[45] Tlaloc was honored with a temple on the top of the

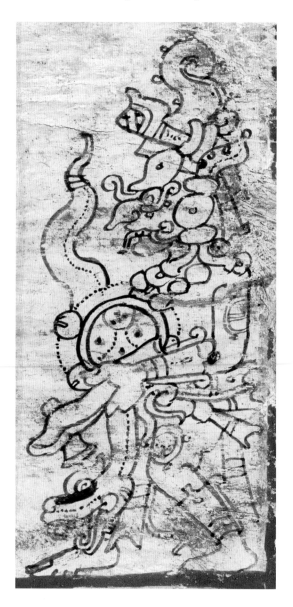

100
Detail of Dresden Codex, p. 66. Yucatán, Mexico, Late Postclassic period (1250–1524). Amate paper, pigment, folio H. 9 ⅞ in. (25 cm). Sächsische Landesbibliothek – Staats- und Universitätsbibliothek Dresden, Codex Dresdensis

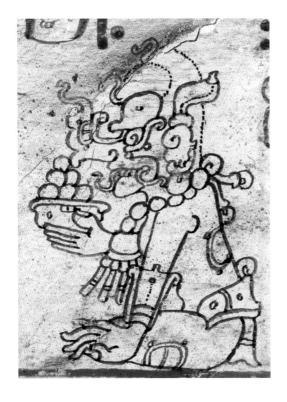

Templo Mayor, the sacred heart of Tenochtit-
lan, that was twinned with a temple dedicated
to the Sun God, Huitzilopochtli, the Mexica's
patron deity. Oblations on the northern axis
associated with Tlaloc included Offering
23, which was notable for its large quanti-
ties of fish remains as well as those of toads,
serpents, a white heron, and a puma.[46] Rain
was recognized as a parallel force to the sun
in creation, and the personification of storms

and lightning formed the venerated aquatic
counterpart to the solar creator.

In the scenes of deities in Maya codices,
both Chahk and K'awiil appear frequently as
major and interrelated players in the Postclas-
sic pantheon (figs. 100, 101).[47] The Rain God
in the illuminated manuscripts is character-
ized by a long nose and the axes or serpents
he wields. In the Dresden Codex in particu-
lar, Chahk is depicted in quadripartite form,
reflecting the cardinal directions and their
associated colors. Some examples in other
contexts show Chahk wearing a K'awiil head-
dress. After the Classic period, K'awiil also
has a long, upturned nose, but he often lacks
the forehead element and serpent foot and
sometimes has wings. The close relationship
between Chahk and K'awiil in the Postclas-
sic period is seen in a local Yukatek Maya god
known as Ah Bolon Dzacab (He of the Nine
Generations), which has been associated with
both deities. A descendent form of Chahk was
considered a vital force by Yukatek Maya in
southern Mexico into the colonial period and
beyond; indeed, rainmaking rituals involv-
ing Chahk are still practiced in the northern
Yucatán.[48] The close stewardship of land and
waters in such communities across the region
today underscores the longevity of an embod-
ied torrent in Maya consciousness.

Maize, Rebirth

DANIEL SALAZAR LAMA

WHETHER PAINTED ON VESSELS or building walls, modeled in stucco, sculpted on facades, or carved in jade, shell, or bone, the Maya visual arts were replete with scenes of the life of the Maize God. Like Chahk, the rain god, the Maize God was venerated across the Maya region for millennia. The manner in which he and his life cycle were depicted, however, evolved over the centuries, responding to tradition, experimentation, innovation, and adaptation. The resilience of his stories and the creative ways in which he was portrayed in some of the most remarkable works of Maya art attest to the importance of the Maize God to the ancient Maya.

Once understood by scholars as a sequential series of episodes — including his death from drowning; his rebirth in the aquatic underworld, either from a split seed or after having been rescued

102
Monument 1, La Merced,
Veracruz, Mexico. Drawing
by Daniel Salazar Lama

103
Architectural mask from
Substructure IIC, Calakmul,
Campeche, Mexico. Drawing
by Daniel Salazar Lama

from the mouth of a piscine monster; his
dressing with the help of women; and his
final resurrection and return to the earth as
an adult deity — representations of the Maize
God life cycle are in fact far more intricate
than unidirectional.[1] Death, underworld life,
different types of rebirths, renascence to the
earth's surface, and even variations in the
story's characters are recorded in numerous
images, each one with a particular narrative
sense. By examining specific episodic features
and textual descriptions, this chapter aims to
illuminate the multiple variants of the Maize
God's mythic saga and the diverse ways in
which Maya artists portrayed his life cycle.

In the Classic-period Maya worldview, the
Maize God's life was more than an allegorical
construction about the agricultural phases of
the corn plant. Rather, it exemplified an ideal
path that rulers and other dignitaries could
follow, step by step, through life, death, and a
return to the world of the living to an ultimate
apotheosis.

Early Depictions

The appearance of the Maize God changed
over the centuries. Throughout the Preclassic
period, representations of the deity at dif-
ferent moments in his life consistently have
an elongated, curved head that mimics the
stylized shape of a corncob, while his physiog-
nomy follows an Olmec model, which includes
a prominent upper lip, fangs, and almond-
shaped eyes (fig. 102).[2] Intriguingly, the
architectural masks of Calakmul Substruc-
ture IIC (fig. 103), dated about 400–300 B.C.,
feature trifoliate motifs sprouting from the
Maize God's ear ornaments that are similar to
the leaves and ears of corn in Middle Pre-
classic Olmec iconography (800–300 B.C.).[3]
The masks from Calakmul are the earliest
Maya examples to include those devices, long
predating the foliated corn deities that were
common in Classic-period art.

Early Classic Maya art retained some
Preclassic features in the face of the god while
introducing others. New elements included
seeds and foliage at the top of the head, some-
times with short curly hair and a forelock
falling in front of the face. These details can
be seen in representations of the Maize God's
head in shell, a highly prized material, that
may have been frontals adorning two pairs of
earflares (figs. 104a, b, 105a, b). In both pairs,
the closed eyes denote death; the heads are
severed, like ripened ears of corn harvested
from the stalk. Some scholars have suggested
that the name of the god during the Clas-
sic period was Ixi'm, the word for "maize" in

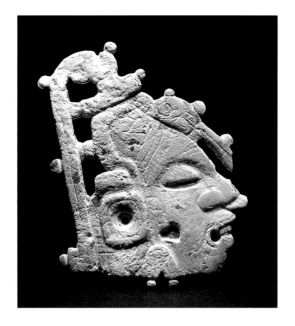
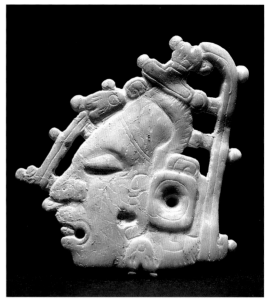

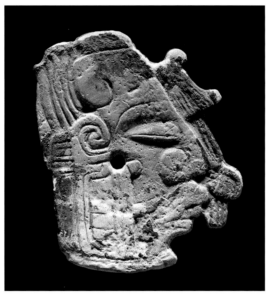

almost every modern Mayan language. He is called Ixi'mte' (Maize Tree) on a carved stone vessel dated 400–500 (see figs. 124a, b).[4] This name corresponds to the undulating *te'* (tree or wood) marks that appear on the legs, arms, and torso of the god in his arboreal form.

During the Late Classic period, the god's appearance evolved into that of a beautiful and graceful young man but retained the long leaves and kernels sprouting from his head, as can be seen on twenty finely carved Maize God busts decorating the ornate facade of

Temple 22 at Copan, Honduras (figs. 106, 107). While changing in shape over the centuries, these traits clearly indicate that the god incarnates the corn plant. A similar appearance persisted into the Postclassic period (fig. 108).

Over time, numerous painters and sculptors left their own imprints on representations of the Maize God's life cycle, modifying the characters, names, episodes, and locations. Nevertheless, the underlying structure and meaning of the deity's story largely resisted historical changes; it included

106
Maize God.
Temple 22, Copan,
Honduras, 715.
Limestone, H. 35 in.
(89 cm). British
Museum, London

107
Maize God.
Temple 22, Copan,
Honduras, 715.
Stone, H. 33 1/2 in.
(85 cm). Sitio Maya
de Copán, IHAH

the god's death, his afterlife in an aquatic environment, and his emergence to the surface as a young lord,[5] each phase corresponding to the maize plant's cycle from seed through germination to sprout.[6] The best-preserved example of the story was painted in a section of the west wall mural of Las Pinturas Sub-1A at San Bartolo, Guatemala, where three episodic units are connected visually as a sequence (see fig. 19). The first episode, to the observer's left, shows a character (probably an aquatic deity), standing with his feet immersed in a current of water, carrying the infant Maize God.[7] This image recalls scenes painted on Late Classic codex-style ceramic vessels, including one from Calakmul Structure II, Tomb 1, which depicts the god as a baby, practically unclad, resting on his back and sprouting from a split seed in an aquatic environment (fig. 109).[8]

The central episode at San Bartolo shows a turtle; inside its hollow body, the Maize God dances frenetically and plays music moments before he emerges reborn from the top of the turtle's shell. He is in the presence of the rain deity Chahk and an anthropomorphic figure with a serpent head who personifies groundwater. Similar scenes often include two assistant gods, Juun Ajaw (also known as God S) and Yax Bahlam (God CH). In the San Bartolo mural, Chahk and the anthropomorphic serpent perform the essential role of providing water, necessary for the plant's germination.[9] In later Classic imagery, Chahk is also

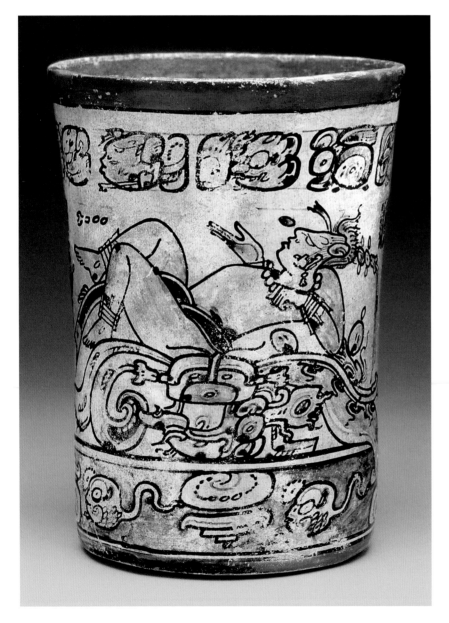

108
Maize God emerging from a split mountain, from Temple of the Jaguars, Chichen Itza, Yucatán, Mexico. Drawing by Daniel Salazar Lama, after Karl Taube

109
Codex-style vessel showing the rebirth of the Maize God. Structure II, Tomb 1, Calakmul, Campeche, Mexico, 650–800. Ceramic, pigment, H. 6 1/8 in. (15.5 cm). Museo Nacional de Antropología, Mexico City, Secretaría de Cultura–INAH

110
Maize God descending into water, from the west subterranean stairs of Palenque Palace, Chiapas, Mexico. Drawing by Daniel Salazar Lama, after Linda Schele and Merle Greene Robertson

111
Eccentric flint depicting a canoe with passengers. Southern Maya Lowlands, Guatemala, Late Classic period (600–900). Flint, W. 16 1/4 in. (41.1 cm). Dallas Museum of Art, The Eugene and Margaret McDermott Art Fund, Inc., in honor of Mrs. Alex Spence

responsible for opening the turtle's carapace with a stone axe to release the Maize God.[10]

The last episode at San Bartolo shows the Maize God, with a snake coiled around his body, descending along a stream of water. This action relates to the hieroglyphic expression *och ha'* (enter the water), a metaphor for death in Classic inscriptions.[11] A stucco relief in the subterranean vaults at the Palenque Palace in Chiapas, Mexico, presents a similar scene of aquatic descent, with the god immersed in water scrolls and maize foliation (fig. 110). In the Late Classic period, the most elaborate death scenes were carved on bones from Burial 116 at Tikal and painted on polychrome vessels elsewhere.[12] The images depict a sinking canoe manned by the Paddler Gods, who are conducting the anguished Maize God in the company of several animals.

Thanks to the examples from Tikal, we can understand what a complex eccentric flint represents (fig. 111). The piece's shape recreates the arched body of an animal, most likely a crocodile, judging by the downward-facing head. The beast serves as a canoe for three maize gods on its back. This is not a strange representation; in other examples of Maya art, aquatic reptiles embody canoes that transport the Maize God.[13] The orientation of the body strongly suggests that the canoe-creature is submerging itself into water, and the three deities are leaning backward in response to the violent movement.[14] The eccentric flint depicts the precise moment the Maize God sinks into the water. In other words, it represents an *och ha'* episode related to his death.

Visual Narratives of the Maize God Life Cycle

The ancient Maya and other Mesoamerican peoples most frequently presented their visual narratives sequentially,[15] as in the San Bartolo west wall mural. They also employed other visual devices, such as juxtapositions

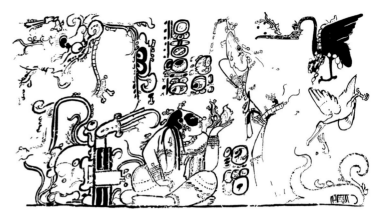

within a single image to represent different narrative moments that occurred simultaneously, and added textual references that complemented the scenes and broadened their scope.[16]

While a significant number of Maya artworks depict the entirety of the Maize God life cycle in a linear sequence, others focus more narrowly on the most eloquent and significant episodes, notably the god's multiple rebirths. A codex-style cylinder vessel from 750–70 shows two important moments in the saga, while the text alludes to a third (fig. 112). In one scene, Yax Bahlam, identifiable by the jaguar-skin marks on his legs, torso, and face,[17] holds up a large dish upon which the baby Maize God lies adorned with jewels, while Juun Ajaw, who has dark spots all over his body, rides a monstrous creature with fish and snake features. That creature, called Xook in many Late Classic textual sources,[18] has particular relevance in representations from the Classic period that show the Maize God, at times resting on his back like an infant, being expelled from the aquatic monster's mouth.[19] The event resonates with other aquatic scenes and in some instances alludes to the god's underwater rebirth. For example, on the vessel from Calakmul (see fig. 109), the baby Maize God appears in an almost fetal position sprouting from a split seed in an aquatic environment.[20] But as recent investigations

have suggested, the infant Maize God in Xook's jaws may refer to the sacrifice of the piscine monster and the rescue of the deity from its guts, sometimes as a baby in a supine posture.[21] If that is the case, the scene on the codex-style vessel must relate to variants of the saga in which Chahk and other deities kill Xook.[22] Alternately, this rescue episode may represent part of the god's journey through the underwater world, perhaps an elaborate and unique version of the start of his aquatic life after his death and descent into the water.[23]

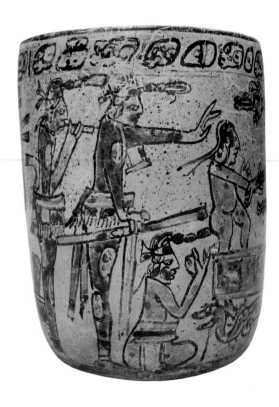

The second scene on the codex-style vessel (at right in figure 112) depicts the Maize God as an adult, scantily clad, adopting a gesture that possibly denotes grief. He is identified as Juun Ixi'm, a name variant from the Classic period. Before him, a woman is seated within the maws of an enormous centipede, which represent the portal of the underwater world. She offers him a spondylus shell with a stylized Xook head attached. The small size of this head may indicate that the creature was previously defeated, a convention seen in representations of other vanquished monsters.[24] Variations of the same episode show two or more people, usually women, dressing the Maize God in a watery location moments before his emergence to the earth's surface (figs. 113a, b).[25] In those contexts, the attendants inset all elements of the attire that the god will use on earth — the new corn plant, the shell, and the Xook head — as jewels in the god's belt to mark his dominance over the defeated creature.[26]

The episode of two women clothing the god may have sexual connotations, as suggested by other versions of the narrative that describe aquatic environments, such as rivers, lagoons, and water sources, as ideal for sexual intercourse. Classic-period scenes of the episode reinforce this idea by the women's nudity;[27] the Maize God, too, is only rarely clothed. Although we do not fully understand these scenes, they most likely recount the god's adult life in the underwater world.

The glyph caption on the codex-style vessel reads *och ha' juun ixi'm wak ajaw uhtiiy* (he water-entered, One Maize Wak Ajaw, it has happened).[28] Although there is no depiction of the Maize God entering the water, the images on the vessel connect to the text. The caption alludes to a precipitating event — the death of the Maize God — while both scenes show his aquatic life as a result, creating a before-and-after sequence.[29] The text's external reference provides a broader episodic and narrative sense and gives the observer background information about the events depicted.[30]

The gods Yax Bahlam and Juun Ajaw are actively involved in the entire Maize God life

113A
Vessel depicting Maize God myths. 700–900. Ceramic, pigment, H. 6⅜ in. (16.2 cm). Geography & Map Division, Library of Congress, Washington, D.C.

113B
Rollout view

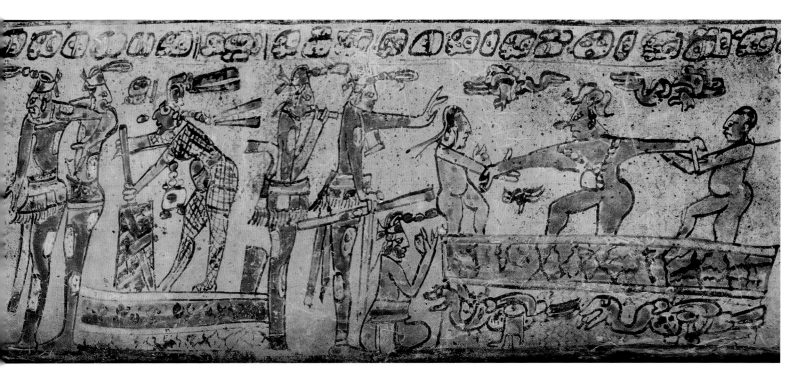

114
Codex-style plate showing the Maize God emerging from a turtle. Guatemala or Mexico, 680–740. Earthenware, pigment, slip, Diam. 12 ⅝ in. (32 cm). Museum of Fine Arts, Boston, Gift of Landon T. Clay

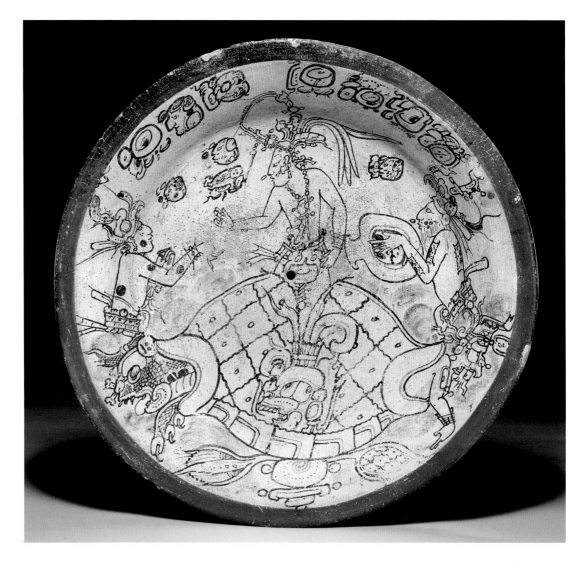

cycle. Sometimes only Juun Ajaw is present at the dressing of the Maize God or his entry into the water.[31] But most scenes show Yax Bahlam and Juun Ajaw together, participating in the emergence episode,[32] on the sidelines of the clothing episode,[33] or leading the Maize God in canoes with the Paddler Gods.[34]

Yax Bahlam and Juun Ajaw appear prominently on a codex-style plate that depicts the emergence of the triumphant, dancing Maize God from the turtle carapace after his journey across the underwater world (fig. 114). The turtle is essential to the scene's meaning: its shell represents the earth's surface, which opens to make way for the Maize God, who will emerge through the crack.[35] On the right,

Yax Bahlam pours water from a jar marked with the *ahk'ab* (night or darkness) sign. This sign designates the pot as the same one used by Chahk to dispense rain on the earth in other Classic Maya scenes.[36] On the left, Juun Ajaw extends a hand to assist the Maize God. The name glyphs of Yax Bahlam and Juun Ajaw are written near their portraits. The arrangement of two deities flanking, assisting, or giving offerings to the resurrected Maize God recalls the composition on the San Bartolo west wall mural and several other emergence scenes. This may be a Meso-american iconographic convention related to agricultural abundance, the growth of trees, and the regeneration of life.[37]

115

Left to right: Glyphic name
Juun Ixi'm Ahiin from
codex-style plate; Juun
Ixi'm pectoral from codex-
style plate; jade jewel from
funeral paraphernalia of
K'inich Janaab Pakal I (after
Karl Taube). Drawings by
Daniel Salazar Lama

A name glyph next to the Maize God identifies him as Juun Ixi'm Ahiin (One Maize Crocodile). The deity wears a jewel pectoral with the same components found on the name glyph: a young male face and a saurian head with prominent fangs. An almost identical carved jade jewel formed part of the funeral paraphernalia of K'inich Janaab Pakal I in the Temple of the Inscriptions at Palenque (fig. 115). The downturned crocodile heads in these jewels are abbreviated references to saurians that transformed into trees — their bodies becoming trunks and their limbs branches — growing at the four cardinal points and at the center of the terrestrial plane.[38] The Maize God often adopted the same inverted posture when reborn as a tree (see fig. 126). On the codex-style plate, the crocodile epithet and motif probably associate the deity with a saurian tree, rising in the center of the terrestrial plane as a new maize plant.

While several deities participate in the emergence of Juun Ixi'm Ahiin from the underworld, Chahk is a main figure in many episodes, revealing his active role in all the regenerative phases of maize as a nodal subject of the Maize God myth.[39] Indeed, one of the deity's primary names in the Classic period is Yax Ha'al Chahk (First-Rain Chahk). This is notably similar to Yax Ha'al Witz Nal (First-Rain Mountain Place), one of the names of the mythical mountain of sustenance, which is associated with fertility and abundance. On the Temple of the Foliated Cross at Palenque, this mountain is depicted with corn foliations copiously sprouting from its summit, as if the actions of Chahk at the beginning of the rainy season led to the proliferation of maize (fig. 116).[40]

A large tripod plate presents a complex cosmological arrangement, with Chahk at the center of the scene generating vegetation in an environment of fertility and abundance (see fig. 79a). The Maize God is just below him, rising from a skull and surrounded by aquatic plant motifs. The text describes the location as a black cenote, or sinkhole,[41] and the artist complemented this information by showing the open jaws of the underworld below a surface of dark water, in which the Rain God is partially submerged. The Maize God dances in an erect posture, immersed in dark waters. Practically naked, he does not wear luxurious dress or jewels. Such corporeal language is distinctive to his final emergence, and the absence of jewels and attire is an essential characteristic that links him in the underwater realm with the infant Maize God.

A codex-style plate from southern Campeche has a similar composition, showing the dancing, naked god, probably playing music with a shell, immersed in a watery environment (fig. 117). The scenes here and on the tripod plate clearly compress into a single image two salient episodes of the Maize God

116

Mountain with corn leaves,
from Temple of the Foliated
Cross, Palenque, Chiapas,
Mexico. Drawing by Daniel
Salazar Lama

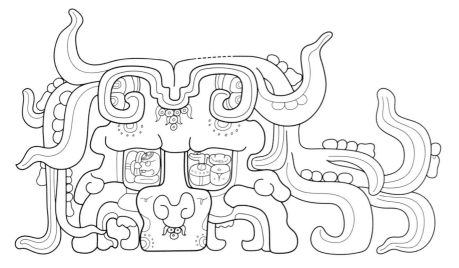

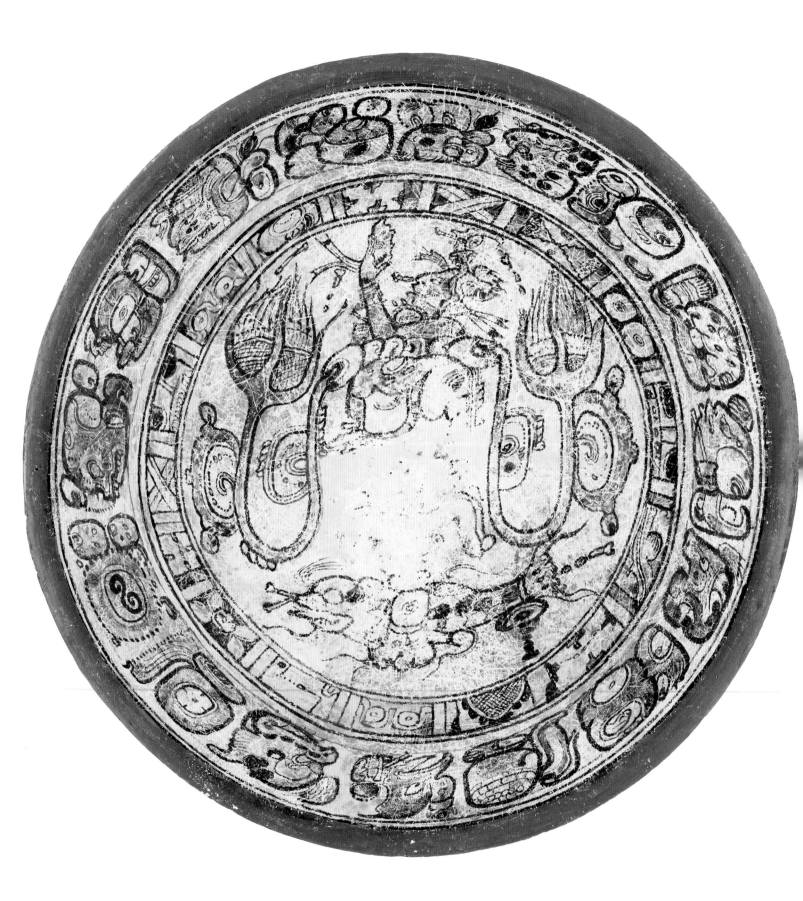

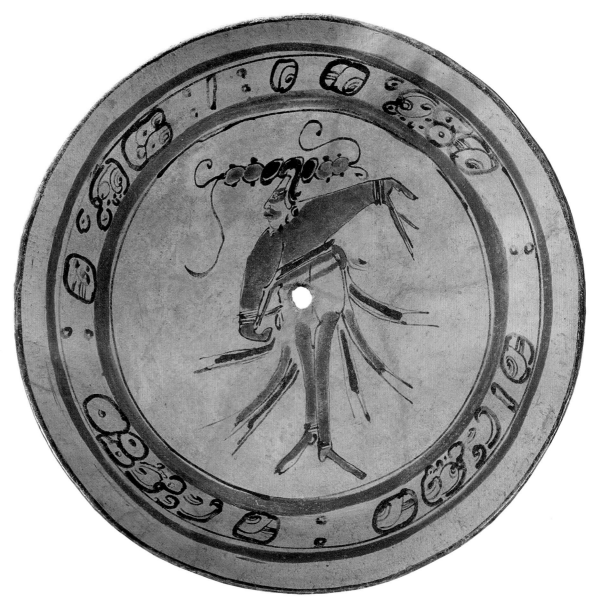

117
Codex-style plate depicting the watery underworld. Southern Campeche, Mexico, 650–800. Ceramic, slip, Diam. 15 ½ in. (39.4 cm). Los Angeles County Museum of Art, Anonymous gift

118
Plate with the Maize God. Burial A3, Structure A-1, Uaxactun, Guatemala, Late Classic period (600–900). Ceramic, Diam. 12 ¾ in. (32.4 cm). Museo Nacional de Arqueología y Etnología, Guatemala City, Ministerio de Cultura y Deportes de Guatemala

saga: his final emergence to the surface of the earth from the underwater world and his first sprouting or rebirth in an aquatic realm.[42] The combination of moments into a single visual representation creates a narrative flow, in which one episode prefigures the other.[43]

A similar, although not identical, treatment is seen on figure 114, the previously discussed codex-style plate, which alludes to different moments in the life cycle. Here, the dancing Maize God rises from the split turtle carapace; below him, his previous rebirth in water is signaled by an aquatic split skull,

which is tagged as a dark place by the *ahk'ab* sign in the orbital socket.[44]

An intriguing image that might employ this strategy of conjoining moments appears on a plate from a burial in Structure A-1 in Uaxactun, Guatemala (fig. 118). It depicts the Maize God dancing and wearing over his waist and hips a protective belt that denotes him as a ballplayer.[45] Ballgames among the gods were recounted in mythical narratives and were reenacted by Classic-period lords; the Maya ballgame was not only a popular sport but a sacred ritual and a political event. Ceramic

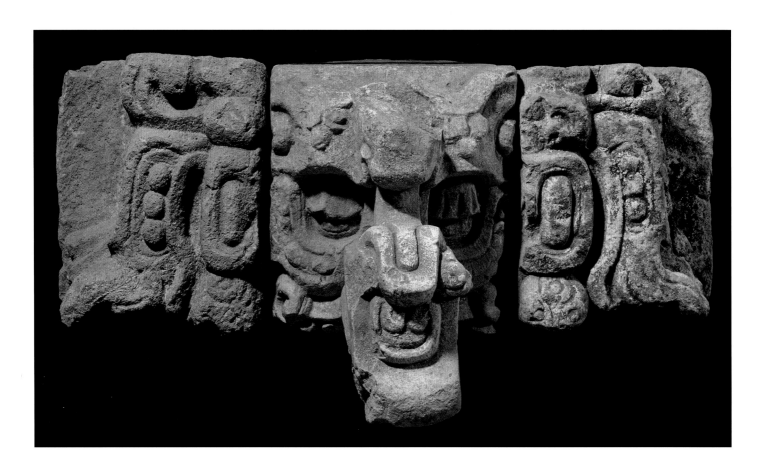

119
Carved blocks showing
a personified moun-
tain. Temple 22, Copan,
Honduras, 8th century.
Stone, W. 39⅜ in. (100 cm).
Sitio Maya de Copán, IHAH

120
Mountain with maize gods
and corn foliations, from
Stela 1, Bonampak, Chiapas,
Mexico. Drawing by Daniel
Salazar Lama, after Peter
Mathews

121
Maize God in corn husk.
Mexico, Late Classic period
(600–900). Earthenware,
pigment, H. 5½ in. (14 cm).
Museum of Fine Arts,
Houston, Gift of Frank
Carroll in memory of Frank
and Eleanor Carroll

plates show the Maize God as a ballplayer
surrounded by stylized representations of
ballcourts.[46] For the Uaxactun plate and
similar examples, the question remains: Does
the image represent a dance performed within
a ballcourt? Or is it more likely that the plate
juxtaposes the Maize God's emergence to the
earth's surface with his role as a ballplayer?[47]
Two engraved vessels of unknown provenance
certainly combine the god as a ballplayer with
his emergence amid vegetal abundance,[48]
perhaps suggesting that his dance in the ball-
court is closely related to — and responsible
for — fertility.

These beautifully painted serving ves-
sels, with their complex imagery suggesting
different moments in the Maize God's jour-
ney, surely provided food for thought to those
privileged to behold them at banquets or
those who handled them as part of funerary
celebrations.

The Place of Emergence

Connections between the Maize God life
cycle and the production of maize are often
highlighted in the visual narratives. The
cleft in the turtle shell from which the Maize
God sprouts sometimes includes a *k'an* sign,
which means "yellow, precious, or ripe" and
connotes fecundity and preciousness.[49] In
the San Bartolo murals, a *k'an* sign appears
in the eye of the mountain covered with flora
and fauna, which several scholars consider a
prototypical example of the Mesoamerican
sustenance mountain.[50] These images suggest
that the Maize God emerged to encounter a
fertile earth with abundant vegetation and
natural resources.

The main facade of Temple 22 at Copan has
an enormous zoomorphic mask at the entrance
and several *witz* (mountain) figureheads at the
four corners, tagging the whole building as a

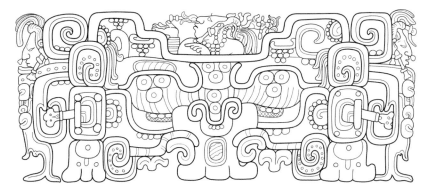

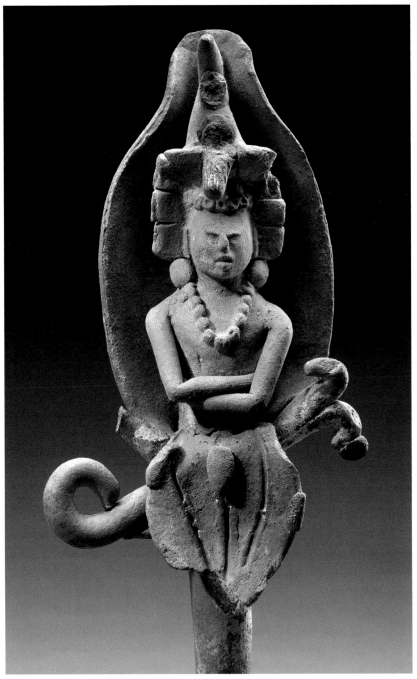

living mountain. Twenty additional mountain masks (fig. 119) and the twenty aforementioned busts of the Maize God (see figs. 106, 107) were located in architectural niches in the upper section of the first level of this temple.[51] With the Maize God dancing and rising from the mountaintop, the composition of the sculptural program would be no different from that of other variants of the final emergence episode, with maize growing at the base of hills or from cleft mountains (fig. 120). The *witz* masks at Temple 22 have maize foliation and corn kernels sprouting from the earflares, alluding once again to the fecundity and the preciousness of the sustenance mountain.

The Maize God busts from Temple 22 are posed as dancers, recalling the rising god on both the tripod plate and the plate with the turtle carapace. Conceivably, the sculptural program of this building featured twenty different images of the Maize God marked with distinctive colors, foliations, and postures that were possibly related to different phases of corn germination, maturation, and harvest.[52] In this way, Temple 22 may have appeared as a sustenance mountain that recreated the agricultural cycle of corn, in accordance with the god's life phases, at the heart of the Copan acropolis. The idea of the Maize God embodying the maize plant and its stages of growth was depicted in small modeled ceramics in the Jaina style, in which the deity, young and slender, takes the place of the ear of corn (fig. 121).[53]

Maya artists depicted the Maize God's place of emergence in two distinct ways — as the sustenance mountain or as the turtle shell — with details specific to each representation. Despite such differences, the essential importance of both places relates to sprouting maize. In this regard, the *k'an* sign integrated into the earth-turtle and the mountain has an iconographic equivalence in the abundance of vegetation and animals, which alludes to the preciousness of each place.

Resurrection, Emergence, Birth, or Rebirth?

In their seminal work on the corn deity in Classic Maya art, scholars Michel Quenon and Geneviève Le Fort refer to the final phase of the Maize God life cycle as a resurrection, while the images of the baby god immersed in a pool of water are taken as scenes of rebirth.[54] This terminology has become generalized in the studies of maize mythology and has defined — and sometimes limited — our understanding of both events. Indeed, many representations of the Maize God life cycle contain more nuanced textual and iconographic expressions that can expand our comprehension of this complex saga.

Multiple versions of the Maize God life cycle include two birth episodes after his death entering the water. The first takes place in the aquatic world, where the deity appears as a baby, likened to a seed. This episode inaugurates his childhood and subsequent life in the watery realm underground. The second birth relates to his sprouting from the underworld to the surface of the earth as a young, slender, and beautiful god with particular cosmological attributes.

In depictions of the Maize God as a baby on codex-style vessels, such as the one found at Calakmul (see fig. 109), he rests on his back while emerging from a split seed submerged in water. The hieroglyphic text on a similar vessel, probably from Calakmul, reads *ajsihya[j] ichiil* (he who was born within).[55] This caption is consistent with the god's fetal position and with his emergence from the submerged split seed, making clear that the action occurred underwater and thus represents the deity's first birth.[56]

The final emergence of the Maize God is actually his second birth, which takes place on the earth's surface — that is, on the turtle carapace or the mountain summit. In these scenes, the Maize God appears upright, often with his arms and hands outstretched.[57] The upright position indicates a vertical trajectory between cosmological levels, from the earth's interior to its surface and even to the sky.[58] The Maize God's stance is probably related to the dancing posture he adopts in other episodes, such as when emerging from a turtle or a mountain. However, the gesture of outstretched arms and hands is not unique to the Maize God, as formerly thought.[59] In the mural paintings of Las Pinturas Sub-1A at San Bartolo, five babies with long umbilical cords are expelled from a cracked gourd amid splattering blood (see fig. 18).[60] The triangular split in the gourd relates to the logogram **SIH** (to be born).[61] Notably, the baby in the center holds arms and hands outstretched, suggesting that this gesture denotes the action of being born.

The representation of a birth from a split gourd and the posture of the central baby in the San Bartolo painting have surprising parallels with a scene on a carved vessel made hundreds of years later, likely in the Late Classic period, suggesting an enduring convention for birth episodes.[62] Interestingly, the Maize God again appears upright, with outstretched arms and hands, and rises from a similar cleft in a mountain's summit on the carved relief from the Temple of the Jaguars at Chichen

122
The Maize God resurrected from the turtle shell, detail of rollout view of cylinder vessel. Drawing by Daniel Salazar Lama

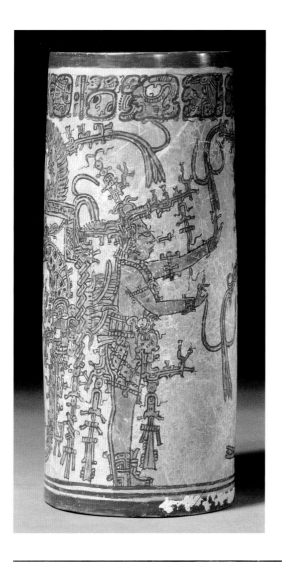

Itza (see fig. 108). Thus, it is likely that the deity's emergence from a turtle or a mountain was a birth episode, probably corresponding to his second birth.

On the previously discussed vessel depicting the bathing and clothing of the Maize God, his gesture is characteristic of the second birth, and the position of his legs suggests he is dancing (see fig. 113b). The wavy reticular pattern on the platform upon which he stands emulates the markings on a turtle, while the people on either side of the god allude to the clothing and bathing episode, an apparent juxtaposition of two events. These details recall other representations of the god emerging from a cleft carapace (fig. 122).[63]

The strong link between the Maize God's second birth and the turtle shell is reinforced in several other representations. On a vessel from the site of Buenavista del Cayo, Belize, the reticular pattern of the shell is replicated in the net skirts worn by youthful dancing maize gods (figs. 123a, b). Quenon and Le Fort have argued that the skirt represents the carapace and refers to the moment of emergence when worn by the Maize God in subsequent

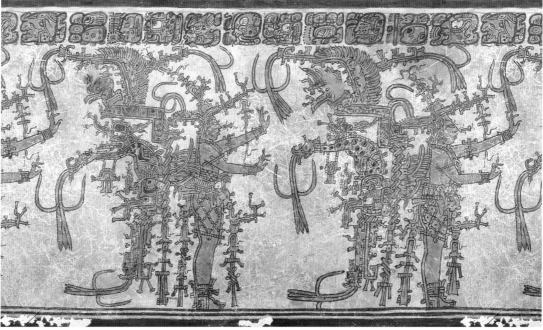

episodes.[64] Maya rulers and other nobles were often depicted wearing such skirts in sculpture, suggesting that they did so to identify themselves with the Maize God and his second birth from the turtle. The reticular pattern on these skirts also resembles water-lily pads.[65] Recent studies suggest that such a garment was also worn by human impersonators of the Moon Goddess, the aquatic solar deity known as GI, and the water-lily serpent Witz', implying a generalized link with the aquatic world associated with those deities.[66]

On the Buenavista vessel, the dancing maize deities are especially relevant to the cosmological aspect the Maize God acquired after his second birth. They each carry a *paat pi'k* (backrack, literally "back dress") with stepped celestial bands at the top, representing the vault of the heavens.[67] Birds with arched bodies and spread wings perch on the celestial bands. Below these bands, at the height of the gods' hips, are animated mountains with serpentine banners hanging from their mouths. Mythical animals sit on the mountains and hold small heads with feathers and foliation, probably corncobs, that represent versions of the corn deity.

The creatures seated on the mountains are tied to the main toponymic sign of specific emblem glyphs. The spotted feline is related to Mutu'l, the place-name of Tikal, and the reptilian figure is surely connected to Kaanul, the snake kingdom at Calakmul, but the toponymic expression may refer to both sites imprecisely. Epigraphers Christophe Helmke and Felix Kupprat have suggested that the depictions of the different maize gods on this vessel "would seem to represent distinct and localized manifestations of the same deity, each embodying mythological beings of particular city-states."[68] In sum, on the Buenavista vessel and related objects, the Maize God dances with a backrack ensemble that recreates a model of the cosmos, connecting its vertical layers.[69]

The attributes of the Maize God vary from one episode of the saga to another. The different postures and clothing shown for each occasion allow viewers to distinguish the episodes and follow a narrative sequence. These artistic conventions blended, however, with artistic license that combined moments of the saga into innovative representations of the myth.

Recreating the Cycle, Enacting the God

In the second birth scenes, the Maize God, surrounded by an abundance of corn and vegetation, is adorned with jade jewelry that symbolizes the green foliage of the new plant.[70] His return to the surface after a long journey through the underworld, the essential metaphor for regeneration, provided a way to conceptualize the death and apotheosis of the rulers and lords who followed his path.

A carved stone bowl from the Dumbarton Oaks collection illustrates this concept (figs. 124a, b). Originally, its three roundels each depicted a young character with the physiognomy of the Maize God. The seedlike motif with foliations atop an elongated head, the wavy *te* signs marking the body, and the cacao pods sprouting from the limbs designate each figure as a representation of the Maize God as a cacao tree.

In one roundel, the godlike figure sits on a decorated throne covered with a feline skin and points his finger at a vessel (see fig. 124a). The next roundel has a similar scene, now almost completely worn away. The third roundel depicts an aquatic environment, as denoted by a water bird (see fig. 124b). The figure rests on his belly while examining an open book. The text emphatically states *paklaj Ixi'mte'* (the Maize Tree is facedown).[71] The posture in the first roundel is unusual for anthropomorphic trees; the third roundel

124A
Bowl with Maize God as
cacao tree. Guatemala
or Mexico, 400–500.
Carbonate stone, Diam.
6 ¼ in. (15.9 cm).
Dumbarton Oaks Research
Library and Collection,
Pre-Columbian Collection,
Washington, D.C.

124B
Another scene on bowl

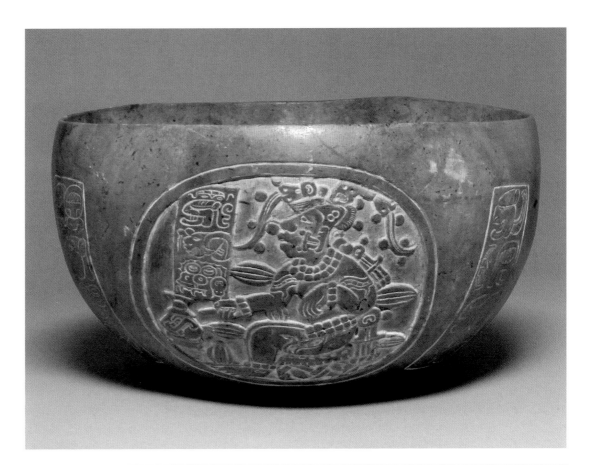

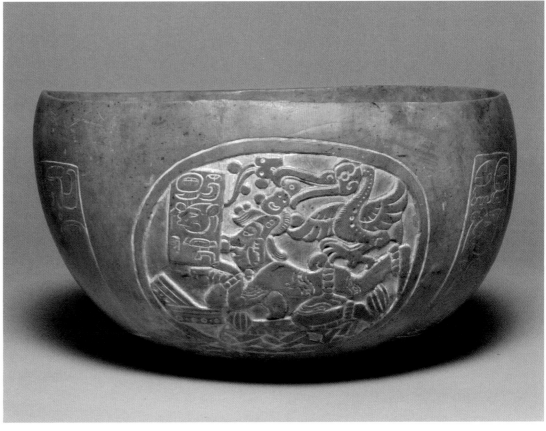

depicts the more common pose, which corresponds to the inverted bodies of maize-related characters known as "acrobats" (fig. 125).[72] Corn deities and their human impersonators took this posture when embodying the maize-cacao tree, with their back and limbs transformed into the trunk and branches. The seeds and leaves that appear on the acrobats' heads may allude to the growing plant.

The hieroglyphic captions on the bowl identify the protagonist as *ubaah* [...] *Ixi'mte' ch'ok chan[al]* ([it is] the image of [...] Maize God Tree Young Snake) and as *uh chan ixi'm aj ch'ok chanal* (Jewel[ed] sky Maize God, Young Snake person). According to Simon Martin, Ch'ok Chanal (Young Snake) is the name of a lord recorded on Calakmul Stela 114 from A.D. 435. The stela is roughly contemporary with the bowl, leading Martin to surmise that Young Snake was a nobleman or ruler who impersonated the Maize God and was portrayed on the stone bowl under the aspect of Ixi'mte' and in

the process of becoming a tree.[73]

Rebirth amid exuberant plant and animal life is portrayed on a tripod vessel on which a figure incarnates a cacao tree at the sustenance mountain or an equally precious place suitable for regeneration (fig. 126). The cacao tree in the center represents a deceased Maya lord who has become conflated with the Maize God. He is identified by the name tag on his headdress. The same name is written on one of the supports, suggesting that this lord was the owner of the vessel. The scene illuminates the fate of Maya lords: once they incarnate the cacao tree, a rebirth awaits.

With regard to the Dumbarton Oaks stone bowl, the expression *uh chan*, which precedes the name Ch'ok Chanal, alludes to that lord's apotheosis in a jeweled sky.[74] This interpretation finds parallels in representations of deceased rulers who rise from the jaws of the underworld or the sacred mountain to retrace the path of the Maize God and emulate his renascence. In these scenes, the background is filled with glittering objects, jewelry, and flowers that denote an idyllic environment for rebirth.[75] Other compositions show the apotheosis of rulers surrounded by the same elements, probably in a heavenly place called Wak Chan (6 Sky). The rulers take on the appearance of the Maize God, with foliations and corn seeds on their headdresses.[76]

125
Acrobat Maize God inside a quatrefoil cave motif, detail from a lidded vessel, Structure F8-1, Burial 9, El Zotz, Guatemala (see fig. 74). Drawing by Daniel Salazar Lama, after a photograph by Jorge Pérez da Lara

126
Mountain with Maize God tree, rollout view of a tripod vessel, Ethnologisches Museum, Berlin. Drawing by Nicolas Latsanopoulos

127 *(opposite)*
Funerary mask. Burial 160, Structure 7F-30, Tikal, Guatemala, 522–25. Jade, shell, obsidian, H. 16 in. (40.6 cm). Museo Nacional de Arqueología y Etnología, Guatemala City, Ministerio de Cultura y Deportes de Guatemala

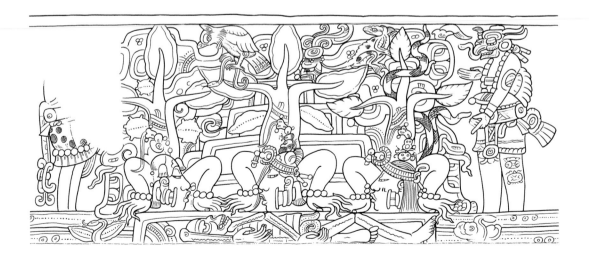

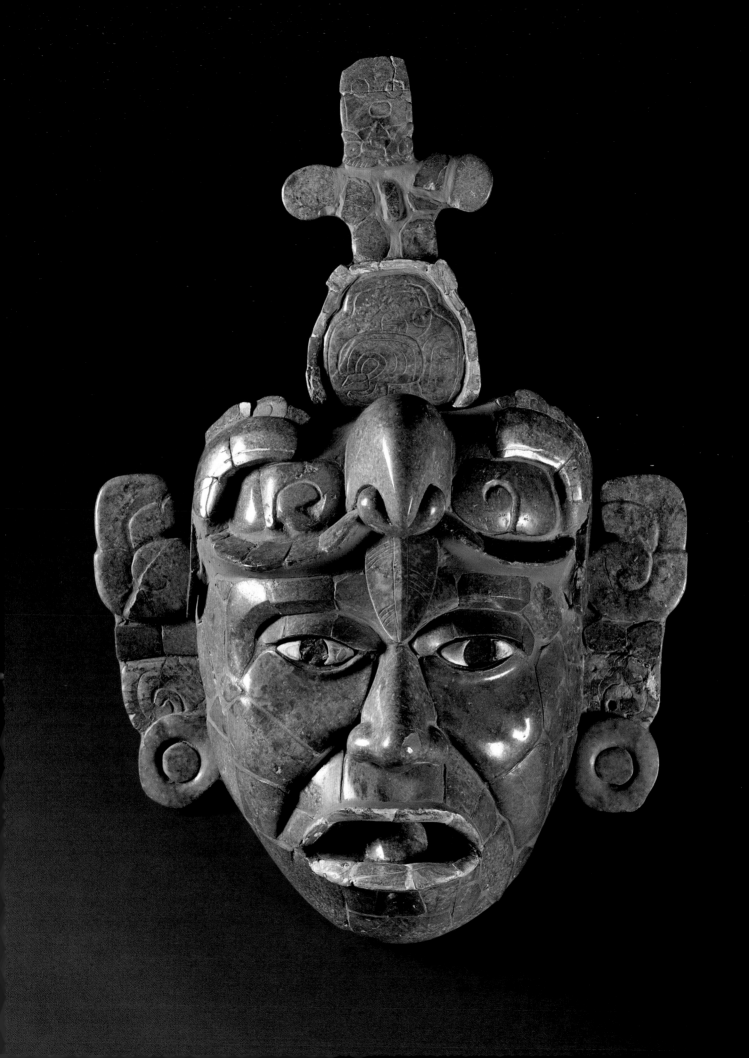

128
Lid from sarcophagus of
K'inich Janaab Pakal I,
Temple of the Inscriptions,
Palenque, Chiapas, Mexico.
Drawing by Daniel Salazar
Lama

By following the footsteps of the Maize God, deceased rulers could replicate the life cycle of the plant, returning in a climactic regeneration.

For the Maya, dying is a transitional state, a crossing to the interior of the earth. Being born (or reborn) is equivalent to emerging from that place, rising as the corn plant does every season and the sun does every day.[77] Maya rulers sought to reproduce this cycle by retracing the path of the Maize God after death, symbolically descending to the underworld by entering the water (*och ha'*), to be born again.

The Maya conceived of mortuary spaces as caves or subterranean enclosures within temples that were equated to mountains.[78] The ceramic and stone vessels deposited in their royal tombs often feature aquatic iconography — skulls replete with water lilies, reptiles, fish, and other marine life[79] — turning funerary spaces into underwater environments where rulers began their cosmic journey. Funerary objects also include multiple references to the life cycle of maize and the rising sun over the horizon (see figs. 8, 74, 75).[80] Their function was more than symbolic; they served as guides to the ways deceased sovereigns could engage with the life stages of the gods and retrace their paths.

Sumptuous funerary attire helped to assimilate the ruler's remains with the body of the Maize God, who was frequently shown adorned with jewelry and ornaments.[81] Masks of jade mosaic replaced rulers' decayed visages with those of the gods they were to become. Most of these masks immortalize their idealized, young faces in lustrous greenstone, a material that alludes to fertility and preciousness.[82] A Late Classic–period mask from Tikal reinforces these connections with elements that linked its wearer to the image of maize sprouting (fig. 127).

Visual narratives of the corn deity's life cycle permeated scenes of royal apotheosis. Deceased rulers were believed to embody the cycle, returning to the world of the living and bringing with them the fruits of the earth, particularly abundant corn. The lid of the sarcophagus of K'inich Janaab Pakal I from the Temple of the Inscriptions at Palenque is a clear example (fig. 128): the ruler is about to emerge from the open jaws of the underworld in a vertical trajectory across the axial cosmic tree. There are multiple allusions to the god's rebirth. Pakal's head has the shape of an ear of corn and hair like corn silk; he wears a net skirt and a turtle-shaped pectoral, apparent references to the Maize God and his emergence from a turtle. However, his body is not upright, recalling representations of the supine Maize God as a baby and his first birth in water. The conflation of the two most eloquent episodes of the saga on the sarcophagus lid affirms that the deceased king is following the Maize God's sacred path.

Although written accounts of the Maize God saga from the Preclassic and Classic periods have not survived, the scenes that fill Maya artworks and a rich oral tradition elucidate the heroic narrative, in which the Maize God emerges from the earth in a splendid dance, reenters the soil, and becomes a seed that will germinate into a new plant. As the saga was retold and reimagined visually over the centuries, it was enriched with modifications to the order of the episodes, the names of the deities, and the places where events occurred. Some scholars maintain that the visual and oral traditions influenced one another, creating an exchange that made the myth a dynamic construction, constantly evolving in its details but persistent at its core:[83] a tale of birth, death, and rebirth echoing the natural cycle the Maya saw repeated in the cornfields season after season.

Divine Humans, Patron Deities

CAITLIN C. EARLEY

THE FIRST HUMANS were born into a world of darkness, according to the K'iche' epic history, the *Popol Wuj*. "Weary in their hearts as they awaited the dawn," the first mothers and fathers decided to search for a guardian. They traveled to a place called Tulan to find "one who may protect us."[1] There, the gods went out to them, and the first people carried their deities home. Although this history was recorded in the mid-sixteenth century, after the invasion of the Spanish — and many centuries after Classic Maya cities fell silent — it evocatively hints at what ancient religious practice might have been like. Humans, it suggests, did not simply receive the beneficence of the divine. Instead, Maya people were responsible for their gods: finding them, carrying them on their backs, and ensuring they were cared for, providing them shelter, honor, and sustenance.

In the Classic period, Maya communities maintained relationships with both universal gods associated with the natural world, such as Chahk, and local gods, often called patron deities, who were associated with specific Maya cities and were involved in their affairs. Gods were routinely part of everyday Maya life: impersonated by the ruler in public rituals; cared for in effigy in sacred temples; and, as ephemeral manifestations, solicited through the sacrifice of blood, both royal and nonroyal. Maya rulers across the region bore a particular responsibility for maintaining relationships with deities. From their regnal names to their ritual regalia, Maya rulers connected with aspects of the divine.

They were trained in the stewardship of the divine from an early age. A panel from Dos Pilas shows this in touching detail: a young prince performs his first act of penance, or *yax ch'ahb*, overseen by his parents and a guardian.[2] Once taking the throne, the king assumed his regnal name, the *uk'alhuun k'aba'* (headband-raising, or crowning, name).[3] Royal names regularly included the names of deities, especially K'awiil, Chahk, and Itzamnaaj, and were often modified by "K'inich," marking the king as "radiant." Other monikers incorporated words for powerful animals like jaguars, snakes, and crocodiles.[4] While many royal names remain poorly understood, they were clearly a way to link individuals to dynastic predecessors and qualities of the divine.[5] Maya kings did not refer to themselves in hieroglyphs as gods (*k'uh*) but as holy or godlike (*k'uhul*).[6] This phrasing emphasizes their connection to the sacred, referring, in part, to their ability to access godly beings and energies. The duly named new king's responsibilities included serving as military leader, dynast, and intermediary between community members and the gods.

Maya artists commemorated two major types of interactions between rulers and deities on stone sculptures: impersonation and summoning. "Impersonation" is an imperfect translation of the Maya term *ubaahil aan/ahn* (it is his/her image), written using a hieroglyph of a pocket gopher with the glyph *k'an* (precious/yellow) infixed in its cheek.[7] When ritually impersonating a god, a ruler assumed part of the deity's vital essence — a layering, rather than a replacement, of identities.[8] This duality is visible in the regalia worn during acts of impersonation: the king may wear masks or carry specific godly implements but is recognizable as human. Still, the act of impersonation was powerful; viewers would have understood both identities to be present, the vital power of universal gods infusing the actions of the ruler. Rulers impersonated deities for many types of events, including dancing, conjuring ceremonies, and rites that celebrated the conclusion of major periods of time, referred to by modern specialists as period-ending rituals.[9] Impersonation allowed kings to reenact mythic narratives and set human events within deep cosmological time.[10]

Maya scribes also recorded the act of summoning deities, or *tzak k'uh*. This act is shown metaphorically in Maya hieroglyphic writing as a hand grasping a fish. Once summoned, deities oversaw human events, sanctioning the actions of the ruler and lending their otherworldly power to human affairs. These events come into vivid focus at Yaxchilan, a center located on the powerful Usumacinta River, where a dynasty of jaguar kings commemorated a dizzying array of ceremonies on carved stone lintels. On Lintel 25, an important queen conjures a fantastic image (fig. 129). Lady K'abal Xook, the wife of Yaxchilan king Shield Jaguar III (Itzam Kokaaj Bahlam III), looks at an enormous two-headed creature, part centipede and part snake, rising from a bowl placed along the lower frame of the lintel. The bowl is full of ritual implements

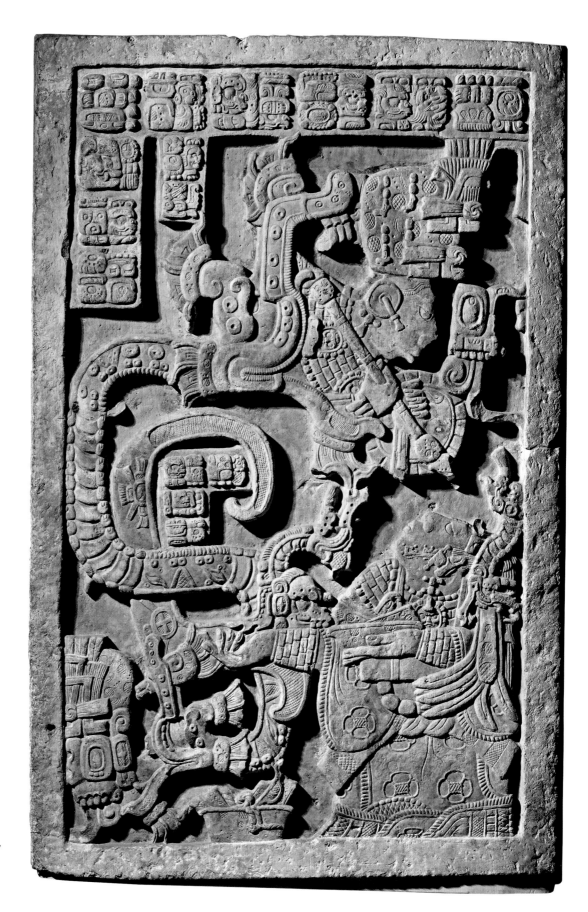

129
Lintel 25. Structure 23,
Yaxchilan, Chiapas, Mexico,
725. Limestone, H. 47⅝ in.
(121 cm). British Museum,
London

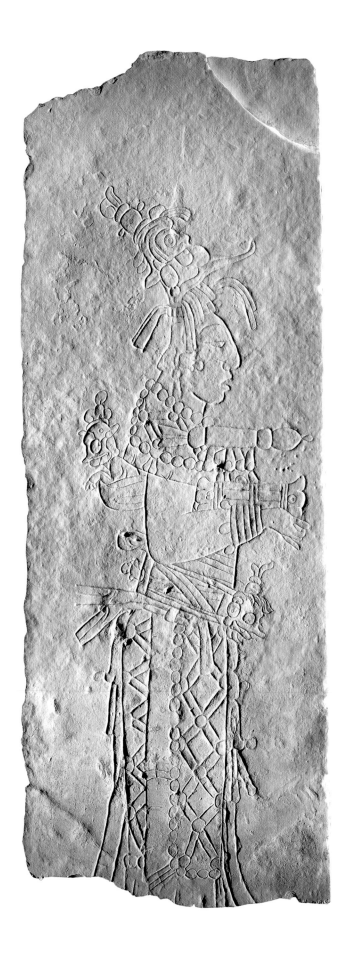

that have been burned to produce smoke; indeed, the queen is described in the accompanying hieroglyphs as a *ch'ajoom* (scatterer or burner). The serpent's two sets of jaws are open wide, and from the upper pair emerges a portrait of Shield Jaguar III. The glyphs, which span the upper edge and left corner of the lintel, make clear that he appears in the guise of the patron god Aj K'ahk' O' Chahk.[11] The creator of this lintel made evident the impersonator's double identity: in front of the king's human face is a mask, also depicted in profile, with a huge eye and skeletal upper jaw. The mask and the king's "balloon" headdress are in the style of Teotihuacan, a central Mexican metropolis that wielded power over large parts of Mesoamerica. The event depicted took place upon the king's accession in 681 and marked the reemergence of Yaxchilan as a potent political force. Through the ritual actions of Lady K'abal Xook, Shield Jaguar marshaled the power of a deity associated with warfare, enabling him to prevail against foes throughout the Usumacinta region in the late seventh and early eighth centuries.[12]

Impersonation and summoning also played out at a local scale, as communities throughout the Maya region worshiped their own patron gods, often multiple ones. Some patron deities appear at only one site, while others were claimed by many centers. At some places, hieroglyphic inscriptions record increasing numbers of deities over time.[13] The entire community was tasked with maintaining the relationship between patron deity and humans, but the person with direct responsibility was the ruler.[14] Patron deities are routinely described, by the phrase *uk'uhuul* (the god of), as "belonging" to rulers. The relationship between deities and rulers extended beyond ownership, however. Scribes often characterized it with the same phrase that describes the relationship of a child to his or her mother, *ubaah ujuuntahn* (the cared/

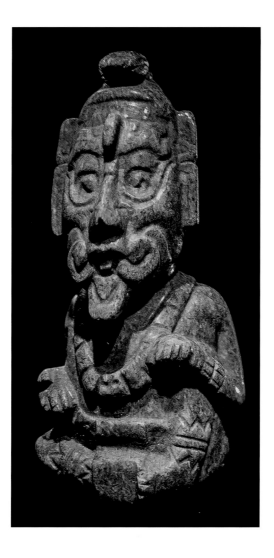

precious one of).[15] Maya rulers, the glyphs
imply, cared for their community gods much
as they would their children.

The performance of such care was directed
at the effigies that gave the patron deities
physical form. This can be seen in imagery
from Palenque, where both a panel from
Temple XIV and a tablet in the Temple of the
Foliated Cross depict a royal woman holding
an effigy of K'awiil, the lightning god. In both
examples, cloth hanging from the hands of the
person offering the image suggests the effigies
were bundled or wrapped in cloth, a standard
way of keeping or holding precious objects
in Mesoamerica.[16] At Xupa, a small site near
Palenque, a panel shows a woman carrying
a deity effigy on her back (fig. 130).[17] Similar

imagery appears at sites in Guatemala. The
kings of Xultun are commonly shown carry-
ing a small jaguar in their hands. A substance
emerging from the mouth of the jaguar sug-
gests it may be speaking or singing.[18]

Of the effigies themselves, we have only
traces, most recovered from tombs, such as a
jade figurine from the tomb of K'inich Janaab
Pakal I of Palenque (fig. 131). The figure sits
with its left hand perched on a raised knee,
wears its own jade jewelry, and looks straight
ahead. The undereye ornaments and protrud-
ing central tooth suggest associations with
Chahk or "GI," one of Palenque's powerful
patron deities. Found at the feet of the dead
king with his most intimate possessions, this
figure most likely represents a deity effigy.

The creation of effigies required multiple
steps, from sculpting the object to imbuing
it with godly essence. Inscriptions from the
Cross Group at Palenque describe the *patlaj*
(building or shaping) of "the precious ones
of the king," referring to the patron deities
of Palenque. This passage seems to describe
the creation of deity effigies more than a year
before the dedication of the buildings. The
day after the effigies' creation, the gods were
conjured by an important noble at Palenque,
according to the inscriptions. The implica-
tion is that certain actions were necessary
to tether the deities to the effigies.[19] These
images required periodic renewal and
replacement; for example, inscriptions at
Calakmul describe the creation of a new effigy
of the patron god Yajaw Maan, perhaps to
replace the one abducted by Tikal, where the
captive deity is fearsomely depicted on a lintel
(see fig. 135).[20]

Maya perceptions of personhood were
fluid, and effigy sculptures, considered
physical manifestations of godly power,
were treated as living beings. Hieroglyphic
inscriptions tell us that effigies of deities
were ritually bathed, housed, dressed, and

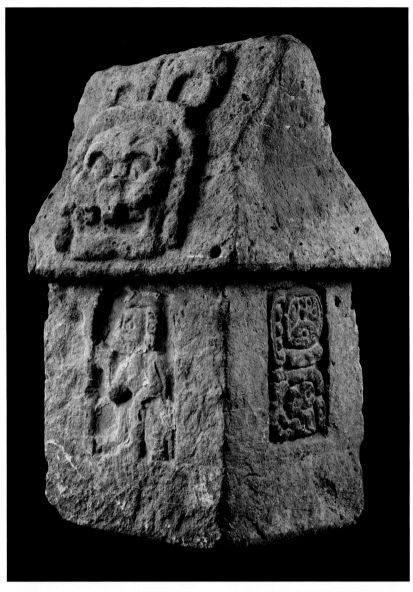

fed. They lived in houses called *wayib* (sleeping place) or *otoot* (dwelling), described at Tikal, Palenque, and La Corona, among other places.[21] At Copan, a series of small house models is marked with glyphs that describe them as *wayib* for a Copan patron god (figs. 132a–c). The *k'uh* — a general representation of a god — stands in the doorway of the house models, emphasizing their role as divine sleeping places.[22] Inscriptions at a number of sites describe the bathing and adornment of patron deities.[23] They also dined: Stela 35 from Yaxchilan refers to a captive who was eaten by two of the site's patron deities, while a tablet from the Temple of the Inscriptions at Palenque tells us, "the gods drink."[24] This corresponds with archaeological investigations at La Corona, where middens associated with several patron deity temples contained large numbers of drinking vessels. Patron gods at this site, it seems, were venerated by community members primarily with liquid offerings.[25] Although the glyphs describe these acts of care, they are rarely depicted in art, suggesting a strict code for visual representations. While certain rituals were commonly depicted, the ruler's nurturing of the deity remained private, inaccessible to viewers both ancient and modern.

Effigies of patron gods played vital political roles. Maya leaders used effigies to cement political alliances: at Caracol, inscriptions describe the arrival of a patron god, a gift of the Kaanul dynasty, in 622. Yet this god is described in previous inscriptions at Caracol, indicating that a new effigy could replace old ones.[26] The exchange of god effigies to secure alliances finds parallels in other parts of Mesoamerica, including among the Aztecs.[27] If the relationship turned sour, deity effigies could be taken as prisoners of war, just like humans. The lintels of Tikal provide striking visual evidence of this circumstance, showing triumphant Tikal kings carried on palanquins

132A–C
House model (three views).
Group 10L-2, Copan,
Honduras, eighth century.
Rhyolite, H. 34 5/8 in.
(88 cm). Peabody
Museum of Archaeology
and Ethnology, Harvard
University, Cambridge,
Mass., Peabody Museum
Expedition, 1891–92

beneath their rivals' deities; the hieroglyphs describe the effigies as captives. The Aztecs would place the deity images they seized in a *coateocalli*, a temple dedicated to such beings.[28]

Throughout the Classic period, patron deities in Maya art helped frame human action in a grand cosmological span. Revered intercessors, patron deities provided rulers supernatural sanction, whether for alliances or altercations, and were key to the negotiation of political authority.[29] At sites throughout the Maya area — such as Tikal, Calakmul, Naranjo, Piedras Negras, Palenque, Copan, and Tonina — works of art reflect the mutual participation of gods and rulers in affairs both human and divine.

Tikal

Dynastic records at Tikal, a city set amid dense forest in the heart of the Maya area, indicate it was home to an ancient royal line. By A.D. 292, conventions for the depiction of kings at Tikal had been established: Stela 29 depicts a ruler in profile, wearing an elaborate headdress and carrying a ceremonial bar. In 378, however, everything changed. Texts from throughout Petén, the central lowland region encompassing Tikal, record the *huley* (arrival) of an individual named Sihyaj K'ahk'. On the day he came to Tikal, the reigning king, Chak Tok Ich'aak I, died. A new ruler, Yax Nuun Ahiin I, was installed one year later, overseen by Sihyaj K'ahk'. The new king is described in the glyphs as the son of Spearthrower Owl, perhaps the ruler of the distant metropolis of Teotihuacan.[30]

These dramatic events may represent a Teotihuacan incursion into the Maya area centered at Tikal, although the exact nature of the interaction between the two sites remains unclear.[31] On sculptures produced after the arrival event, artists at Tikal showed

rulers posed frontally, as in Teotihuacan, and wearing Teotihuacan-style headdresses. Texts from Tikal also describe the arrival of a new deity: Waxaklajuun Ubaah Kaan (Eighteen Are the Images of the Snake). This serpent deity — probably the same one featured on architectural relief sculpture at Teotihuacan — was a prominent patron of warfare, and its visage appeared throughout the Maya area for centuries to come. It did not replace Maya patron deities but appears to have been added to the pantheon.[32] Later images of Tikal kings returned to the traditional Maya depiction in profile, emphasizing Maya artistic heritage in concert with Teotihuacan influence.

After Tikal's defeat by its archenemy Calakmul in 562 — a defeat recorded at the victor's ally Caracol rather than at Tikal — the monumental record of Tikal goes silent for more than one hundred years. It is not until the reign of Jasaw Chan K'awiil I and his defeat of Calakmul in 695 that Tikal again took the stage as a regional superpower. Jasaw Chan K'awiil's victories are commemorated on two wooden lintels recovered from his funerary temple, Temple I. The lintels are made of burnished sapodilla, a durable wood. Their placement in the upper frame of temple doorways, combined with their intricate, low-relief carving, would have made them difficult for ancient viewers to study in detail. They may have served commemorative rather than didactic purposes, as reminders of specific events.[33]

For contemporary viewers, the lintels offer compelling insights into the role of deities and their effigies in warfare. Lintel 2 displays the king seated on a short throne on a palanquin beneath a towering serpent (fig. 133). The latter is Waxaklajuun Ubaah Kaan, the Teotihuacan deity adopted by Tikal and commonly referred to as the War Serpent. Owing to damage to the lintel, only the serpent's open

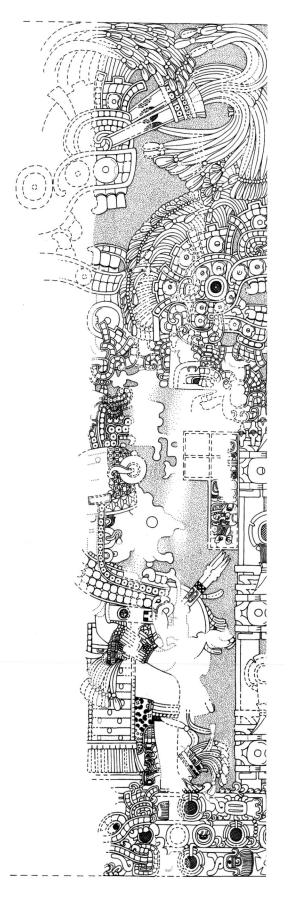

133

Jasaw Chan K'awiil I seated wearing a mask, from Temple I, Lintel 2, Tikal, Guatemala. Drawing by William R. Coe

jaws and protruding teeth, beneath a cascade of feathers, are visible. The lintel itself commemorates a triumphal procession.[34] Both figures wear a headdress represented entirely in mosaic; the king also wears a mask, although its details are lost to degradation. He carries a round shield and small darts, implements traditionally used by Teotihuacan warriors. By the time this lintel was carved, Teotihuacan was no longer in power. This lintel is a powerful statement of its legacy, and a proclamation that the ruler of Tikal worked in concert with the War Serpent itself.

Perhaps no monument demonstrates the visceral power of the War Serpent like Lintel 3, created by Tikal's next ruler, Yihk'in Chan K'awiil (fig. 134). This work was placed in the upper sanctuary of Temple IV, a 212-foot-tall structure that was itself an imposing statement of power. The text of this lintel describes a war in 743 against El Perú-Waka', a kingdom to the west of Tikal, and the capture of its patron deity: a version of Akan, a deity associated with drunkenness, death, and the underworld.[35] Three years later, as the text continues to explain, the deity — now described as the god of the Tikal ruler — is impersonated, presumably by that king, who is carried on a palanquin. The accompanying scene probably depicts this event: Yihk'in Chan K'awiil, bedecked in death imagery, is framed by the arc of a great serpent, most likely Waxaklajuun Ubaah Kaan. The serpent seems to writhe behind him, while the Principal Bird Deity perches on top. The text goes on to describe the construction of the Akan Haab Nal, which may be a new temple or palanquin associated with the captured deity.[36] Combined with the other lintels of Tikal, this work demonstrates both the power and the precarity of godly images, who could lend their might not only to their home community but also to its rivals.

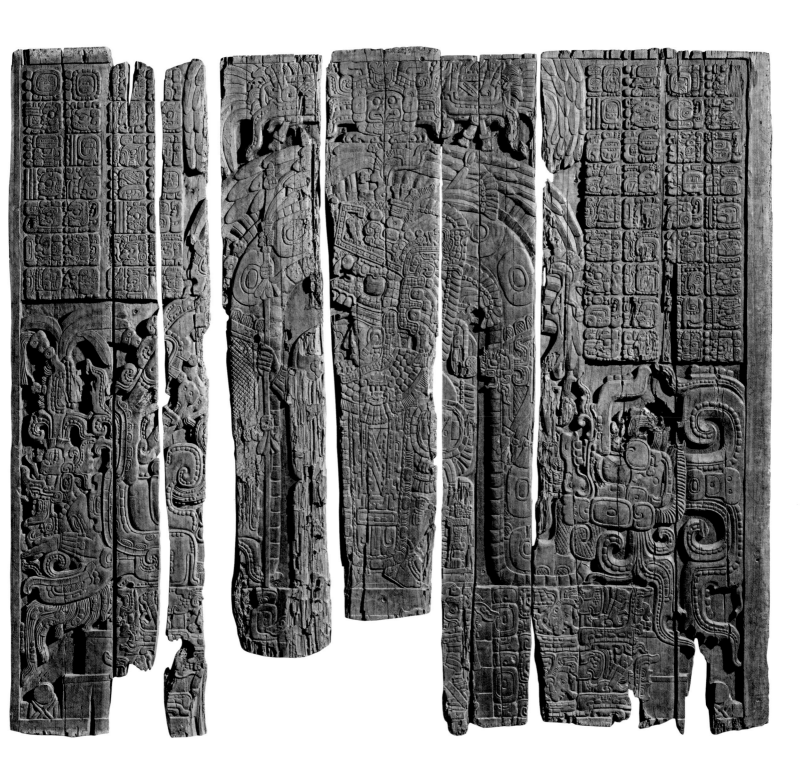

134
Lintel 3. Temple IV, Tikal,
Guatemala, ca. 747. Wood,
W. 80¾ in. (205 cm).
Museum der Kulturen Basel

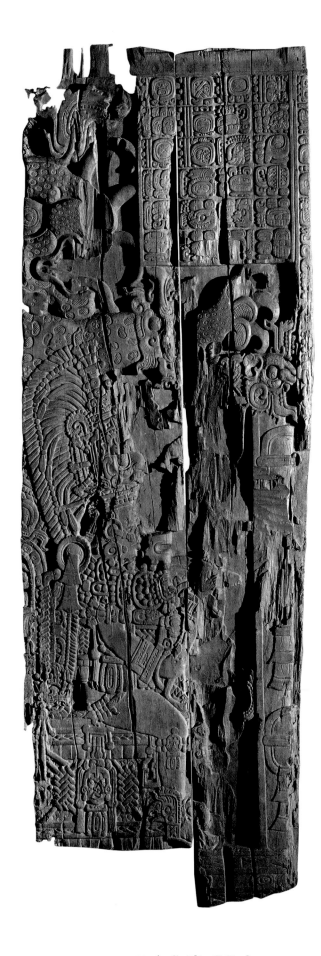

Calakmul

In the Late Classic period, Calakmul was the home of the Kaanul (Snake) dynasty, rulers who constructed enormous buildings and erected stelae throughout the seventh and eighth centuries. Although the dynasty was originally based at Dzibanche, textual sources record a civil war at that site and the reestablishment of the Kaanul dynasty at Calakmul — called Uxte-tuun Chiiknahb — by the mid-seventh century. Texts describing this shift use the term *k'awiilil* (K'awiil-ness), a personification of kingly power as lightning, to emphasize its presence at Calakmul (see "Rain, Lightning," in this volume).[37] Poor limestone from the area around Calakmul has resulted in loss of detail on many sculptures, but the monuments that remain there and at its subsidiary sites speak of a powerful dynasty with mighty patron gods and imperial reach.[38]

The city's most powerful ruler, Yuknoom Ch'een II, established the Snake dynasty as a regional superpower in the seventh century — not coincidentally, a time of strife at its rival site Tikal — by consolidating alliances with a number of smaller sites in the area. At some of these sites, texts describe ceremonies overseen by Calakmul's ruler and patron deities, signaling Calakmul's primary status in the relationship. For example, Yuknoom Ch'een II and both Yajaw Maan and Ho Kohkan K'uh, two important patron deities of Calakmul, oversaw the installation of a new ruler at the subsidiary site of Cancuen in 656.[39] Accordingly, Calakmul's growing influence was the result not only of human power but also of otherworldly might.

135
Lintel 3. Temple I, Tikal, Guatemala, ca. 695. Wood, H. 72 in. (183 cm). Museum der Kulturen Basel

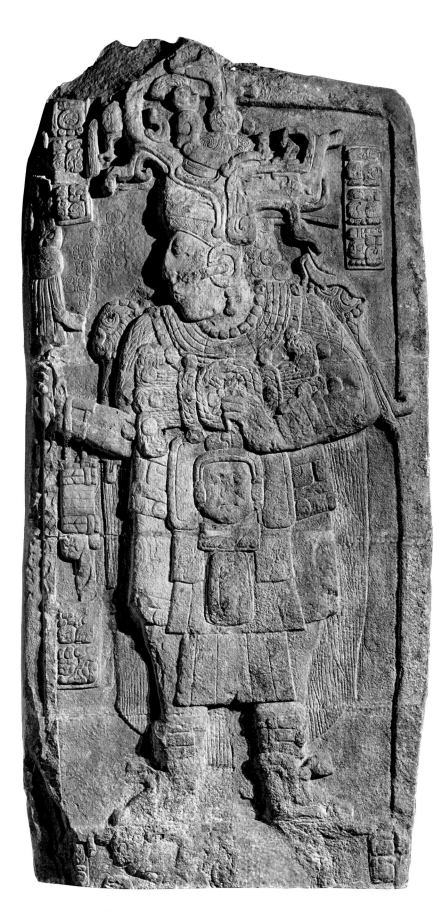

Yuknoom Ch'een II's successor, Yuknoom Yich'aak K'ahk', oversaw less glorious events. It was under his leadership in 695 that Calakmul suffered a devastating defeat by Tikal, its nemesis. The ramifications of the loss appear on Lintel 3 from Tikal's Temple I, which describes the capture of Yajaw Maan, a Calakmul patron deity, and Tikal's triumph forty days later (fig. 135). The lintel depicts the king of Tikal seated on a throne beneath an enormous upright jaguar with extended arms; the entire scene takes place upon a palanquin, presumably paraded through Tikal. The artist has lavished particular attention on the curved claws of Yajaw Maan, emphasizing the Calakmul deity's deadliness. Tikal's ruler Jasaw Chan K'awiil wears a typical kingly outfit, including an enormous jade pectoral, celts (ceremonial axe blades) at his waist, and elaborate kneelets and sandals. He holds a round shield in his left hand and a K'awiil scepter in his right, reminding viewers of his dynastic heritage and legitimacy. This depiction and the text associated with it suggest that Jasaw Chan K'awiil framed his victory as a divine abdication of the Calakmul polity, imbuing human politics with supernatural power. Rather than destroying the effigy, he claimed it as his own. Calakmul did not accept the loss of its deity effigy permanently, however: a text on Stela 89 from that site indicates that artists created a new palanquin and effigy for the god in 731.[40]

At Calakmul itself, the sculptural tradition continued to flourish even as the polity's power declined. Some of its finest carvings date to the reign of Yich'aak K'ahk's successor,

136
Sak[…] Yuk[…] Took' and Sak[…] Yib'ah Tzak B'ahlam (Maya sculptors, active 8th century). Stela 51. Calakmul, Mexico, 731. Limestone, H. 9 ft. 10 ⅞ in. (3 m). Museo Nacional de Antropología, Mexico City, Secretaría de Cultura–INAH

Yuknoom Took' K'awiil, who consolidated political alliances after the city's subjugation by Tikal. Known for erecting ambitious numbers of sculptures, this ruler marked the 731 katun ending — the conclusion of a twenty-year period — with a set of seven stelae.[41] Among them was Stela 51, one of the finest surviving stelae from the site (fig. 136). It depicts the ruler with an abundant mane of curls, an elaborate pectoral and deity headdress, and a long feathered cape. Although the visual focus is the ruler in his finery, the stela bears political implications: finely incised glyphs indicate the stela may have been given to Calakmul as tribute from a subsidiary site.[42]

Naranjo

Located at a key point along trade routes, the Sa'al dynasty capital of Naranjo was swept up in many of the political upheavals of the Classic-period lowlands. While the archaeological site has been heavily damaged by looters, its monumental sculptures record a history replete with turbulence and divine intervention.

Naranjo's regional power solidified with the arrival of a princess, Ix Wak Jalam Chan, in 682. Born in Dos Pilas, Ix Wak Jalam Chan likely moved to Naranjo as the result of a marriage to consolidate a political alliance, a common tactic in the Classic Maya world. Her five-year-old son acceded to the throne in 693, and Ix Wak Jalam Chan almost certainly served as regent as Naranjo waged wars against the neighboring towns of Tuubal and Bital.[43] Inscriptions from the site indicate that Naranjo expanded under the auspices of Calakmul; like some queens of that larger site, Ix Wak Jalam Chan appears on carved stone monuments as a warrior-queen. On Stela 24, she wears a net skirt and a belt assemblage that includes a watery being, sometimes

called the "xook" monster, as well as a spondylus shell (fig. 137). In her arms she holds a bowl with implements of sacrifice, such as flint and obsidian knives and stingray spines, ceremonially used to draw blood. Dripped onto paper and then burned, the blood helped to sustain the gods. According to the text, she impersonated a deity as she completed a ritual in 702. While the queen's depiction refers to divine authority, her power in the human realm is also clear: she stands on a contorted captive, whose closed eyes indicate he is dead. The stela leaves no doubt about Naranjo's ability to subdue competing polities and complete the appropriate ritual actions.

Her son, K'ahk' Tiliw Chan Chahk, went on to secure military victories against a number of area centers. Stela 22 describes the king's numerous triumphs at sites like Komkom and Witzna; at the latter, paleoenvironmental evidence corroborates the burning of the city that was recorded in hieroglyphic inscriptions (fig. 138).[44] Naranjo's list of victories, while impressive, is, however, confined to relatively small centers, which may indicate a consolidation of regional power rather than an expansion.[45] The iconography of Stela 22 supports the textual account of dominance. K'ahk' Tiliw Chan Chahk sits atop a jaguar-skin throne that itself is perched on an enormous skull. The king is bedecked in rich accoutrements, wearing a headdress that includes the elements of his regnal name. He holds a ceremonial bar from either end of which emerges a head, one of them representing K'awiil. Below him, as if appearing from the snout of the skull, sits the captive king of Ucanal, one of the sites burned by Naranjo in the preceding years. Almost naked, wrists bound, and in a position of subservience, the captive king looks up at his conqueror. An accompanying text describes the former as "without genesis, without darkness," the powers ascribed to kings,[46] making clear that to be captured was

137
Stela 24. Naranjo, Petén, Guatemala, 702. Stone, H. 78 in. (198.1 cm). Museo Nacional de Arqueología y Etnología, Guatemala City, Ministerio de Cultura y Deportes de Guatemala

138
Stela 22. Naranjo, Petén, Guatemala, 702. Stone, H. 9 ft. 10 ⅛ in. (3 m). Museo Nacional de Arqueología y Etnología, Guatemala City, Ministerio de Cultura y Deportes de Guatemala

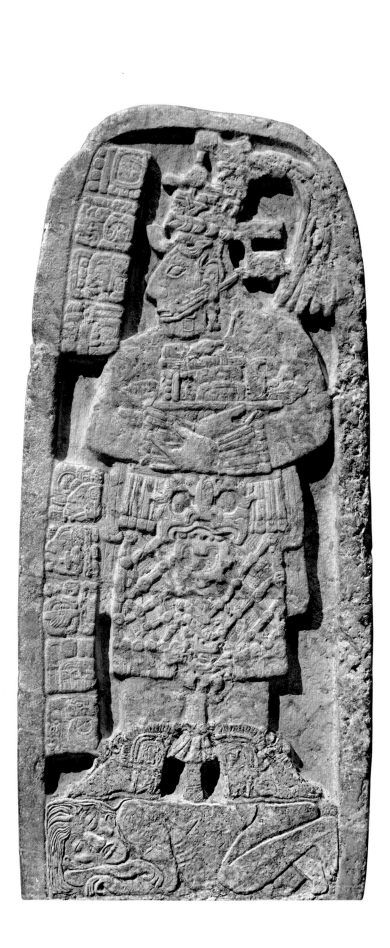
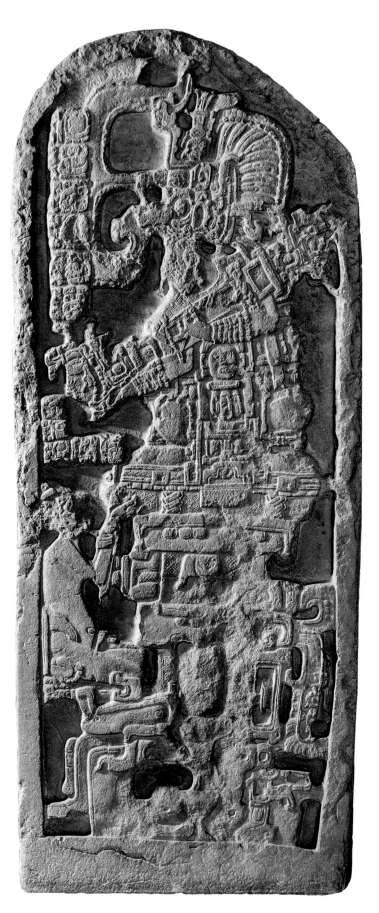

to lose one's kingly essence — and the ability to provide for one's patron deities.

Throughout Naranjo's sculptural program, rulers are shown impersonating deities, particularly the powerful Jaguar God of the Underworld. Wearing a twisted cord under the eye, a scalloped chin piece, and jaguar ears, rulers at Naranjo stood atop captives on at least four monuments in the late seventh and eighth centuries. On Stela 21, K'ahk' Tiliw Chan Chahk's long robe of feathers is marked with the glyph for "blood." His regalia, combined with the spear and shield — also marked with the distinctive attributes of the Jaguar God of the Underworld — suggests that the god's presence is associated with the ruler's victories.

The tide turned for Naranjo's regional dominance with the declining power of its patron Calakmul in the eighth century. A final, extraordinary lintel from the immense Temple IV at Tikal showcases a Tikal victory over Naranjo, at the time ruled by Yax Mayuy Chan Chahk (fig. 139). The text describes Tikal forces capturing the Naranjo ruler's deities in 744 and a later procession at Tikal in which its king, Yihk'in Chan K'awiil, was borne by a *tz'unun pi'it*, or hummingbird litter (so called because it bears the patron deity Hummingbird Jaguar). The imagery seems to depict this event, showing the king enthroned atop an enormous palanquin. He is positioned in the center of the lintel, his face in profile and looking to the left. He carries a round shield in his left hand and a K'awiil scepter — a common accoutrement for Classic-period kings — in his right. Although the king is an important part of this narrative, the image is dominated by the anthropomorphic figure looming above him. That figure stands in profile, also facing to the left, with its hands extending straight in front of its body. Its face is marked with several familiar aspects of the Jaguar God of the Underworld: a twisted cord under the

139
Lintel 2. Temple IV, Tikal, Guatemala, ca. 747. Wood, approx. H. 70¾ in. (179.7 cm). Museum der Kulturen Basel

eyes and over the nose; a jaguar ear; and a shell chin attachment, visible as an undulating object between the chin and arm. Three spots on the figure's thigh confirm its jaguar identity. The figure also wears an elaborate headdress. In front of its nose is a beaklike projection that, while damaged on the lintel, identifies the figure as the Hummingbird Jaguar, one of Naranjo's patron deities, who is associated with warfare. As if to confirm the home community of this captured deity, the base of the palanquin is ornamented with *sa'al* signs, part of the ancient name of Naranjo.

That the lintel depicts the hummingbird litter is confirmed by graffiti at Tikal, which shows the same hulking figure atop a litter carried by two individuals. On that version of the scene, the figure clearly wears a beak and the disk that identifies a hummingbird proboscis. The litter is also pictured on a sixth-century ceramic from Naranjo, as the anthropologist Simon Martin has shown. This evidence clarifies that the figure on the Tikal lintel is an effigy of Naranjo's patron deity, the Hummingbird Jaguar, and that it was taken captive in battle before being paraded through Tikal.[47]

Piedras Negras

Located on the mighty Usumacinta River, Piedras Negras — known as Yo'kib in the Classic period — maintained a network of subsidiary sites in the Late Classic period as its rulers waged war against Yaxchilan, a rival to the south. Royal names at Piedras Negras often incorporate the name of Itzamk'anahk, an aged deity associated with the ancestors and the cardinal directions. "K'anahk" means yellow or precious turtle, and the lords of Piedras Negras are often referred to as the Turtle Lords.

Dating to about 518, Panel 12 is the earliest contemporary record of Piedras Negras

history — and a potent example of the layering of political and divine topics (fig. 140). The imagery focuses on a political message that hints at Piedras Negras's growing power in the Usumacinta region. The ruler of Piedras Negras is shown on the right with a captive behind him; in front of him, separated by a band of text, are three kneeling prisoners from Yaxchilan, Santa Elena, and perhaps Lakamtun,[48] spelling out his territorial control. Especially intriguing is a statement suggesting the Piedras Negras ruler is subject to an overlord, perhaps associated with Teotihuacan.[49] The panel also marks the dedication of a patron deity temple and tells viewers that the ruler performed a house-censing ritual in the temple of three deities belonging to him:[50] K'inich Ajaw, the sun god; Waxak Ha'Naak; and a third deity whose name is undeciphered. The mirroring of the three named captives and three deities suggests a synchronicity of political and religious events.

While the rulers of Piedras Negras clearly maintained relationships with patron deities, they are rarely depicted impersonating or summoning such deities on monumental sculpture. Instead, the Late Classic rulers of Piedras Negras followed several sculptural paradigms established by K'inich Yo'nal Ahk

I, who acceded to the throne in 603.[51] One typical format for Piedras Negras sculptures depicts the ruler as a warrior wearing the plated headdress of Waxaklajuun Ubaah Kaan, with captives cowering beneath.[52] The Turtle Lords typically celebrated their accession to office with their depiction in a niche atop a scaffold and under an enormous image of the Principal Bird Deity. These images are clear about the elements necessary to rule — divine sanction, military might, and sacrifice chief among them — but the lords themselves remain in human form.

Panel 3, long recognized as a masterpiece of Maya relief sculpture, was created near the end of the Classic-period history of Piedras Negras, during the reign of K'inich Yat Ahk III (fig. 141). It is a retrospective monument: although it was produced at the end of the eighth century, it commemorates Itzam K'an Ahk IV, who ruled several generations earlier. The main text describes the celebrations undertaken upon Itzam K'an Ahk IV's first katun of rule in 749, including dancing and feasting, before touching on his death and burial. The text then jumps to more contemporary events, describing the ritual burning of his tomb by the current king, K'inich Yat Ahk III. The panel's imagery is strikingly dynamic.

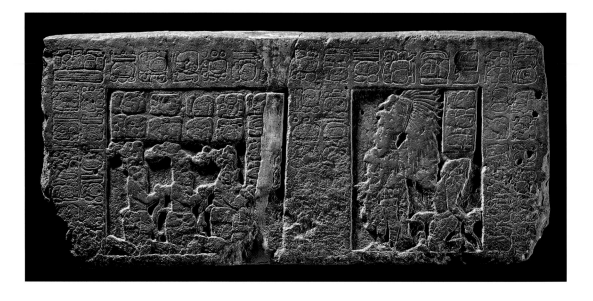

140
Panel 12. Piedras Negras, Petén, Guatemala, ca. 518. Limestone, L. 46 in. (116.8 cm). Museo Nacional de Arqueología y Etnología, Guatemala City, Ministerio de Cultura y Deportes de Guatemala

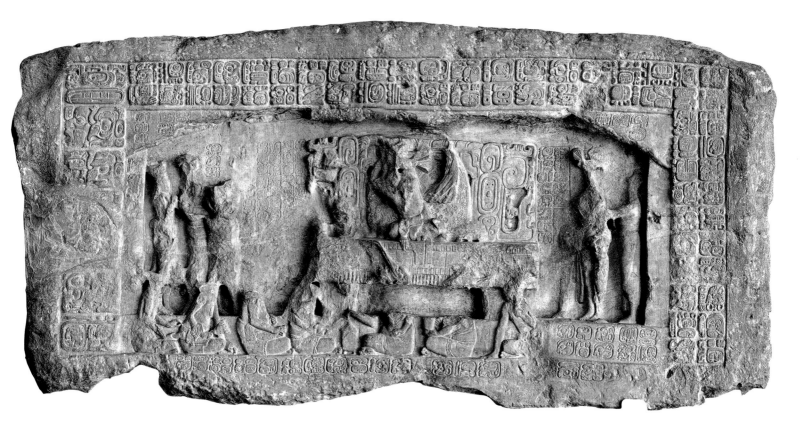

141
Wajaat Na Chahk and
a collaborator (Maya
sculptors, active 8th
century). Panel 3. Piedras
Negras, Petén, Guatemala,
ca. 782–95. Limestone,
W. 39⅜ in. (100 cm). Museo
Nacional de Arqueología y
Etnología, Guatemala City,
Ministerio de Cultura y
Deportes de Guatemala

The scene takes place in a throne room cir-
cumscribed by texts that double visually as
architecture. In the center, Itzam K'an Ahk IV
sits on a throne surrounded by subordinates,
including a ruler of Yaxchilan and a *ch'ok*
(young thing, sprout) or prince of Piedras
Negras. The king seems to lean into the view-
er's space, while two nobles converse with
one another at far left; other individuals seem
poised in midaction, creating a vibrant courtly
tableau. In contrast to the stiff, formal compo-
sitions favored by many Maya artists, Panel 3
feels convivial and intimate. Amid the figures,
hieroglyphic passages inscribed in smaller,
shallower form enliven the scene with first-
and second-person speech that helps clarify
the intended message. The first-person
narrative delivered by the Piedras Negras
ruler seems aimed at the visiting Yaxchilan
king, recounting the role of Piedras Negras
in overseeing the accession of previous kings
at Yaxchilan. At a time when the fortunes of

Piedras Negras were falling (K'inich Yat Ahk
III met his end as a captive at Yaxchilan in the
early ninth century), sculptors understand-
ably celebrated an era in which its dominance
was secure.[53]

The magnificent throne depicted on Panel
3 finds a three-dimensional parallel in Throne
1, another work dating to the reign of K'inich
Yat Ahk III (fig. 142). The throne's back is
styled as a *witz*, or animate mountain. From
each of the mountain's eyes emerges a human
figure, visible from the shoulders up. The two
figures, perhaps the parents of the ruler, ges-
ture as if speaking; their elaborate hairstyles
curl toward the top of the sculpture. Text at
the upper center refers to an important noble
from La Mar, a subsidiary site within the
Piedras Negras polity. The same individual
appears on Panel 3, suggesting the impor-
tance to K'inich Yat Ahk III of this noble's
alliance. Combined, the text and imagery on
the throne's back tell viewers that the king

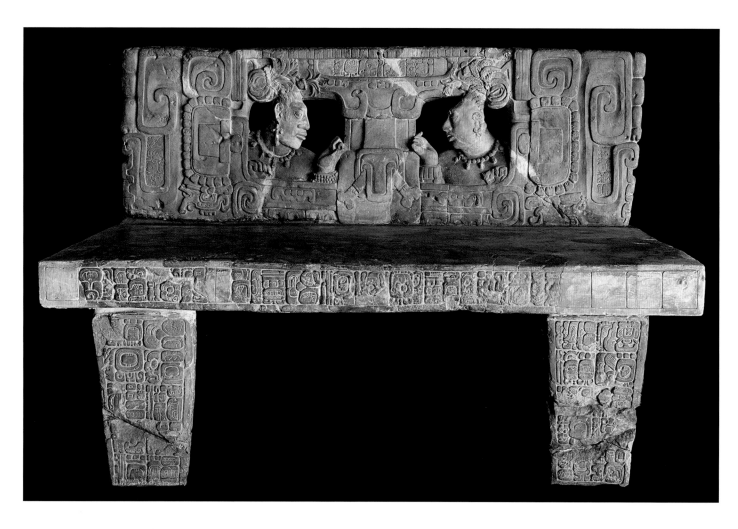

142
K'in Lakam Chahk and
Patlajte K'awiil mo[…]
(Maya sculptors, active 8th
century). Throne 1. Piedras
Negras, Petén, Guatemala,
785. Limestone, W. 78¾ in.
(200 cm). Museo Nacional
de Arqueología y Etnología,
Guatemala City, Ministerio
de Cultura y Deportes de
Guatemala

was supported by his royal heritage, his loyal subjects, and the animate earth itself. Interestingly, this sculpture, unlike many Maya works, can be attributed to specific individuals: a row of glyphs on either side of the throne back, placed within volutes emerging from the central mountain motif, contains artists' signatures. On the front edge and legs of the throne is a long text that describes events in the life of the previous ruler, Ha' K'in Xook, including his death or abdication in 781, and the rituals K'inich Yat Ahk III undertook to accede. The text helps piece together dynastic history within a rubric of ancestral power, emphasizing the ties between the earlier king and K'inich Yat Ahk III, and describes the transport and arrival of a sacred object as a necessary precursor to the latter's

crowning.[54] Investigators found Throne 1, originally installed in a niche in Structure J-6, part of the royal palace, deliberately smashed and scattered. Analysis of the monument suggests special attention was paid to the destruction of the human faces (those shown are reconstructions), underscoring the violence that accompanied the end of the dynasty at Piedras Negras.[55]

Palenque

Perched at the edge of the Chiapas Highlands, Palenque was home to a dynasty whose rulers referred to themselves as *k'uhul baakal ajaw*, or divine bone rulers. Its art and architecture preserve one of the most vivid accounts of patron deities in the Maya world.

We can trace the first ruler of Palenque to 431, but the history of the center goes back much further, into primordial time. According to inscriptions from the seventh and eighth centuries, the three patron gods of Palenque were born at a place called Matwiil in 2360 B.C. Known as the Palenque Triad, they are called GI (an abbreviation of "God I"), GII, and GIII (fig. 143). Each has distinct associations. GI is an aquatic solar deity, perhaps associated with the rising of the sun from the eastern ocean in the morning. GII, also known as Unen K'awiil, is an infant form of K'awiil,

143
Detail of Tablet of the Foliated Cross, Palenque, showing the names of the Triad Gods. Photograph by Jorge Pérez de Lara, 2008

144
Cross Group, Palenque, Chiapas, Mexico. Photograph by Jorge Pérez de Lara, 2022

the deity connected with lightning, ancestry, and agricultural fertility. GIII is an aspect of K'inich Ajaw, the sun god, and is associated at the site with warfare and the underworld.[56] Although these gods are worshiped elsewhere individually, only at Palenque do all three appear consistently together. GI provides particular insight into the genesis of patron deities, as he is described in various texts both before and after his "birth" at Palenque. His arrival at the site, also described as "earth touching," represents his transition from a general deity to a patron deity specifically connected to the Palenque community.[57]

The Triad Gods take their most visible form in three buildings known as the Cross Group (fig. 144). Commissioned by K'inich Kan Bahlam II, the son of the great Palenque ruler K'inich Janaab Pakal, each temple in this group was dedicated to a patron god in 692: the Temple of the Cross to GI, the Temple of the Foliated Cross to GII, and the Temple of the Sun to GIII. Each building contains an interior shrine with a large tablet carved in low relief. The complex texts and imagery of these tablets place Kan Bahlam within mythic and historical context. The tablet from the Temple

of the Cross, for instance, depicts the king at two points in his life: as a child on the left, and as an adult on the right. The two Kan Bahlams stand on either side of a world tree, an axis mundi that connects the layers of the universe. The Principal Bird Deity perches atop the tree, which grows from a sacrificial bowl. Combined, the elements of the tablet echo the sarcophagus lid of Janaab Pakal, where the same deity appears atop the tree as Pakal emerges from the underworld (see fig. 128). The three temples stand as enduring statements of patron deity veneration but also served to anchor Kan Bahlam and his family in the mythic history of Palenque and connect them to the exploits of Pakal, his powerful predecessor.

Later kings of Palenque oversaw the creation of masterful stucco sculptures that imbued earthly affairs with divine sanction. Temples XIX and XX were dedicated in 734–36, during the reign of K'inich Ahkal

Mo' Nahb III. Texts on the South Panel from Temple XIX describe the mythical accession of GI to rulership in 3309 B.C., overseen by the deity Yax Naah Itzamnaaj. Both the text and the imagery explicitly link the accession of this important patron god to Ahkal Mo' Nahb's own accession.[58] The ruler impersonates GI in the center of the composition, while his cousin Janaab Ajaw, seated to the left, impersonates Yax Naah Itzamnaaj. Wearing the headdress of the Principal Bird Deity, he hands the royal headband to the king.

Palenque kings consistently framed their rule within a larger, mythic history, and the center's inscriptions tie the kingdom's success directly to the care of the gods. Yet the last traces of dynastic commemoration at Palenque focus on mortal beings. The Tablet of the 96 Glyphs, commissioned to celebrate the first katun anniversary of K'inich K'uk' Bahlam II in 783, emphasizes the actions of Janaab Pakal and his predecessors, highlighting the ruler's ancestors rather than the gods.

Copan

Copan preserves one of the most complete dynastic histories in the Maya corpus. Hugging the Copan River in what is today Honduras, Copan sits on the eastern edge of the Maya cultural zone. Kings at this site took names that featured K'inich, K'awiil, and Yopaat. The founder of the Copan dynasty, K'inich Yax K'uk' Mo' (Radiant First Quetzal Macaw), had strong ties to Teotihuacan and may have grown up in another part of the Maya area. Information about this dynastic founder comes from Altar Q, an eighth-century sculpture (figs. 145a–e). Glyphs on Altar Q record that Yax K'uk' Mo' acceded to rulership when he "took the K'awiil"—a distinctly Maya reference to accession that probably involved K'awiil scepters—in 426 at a place called Wiinte'naah. One hundred

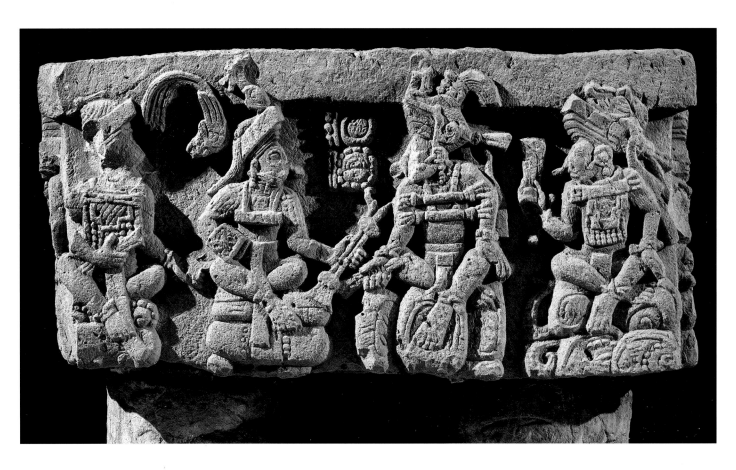

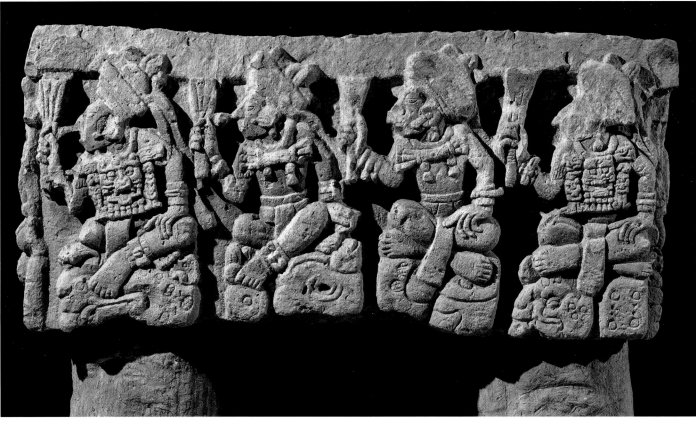

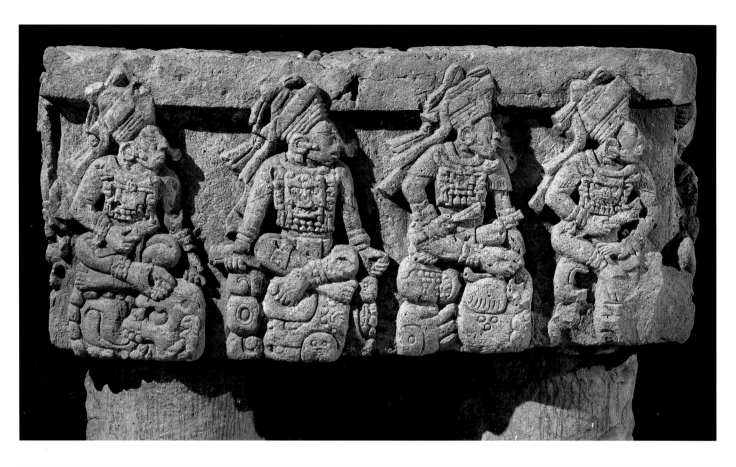
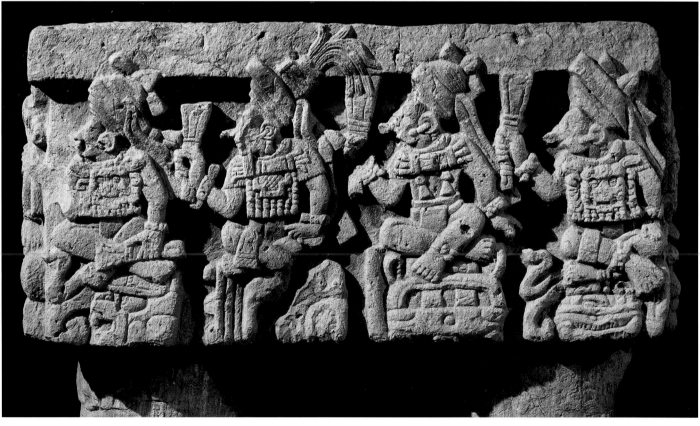

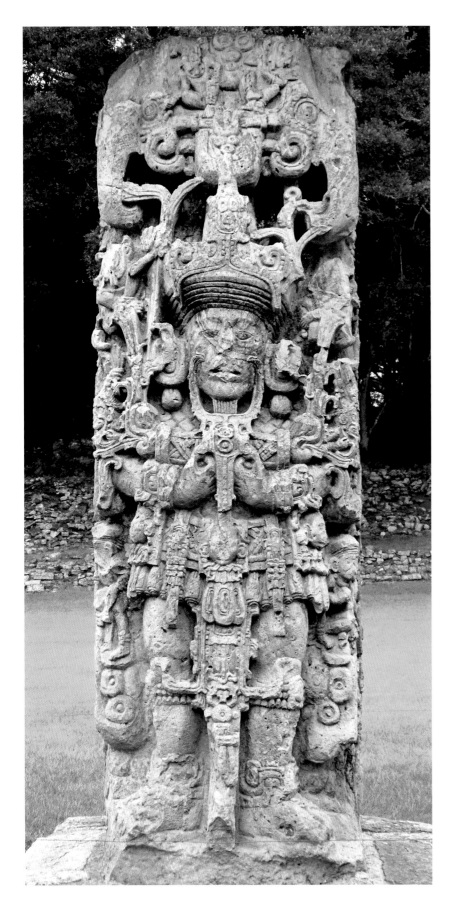

and fifty-two days later, the new king arrived at Copan. This process, including the reception of a deity effigy in a faraway place and its transport home, prefigures the narrative of the much later *Popol Wuj* (see "Wood, Stone," in this volume). The dynastic founder loomed large in the architecture of Copan, as his successors reworked the shrine associated with his tomb over subsequent centuries.

The twelfth and thirteenth rulers in the Copan dynasty oversaw the pinnacle of Copan's creative achievements. K'ahk' Uti' Witz' K'awiil, long known as Ruler 12, and his son Waxaklajuun Ubaah K'awiil (Eighteen Are the Images of K'awiil) created sculptures that redefined the city center. Late Classic–period stelae from Copan are known for their three-dimensionality and their dynamic modeling, mimicking in stone the stucco works of previous generations. Acceding to the throne in 695 after his father's long reign, Waxaklajuun Ubaah K'awiil impersonated patron deities on Stelae A, B, and C. Executed in three-dimensional form in volcanic tuff, these stelae depict the standing king holding ceremonial bars. Stela B, which commemorated the 731 katun ending, depicts the deity Mo' Witz Ajaw (Macaw Mountain Lord) on one side and the impersonating king on the other (fig. 146).[59] He wears a scalloped chin attachment and a turban typical of Copan kings; the ancestral heads worn at his belt position him as both axis mundi and inheritor of royal legacy. The whole scene takes place on a *witz*: visible amid the sculpture's dizzying details are three circles at the top that denote the stony environment.

The gods were involved in politics at Copan as well. Waxaklajuun Ubaah K'awiil met an unfortunate end at nearby Quirigua,

146
Stela B. Copan, Honduras, 731. Stone, 12 ft. 2 3/4 in. (3.73 m). Sitio Maya de Copán, IHAH

whose people rose up against their former overlord to capture and behead its king in 738. At Quirigua, inscriptions relating this victory connect the fall of the Copan ruler to the overthrow of two of Copan's patron deities; although the hieroglyphic passage is difficult to parse, it seems to refer to wood effigies that were toppled six days before the king's death.[60] The fifteenth king, K'ahk' Yipyaj Chan K'awiil, placed this defeat in the context of the revitalization of Copan in Structure 26's Hieroglyphic Stairway, a monumental text he commissioned to recount the history of the dynasty.

By the reign of its sixteenth ruler, Yax Pasaj Chan Yopaat, Copan was in decline. While he commissioned important works like Altar Q, the rising power of elite factions may have contributed to political fractures at the site. Stela 11, placed at the base of Yax Pasaj Chan Yopaat's funerary temple, depicts the deceased ruler at the moment of rebirth (see fig. 98a). Much like the imagery on the abovementioned sarcophagus lid of Janaab Pakal, the Copan king is dressed as the Maize God and stands above the maw of the underworld, here depicted as a bony cleft. A flaming torch emerges from his forehead, indicating that he also impersonates K'awiil.[61] The text refers to both Yax Pasaj Chan Yopaat and K'inich Yax K'uk' Mo'. Like the descendents of Janaab Pakal at Palenque, the later kings of Copan recalled their dynastic founder as well as the gods as they began their own rebirth.

Tonina

On the opposite side of the Maya world, the enormous acropolis of Tonina was home to the Centipede Kings. Rising like a mountain in the Chiapas Highlands, the acropolis comprised seven levels; at its base was a sunken ballcourt in a vast plaza where thousands could have gathered. Tonina's buildings,

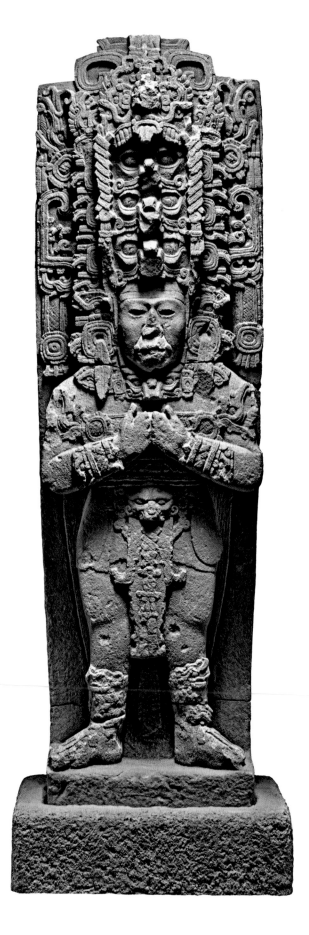

elaborately ornamented with stucco modeling, and its sculptures, known for their in-the-round dynamism, together emphasized both the might of its kings over subordinate bodies and the presence of the divine.

Monument 168 exemplifies Tonina's distinctive sculptural style (fig. 147). Carved in deep relief, it is a portrait of an Early Classic–period king known as Jaguar Bird Tapir (perhaps read as Bahlam Yaxuun Tihl), whose royal regalia in every aspect invoked the presence of the otherworldly. The sculptor has lavished attention on the headdress, which is composed of a series of stacked masks, executed in high relief. Zoomorphic heads in low relief emerge from either side. Serpent heads spring from either end of a bar clutched by the ruler; below, a jaguar snarls at his waist. Circular "medallion" glyphs, typical of the low-relief Early Classic sculpture from the site, mark the sides of this monument, describing the accession of the king.[62] This sculpture marks the definitive shift from low-relief works to in-the-round sculpture at Tonina.

Bahlam Yaxuun Tihl's successors established Tonina as a regional power, installing subsidiary lords and engaging in altercations with Palenque, culminating with that site's defeat during the reign of K'inich Baaknal Chahk (Radiant Bone-Place Chahk). Baaknal Chahk oversaw the installation of the Sunken Ballcourt and its captive sculptures, dedicated in 699 in celebration of his victory against Palenque. Set into the sides of the ballcourt, the captives are identified by hieroglyphic texts on their shields. One of these captives, Yax Ahk', appears on another important sculpture from Tonina, recovered from the fifth terrace of the acropolis. Monument 155 depicts him seated and twisting his back, with his arms bound behind him (fig. 148). He wears the jaguar ear and twisted cord of the Jaguar God of the Underworld, a deity

associated with warfare, fire, and the night sun; here, the figure can be interpreted as embodying both the human and the divine.

This sculpture was one of a group of at least three works. Another from the group similarly displays a seated captive, looking to one side, with his arms bound behind his back (fig. 149). Glyphs on his belly, legs, and loincloth identify him as Muwaan Bahlam and indicate that he was captured in 695. Like his counterpart on Monument 155, Muwaan Bahlam wears a jaguar ear and undereye ornament. While kings impersonate the militaristic Jaguar God of the Underworld on many Maya monuments, impersonations by captives are less common. Two artworks depicting an episode in Maya mythic history — the burning of a jaguar deity — help illuminate these unusual sculptures. One is a painted ceramic vessel on which a young god prepares to set ablaze a jaguar deity whose arms are tied behind its back. A similar scene appears on Stela 35 from Naranjo, on which the king holds a torch above a captive, with text connecting the scene to the myth. All these works suggest that captives at Tonina may have been forced to perform a narrative in which the Jaguar God of the Underworld is sacrificed, placing warfare within a mythological framework and emphasizing that even a god can meet a gruesome end.[63]

Gods and Humans in Maya Art

Maya works of art chronicle the changing fortunes of dynasties, the rituals that ensured world order and royal authority, and the participation of gods in human affairs. Throughout Classic Maya art, both text and image focus on the special relationship between deities and rulers. Deities are impersonated or summoned by rulers. They are held by or presented to rulers. They are captured and paraded by kings. Yet visual

one center, while others were worshiped over wide swaths of the Maya region. And although patron deities protected the community, they were owned by the king. These dichotomies remind modern viewers of the complexity of ancient religious practice and artistic representation.

Representations of the divine point to distinctly human concerns, demonstrating, for instance, how rulers jockeyed for position among their rivals as they pursued specific goals. The introduction of new deities and the construction of new deity temples amount to statements about the negotiation of power. Tracking such developments reveals the political intricacies of the Classic period. Rulers introduced new patron deities in times of crisis to promote community cohesion and to remind the public of their own access to divinity. Growing numbers of patron deities and the multiplying accounts of deity impersonation in the Late Classic period may indicate increasing conflict — although it may also be true that such acts were recorded more regularly over time.[65]

Perhaps most important, the interactions between humans and gods captured in Maya works of art point to a rich and complex ritual life, only glimpses of which survive today. We can envision a world in which the divine intermingled with the prosaic, in which gods could be enticed to "touch the earth" on behalf of humans, where deific kings could harness their power in exchange for care. Representations of divine humans and patron lords suggest diverse practices around the sacred. These works open a window onto the ways specific dynasties and their communities envisioned their place within the grand Maya pantheon, and offer a glimpse of the electric moments of contact between the world of humans and the world of the divine.

148
Monument 155. Tonina, Chiapas, Mexico, ca. 700. Sandstone, H. 22 ½ in. (57 cm). Museo de Sitio de Toniná, Secretaría de Cultura–INAH

149
Monument 180. Tonina, Chiapas, Mexico, ca. 700. Sandstone, H. 22 ⅞ in. (58 cm). Museo de Sitio de Toniná, Secretaría de Cultura–INAH

representations of patron deities diverge from the written ones. While hieroglyphic inscriptions describe the feeding, bathing, and dressing of patron gods, for instance, the images do not record such acts.[64] And though inscriptions regularly mention patron gods, such deities are depicted infrequently and are often merged with human identities via impersonation when they do appear.

The disparity between the hieroglyphic description and the visual rendering of patron deities is just one of many paradoxes of their depiction. Masterpieces of Maya art remind us that deities could be small or enormous. They were fearsome protectors yet required constant care. Some deities appeared in only

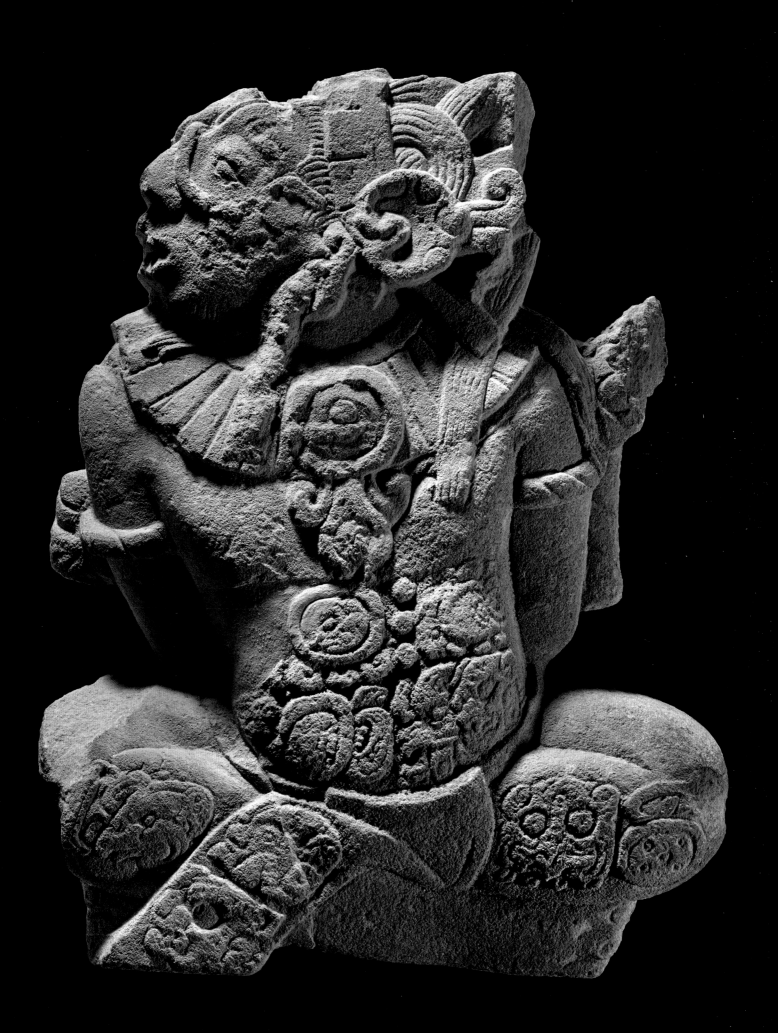

Wood, Stone

IYAXEL COJTÍ REN

Let's go to seek, we go to see if any will care for us.
When we find him, we shall speak before his face.
Such as we are, we have nobody
to watch over us.

— POPOL WUJ

AN INTRICATELY CARVED stone bench from the site of Copan reveals a striking vision of the Sun God emerging from the earth as he embarks on his daily journey. The legs of the bench combine text and image to convey the idea of a magisterial awakening: resting on the earth, the Sun God, seen in profile on each leg, looks upward to the sky (fig. 150). Both legs contain animated, large-scale versions of the verb *pas*, which means "to awake, dawn, or open," and metaphorically refers to the Sun God making his way between the earth and the sky at dawn. The hieroglyphic text on the bench's seat begins with the dedication phrase *t'ab'ay k'inich pas* [...] *Tuun* (it rises, Sun God Dawn [...] Stone), naming the bench "Sun God Dawn [...]" and designating it a stone. (The ellipsis corresponds to an undeciphered part of the name.) The "rising" of this stone refers to the dedication of the bench but may double as a reference to the rising of the sun.

150

Hieroglyphic bench. Group
10K-4, Copan, Honduras,
8th century. Stone, approx.
W. 72 7/8 in. (185 cm). Sitio
Maya de Copán, IHAH

Here, word and image celebrate the dawn, a
key concept in Mesoamerican thought. Seated
upon the monument, a lord would be placed
within a cosmological frame, projecting a
palpable link between earthly leaders and
primordial powers.

Rich in both religious and political signifi-
cance, dawn was at the heart of foundation
rituals performed when a new territory was
occupied, a political alliance was consoli-
dated, or a new ruler or ruling lineage was
established. These events were likened to the
rise of the sun and thus designated "dawns,"
representing a recurrence of the primordial
dawn and a new phase in the community's
history.[1] The rituals performed on these
occasions centered on patron deities known
as *k'ab'awil*. These gods, which propitiated the

dawn, played an important role in the forma-
tion and protection of political communities
in highland Guatemala.

Dawn

Monumental works from the southeastern
lowlands, such as the Copan bench, allude to
the importance of dawn in the Classic period,
but we know more about specific practices
during the Late Postclassic period (1250–
1524) in the Guatemalan Highlands.

There, members of newly formed alli-
ances took possession of territories after
setting up foundation shrines called *saqirib'al*
(dawning places) around the new settlement.
Each shrine belonged to one of the alliance's
member groups and was dedicated to that

member's *k'ab'awil*. Indigenous texts some-
times referred to these deities as *che' ab'äj*
(wood, stone), the materials used to carve
their effigies. Their shrines provide essen-
tial insights into the religio-politics of Maya
communities in the past as well as the vibrant,
albeit threatened, traditions practiced today.

This study draws in particular on the
colonial and modern texts and traditions of
the K'iche' and Kaqchikel, two Maya peoples
of Guatemala's western highlands (see map
on p. 192). In the early colonial period, K'iche'
and Kaqchikel scribes used a Latin script
introduced by Spanish friars to write long
and elaborate texts, including the *Popol Wuj*,
in their own languages (see Introduction, in
this volume). These texts, along with studies
of contemporary practices, illuminate our

understanding of Maya communities, their
devotional practices, and their patron deities
from the precolonial period through the pres-
ent day.

The political connotations of dawn are
apparent in the *Popol Wuj*. The authors of this
K'iche' epic asserted that subjugated peoples
would not be able to experience the dawn,
meaning they lacked the power or autonomy
to have *k'ab'awil* or settlements of their own.
The early colonial Nahua of central Mexico
understood the links between patron deities
and political groups in a similar way. When a
political group grew in importance, its patron
deity was compared to the sun and took a
predominant place in the history and rituals
of the entire community. If that people lost
hegemony, it was said that another sun was

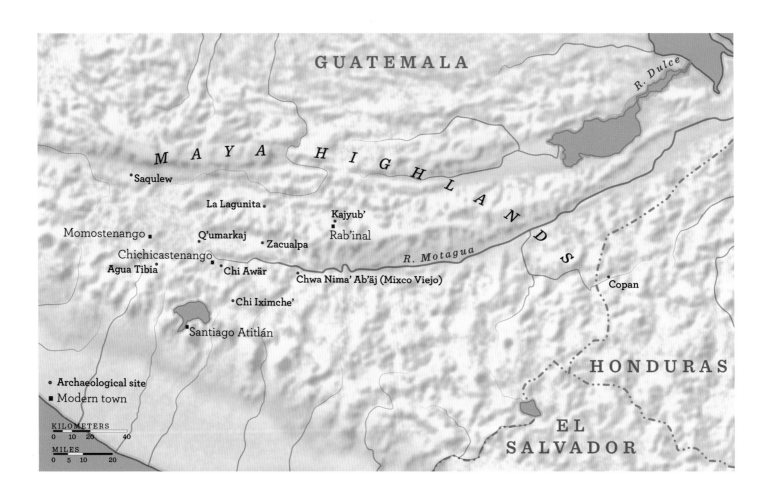

Sites and towns in the Maya Highlands

151
Scribe. Structure 9N-82, Copan, Honduras, 8th century. Stone, H. 21¼ in. (54 cm). Sitio Maya de Copán, IHAH

ascendant. The patron deity whose status consequently declined was then compared to the lesser moon and stars or was thought to belong to a cycle that had already been completed.[2]

K'ab'awil Patron Deities

The patron deities belonging to specific social groups were, along with language and territory, key elements in establishing a community's collective identity. As noted above, their significance was not only religious and cultural but also political. *K'ab'awil* played an important role in the formation of political communities and in the definition and maintenance of power relations among them. They were deeply connected with the political life of the social group under their protection.

As to the *k'ab'awil*'s physical form, valuable clues come from entries in colonial-period dictionaries, which reflect their writers' Christian biases but also record important Indigenous beliefs. A seventeenth-century Kaqchikel dictionary compiled by the Franciscan friar Thomas de Coto defines *k'ab'awil* as "wood, stone, obsidian, carved on the surface."[3] The dictionary also contains entries for the word *idolatrar* (to worship idols) that incorporate the term *k'ab'awil*, among them "idolatría [idolatry] — *qabovilanic*" (*k'ab'owilanik*) and "ídolo [idol] — *qabovil*" (*k'ab'owil*). Generally anthropomorphic or zoomorphic, the *k'ab'awil* could also take the shape of other elements in nature. A seated figure from Copan illuminates one of the ways a divine being could be portrayed in stone (fig. 151). At first glance, the figure appears human, seated cross-legged, one hand holding a shell ink pot, the other a stylus — the tools of a scribe. Yet close examination reveals that

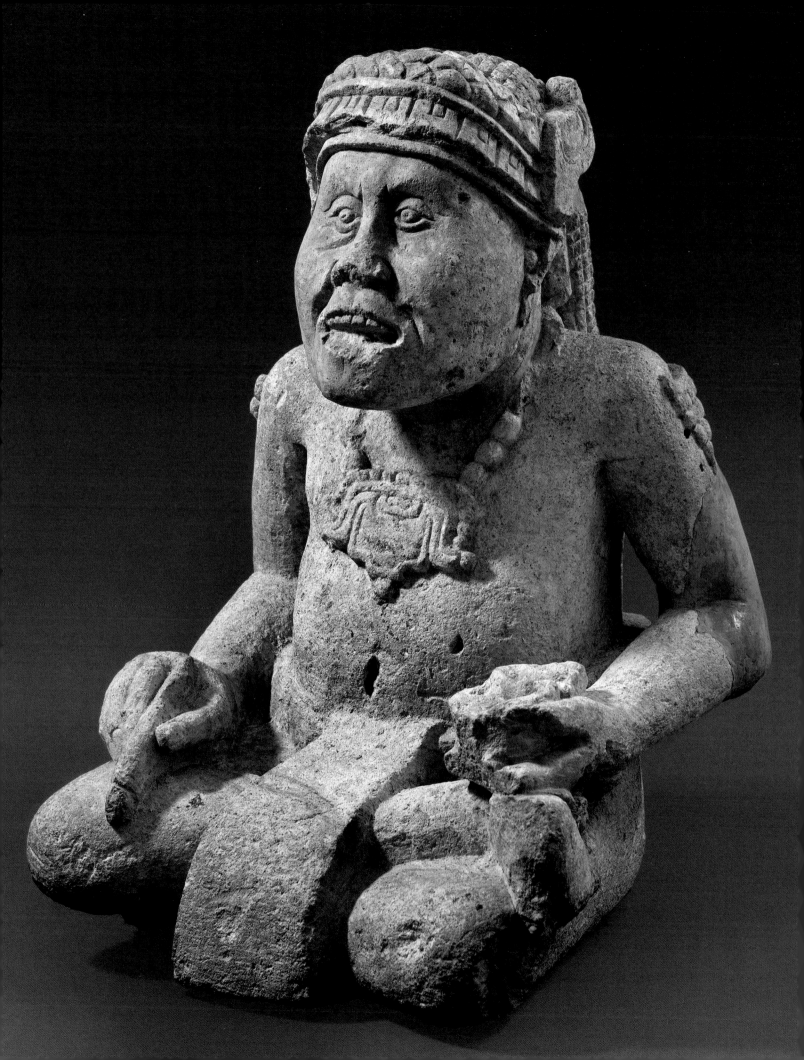

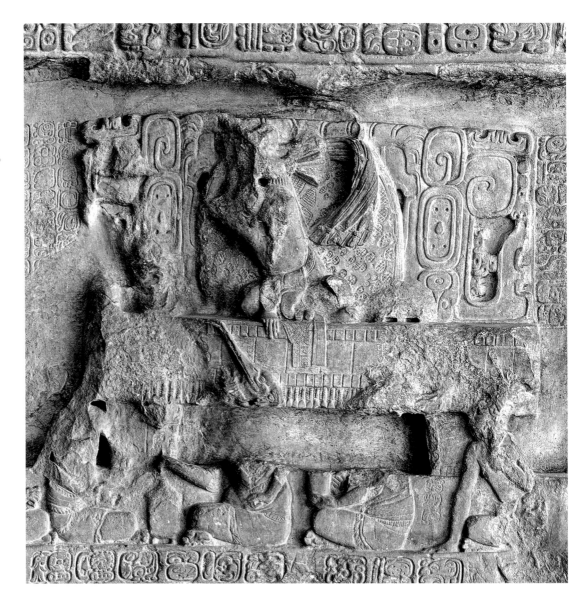

152
Wajaat Na Chahk and a collaborator (Maya sculptors, active 8th century). Panel 3, detail (see fig. 141). Piedras Negras, Petén, Guatemala, ca. 782–95. Limestone, overall W. 39⅜ in. (100 cm). Museo Nacional de Arqueología y Etnología, Guatemala City, Ministerio de Cultura y Deportes de Guatemala

the figure resembles a monkey. He also wears a net headdress, a pointed ornament above the ear, and an elaborate pectoral, all of which are common attributes of the monkey deities who presided over the arts of painting and writing. He is a divine *ajtz'ihb*, the term for scribes, artists, and painters.[4]

A passage in the *Popol Wuj* alludes to the importance of material representations of patron deities to communities and suggests that the earliest people had none: "There was no existing wood or stone that would care for our first mothers and fathers."[5] The text describes the founders of the K'iche' nation

as disconsolate at having nobody to talk to and no one to protect them until they received *k'ab'awil* representations, which helped them establish their first settlements, multiply to found new communities, and defeat their rivals.

The *k'ab'awil* were closely linked to the sociopolitical organization of the Guatemalan Highlands in the Late Postclassic period. They were indispensable to strengthening relations among members of small social groups (*chinamit*) or expanding polities (*winaq*). The *chinamit* was the basic unit of sociopolitical organization in the highlands. It

originated from extended families or lineages whose numbers increased through alliances and marriages outside the social group. (The K'iche' and the Kaqchikel practiced exogamy, as revealed by studies of marriages in Indigenous texts.[6]) *Chinamit* had a dual significance, referring to both a social group and the territory shared by its members. A *chinamit* would commonly establish alliances with other *chinamit*; a group of *chinamit* was called *amaq'*, a confederation or people. The representatives of the *chinamit* that formed an *amaq'*, who bore the titles of *ajpop*, would meet in council at a *nimja* or *nimajay* (great house). *Amaq'*, a term sometimes interchangeable with *winaq* (a nation or polity), can be understood as a people whose members shared a territory, common interests, a language, and a patron deity — features that distinguished one people from another.[7] The K'iche' attained the most complex level of organization, followed by the western Kaqchikel, who likewise succeeded in consolidating alliances among various *amaq'* to construct their own *tinamit*, or civic-ceremonial center. The *tinamit* contained the principal administrative and religious buildings, including temples for the patron deities, council houses, ballcourts, and other constructions for both public and private activities.

The complexities of highland Maya political organization echo earlier precedents from the lowlands. Late Classic–period palace scenes depicted on monuments and ceramic vessels show gatherings of dignitaries whose titles were indicated in the accompanying hieroglyphic texts. Both the pictorial compositions and the texts reveal complex social hierarchies. Panel 3 from Piedras Negras, for example, shows a banquet scene where the ruler Itzam K'an Ahk IV is gathered with nobles, officials, and members of his family (see fig. 141). The heads of the figures were defaced in antiquity, but the surrounding text makes clear the guests' social distinctions.

Some individuals are identified with the title *sajal*, a member of the nobility. The principal figure, however, is Itzam K'an Ahk IV, the *k'uhul ajaw*, shown seated on an elaborate throne in a central position, elevated above the other participants, who look toward him (fig. 152). The Piedras Negras panel records important historical events in this ruler's life, especially his diplomatic ties with dignitaries from other cities, giving us a taste of both palace life and the crucial importance of strategic alliances. As is often the case in Classic-period monuments, this one was commissioned not by Itzam K'an Ahk IV himself but by a descendant, K'inich Yat Ahk III.[8]

Returning to the highlands, in later periods the Kaqchikel *amaq'* managed to strengthen its position vis-à-vis the dominant K'iche' while consolidating its internal sociopolitical organization. Supporting the K'iche' expansionist campaigns as military auxiliaries enabled the Kaqchikel to demand greater privileges and independence from the K'iche'. The Kaqchikel *amaq'* was able to have its own government and a degree of self-rule. Most important was winning the right to have its own patron deities. Far from passive elements, the patron deities — the *k'ab'awil* — were believed to work actively to strengthen a political community's alliances and provide a measure of power and autonomy.

K'ab'awil and the Formation of the K'iche' Political Community

There is a tale from the K'iche' town of Chichicastenango about a lord who disguised himself as a cow so that the giant two-headed bird called Klavikot would carry him off to its nest on the other side of the ravine, a primordial place. After the bird flew him to its nest, the lord took out his machete, killed the chicks, and collected the bird's great feathers. Through trickery, the lord managed to defeat

other beings who lived in that place and get from them a *koj* (American puma) that helped him return to earth. There, he delivered the giant feathers he had collected to Saint Thomas, the town's patron saint, whose palanquin is adorned with them and processed on feast days (fig. 153).[9] A Catholic church was being built in Chichicastenango, but Klavikot, defending the old ways, repeatedly knocked the structure down. Finally the townspeople gathered to catch the bird with bait and a net, and then the church was completed, initiating a new era — that of Christianity.

Klavikot is a mythical bird thought to have lived in the past, but it also exists in another dimension "on the other side of the ravine." The threshold between this world and the one inhabited by divine beings may be aquatic as well as geological. In the Tz'utujil town of Santiago Atitlán, phrases referring to "the other side of the sea or the lake" metaphorically denote such a place, and stories tell of a man who was swallowed by a fish that transported him to a distant world.[10] These topographical phrases in modern oral narratives from highland Guatemala find parallels in the early colonial text of the *Popol Wuj*. It describes Tulan, the *k'ab'awil*'s place of origin, as located "on the other side of the sea or lake" or "on the other side of the ravine."[11] That is where representatives of the four allied *chinamit* that formed the Nima K'iche' *amaq'* went along with other peoples to seek their gods.[12]

In K'iche' and Kaqchikel texts, Tulan — that is, Tulan Zuywa, Wuqub' Pek, Wuqub' Siwan (Tulan Zuywa, Seven Caves, Seven Ravines) — can be interpreted as a mythical place of primordial origins; other primordial places for Mesoamerican peoples include Tula (also called Tollan), Chicomoztoc, and Aztlan. These mythical places could have earthly representations, sites considered sacred and politically prestigious. For the primordial Tula, earthly representations included sites known today in Mexico as Teotihuacan, Cholula, Tenochtitlan, Chichen Itza, and a site in the state of Hidalgo known as Tula.[13]

In highland Guatemala, earthly representations of Tulan might include the seven caves and seven ravines referenced in the site's name. The K'iche' city of Q'umarkaj and the Mam city of Saqulew, for example, were built over either natural caves or caves that were excavated to emulate the primordial Tulan. Caves and mountains are prominent features in Classic-period Maya art and culture. They were considered sacred places, indispensable for religious practice and the maintenance of worldviews. Mountains and caves were regarded as living beings, and so they are generally depicted with eyes, a nose, and a large jaw, and are often shown interacting with other divine and human beings. A remarkable carved stone panel that once formed the back of a throne features three silhouetted figures enclosed within a frame representing a *witz,* or mountain deity (see "Lively Gods, Godly Lives," in this volume), suggesting that the scene takes place inside a *ch'een,* or cave (fig. 154). The two larger figures, likely a ruler and a courtier, flank a small, central figure, an avian deity, which has just descended from a celestial location as a messenger from the god Itzamnaaj.[14] As with the Copan bench, rulers seated on such a throne would be placing themselves within a cosmological scene, linking themselves to ultimate powers.

It is said that when the founders of the four *chinamit* that made up the *amaq'* Nima K'iche' arrived in Tulan, seeking their gods, the *k'ab'awil* appeared to each of them. The *Popol Wuj* specifies which deities appeared first, who received them, and which *chinamit* each one represented: Kaweq, Nija'ib', Ajaw K'iche', or the fourth *chinamit*, whose name is lost. Tojil was the first *k'ab'awil* the K'iche' received, by the founder of the Kaweq

153
Procession of Saint Thomas the Apostle, Chichicastenango, El Quiché, Guatemala. Photograph by Peter Langer, 2005

Keje' k'ut ub'inam wi oxib' chi K'iche'.
Xma xutzoqopij wi rib'
rumal xa junam ub'i k'ab'awil:
Tojil K'iche',
Tojil chi Tamub', chi Ilokab'.
Xa jun ub'i uk'ab'awil ke.
K'u mawi xujach wi rib'
rox ichal K'iche'.

These are the names of the three K'iche' groups.
They did not separate
because they had one and the same deity:
Tojil for the K'iche',
Tojil for the Tamub' and the Ilokab'.
One only was the name of their deity for them.
And so there was no separation
among the three K'iche' groups.[15]

154
Throne back. Usumacinta River region, Guatemala or Mexico, 600–909. Limestone, W. 66½ in. (169 cm). Museo Amparo Collection, Puebla, Mexico

chinamit, which explains Tojil's symbolic predominance over the other patron deities and the power of the Kaweq over the other *chinamit* of the Nima K'iche' *amaq'*. Eventually this *amaq'* formed a triple alliance, or *winaq*, with two other *amaq'*, the Tamub' and the Ilokab'. The principal patron deity of this triple alliance was Tojil, who was therefore considered paramount, superior to all the *k'ab'awil* of the polity. A passage from the *Popol Wuj* highlights the patron deity's role in uniting the K'iche' *winaq* (see opposite page).

As the predominant patron deity, Tojil was the face of the K'iche' political community but not its only *k'ab'awil*, which included Awilix, Q'aq'awitz, and Q'ukumatz. The remains of four temples consecrated to all four *k'ab'awil* of the Nima K'iche'—the principal *amaq'* of the triple alliance—still occupy the central plaza of the site of Q'umarkaj (fig. 155).

According to their texts, the K'iche' shared a patron deity with other polities, including the Yaki (a term that designated Nahua-speaking peoples or foreigners). In the *Popol Wuj*, the Yaki were among several peoples who experienced the dawn together with the K'iche', and their gods were Tojil and Yolkwat Quetzalcoatl.[16] The passage may refer to an alliance between the K'iche' and a Yaki group that involved a mutual recognition of both *k'ab'awil*, as happened with other groups of similar political status. The K'iche' also shared a *k'ab'awil* with the Rab'inaleb', who spoke K'iche' and therefore, according to the *Popol Wuj*, were related to the K'iche'.[17] The Rab'inaleb' used a slightly different name, Jun Toj, to refer to the same deity.

The territory where the Rab'inaleb' built their last capital, Kajyub', was originally occupied by Poq'om peoples who sustained various onslaughts from the K'iche' and their allies, including the Kaqchikel and the Rab'inaleb', until 1350–1450, when the Rab'inaleb' finally occupied the basin.[18] Late sixteenth-century

sources affirm that the ruler K'oka'ib', a member of the Kaweq lineage of the K'iche', constructed masonry buildings in Rab'inal (perhaps at Kajyub'), and that this K'iche' leader designated authorities and captains in the region, established laws, and demanded the payment of tributes.[19] Representatives of the Rab'inaleb' and K'ub'uleb', among other peoples, came to Q'umarkaj to pay tribute to the K'iche' authorities, suggesting that even allies were obliged to provide various forms of service.[20] Narratives written by subjects of the K'iche', including the Rab'inaleb'[21] and the Xpantzay[22] of the Kaqchikel polity, mention abuses by the K'iche'. The texts also suggest that the Kaweq authorized the Kaqchikel and the Rab'inaleb' to concentrate and settle in a *tinamit*. Arguably, this may have been a K'iche' strategy to control their dependent allies. But the fact that the Nima K'iche', Tamub, Ilokab', and Rab'inaleb' shared a *k'ab'awil* denotes not only close alliances but also the construction of a collective identity, in which territory and language were key elements.

The *Título de Totonicapán*, like the *Popol Wuj* a significant mid-sixteenth-century K'iche' text, describes a collective ceremony held in Q'umarkaj to recognize the authority of the fifteenth-century ruler K'iq'ab' and his principal officials at an important date, the month of Tz'ikin Q'ij. The participants represented the three *amaq'* of the K'iche' polity and the thirteen peoples allied with the K'iche', among them the leaders of the Kaqchikel *amaq'*.[23] A central part of this gathering was a dance, in which the *k'ab'awil* of the Nima K'iche', Tamub', Ilokab', and possibly the Rab'inaleb' were carried through the corridors of the buildings of Q'umarkaj. Participants injured themselves, possibly to make offerings of their own blood, and donned the flayed skins of thirteen lords who had been captured during a confrontation with the *amaq'* comprising the K'ojayil and

Temples dedicated to
the protective deities in
Q'umarkaj, El Quiché,
Guatemala. Photograph by
Roberto Quesada, 2010

Uxajayil.[24] The K'ojayil and the Uxajayil had killed the previous K'iche' ruler (K'otuja in this text and Q'ukumatz in Kaqchikel texts), and the Kaqchikel *amaq'* had played a vital role in their defeat. The ruler K'iq'ab', who had led the military campaign against the K'ojayil and the Uxajayil, had his nose pierced in token of acclaim. The ceremonies were dedicated to the patron deity Tojil, and the allies of the K'iche' took an active role, recognizing the K'iche' authorities and their patron deity while commemorating the military victory.

In the political sphere, the *k'ab'awil* played a key role not only in strengthening alliances but also in the expansion of K'iche' hegemony. During the governments of Q'ukumatz (1400–1425) and K'iq'ab' (1425–75), the K'iche' undertook expansionist campaigns toward the west, northwest, and south of what is now Guatemala. The *Popol Wuj* provides evidence of prohibitions placed by the K'iche' upon some of their allies as well as upon subjugated peoples, who could neither experience dawn nor have their own patron deities.[25]

Patron Deities of the Kaqchikel

According to their historical accounts, the Kaqchikel celebrated several dawns without the presence of any *k'ab'awil*, as they were

dependent allies of the K'iche'. They were able to have their own government and eventually their own *k'ab'awil*, but only after the K'iche' ruler K'iq'ab' authorized them to settle in a citadel called Chi Awär, located in today's municipality of Chichicastenango. As they did with the Rab'inaleb', the K'iche' had some influence over the clustering of Kaqchikel settlements, ultimately centralizing their rulership.

The Kaqchikel begin their history by presenting themselves as an *amaq'* comprising four *chinamit*: the Xajil, the Q'eqak'uch, the Sib'aqijay, and the B'akajol. These four *chinamit* formed an alliance with two K'iche' *chinamit*, the Kaweq and the Kejay, with whom they experienced their first dawn. There is no mention of any patron deity in records of this dawn, yet five *saqirib'al* (foundation shrines) were set up around the first settlement. Every member of the alliance had a dedicated altar, so there were four Kaqchikel shrines and one K'iche' shrine shared by the Kaweq and Kejay. The next dawn experienced by the Kaqchikel took place in the company of new allies, the *amaq'* Sotz'il, Tuquche', and Aqajal. No patron deity is mentioned in this dawn, either, as the Kaqchikel and their allies still held no power. After several years of providing the K'iche' with various services

as dependent allies, the Kaqchikel were rewarded by K'iq'ab' with a degree of autonomy, reflected in the reproduction of more dawns, now with their own *k'ab'awil*.[26]

The first *tinamit* of the Kaqchikel, Chi Awär, was occupied between approximately 1430 and 1470. At this point in the history of the Kaqchikel, their settlement patterns changed. The *saqirib'al* were no longer placed around settlements but instead were set up in the main plazas of the citadels. Chi Awär's remains, now an archaeological site, include three main plazas with temples dedicated to the Kaqchikel's *k'ab'awil*.[27] The clustering of settlements and their defensive locations may have resulted from K'iche' efforts to concentrate their allies geographically and have places of refuge if revolts erupted.

The sixteenth-century Xajil Chronicle provides a detailed account of Kaqchikel history. Initially, the Kaqchikel made a journey east to the *tinamit* of Tulan Zuywa, Wuqub' Pek, Wuqub' Siwan, the aforementioned place of primordial origins. When they entered the citadel, the Kaqchikel were attacked by animated entities that included houses and domestic animals. The names of the places where each of the allied peoples of the Kaqchikel *amaq'* took refuge from the ambush became the names of their patron deities, as described in the passage on the following page.

The Kaqchikel polity was composed of four *amaq'*: Kaqchikel, Sotz'il, Tuquche', and Aqajal. Generally, the strongest *amaq'* in the alliance gave its name to the whole polity. The patron deity of the Kaqchikel *amaq'* was Chi Taq'aj, who took refuge in Nik'aj Taq'aj (in the middle of the plateau or valley). This name is similar to that of one of the K'iche' patron deities, Nik'aqaj Taq'aj (in the midst of the plateau or valley).[28] This deity was received by the K'iche' founding father, Ik'i B'alam, who died young and was succeeded by Lord Tz'utuja of the Saqik *chinamit*.[29] It is quite possible that the K'iche' deity Nik'aqaj Taq'aj was incorporated into the Kaqchikel *amaq'* after the establishment of alliances among the K'iche' and Kaqchikel *chinamit*. In their historic documents, the K'iche' downplayed their close alliance with the Kaqchikel, as the relationship came to an abrupt end in about 1470. Nevertheless, evidence such as the K'iche' foundation shrines that were present at Kaqchikel settlements from the first dawn testifies to the long and close alliance.

Some scholars suggest that the presence of double or twin temples in the main plazas of several sites occupied by subordinate groups reflects K'iche' cultural and political dominance.[30] In other words, the subordinate groups may have venerated both their local patron deity and deities belonging to the K'iche' or other allied groups. (No such temples have been identified at K'iche' sites, as their members did not incorporate *k'ab'awil* from other political units.) For instance, the plaza of the Kaqchikel citadel Chi Awär has double and twin temples, which may indicate some alliance with the K'iche' and possibly with the Aqajal. The Aqajal, the so-called eastern Kaqchikel, also came to have a complex sociopolitical organization.[31] Their citadel, Chwa Nima' Ab'äj, has twin temples too (fig. 156). Although they struggled to maintain their autonomy, the Aqajal were subordinated first by the K'iche' and afterward by the Kaqchikel, perhaps because their territory contained an important source of obsidian. Given the alliances across polities, it can be assumed that the population of many of the principal civic-ceremonial centers in the highlands was multiethnic, including members of various groups.

Early in the history of the Kaqchikel *amaq'*, its members strategically sought to raise their economic and political status by developing military expertise, allying with other *amaq'*, and marrying women from stronger polities,

Töq xqak'utub'ej k'a qi':	Then we asked one another:
"B'a xakolo' wi awi'?"	"Where were you, yourself, saved?"
xojcha chi re K'iche' winäq.	we said to the K'iche' people.
"Xa kitojoj kijilil xib'e chi kaj.	"Sliding through thunderbolts, I went to the sky.
Xa chi kaj xb'enukolo' wi wi'," xcha.	Alone in the sky, I left and was saved," he said.
Ke re' k'a xub'ina'aj wi Tojojil ri'.	For that reason, this (deity) was called Tojojil (Tojil).
Xcha chïk k'a Sotz'il winäq:	Then the Sotz'il people said:
"Xa xik'oje kan chi ri'. Xa xikolo' wi'	"Alone I remained there. Alone I was saved
pa ruchi' Kaqix," xcha.	in the mouth of the macaw," he said.
Ke re k'a xub'ina'aj wi Kaqix kan ri'.	For that reason, this (deity) was called Kaqix Kan.
Xojcha chïk k'a oj Kaqchikel winäq:	Then we the Kaqchikel people said:
"Xa nik'aj taq'aj xnuqöl wi wi'.	"Alone in the middle of the plain I was saved.
Xa xiqa pan ulew."	Alone I descended to earth."
Ke re' k'a xub'ina'aj wi Chi Taq'aj.	For that reason, this (deity) was called Chi Taq'aj.
Q'ukumätz tuche'ëx jun chik,	Another (deity) was called Q'ukumätz,
xa pa ya' xuköl wi ri'.	alone in the water he was saved.
Xcha chïk k'a Tuquche' winäq:	Then the Tuquche' people said:
"Xa xikolo wi' ajsik, chupam jun amaq'," xcha.	"Alone I was saved above, within an *amaq'*," he said.
Ke re' k'a xub'ina'aj wi Ajsik Amaq' ri'.	This (deity) was then called Ajsik Amaq'.
Xha chïk Aqajal winäq: "Xa xinköl wi	Then the Aqajal people said: "Alone I was saved
chupam aqaj," xcha.	inside a wasps' nest," he said.
Ke re' k'a xub'i'na'aj wi Aqalajay ri'.	For that reason, this (deity) was called Aqalajay.
Ke re' k'a xeb'ina'aj wi konojel ri'.	Thus, all of them were named.[32]

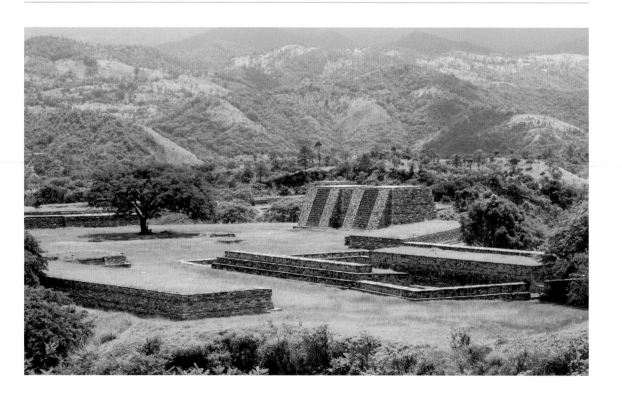

156
Double temples in
Chwa Nima' Ab'äj
(Mixco Viejo), San
Martín Jilotepeque,
Chimaltenango,
Guatemala.
Photograph by Roberto
Quesada, 2010

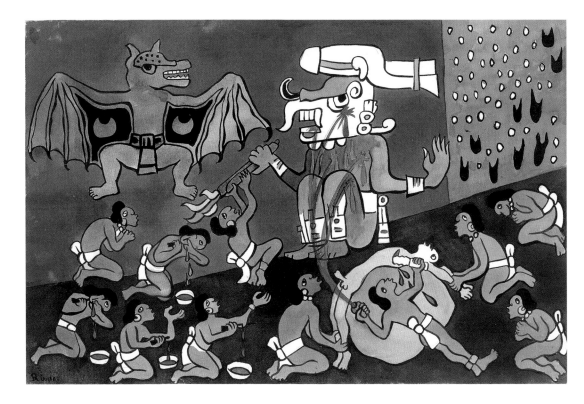

157
Diego Rivera (Mexican, 1886–1957). *Human Sacrifice before Tohil* [illustration for *Popol Wuj*], 1931. Watercolor and gouache on paper, 12 1/4 x 18 7/8 in. (31 x 48 cm). Library of Congress, Washington, D.C., Jay I. Kislak Collection

notably the Aqajal and later the K'iche'. As noted above, the Kaqchikel ruled from Chi Awär under the auspices of a K'iche' governor but had a number of patron gods of their own, including a powerful advocate, a *k'ab'awil* called Chimalkan.[33]

Chimalkan's strength is recalled in an episode of the K'iche' *Popol Wuj*, where he is described as having the form of a bat. In this episode, a great storm falls on Tulan, affecting communities across the highlands; people grew so cold that their bodies shriveled and became numb. Several communities had fire, but the rain extinguished it. Only the K'iche' *k'ab'awil* Tojil managed to make more fire by spinning around on his sandal. To those who asked him for fire, Tojil replied that he would supply it if they agreed to offer their flanks in sacrifice. The Kaqchikel, the only people who did not submit to his demand, then stole the fire with the aid of their *k'ab'awil* Chimalkan.[34] This mythical story suggests that the K'iche' respected the fortitude of the Kaqchikel and their patron deity, whereas the

other peoples of the highlands had to accept the hegemony of the K'iche' and their god Tojil. Both deities were memorably imagined by the twentieth-century Mexican painter Diego Rivera in his illustrations for the K'iche' epic (fig. 157).

The possession of patron deities by lineages or expanding polities is an old tradition. Different sources of information, mainly epigraphic, iconographic, and archaeological, have helped to ascertain the presence of patron deities in Maya cities such as Tikal, Palenque, La Corona, Chichen Itza, and Yaxchilan as early as the Classic period.[35] (See "Divine Humans, Patron Deities," in this volume.) These deities had similar functions as the *k'ab'awil* of the Postclassic period. At Yaxchilan, lintels spanning the entryways of temples atop stone platforms feature striking compositions that speak to the close relationship between rulers and divine power. The four lintels of Structure 23 — the house of Lady K'abal Xook, spouse of the ruler Itzam Kokaaj Bahlam III, also known as Shield

Xook in these rituals hints at the importance of her lineage in communicating with these protective deities — and their crucial role as supporters of her husband's reign.[39]

This exceptional relief sculpture reminds us of the importance of patron deities to the formation and development of political communities in Maya territories. Their presence permitted the consolidation of new alliances and the strengthening of collective identities. In central Mexico, deities could similarly be the patrons of a *calpulli* (political ward), an *altepetl* (city-state), a province, or even an empire. Mirroring the political structure of human communities, the gods are hierarchical: in every case, one ranked above the others — the patron deity who belonged to the most important social group of the political community.[40] In the highlands, it was the *k'ab'awil* — the patron deities who brought forth the dawn, who made it possible to take possession of new territories, and who ensured the welfare of recently formed polities and their inhabitants.

Continuity and Change in the Tradition of the *K'ab'awil* in the Maya Highlands

Since the Spanish invasion in the sixteenth century and the devastation of the way of life of highland Maya peoples, the tradition of the *k'ab'awil* has changed and is now at risk of disappearing. In response, Oxlajuj Ajpop, a Maya community organization, proposed a law for Indigenous management of sacred sites, which individuals, families, or groups can use to give thanks and make petitions. It describes them as "natural or constructed spaces regarded as confluences of energy for communication with the ancestors; they are special places for the spiritual, philosophical, scientific, technological, or artistic practice and development of members of Indigenous communities."[41]

Jaguar III — commemorated the rituals that sacralized certain parts of the house and the lintels themselves,[36] transforming the structure into a space for private devotion (fig. 158). The lintels depict the personifications of patron deities summoned to oversee particular events,[37] including the accessions of rulers and possibly military campaigns.[38] Lintel 25, originally set above the central doorway, commemorates the enthronement of Itzam Kokaaj Bahlam (see fig. 129). Lady K'abal Xook conjures a monumental serpent, perhaps a *k'ab'awil*, from whose maw springs forth a fully armed warrior. The participation of Lady

Notwithstanding Guatemala's prevailing internal colonialism,[42] many *saqirib'al* continue to be holy places for the celebration of *xukulem* (ceremonies) by practitioners of Maya spirituality, who are guided by the *ajq'ijab'* (day counters), keepers of traditional knowledge. In Chichicastenango, the K'iche' population still uses the foundation shrines that surround the urban center, including two altars in the central plaza, one at each church (Saint Thomas and Calvary). The foundation shrines are oriented to the four cardinal directions of the universe, so each has particular energies and qualities of its own, though they form a unified group of altars. The *ajq'ijab'* determine the right altar for holding ceremonies or for specific petitions such as the healing of the sick, the blessing of seeds, or the resolution of conflicts. The arrangement of the foundation shrines in Chichicastenango is shown in the map above.[43]

In ancient times, these altars were probably related to the celebration of calendrical occasions, such as the yearbearer (the first day of the 365-day Maya calendar year) and the beginning of the 260-day cycle, or *cholq'ij*.

The yearbearer — called *mam*, grandfather, in K'iche' communities of the Guatemalan Highlands — corresponds to one of four days in the *cholq'ij* calendar (Kej, Iq', No'j, and E') and determines the nature of the year he rules.[44] In Momostenango and other highland communities, the *Waqxaqib' B'atz* ceremony, which initiates the *cholq'ij* cycle, is still celebrated at sacred altars on top of hills. On this special date, new spiritual leaders are appointed, new *ajq'ijab'* are initiated, and collective ceremonies are held for the four yearbearers.

In Chichicastenango, the southern altar, Chu Turk'a, bears an anthromorphic *k'ab'awil* whose pieces were cemented together after repeated vandalism (fig. 159).[45] In this town, material representations of the patron deities are often called *alaxik*. The term may have superseded *k'ab'awil* (which is little used today but is being rediscovered by a new generation of *ajq'ijab'*) because *k'ab'awil* were linked to the forms of K'iche' and Kaqchikel government that were eliminated after the imposition of Spanish colonial institutions. Many spiritual practices of a more secular

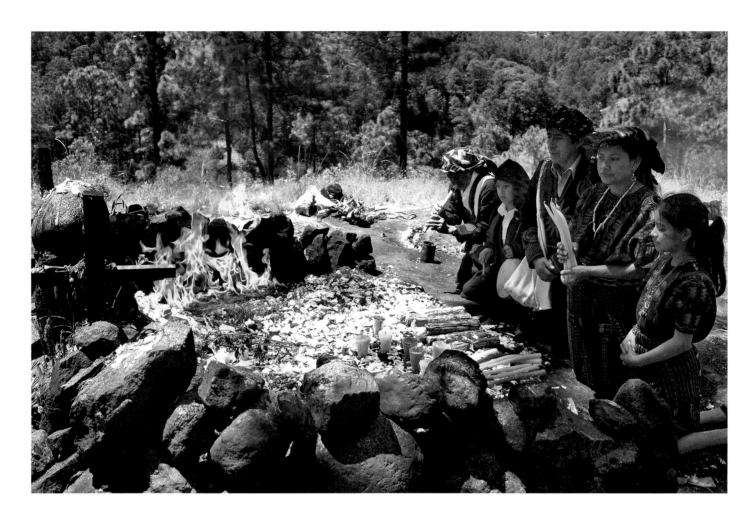

159
Chu Turk'a altar,
Chichicastenango,
El Quiché, Guatemala.
Photograph by
Ricky López Bruni and
Haniel López, 2013

character have nevertheless survived among the nonelite population, and aspects of *k'ab'awil* can be discerned in the two meanings of the word *alaxik*: it is a verb that means "to be born" and a noun meaning "family, lineage, relatives, or descendants." The *alaxik* can also have particular names, generally days of the 260-day *cholq'ij* calendar.

Some *alaxik* are ancient *k'ab'awil* effigies, and their identity is revealed to their new owners through dreams or messages received directly or transmitted by third parties. New *alaxik* can also be made, and their energy built up through offerings and prayers. These *alaxik* are commonly seen on domestic altars, which tend to be passed down from one generation to the next (fig. 160). Both the *k'ab'awil* and the *alaxik* may have belonged originally to families or lineages, but some of them went on to

have a role at the community level. Currently, *k'ab'awil* is understood as a philosophical term referring to the ability to see beyond the material or physical things around us: to see with the eyes of the heart. The combination of these abilities, to see both the tangible and the intangible, is the experience of *k'ab'awil*.[46]

Alaxik may be monumental, as on Chichicastenango's southern altar, or small, even portable. In Chichicastenango, the latter are called *kamawil*, a term perhaps derived from *k'ab'awil*. Like the large *alaxik*, these effigies can be of ancient origin or recently made. In the highland territory of the K'iche', *kamawil* have been found in archaeological contexts at the sites of Zacualpa, La Lagunita, and Agua Tibia.[47] Ethnographic studies in Chichicastenango show that these "little idols" are considered beings with powers who act

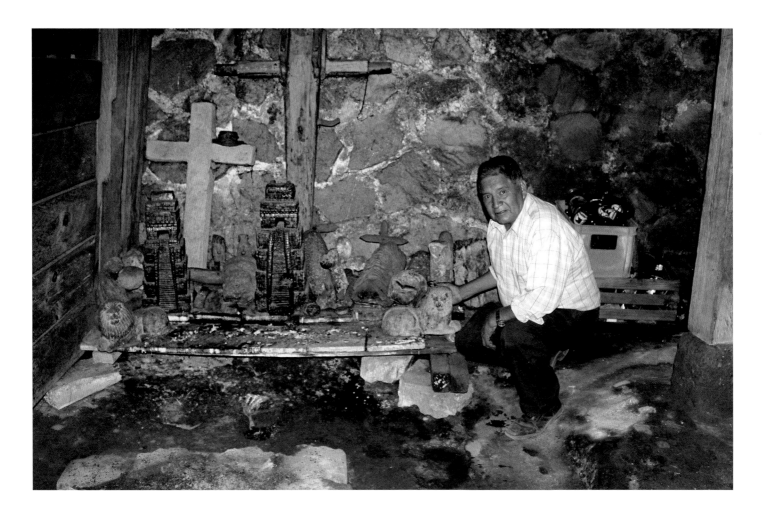

160
Family altar in
Chichicastenango,
El Quiché, Guatemala.
Photograph by
Juan V. Luis, 2016

as companions or assistants to the people who present themselves before the large *alaxik*.[48] Today, some believe that *kamawil* may be representations of grandparents who had a prominent position in the community, and whose memory and energy continue to guide the new generations who remember and invoke them.

Regrettably, many of the shrines in Chichicastenango and elsewhere are at constant risk of destruction owing to racism, ignorance, and religious fundamentalism. Nowadays, those who practice Maya spirituality endure threats and criticisms from various sectors of Guatemalan society, which belittle it as a cultural practice.[49] The country's predominant religions accuse Maya spirituality of devil worship or witchcraft, and the state fails to guarantee the right to religious freedom, declining to comply with the Constitution and the international conventions it has ratified for the collective and individual rights of original peoples.[50] The destruction of Maya shrines and the physical assault of the *ajq'ijab'*, Maya day keepers, and other spiritual specialists receive scant attention from authorities. It is therefore essential to press those authorities to investigate thoroughly all violence against the *ajq'ijab'* and the practice of Maya spirituality and to bring the perpetrators to justice. It is equally important to educate and raise awareness, to dispense with stereotypes of Maya spirituality and foster respect for the country's cultural and religious diversity. Only in this way can Maya peoples hope to experience new dawns, fortify their cultural heritage, and strengthen their political voice.

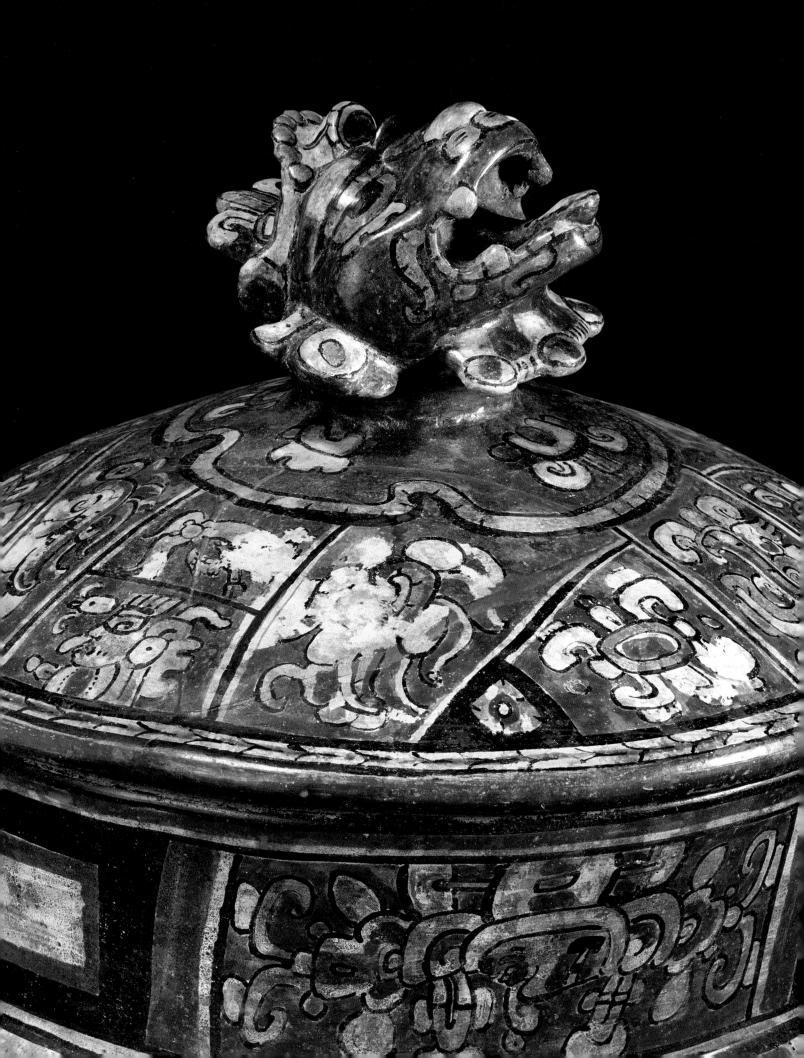

Notes

Introduction

1. I thank Kate Fugett and Sara Levin of The Metropolitan Museum of Art for creating X-ray images of these whistles.
2. Arnold et al. 2008; Doménech et al. 2009.
3. On Mayan languages, see Aissen, England, and Zavala Maldonado 2017. On diaspora communities, see García 2020.
4. Barrera Vásquez 1991, p. 648; Knowlton 2010, p. 56.
5. González González et al. 2008; Prufer, Robinson, and Kennett 2021.
6. López Austin 1993. On Mesoamerican archaeology, see Nichols and Pool 2012.
7. Recent overviews of ancient Maya civilization include Demarest 2004; McKillop 2004; Houston and Inomata 2009; Coe and Houston 2015; Hutson and Ardren 2020.
8. M. Pohl, Pope, and Von Nagy 2002; Lacadena 2010.
9. S. Martin and Grube 2008; Canuto et al. 2018; S. Martin 2020.
10. On the Maya collapse, see Webster 2002; Douglas et al. 2016; S. Martin 2020, pp. 277–99.
11. G. Jones 1998; P. Rice and D. Rice 2009.
12. On colonial and modern Maya societies, see Farriss 1984; Smith 1992; Restall 1999; Grandin 2000; Lovell and Lutz 2013.
13. Schellhas 1892, 1904; Landa 1941, 1982.
14. Spinden 1975; Eduard Seler, "The Animal Pictures of the Mexican and Maya Manuscripts" (1909–10), in Seler 1996, vol. 5, pp. 165–340.
15. Roys 1967; Thompson 1970.
16. Ethnographic studies of modern Maya religion include Thompson 1930; Guiteras Holmes 1961; Girard 1962; Mendelson 1965; Bricker 1973; Vogt 1976; B. Tedlock 1992; Wilson 1995; Pitarch Ramón 1996; Tarn 1997; Cook 2000.
17. Coe 1973, 1977, 1978, 1989.
18. For Modern English translations of the *Popol Wuj*, see D. Tedlock 1996; Christenson 2007.
19. Acuña 1998; Sparks 2020.
20. Lowe 1982; Guernsey 2006, pp. 111–12; Chinchilla Mazariegos 2010a, 2017, pp. 131–38; K. Taube et al. 2010, pp. 16–18, 28–30.
21. Coe 1992; Houston, Chinchilla Mazariegos, and D. Stuart 2001.
22. Schele and Miller 1986; D. Stuart 1987; K. Taube 1992; Freidel, Schele, and Parker 1993; Miller and K. Taube 1993; A. Stone 1995; Milbrath 1999; Miller and S. Martin 2004; Houston, D. Stuart, and K. Taube 2006; A. Stone and Zender 2011; Vail and Hernández 2013; Chinchilla Mazariegos 2017.
23. Chinchilla Mazariegos 2010a; Knowlton 2010, pp. 75–81; Boremanse 2020, p. 235.
24. Schmidt, D. Stuart, and Love 2008; K. Taube and Ishihara-Brito 2012, no. PC.B.559.
25. K. Taube 2004a; Mathiowetz and Turner 2021.
26. Boremanse 2020, p. 68.
27. Tozzer 1907, pp. 80–92; McGee 1990, pp. 49–53; Balsanelli 2019. On Lacandon drums, see Ochoa Cabrera, C. Cortés Hernández, and N. Cortés Hernández 1998.
28. Mauricio, Hansen, and Guenter 2016.
29. For examples, see Guiteras Holmes 1961; Earle 1986; Wilson 1995.
30. D. Stuart 2017, p. 258.

Lively Gods, Godly Lives

I extend my appreciation to my mentor and friend Stephen D. Houston, with whom I have enjoyed discussing the Maya gods for many years.
Epigraph: Christenson 2003, pp. 64, 268, 287; Christenson 2007.

1. Doyle 2017; Freidel et al. 2017; Inomata et al. 2021.
2. Saturno, K. Taube, and D. Stuart 2005; K. Taube et al. 2010.
3. Saturno, D. Stuart, and Beltrán 2006; S. Martin 2020, p. 113.
4. K. Taube, Saturno, and D. Stuart 2004; D. Stuart 2017.
5. For further reading on the art history, anthropology, and philosophy of religion, see, for example, Eliade 2004, pp. 563–65; Kieran 2005; Eller 2015; G. Graham 2018.
6. See Guthrie 1995.
7. Porter 2000; Spaeth 2013; S. Martin 2015, pp. 223–24; Prager 2018.
8. S. Martin 2015, p. 210.
9. Assmann 2001, pp. 7–8, 37; M. Hill 2007, pp. 3–5; Quirke 2015.
10. Patch 2011, p. 200.
11. See Baines 2000, p. 32; Baines 2011.
12. Allen 1996, p. 3, n. 5.
13. Guy 2014, p. 9.
14. Ibid., p. 92; Lavy 2003.
15. See, for example, the sculpture of Brahma in The Met collection (36.96.3).
16. Platt 2011.
17. See, for example, the bronze sculpture in The Met collection (43.11.4); Hemingway and R. Stone 2017, p. 58.
18. See the example in The Met collection (1978.412.336); LaGamma 2002, pp. 12–20.
19. Nuku 2019.
20. Bambach 2017, p. 15.
21. Pillsbury, Potts, and Richter 2017.
22. See, for example, Plunket and Uruñuela 1998; Ichikawa 2021.
23. See Reinhard 1985; Kuznar 2001.
24. Dean 2010; Bray 2015; Wilkinson and D'Altroy 2018.
25. Rodríguez Alvarez 2008; Oliver 2009; Doyle 2020.
26. See K. Taube 2004b; Berrin and Fields 2010.
27. K. Taube 1996.
28. See, among others, Pasztory 1973; Robb 2017.

29. See, among others, Boone 2000.

30. Navarrete 2011.

31. López Luján 1993.

32. See Quiñones Keber 1988.

33. J. Pohl and Lyons 2010.

34. Olivier 2019. See also Hvidtfeldt 1958; López Austin 1993.

35. S. Martin 2015, p. 211.

36. Chinchilla Mazariegos 2017, pp. 24–25. See also López Austin 1993.

37. Chinchilla Mazariegos 2017, pp. 26–27.

38. Miller and S. Martin 2004.

39. K. Taube 2004a, p. 87.

40. Just 2012.

41. Tokovinine 2020, p. 258.

42. D. Stuart 2013.

43. For a comprehensive survey of the use of the word *k'uh* in Classic Mayan inscriptions, consult Houston and D. Stuart 1996, p. 292; Prager 2013, pp. 21–22, 667–711; D. Stuart 2017, p. 251; Prager 2018.

44. D. Stuart 2017, p. 251. See also Vogt 1969, pp. 369–71; Botta 2022.

45. D. Stuart 2017, p. 251; Prager 2018, pp. 548–49. See also Ringle 1988; D. Stuart 1988.

46. See Prager 2018.

47. Ibid., p. 559.

48. Alexandre Tokovinine in Pillsbury et al. 2012, pp. 71–72; Prager 2018, p. 602.

49. Prager 2018, pp. 561–62.

50. Houston 2021, pp. 138–42.

51. Kettunen 2019, pp. 250–51.

52. Houston and K. Taube 2000, pp. 281–87.

53. Houston, D. Stuart, and K. Taube 2006.

54. S. Martin 2015, p. 210.

55. Baron 2016a; Baron 2016b, pp. 52–59.

56. S. Martin 2020, p. 146. See also McAnany 2014.

57. D. Stuart 2017, pp. 255–57.

58. S. Martin 2020, p. 153.

59. Houston and D. Stuart 1996, p. 296; Houston, D. Stuart, and K. Taube 2006; S. Martin 2020, pp. 70–72, 146.

60. Vail 2020. See also Schellhas 1904; K. Taube 1992, p. 5.

61. Christenson and Sachse 2021, p. 7. See also the Ximénez manuscript of the *Popol Wuj*, "Arte de las tres lenguas kakchiquel, quiché y tzutuhil" (1700–1703), Newberry Library, Chicago, Special Collections, Edward E. Ayer, Ayer MS 1515.

62. Coe 1973; Freidel, Schele, and Parker 1993; Moyes, Christenson, and Sachse 2021.

63. Chinchilla Mazariegos 2017, p. 41.

64. Hull 2011.

65. See Christenson 2001, pp. 186–90.

66. Schellhas 1904; Thompson 1970; Hellmuth 1987; K. Taube 1992, p. 7.

67. Baron 2016a; D. Stuart 2017, pp. 247–48.

Cosmic Struggles, Primeval Transgressions

1. Kidder, Jennings, and Shook 1946, pp. 190–93; Sánchez Santiago 2021. On Andean whistling vessels, see Pérez de Arce 2006.

2. A whistling vessel formed by two adjoined cylinder tripods, from Calpulalpan in the valley of Puebla, was reported in Linné 2003, pp. 65–67.

3. I thank Amanda Chau at The Metropolitan Museum of Art for creating X-ray images of this vessel.

4. Vessel K3105; see www.mayavase.com.

5. There are short mythical references in the augural calendars of Late Postclassic Maya codices. See Vail and Hernández 2013.

6. Thompson 1970, p. 345; Boremanse 2020, pp. 33–34, 40–46.

7. Thompson 1970, pp. 333–48; Chinchilla Mazariegos 2017, pp. 60–69.

8. Scholars employ the term "b'aktun" to refer to periods of 144,000 days in the Long Count calendar used by the Classic Maya and other peoples in Mesoamerica. For a comprehensive explanation of the calendar, see D. Stuart 2013. While often assumed to mark the creation of the world, the 4 Ajaw 8 Kumk'u events remain poorly understood. Readable sentences in the relevant inscriptions refer to the ordering of groups of deities and the dedication of stone monuments by the gods, effectively marking the mythical institution of period-ending celebrations in the Long Count calendar, which were crucial components of Classic Maya kingly rituals. See ibid., pp. 216–24.

9. D. Stuart 2005, pp. 68–77; Velásquez García 2006.

10. D. Stuart 2005, p. 76.

11. D. Tedlock 1996, p. 65; Christenson 2003, p. 71.

12. Christenson 2003, pp. 74–90.

13. Ibid., pp. 193–95. On the archaeobotanical study of maize, see Blake 2015.

14. Beliaev and Davletshin 2014.

15. D. Tedlock 1996, p. 65.

16. Christenson 2003, pp. 91–100. On maize in the *Popol Wuj*, see Chinchilla Mazariegos 2017, pp. 189–92.

17. While useful, this label can be misleading, as it lumps together a diversity of mythical birds; see Bassie-Sweet and Hopkins 2021. The label was coined in Bardawil 1976.

18. Coe 1982, p. 57, ill.

19. Christenson 2003, p. 90.

20. K. Taube 2017, p. 272.

21. Chinchilla Mazariegos 2010a; Chinchilla Mazariegos 2017, pp. 131–37.

22. Galinier 1984; Báez-Jorge 2008.

23. Christenson 2003, p. 95.

24. W. Fash and B. Fash 2000; Chinchilla Mazariegos 2010a.

25. Chinchilla Mazariegos 2017, p. 148; Nielsen et al. 2021.

26. K. Taube et al. 2010, pp. 39–41.

27. Mathews and Justeson 1984; Chinchilla Mazariegos 2020.

28. López Austin 1997.

29. Coe 1973, 1989.

30. Houston, D. Stuart, and K. Taube 2006, p. 236. Other possible readings are discussed in Boot 2008; S. Martin 2015, especially pp. 208–9.

31. S. Martin 2015, p. 215.

32. The paradox was noted in ibid., p. 214, and explored in Guernsey 2021. On Itzamnaaj as paramount god, see K. Taube 1992, p. 31.

33. Houston, D. Stuart, and K. Taube 2006, p. 170.

34. Christenson 2003, pp. 157–58.

35. Zender 2005; Chinchilla Mazariegos 2017, p. 164; Bassie-Sweet and Hopkins 2021, p. 238.

36. Guernsey 2006, pp. 91–117.

37. Nicholson 1971; Graulich 1997, pp. 62–75.

38. García Escobar 2005.

39. Ibid., p. 13. The explanation originated from Mrs. Ana Cho de Rax, the former owner of the dance, who oversaw its

performance for many years. Recently, she transmitted the dance to her grandson, Alejandro Rax.

40. Búcaro Moraga 1991, pp. 70–71.
41. S. Martin and Grube 2008, p. 149; Looper 2009, p. 20.
42. Chinchilla Mazariegos 2010b.
43. Graulich 1983; Olivier 2020.
44. Christenson 2003, pp. 128–30.
45. Braakhuis 2010; Chinchilla Mazariegos 2010b.
46. Chinchilla Mazariegos 2010b, pp. 47–48.
47. Chinchilla Mazariegos 2017, pp. 97–103. On K'awiil, see K. Taube 1992, pp. 69–79; Valencia Rivera 2011; Chinchilla Mazariegos 2021a.
48. Boremanse 2006, pp. 313–19.
49. The animal is depicted realistically but does not have distinctive features. The absence of certain features rules out some animals, such as a three-pointed ear that is typical in representations of dogs and coatis. See Grube and Nahm 1994; A. Stone and Zender 2011, pp. 180–99.
50. Bricker 1986; Chinchilla Mazariegos 2018.
51. Modified from Beliaev and Davletshin 2006, p. 30. On objects that show Itzamnaaj riding animals, see Looper 2019, pp. 162–63.
52. Miller and S. Martin 2004, p. 96; R. Taube and K. Taube 2009; Miller 2019.
53. García Barrios and Valencia Rivera 2011.
54. Christenson 2003, pp. 193–95.
55. On the Lunar Series in the Mayan inscriptions, see Thompson 1971, pp. 230–46. On the vessel with lunar gods, see Chinchilla Mazariegos 2011, p. 205; Zender and Skidmore 2012, p. 9.
56. D. Stuart 2007a offers insights on its possible reading.
57. On the lunar Maize God, see Chinchilla Mazariegos 2017, pp. 202–7. On the Water-lily Serpent, see Hellmuth 1987, pp. 160–66; Ishihara, K. Taube, and Awe 2006; M. Robertson 2011.
58. K. Taube 2004a; Chinchilla Mazariegos 2006.
59. Chinchilla Mazariegos 2017, pp. 159–223; Chinchilla Mazariegos 2021b. On the Pearlman conch-shell trumpet,

see Coe 1982, pp. 120–23; Zender 1999, pp. 77–83.
60. See examples in Joyce 1932, pl. 8, no. 12; Moholy-Nagy 2008, figs. 42, 43.
61. See note 8.
62. The vessel is K1398; see Beliaev and Davletshin 2006; www.mayavase.com.
63. Miller and S. Martin 2004, p. 60.
64. Guiteras Holmes 1986, pp. 221–22; Christenson 2016, pp. 15, 136. On rituals that evoke primeval chaos, see Bricker 1986; Gossen 1992.
65. D. Stuart 2013, p. 266.
66. Gonlin and Lohse 2007.

Day, Night

I thank James Doyle for the pleasure of discussing this project over the years. As always, Charles Golden, Simon Martin, Andrew Scherer, David Stuart, and Karl Taube helped me refine the chapter with suggestions, evidence, and the inspirational example of their own thought and writing.

1. Houston 1998a, p. 349, fig. 13; Tokovinine 2003.
2. Kidder, Jennings, and Shook 1946, fig. 44. Curiously, the earspool refers to the founder of the Tikal dynasty. It was found at Kaminaljuyu, far to the south of that lowland Maya city. The retrograde text faces toward the viewer of the ornament, a probable, orientational explanation for many retrograde inscriptions among the Maya; see Houston 1998a, p. 347, figs. 10, 11. The glyphs tease apart the number and main element of the *day* sign ("4" and "Ajaw"), inserting a sign marked with the *k'in*. The observation about blood- and day-sign cartouches comes from David Stuart, personal communication, 2004; for the blood sacrifice at the beginning of time, see D. Stuart 2005, pp. 68–77; K. Taube 2010.
3. The observation about night markings on creatures comes from Marc Zender, personal communication, 2008. On polished adzes and spirits within, see D. Stuart 2010. See also Houston 2014b, pp. 91–93.
4. Mathews 2001, pp. 394–95.

5. Miles 1957, p. 749; translation amended by author after consulting the original passage, Fuentes y Guzmán 1932, p. 266.
6. Zender 2004, pp. 195–210. An alabaster vessel in the Museo Popol Vuh, Guatemala City, bolsters the bundling of priestly roles, in that the *yajaw k'ahk'* title appears last in a set of three for one nobleman. This may reflect a ranking of roles or the order in which they were bestowed. On fire rituals, see Scherer and Houston 2018.
7. This vessel may have been created with a quill because of the angular lines and highly irregular discharge of ink. Known as *chehb*, quills are attested in surviving glyphic texts, and bowls are labeled for cleaning them, indicating repeated use. On quills, see Coe and Kerr 1997, pp. 148–50; for glyphic mentions, such as *u-pokol chehb*, on a bowl belonging to what may have been a priestly subordinate to a ruler, see Boot 1997.
8. For this vessel, see Coe 1973, pp. 106–9. For additional thoughts, although they do not reference a dawning event, see M. Carrasco 2010, pp. 609–11.
9. For decipherment of the *way* sign, see Houston and D. Stuart 1989. For an inventory, see Grube and Nahm 1994. For rulers, sorcery, and control of disease, see Helmke and Nielsen 2009; D. Stuart 2021.
10. On *wayib*, see D. Stuart 1998, pp. 399–400.
11. For celestial crocodiles, see S. Martin 2015, pp. 192–96.
12. S. Martin 2015, pp. 208–9.
13. D. Stuart 2003.
14. Lothrop 1952, pp. 77–79, fig. 62; Coggins 1984, pp. 118–19, pls. 135, 136.
15. Webster et al. 1998, pp. 331–34, figs. 10–12. For reconstruction of the throne and facades, see B. Fash 2011, pp. 165–71, figs. 196, 197.
16. On sky bands, see Carlson 1988.
17. For reconstructed terms, see Kaufman and Norman 1984, p. 117.
18. D. Stuart, Strauss, and Lopez-Finn 2017. A creator deity on a Postclassic rock carving from near Yauhtepec, Mexico, has him either carving such a sky band/book with a bone awl or consulting it

with a reading stylus, perhaps in augury of the future. The *yad*, a reading stylus used in Jewish practice, is a useful analogy: it distances contaminating hands from a Torah scroll, offering a parallel to the act shown at Yauhtepec.

19. On human reactions to snakes, see Bertels et al. 2018; Jensen and Caine 2021.

20. For such crocodiles, see S. Martin 2015, pp. 216–23. For the Milky Way, see D. Stuart 2005, p. 72.

21. The Sun God usually went by K'in or K'inich Ajaw. In an alternate reading, this might read Aj K'in Ajaw (He of the Sun God), a label appropriate to impersonation.

22. For centipedes, see Grube and Nahm 1994, p. 702, fig. 30; Boot 2000, p. 193.

23. On sun gods, see K. Taube 1992, pp. 50–56. For the mask with golden-brown hair, see Ishihara-Brito and K. Taube 2012. A meticulous study of Maya myths, strongly centered on Indigenous folklore from more recent times, focuses on the solar features of the "hero twins," less so on the deity targeted here; see Chinchilla Mazariegos 2017, pp. 34–35 (fig. 13), 158–83.

24. Moholy-Nagy 2008, pp. 24–26, figs. 42–54. Although rare, such caches have also been found at Uaxactun, Guatemala; see Kidder 1947, pp. 21–23, figs. 69–72. For glyphic tag, see ibid., fig. 72, retrieved from unspecified stelae at Tikal. Compare with similar glyph on the Caracol Stela 16:B14; see Beetz and Satterthwaite 1981, fig. 15a.

25. K. Taube et al. 2010, pp. 52–57, fig. 37.

26. For Tonina Monument 167, a ballcourt ring, see I. Graham et al. 2006, p. 110.

27. For the Jaguar God of the Underworld being tortured by flames, see S. Martin and Grube 2008, p. 82.

28. The carving is Machaquila Stela 13, dating to December 2, 711 (Julian); see I. Graham 1967, pp. 87–88, figs. 33, 42, 66–68. For further fieldwork in this sector of the city, see Ciudad Ruiz et al. 2011.

29. Miller and S. Martin 2004, fig. 27.

30. Laura Rodríguez Cano, Juan Cervantes Rosado, and Diana Molatore Salvejo in de la Fuente and Fahmel Beyer 2005, pls. 30.3, 30.8, 30.12. I thank Karl A. Taube for identifying this being and for bringing him to my attention.

31. For an early depiction of the Sun God at Cerros, Belize, see Freidel and Schele 1988, fig. 2.3. For Taube's identification, see K. Taube, Pérez de Lara Elías, and Coltman 2021. A youthful version of the Sun God may exist far earlier, but in a different guise, as suggested by a jade effigy excavated at Kaminaljuyu, Guatemala; see Kidder 1947, fig. 37. His plump body brings to mind the headless Hombre de Tikal carving from Tikal, Guatemala, whose dorsal text may refer to the impersonation of the Sun God by the ruler of Tikal; see Fahsen 1988, fig. 4, positions C2–D2.

32. For the Sun God title, see Colas 2004, pp. 264–66.

33. For the fending stick, see Geib 2018. Simon Martin identified the stick for me and, with David Stuart and Karl A. Taube, shaped the discussion in this paragraph. On foreigners in Maya imagery, see S. Martin 2020, pp. 289–94; S. Martin 2021.

34. The notional relation of the month and the dry season was observed independently by Nikolai Grube; see Grube 2018.

35. For the Diablo bowls, see Houston et al. 2015, pp. 88–95, 121, 123, 131, 134, figs. 3.3–3.11, 3.34–3.38, 3.45–3.48; ibid., pp. 208–29, coauthored by Karl A. Taube and Stephen Houston, provides detailed discussion.

36. For Sun God impersonations, see Houston, D. Stuart, and K. Taube 2021, pp. 104–12. For the impersonation with flint and shield, see Benavides Castillo et al. 2009, fig. 7. On the Bonampak murals, see Miller and Brittenham 2013.

37. For the moon gods, see K. Taube 1992, pp. 64–69; Chinchilla Mazariegos 2017, pp. 202–7, figs. 105–8, 110, 112.

38. The connection between this vessel and the lunar series of Glyph C was first pointed out to me by David Stuart, personal communication, 2002.

39. Barrera Vásquez 1980, p. 242.

40. For discussion, see Grube and Gaida 2006, pp. 116–31.

41. For El Escorial and its royal mausoleum, see Kamen 2010, p. 70. For Henry VIII and his queen, see Highley 2016. For Chinese concubines and imperial heirs, see McMahon 2016, pp. 97–98.

42. For Chicozapote, see Maler 1903, pp. 10–14, pls. XXXVII, XXXVIII. For the current location of the lintels, see García Barrios and Velásquez García 2018, p. 147, fig. 1.3. Another piece in this museum presents an unusual image of the Sun God in conversation with a moon goddess or god; see ibid., fig. 5.13.

43. For Yaxchilan carvings, see Tate 1992, figs. 71 (Stela 8), 86 (Stela 4), 124 (Stela 1), 130 (Stela 10).

44. Matsumoto et al. 2021, pp. 11–12, fig. 12. For another solar and lunar disk in a ballcourt marker, see North Carolina Museum of Art (82.14).

Rain, Lightning

1. K. Taube and Zender 2009, p. 162.

2. K. Taube 1992, p. 17; García Barrios 2008a; Pallán Goyol 2009; García Barrios 2011. See also Bassie-Sweet 2021, pp. 38–81.

3. K. Taube 1992, p. 79; A. Stone and Zender 2011, pp. 48–49.

4. Doyle 2016.

5. K. Taube 2004a; Vogt and D. Stuart 2005; Chinchilla Mazariegos 2017, pp. 68–69; S. Martin 2020, p. 149.

6. S. Martin 2002.

7. Schele and Miller 1986, pp. 310–12, pl. 122; Doyle and Houston 2017.

8. Velásquez García 2006, fig. 5; S. Martin 2015.

9. The gods are designated by the collocation **ma-ta-K'UH**; see D. Stuart and G. Stuart 2008, pp. 211–15.

10. Feline or jaguar: **hi-HIX**.

11. Agurcia Fasquelle, Sheets, and K. Taube 2016, p. 24.

12. Chinchilla Mazariegos 2017, pp. 217–18.

13. See Robicsek 1978; Loughmiller-Cardinal and Eppich 2019.

14. Doyle 2016; Aimi and Tunesi 2017; O'Neil 2019.

15. See Guernsey 2006. An Early Classic version of a fishing deity appears on murals at Uxul, Campeche; see Grube and Delvendahl 2015, fig. 12.
16. Doyle and Houston 2012.
17. Other representations of Chahk, such as Quirigua Zoomorph P, also portray him as producing deluges in the form of outpouring vessels.
18. Alexandre Tokovinine in Pillsbury et al. 2012, p. 342, pl. 61.
19. Stephen Houston and Karl A. Taube in Pillsbury et al. 2012, p. 43, pl. 1.
20. Miller and S. Martin 2004, pp. 221–22, pls. 119, 121.
21. Whitening: **SAJ-ja**.
22. E.g., vessels K1644, K1815; www.mayavase.com. See García Barrios 2008b, p. 143. See also Boot 2004.
23. K. Taube and Zender 2009.
24. Striker: **ja-JATZ'-ma**, *jatz'oom*.
25. Houston 2016, p. 401.
26. García Barrios 2008b.
27. See also Bassie-Sweet 2021, pp. 120–22.
28. García Barrios 2008b, p. 24
29. K. Taube and Zender 2009, p. 162.
30. Looper 2003; K. Taube and Zender 2009, p. 186; Gutiérrez González 2018.
31. S. Martin 2015, p. 212.
32. Christenson 2003, 2007. See also Bassie-Sweet 2021, pp. 41–42.
33. See K. Taube 1992, p. 17.
34. Søren Wichmann, "The Grammar of the Half-Period Glyph," in Wichmann 2004, pp. 332–33; Prager 2018, p. 582.
35. Houston 2016, table 13.5.
36. Clark, Nelson, and Titmus 2012.
37. Agurcia Fasquelle, Sheets, and K. Taube 2016.
38. B. Fash 2011.
39. Clark, Nelson, and Titmus 2012, p. 280, figs. 161, 163a, b, 164; Agurcia Fasquelle, Sheets, and K. Taube 2016, pp. 29–30.
40. Brown 2015.
41. Vogt 1969, p. 301.
42. Thompson 1970, p. 253; Barrera Vásquez 1980, p. 39.
43. See, for example, Staller and Stross 2013, p. 11.
44. S. Martin 2020, pp. 128–29.
45. See, for example, the *Codex Ixtlilxochitl* manuscript in the Bibliothèque Nationale de France, Paris, fol. 109v; Olivier 2003.
46. Guzmán and Polaco 2000; López Luján 2005.
47. K. Taube 1992; García Barrios 2008a, pp. 200–212.
48. See, among others, Villa Rojas 1987; Freidel, Schele, and Parker 1993, pp. 25–33; Vidal-Lorenzo and Horcajada-Campos 2020.

Maize, Rebirth

To my splendid teacher, the honorable Alfredo López Austin, who recently entered the path of the Maize God.

1. See Quenon and Le Fort 1997.
2. K. Taube 1996; Pérez Suárez 1997; K. Taube and Saturno 2008.
3. K. Taube 2004b, figs. 11, 12a, b.
4. S. Martin 2006, p. 156; Simon Martin in Pillsbury et al. 2012, p. 111, no. PC.B.208.
5. López Austin and López Luján 2009, pp. 27–36; Alfredo López Austin, "Icono y mito: Su convergencia," in López Austin 2014, p. 167.
6. López Austin 1994, pp. 15–16.
7. K. Taube et al. 2010, p. 73.
8. Quenon and Le Fort 1997, p. 891; Nicholas Carter in Finamore and Houston 2010, p. 260, no. 63.
9. Karl A. Taube in Finamore and Houston 2010, p. 255, no. 12.
10. Zender 2006, fig. 10a.
11. K. Taube et al. 2010, pp. 84–86.
12. Zender 2020.
13. See, for example, a carved bone from Tikal Tomb 116 (object 4P-113[19]/2, MT 50) in Moholy-Nagy 2008, fig. 190.
14. See Carol Robbins, "Eccentric Flint Depicting a Crocodile Canoe with Passengers (1983.45.McD)," in Kotz 1997, p. 189; Finamore and Houston 2010, p. 153.
15. For a sequential visual narrative, see Small 1999.
16. See Brittenham 2011; Velásquez García 2017.
17. K. Taube 1992, pp. 56–64.
18. Quenon and Le Fort 1997, pp. 887–90; Alexandre Tokovinine in Pillsbury et al. 2012, pp. 339–40, no. PC.B.584.
19. Quenon and Le Fort 1997, figs. 5–7. See also the polychrome vessel K3033 in the digital archives of Justin Kerr, http://research.mayavase.com.
20. Quenon and Le Fort 1997, pp. 886–91.
21. Chinchilla Mazariegos 2011, chapter 2; Alexandre Tokovinine in Pillsbury et al. 2012, pp. 339–40, no. PC.B.584.
22. Alexandre Tokovinine in Pillsbury et al. 2012, fig. 186a.
23. Chinchilla Mazariegos 2011, p. 78.
24. See the example of the Principal Bird Deity defeated in K. Taube et al. 2010, fig. 12.
25. Quenon and Le Fort 1997, p. 892; Chinchilla Mazariegos 2017, pp. 195–202.
26. Quenon and Le Fort 1997, pp. 892–94; Helmke and Kupprat 2017, p. 111.
27. Chinchilla Mazariegos 2011, pp. 59–71.
28. Helmke 2012, p. 111.
29. Wichmann and Nielsen 2016.
30. Velásquez García 2017, p. 375.
31. See the scenes from vessels K4479 and K1202 in the digital archives of Justin Kerr, http://research.mayavase.com.
32. Quenon and Le Fort 1997, fig. 25.
33. For example, see vessel K7268 in the digital archives of Justin Kerr, http://research.mayavase.com.
34. Chinchilla Mazariegos 2017, figs. 119, 120.
35. K. Taube 2010, p. 212.
36. Stephen Houston and Karl A. Taube in Pillsbury et al. 2012, p. 45, no. PC.B.528.
37. Turner 2021, p. 158.
38. K. Taube 2005, pp. 25–28.
39. Doyle 2016. As James Doyle mentions, the reiteration of an iconographic complex in which Chahk and the Maize God are associated in the same episodes may denote the existence of "macro- or meta-narratives — of a larger story or myth behind these images." See, for example, the three codex-style vessels in The Met collection in this volume (figs. 17a, b, 77a, b, 89a, b).
40. See also S. Martin 2002, p. 57.
41. Doyle and Houston 2017.
42. Quenon and Le Fort 1997, p. 896.
43. Velásquez García 2017, pp. 370–75.
44. Salazar Lama forthcoming b.
45. Boot 2003, p. 2.

46. For more examples, see the complete catalogue of the plates in ibid.

47. Velásquez García 2017, pp. 374–75. According to this author, both moments are explicitly shown on another contemporary vessel; see K5226 in the digital archives of Justin Kerr, http://research.mayavase.com.

48. See vessels K7019 and K5226 in the digital archives of Justin Kerr, http://research.mayavase.com.

49. See S. Martin 2015, p. 191, fig. 8a.

50. Saturno, K. Taube, and D. Stuart 2005, p. 14; Salazar Lama forthcoming b.

51. Von Schwerin 2011.

52. Barbara Fash in Pillsbury et al. 2012, p. 81, no. PC.B.146.

53. For the head of the Maize God sprouting like an ear of corn, see also Maya ceramic vessels in The Met collection (1992.4) and in the Dallas Museum of Art (1973.32). For an analysis of the iconography, see Boot 2020.

54. Quenon and Le Fort 1997, p. 885.

55. See the codex-style vessel K2723 in the digital archives of Justin Kerr, http://research.mayavase.com.

56. Velásquez García 2009b, p. 5.

57. For more examples of the arm gesture combined with an upright body position in the Izapa Stelae 22 and 67, see Guernsey-Kappelman 2002, figs. 5.1, 5.2.

58. Salazar Lama forthcoming a.

59. Ancona-Ha, Pérez de Lara, and Van Stone 2000, pp. 15–16, vessels K626, K3847, K4479, K4681.

60. Saturno, K. Taube, and D. Stuart 2005, fig. 5.

61. Ibid., p. 8; Velásquez García 2009a, pp. 344–49; K. Taube et al. 2020, pp. 67–71.

62. See vessel K5761 in the digital archives of Justin Kerr, http://research.mayavase.com.

63. See an alternative interpretation in Chinchilla Mazariegos 2017, p. 213.

64. Quenon and Le Fort 1997, p. 895.

65. Zender 2006, pp. 3, 7, figs. 3, 7, 8.

66. Kupprat forthcoming.

67. Tokovinine 2008, p. 281.

68. Helmke and Kupprat 2016, p. 63.

69. Reents-Budet 1991.

70. Miller and S. Martin 2004, p. 71.

71. Ibid., p. 78; S. Martin 2006, p. 155.

72. Simon Martin in Pillsbury et al. 2012, p. 113, no. PC.B.208.

73. Ibid., pp. 111–12, 115.

74. S. Martin 2006, pp. 178, 180; Simon Martin in Pillsbury et al. 2012, p. 119.

75. For a discussion of bejeweled and flowery environments, see K. Taube 2004a.

76. See, for example, the Placeres frieze in the Museo Nacional de Antropología of Mexico City; Salazar Lama 2019, pp. 352–55, 424–28.

77. S. Martin 2002, p. 53.

78. Ashmore and Geller 2005, pp. 84–87.

79. For other examples in the Maya area, see Boucher, Campaña, and Palomo 2004; Pereira 2014.

80. See Houston et al. 2015, "Outfitting a Ruler," pp. 84–179.

81. Alexandre Tokovinine in Pillsbury et al. 2012, p. 443, nos. 1995.489a, b.

82. Miller and S. Martin 2004, p. 69.

83. López Austin 2014, p. 173.

Divine Humans, Patron Deities

1. Christenson 2007, pp. 194–95, 207–8.

2. Houston 2018, pp. 103–5.

3. Grube 2002, p. 325; Eberl and Graña-Behrens 2004.

4. S. Martin and Grube 2008, p. 15

5. Eberl and Graña-Behrens 2004, p. 117; Houston 2018, pp. 160–61.

6. Houston and D. Stuart 1996, pp. 295–97; Houston 2014b, p. 83; Baron 2016b, pp. 50–51.

7. Houston and D. Stuart 1998.

8. Houston 2006, p. 148.

9. Knub, Thune, and Helmke 2009, pp. 187–88.

10. Houston and D. Stuart 1998, p. 81.

11. The text on this lintel is written in "mirror-image" form, with the text beginning on the upper right side of the lintel rather than the upper left. For more on mirror-image inscriptions, see Matsumoto 2013.

12. Schele and Miller 1986, p. 177; Freidel, Schele, and Parker 1993, pp. 308–9; S. Martin 2020, p. 157. Shield Jaguar

also lost some battles; see S. Martin and Grube 2008, pp. 213–26.

13. Baron 2013, 2016b.

14. Baron 2016a.

15. Houston and D. Stuart 1996, p. 294; S. Martin 2020, pp. 150, 153–54.

16. D. Stuart 1996; Guernsey and Reilly 2006.

17. Miller and S. Martin 2004, p. 105.

18. Baron 2013, pp. 536–37.

19. D. Stuart 2006, pp. 96–98.

20. Baron 2013, p. 199.

21. Houston and D. Stuart 1989; D. Stuart 1998, pp. 376–79, 399–402; Baron 2016b, p. 65.

22. Andrews and B. Fash 1992, figs. 16, 17; Houston and Inomata 2009, pp. 200–201; S. Martin 2020, p. 155.

23. D. Stuart 2005, pp. 166–67.

24. Houston, D. Stuart, and K. Taube 2006, p. 123; Baron 2013, pp. 200–201.

25. Baron 2016b, pp. 157–60.

26. Baron 2013, p. 199; Baron 2016b, p. 62.

27. Townsend 1979, p. 34.

28. Ibid., p. 36; Bernardino 1981; Houston and D. Stuart 1996, p. 302.

29. Baron 2016b, pp. 110–13.

30. D. Stuart 2000.

31. Nearby sites record the arrival of Sihyaj K'ahk', while vessels and murals depict individuals in Teotihuacan dress. At Tikal itself, a recently discovered architectural complex appears to replicate the form of the Teotihuacan Ciudadela, a sunken plaza containing a pyramid; see Houston et al. 2021.

32. Baron 2016a, p. 137.

33. For more on the reception of lintels, see Brittenham 2019.

34. Baron 2016b, pp. 80–82.

35. Grube 2004.

36. S. Martin 1996, 2000; Baron 2016b, p. 84; S. Martin 2020.

37. S. Martin 2020, pp. 128–29, 328.

38. Ibid., pp. 136–42.

39. Baron 2016b, p. 76.

40. Schele and Grube 1994; Baron 2016b, p. 80.

41. S. Martin and Grube 2008, pp. 112–13.

42. S. Martin, Houston, and Zender 2015.

43. Schele and Freidel 1990, pp. 184–89; S. Martin and Grube 2008, p. 74.

44. Wahl et al. 2019.

45. S. Martin and Grube 2008, p. 76.

46. S. Martin 2020, p. 273.

47. S. Martin 1996, 2000, 2020.

48. D. Stuart 2007b.

49. S. Martin 2020, p. 243.

50. Baron 2013, p. 502.

51. S. Martin and Grube 2008, p. 142.

52. A. Stone 1989.

53. D. Stuart, Houston, and J. Robertson 1999, pp. 42–43; O'Neil 2012, pp. 154–56; S. Martin 2020, pp. 134–36.

54. Miller and S. Martin 2004, p. 276; S. Martin and Grube 2008, pp. 151–52; Houston 2018, pp. 132–33.

55. Houston 2014a.

56. D. Stuart 2006, p. 88.

57. Lounsbury 1980; D. Stuart 2005, pp. 170–73; D. Stuart 2006, pp. 171–74; Baron 2016a, p. 127.

58. D. Stuart 2004, p. 264; Baron 2013, p. 495.

59. Baron 2013, pp. 434–35

60. Looper 1999, pp. 268–69; Baron 2016b, p. 79.

61. Miller and S. Martin 2004, p. 57; Baron 2013, p. 439.

62. The dating of the sculpture and the place of this king within the history of Tonina remain in flux. Recent interpretations suggest Bahlam Yaxuun Tihl acceded to the throne in 600 and died in 615; see Nielsen et al. 2019.

63. Sánchez Gamboa, Sheseña, and Yadeun Angulo 2018.

64. This parallels visual and hieroglyphic approaches to rulers, whose daily activities were generally not depicted. One exception is the dressing of rulers, which is depicted on the Bonampak murals and ceramic vessels, most of which would have been seen by restricted audiences.

65. Knub, Thune, and Helmke 2009, p. 178.

Wood, Stone

Epigraph: Sam Colop 2008, p. 140. All translations from K'iche' to Spanish are by the author based on Luis Enrique Sam Colop; all translations from Spanish to English are by Philip Sutton.

1. Cojtí Ren 2020.

2. Umberger 2015, p. 85.

3. "Che, abah (che' ab'äj), chay, qotom ru vach (k'otom riuwäch)"; see de Coto 1983, p. 289. The words in parentheses follow the Kaqchikel alphabet proposed by the Academia de las Lenguas Mayas de Guatemala.

4. W. Fash 1991, pp. 73–75.

5. Sam Colop 2008, p. 140.

6. P. Carrasco 1982, pp. 29–43; de Coto 1983, p. 248.

7. Maxwell and R. Hill 2006, p. 4.

8. S. Martin and Grube 2002, pp. 148–49.

9. Manuela Mejía Xon, personal communication, 2008.

10. Sachse 2008.

11. Ibid.; Sam Colop 2008, pp. 155, 184.

12. Sam Colop 2008, pp. 140–41.

13. López Austin and López Luján 1999, pp. 71–74.

14. Zender 2005, pp. 12–13.

15. Sam Colop 2008, p. 142.

16. Ibid., p. 159.

17. Ibid., p. 160. Linguistically, the people of Rab'inal and adjoining municipalities speak a dialectal variant of K'iche' that is regarded as a different language for political reasons; see England 2001, p. 14.

18. Breton and Martínez 1999, pp. 37–38.

19. *Papel del origen de los señores*, published in Acuña 1982, pp. 59–61.

20. Cabezas Carcache 2008–9, vol. 2, p. 119.

21. Breton and Martínez 1999.

22. Recinos 2001, pp. 133–49.

23. I concur with Dennis Tedlock's translation of the term *uuc amac kib* (*wuk' amaq' kib'*) as "allies." The word is derived from *wuk'* (with me), *amaq'* (federation or people), and *kib'* (between them); see D. Tedlock 1996, pp. 291–92.

24. Carmack and Mondloch 2007, pp. 143–47.

25. Sam Colop 2008, p. 202.

26. Cojtí Ren 2020, pp. 26, 28.

27. Ibid., pp. 21–37.

28. Sam Colop 2008, p. 142.

29. Carmack and Mondloch 2007, pp. 115–17.

30. Sloane 1974; Fox 1987, p. 233.

31. The eastern Kaqchikel inhabited the citadel called Jilotepeque Viejo or Chwa Nima' Ab'äj, located in the current municipality of San Martín Jilotepeque, but they also occupied the territories of the peoples known today as the Sacatepéquez; see R. Hill 1996.

32. Maxwell and R. Hill 2006, pp. 51–53.

33. Cojtí Ren 2020, pp. 28, 30.

34. Sam Colop 2008, pp. 144–48.

35. Baron 2016a, p. 124.

36. McAnany and Plank 2001.

37. López Oliva 2015.

38. McAnany and Plank 2001, p. 116.

39. Ibid., pp. 103, 111.

40. Umberger 2008, p. 81.

41. *Iniciativa de ley de lugares sagrados* 2012, p. 14.

42. Cojtí Cuxil 1996, pp. 21–22.

43. Cojtí Ren 2021, pp. 84–86.

44. B. Tedlock 2002, pp. 85–87.

45. Miguel Ignacio, personal communication, 2022.

46. Sebastiana Pol, personal communication, 2021.

47. Wauchope 1975, pp. 41–44; Ichon 1977; Ciudad Ruiz 1984, 1986.

48. Schultze Jena 1954, pp. 56–61.

49. Pastor and Cherofsky 2020.

50. *Hacia el respeto de los derechos religiosos del pueblo maya* 1996, pp. 121–26.

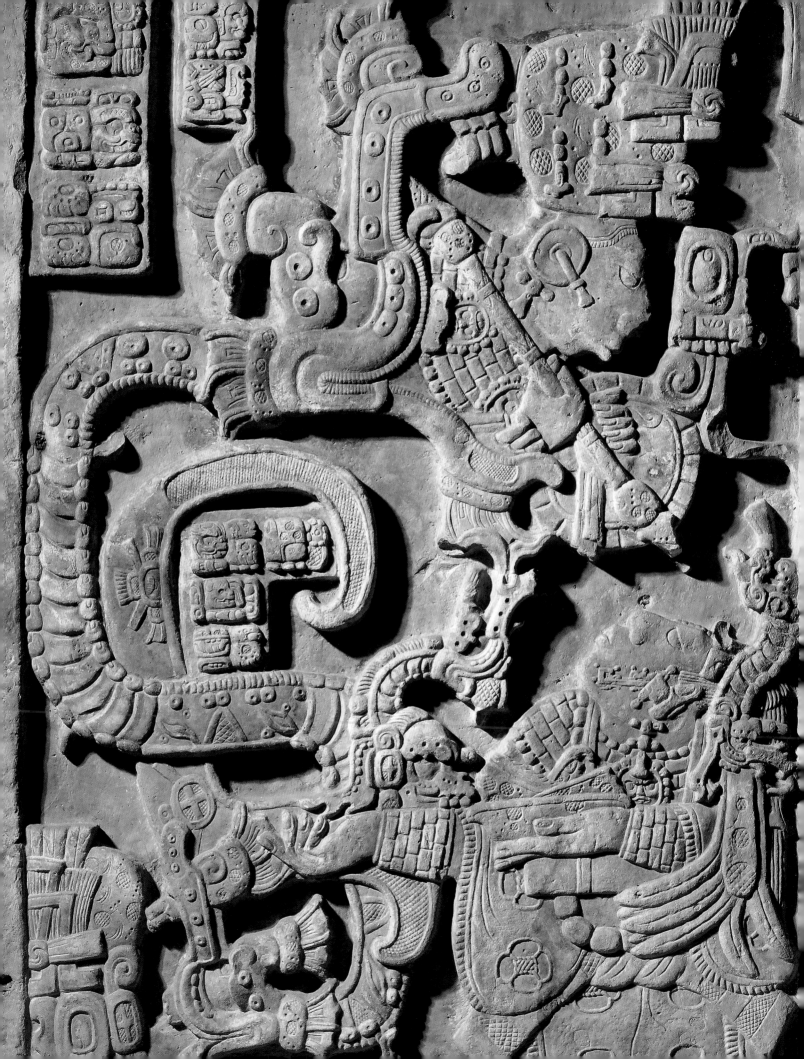

Bibliography

Acuña 1982. René Acuña, ed. *Relaciones geográficas del siglo XVI*. Vol. 1, *Guatemala*. Mexico City: Universidad Nacional Autónoma de México, Instituto de Investigaciones Antropológicas, 1982.

Acuña 1998. René Acuña. *Temas del Popol Vuh*. 1st ed. Universidad Nacional Autónoma de México, Instituto de Investigaciones Filológicas, Ediciones Especiales 10. Mexico City: Universidad Nacional Autónoma de Mexico, 1998.

Agurcia Fasquelle, Sheets, and K. Taube 2016. Ricardo Agurcia Fasquelle, Payson Sheets, and Karl A. Taube. *Protecting Sacred Space: Rosalila's Eccentric Chert Cache at Copan and Eccentrics among the Classic Maya*. Monograph 2. San Francisco: Precolumbia Mesoweb Press, 2016.

Aimi and Tunesi 2017. Antonio Aimi and Raphael Tunesi. "Notas sobre unos nuevos grandes artistas de los sagrados hombres de Chatahn." *Glyph Dwellers* 54 (2017), pp. 1–45.

Aissen, England, and Zavala Maldonado 2017. Judith L. Aissen, Nora C. England, and Roberto Zavala Maldonado, eds. *The Mayan Languages*. Routledge Language Family. Abingdon, U.K.: Routledge, 2017.

Allen 1996. James P. Allen. "The Religion of Amarna." In Dorothea Arnold, *The Royal Women of Amarna: Images of Beauty from Ancient Egypt*, pp. 3–5. Exh. cat. New York: The Metropolitan Museum of Art, 1996.

Ancona-Ha, Pérez de Lara, and Van Stone 2000. Patricia Ancona-Ha, Jorge Pérez de Lara, and Mark van Stone. "Observaciones sobre los gestos de manos en el arte maya." *Mesoweb*, 2000. www.mesoweb.com/es/articulos/Gestos.pdf.

Andrews and B. Fash 1992. E. Wyllys Andrews V and Barbara W. Fash. "Continuity and Change in a Royal Residential Complex." In "The Archaeology of Ancient Copan." Special section of *Ancient Mesoamerica* 3, no. 1 (Spring 1992), pp. 63–88.

Arnold et al. 2008. Dean E. Arnold, Jason R. Branden, Patrick Ryan Williams, Gary M. Feinman, and J. P. Brown. "The First Direct Evidence for the Production of Maya Blue: Rediscovery of a Technology." *Antiquity* 82, no. 315 (March 2008), pp. 151–64.

Ashmore and Geller 2005. Wendy Ashmore and Pamela L. Geller. "Social Dimensions of Mortuary Space." In *Interacting with the Dead: Perspectives on Mortuary Archaeology for the New Millenium*, edited by Gordon Ratika, Jane Buikstra, and Sloan Williams, pp. 81–92. Gainesville: University Press of Florida, 2005.

Assmann 2001. Jan Assmann. *The Search for God in Ancient Egypt*. Ithaca, N.Y.: Cornell University Press, 2001.

Báez-Jorge 2008. Félix Báez-Jorge. *El lugar de la captura: Simbolismo de la vagina telúrica en la cosmovisión mesoamericana*. Colección Investigaciones. Jalapa, Mexico: Gobierno del Estado de Veracruz, 2008.

Baines 2000. John Baines. "Egyptian Deities in Context: Multiplicity, Unity, and the Problem of Change." In Porter 2000, pp. 9–78.

Baines 2011. John Baines. "Presenting and Discussing Deities in New Kingdom and Third Intermediate Period Egypt." In *Reconsidering the Concept of Revolutionary Monotheism*, edited by Beate Pongratz-Leisten, pp. 41–89. Winona Lake, Ind.: Eisenbrauns, 2011.

Balsanelli 2019. Alice Balsanelli. "Creaciones divinas y creaciones humanas: La condición ontológica del ser humano y de los enseres rituales lacandones." *Antrópica: Revista de ciencias sociales y humanidades* 5, no. 10 (July–December 2019), pp. 87–107.

Bambach 2017. Carmen C. Bambach. *Michelangelo: Divine Draftsman and Designer*. With contributions by Claire Barry, Francesco Caglioti, Caroline Elam, Jeffrey Fraiman, Marcella Marongiu, Mauro Mussolin, and Furio Rinaldi. Exh. cat. New York: The Metropolitan Museum of Art, 2017.

Bardawil 1976. Lawrence W. Bardawil. "The Principal Bird Deity in Maya Art: An Iconographic Study of Form and Meaning." In *The Art, Iconography, and Dynastic History of Palenque, Part III: Proceedings of the Segunda Mesa Redonda de Palenque, December 14–21, 1974, Palenque*, edited by Merle Greene Robertson, pp. 195–209. Pebble Beach, Calif.: Robert Louis Stevenson School, Pre-Columbian Art Research, 1976.

Baron 2013. Joanne P. Baron. "Patrons of La Corona: Deities and Power in a Classic Maya Community." PhD diss., University of Pennsylvania, Philadelphia, 2013.

Baron 2016a. Joanne P. Baron. "Patron Deities and Politics among the Classic Maya." In *Political Strategies in Pre-Columbian Mesoamerica*, edited by Sarah Kurnick and Joanne P. Baron, pp. 121–52. Boulder: University Press of Colorado, 2016.

Baron 2016b. Joanne P. Baron. *Patron Gods and Patron Lords: The Semiotics of Classic Maya Community Cults*. Boulder: University Press of Colorado, 2016.

Barrera Vásquez 1980. Alfredo Barrera Vásquez, ed. *Diccionario maya Cordemex: Maya-español, español-maya*. 1st ed. Mérida, Mexico: Cordemex, 1980.

Barrera Vásquez 1991. Alfredo Barrera Vásquez, ed. *Diccionario maya: Maya-español, español-maya*. Mexico City: Porrúa, 1991.

Bassie-Sweet 2021. Karen Bassie-Sweet. *Maya Gods of War*. Louisville: University Press of Colorado, 2021.

Bassie-Sweet and Hopkins 2021. Karen Bassie-Sweet and Nicholas A. Hopkins. "Predatory Birds of the Popol Vuh." In Moyes, Christenson, and Sachse 2021, pp. 222–48.

Beetz and Satterthwaite 1981. Carl P. Beetz and Linton Satterthwaite. *The Monuments and Inscriptions of Caracol, Belize.* University Museum Monograph 45. Philadelphia: University Museum, University of Pennsylvania, 1981.

Beliaev and Davletshin 2006. Dimitri Beliaev and Albert Davletshin. "Los sujetos novelísticos y las palabras obscenas: Los mitos, los cuentos y las anécdotas en los textos mayas sobre la cerámica del período clásico." In *Sacred Books, Sacred Languages: Two Thousand Years of Religious and Ritual Mayan Literature; 8th European Maya Conference, Complutense University of Madrid, November 25–30, 2003,* edited by Rogelio Valencia Rivera and Geneviève Le Fort, pp. 21–44. Acta Mesoamericana 18. Markt Schwaben, Germany: Saurwein, 2006.

Beliaev and Davletshin 2014. Dimitri Beliaev and Albert Davletshin. "'It Was Then That That Which Had Been Clay Turned into a Man': Reconstructing Maya Anthropogenic Myths." *Axis Mundi: Journal of the Slovak Association for the Study of Religions* 9, no. 1 (2014), pp. 2–12.

Benavides Castillo et al. 2009. Antonio Benavides Castillo, Sara Novelo Osorno, Nikolai Grube, and Carlos Pallán Gayol. "Nuevos hallazgos en la región Puuc: Sabana piletas y su escalinata jeroglífica." *Arqueología mexicana* 97 (2009), pp. 77–83.

Benson and Griffin 1988. Elizabeth P. Benson and Gillett G. Griffin, eds. *Maya Iconography.* Princeton, N.J.: Princeton University Press, 1988.

Bernardino 1981. Bernardino de Sahagún. *Florentine Codex: General History of the Things of New Spain.* Vol. 3, book 2, *The Ceremonies.* Edited and translated by Arthur J. O. Anderson and Charles E. Dibble. 2nd ed. Monographs of the School of American Research 14. Santa Fe, N.M.: School of American Research; Salt Lake City: University of Utah Press, 1981.

Berrin and Fields 2010. Kathleen Berrin and Virginia M. Fields, eds. *Olmec: Colossal Masterworks of Ancient Mexico.* Exh. cat. San Francisco: Fine Arts Museums of San Francisco; Los Angeles: Los Angeles County Museum of Art; New Haven: Yale University Press, 2010.

Bertels et al. 2018. Julie Bertels, Clémence Bayard, Caroline Floccia, and Arnaud Destrebecqz. "Rapid Detection of Snakes Modulates Spatial Orienting in Infancy." *International Journal of Behavioral Development* 42, no. 4 (July 2018), pp. 381–87.

Blake 2015. Michael Blake. *Maize for the Gods: Unearthing the 9,000-Year History of Corn.* Oakland: University of California Press, 2015.

Boone 2000. Elizabeth Hill Boone. *Stories in Red and Black: Pictorial Histories of the Aztecs and Mixtecs.* Austin: University of Texas Press, 2000.

Boot 1997. Eric Boot. "Classic Maya Vessel Classification: Rare Vessel Type Collocations Containing the Noun *Cheb* 'Quill.'" *Estudios de historia social y económica de América (EHSEA)* 15 (July–December 1997), pp. 59–76.

Boot 2000. Erik Boot. "Architecture and Identity in the Northern Maya Lowlands: The Temple of K'uk'ulkan at Chich'en Itsa, Yucatán, Mexico." In *The Sacred and the Profane: Architecture and Identity in the Southern Maya Lowlands; 3rd European Maya Conference, University of Hamburg, November 1998,* edited by Pierre Robert Colas, Kai Delvendahl, Marcus Kuhnert, and Annette Schubert, pp. 183–204. Acta Mesoamericana 10. Markt Schwaben, Germany: Saurwein, 2000.

Boot 2003. Erik Boot. "An Annotated Overview of 'Tikal Dancer' Plates." *Mesoweb,* 2003. www.mesoweb.com/features/boot/TikalDancerPlates.pdf.

Boot 2004. Erik Boot. "The Nominal Yaxha'(Al) Chak on Classic Maya Ceramics and a Possible Cephalomorphic Variant for Yax." In Justin Kerr, *Maya Vase Database,* 2004. www.mayavase.com/YaxhaalChak.pdf.

Boot 2008. Erik Boot. "At the Court of Itzam Nah Yax Kokaj Mut: Preliminary Iconographic and Epigraphic Analysis of a Late Classic Vessel." In Justin Kerr, *Maya Vase Database,* 2008. www.mayavase.com/God-D-Court-Vessel.pdf.

Boot 2020. Erik Boot. "The *Baah Kab* 'First of the World' of Comalcalco: On Two Incised, Stuccoed Vessels and a Name at Comalcalco, Tabasco, Mexico." *Axis Mundi* 15, no. 2 (2020), pp. 29–43.

Boremanse 2006. Didier Boremanse. *Cuentos y mitología de los lacandones: Contribución al estudio de la tradición oral maya.* Publicación Especial 42. Guatemala City: Academia de Geografía e Historia, 2006.

Boremanse 2020. Didier Boremanse. *Ruins, Caves, Gods, and Incense Burners: Northern Lacandon Maya Myths and Rituals.* Salt Lake City: University of Utah Press, 2020.

Botta 2022. Sergio Botta. "*Zemi, Teotl, Huaca*: Reconsidering Materiality through Three Emic Concepts in the New World." In "Emic Categories and New Paths: Case Studies in the Scholarly Use of Indigenous Concepts." Special issue, *Religion* 52, no. 1 (2022) pp. 48–66.

Boucher, Campaña, and Palomo 2004. Sylviane Boucher, Luz Evelia Campaña, and Yoli Palomo. "*Dramatis personae* de la ofrenda funeraria en la estructura IX de Becán, Campeche." In *Culto funerario en la sociedad maya: Memoria de la cuarta mesa redonda de Palenque,* edited by Rafael Cobos, pp. 369–94. Mexico City: Instituto Nacional de Antropología e Historia, 2004.

Braakhuis 2010. H. Edwin M. Braakhuis. "Xbalanque's Marriage: A Commentary on the Q'eqchi' Myth of Sun and Moon." PhD diss., Leiden University, 2010.

Bray 2015. Tamara L. Bray, ed. *The Archaeology of Wak'as: Explorations of the Sacred in the Pre-Columbian Andes.* Boulder: University Press of Colorado, 2015.

Breton and Martínez 1999. Alain Breton, ed. and trans., and Jorge Mario Martínez, trans. *Rabinal Achí: Un drama dinástico maya del siglo XV; Edición facsimilar del manuscrito Pérez.* Mexico City: Centro Francés de Estudios Mexicanos y Centroamericanos, 1999.

Bricker 1973. Victoria Reifler Bricker. *Ritual Humor in Highland Chiapas.* Texas Pan American. Austin: University of Texas Press, 1973.

Bricker 1986. Victoria Reifler Bricker. *Humor ritual en la altiplanicie de Chiapas.* Translated by Judith Sabines Rodríguez. Sección de Obras de Antropología. Mexico City: Fondo de Cultura Económica, 1986.

Brittenham 2011. Claudia Brittenham. "About Time: Problems of Narrative in the Battle Mural at Cacaxtla." *RES: Anthropology and Aesthetics* 59–60 (Spring–Autumn 2011), pp. 74–92.

Brittenham 2019. Claudia Brittenham. "Architecture, Vision, and Ritual: Seeing Maya Lintels at Yaxchilan Structure 23." *Art Bulletin* 101, no. 3 (2019), pp. 8–36.

Brown 2015. Linda A. Brown. "When Pre-Sunrise Beings Inhabit a Post-Sunrise World: Time, Animate Objects, and Contemporary Tz'utujil Maya Ritual Practitioners." In *The Measure and Meaning of Time in Mesoamerica and the Andes,* edited by Anthony F. Aveni, pp. 53–77. Dumbarton Oaks Pre-Columbian Symposia and Colloquia. Washington, D.C.: Dumbarton Oaks Research Library and Collection, 2015.

Búcaro Moraga 1991. Jaime Ismael Búcaro Moraga. "Leyendas de los pueblos indígenas: Leyendas, cuentos, mitos y fábulas indígenas." *Tradiciones de Guatemala* 35–36 (1991), pp. 55–127.

Cabezas Carcache 2008–9. Horacio Cabezas Carcache. *Crónicas mesoamericanas.* 2 vols. Colección "Estudios Mesoamericanos" 2. Guatemala City: Universidad Mesoamericana; Galería Guatemala, 2008–9.

Canuto et al. 2018. Marcello A. Canuto, Francisco Estrada-Belli, Thomas G. Garrison, Stephen D. Houston, Mary Jane Acuña, Milan Kováč, Damien Marken, Philippe Nondédéo, Luke Auld-Thomas, Cyril Castanet, David Chatelain, Carlos R. Chiriboga, Tomáš Drápela, Tibor Lieskovský, Alexandre Tokovinine, Antolín Velasquez, Juan C. Fernández-Díaz, and Ramesh Shrestha. "Ancient Lowland Maya Complexity as Revealed by Airborne Laser Scanning of Northern Guatemala." *Science* 361, no. 6409 (September 18, 2018), article 1355.

Carlson 1988. John B. Carlson. "Skyband Representations in Classic Maya Vase Painting." In Benson and Griffin 1988, pp. 277–93.

Carmack and Mondloch 2007. Robert M. Carmack and James L. Mondloch. *Uwujil kulewal aj chwi miq'ina' / El título de Totonicapán.* Guatemala City: Cholsamaj, 2007.

D. Carrasco, L. Jones, and Sessions 2000. Davíd Carrasco, Lindsay Jones, and Scott Sessions, eds. *Mesoamerica's Classic Heritage: From Teotihuacan to the Aztecs.* Boulder: University Press of Colorado, 2000.

M. Carrasco 2010. Michael D. Carrasco. "From Field to Hearth: An Earthly Interpretation of Maya and Other Mesoamerican Creation Myths." In *Pre-Columbian Foodways: Interdisciplinary Approaches to Food, Culture, and Markets in Ancient Mesoamerica,* edited by John Edward Staller and Michael D. Carrasco, pp. 601–34. New York: Springer, 2010.

P. Carrasco 1982. Pedro Carrasco. *Sobre los indios de Guatemala.* Seminario de Integración Social Guatemalteca, Publicación 42. Guatemala: José de Pineda Ibarra y Ministerio de Educación, 1982.

Chinchilla Mazariegos 2006. Oswaldo Chinchilla Mazariegos. "The Stars of the Palenque Sarcophagus." *RES: Anthropology and Aesthetics* 49–50 (Spring–Autumn 2006), pp. 40–58.

Chinchilla Mazariegos 2010a. Oswaldo Chinchilla Mazariegos. "La vagina dentada: Una interpretación de la estela 25 de Izapa y las guacamayas del juego de pelota de Copán." *Estudios de cultura maya* 36 (2010), pp. 117–44.

Chinchilla Mazariegos 2010b. Oswaldo Chinchilla Mazariegos. "Of Birds and Insects: The Hummingbird Myth in Ancient Mesoamerica." *Ancient Mesoamerica* 21 (2010), pp. 45–61.

Chinchilla Mazariegos 2011. Oswaldo Chinchilla Mazariegos. *Imágenes de la mitología maya.* With prologue and text by Michael D. Coe. Guatemala City: Museo Popol Vuh, Universidad Francisco Marroquín, 2011.

Chinchilla Mazariegos 2017. Oswaldo Chinchilla Mazariegos. *Art and Myth of the Ancient Maya.* New Haven: Yale University Press, 2017.

Chinchilla Mazariegos 2018. Oswaldo Chinchilla Mazariegos. "Imágenes sexuales en el *Popol Vuh.*" *Anales de antropología* 52, no. 1 (January 2018), pp. 153–64.

Chinchilla Mazariegos 2020. Oswaldo Chinchilla Mazariegos. "Pus, Pustules, and Ancient Maya Gods: Notes on the Names of God S and Hunahpu." *PARI Journal* 21, no. 1 (2020), pp. 1–13.

Chinchilla Mazariegos 2021a. Oswaldo Chinchilla Mazariegos. "Tezcatlipoca and the Maya Gods of Abundance: The Feast of Toxcatl and the Question of Homologies in Mesoamerican Religion." In *Mesoamerican Rituals and the Solar Year: New Perspectives on the Veintena Festivals,* edited by Elodie Dupey García and Elena Mazzetto, pp. 31–57. Indigenous Cultures of Latin America: Past and Present 1. New York: Peter Lang, 2021.

Chinchilla Mazariegos 2021b. Oswaldo Chinchilla Mazariegos. "The Solar and Lunar Heroes in Classic Maya Art." In Moyes, Christenson, and Sachse 2021, pp. 251–67.

Christenson 2001. Allen J. Christenson. *Art and Society in a Highland Maya Community: The Altarpiece of Santiago Atitlán.* Linda Schele Series in Maya and Pre-Columbian Studies. Austin: University of Texas Press, 2001.

Christenson 2003. Allen J. Christenson. *Popol Vuh: The Sacred Book of the Maya, the Great Classic of Central American Spirituality; Translated from the Original Maya Text.* Winchester, U.K., and New York: O Books, 2003.

Christenson 2007. Allen J. Christenson, ed. and trans. *Popol Vuh: Sacred Book of the Quiché Maya People.* Ebook. Norman: University of Oklahoma Press, 2007. Electronic edition of Christenson 2003.

Christenson 2016. Allen J. Christenson. *The Burden of the Ancients: Maya Ceremonies of World Renewal from the Pre-Columbian Period to the Present.*

Linda Schele Series in Maya and Pre-Columbian Studies. Austin: University of Texas Press, 2016.

Christenson and Sachse 2021. Allen J. Christenson and Frauke Sachse. "Introduction: The *Popol Vuh* as a Window into the Mind of the Ancient Maya." In Moyes, Christenson, and Sachse 2021, pp. 3–17.

Ciudad Ruiz 1984. Andrés Ciudad Ruiz. *Arqueología de Agua Tibia, Totonicapán (Guatemala)*. Madrid: Ediciones de Cultura Hispánica; Instituto de Cooperación Iberoamericana, 1984.

Ciudad Ruiz 1986. Andrés Ciudad Ruiz. "El culto en los caseríos del área quiché: Los camahuiles." In *Los mayas de los tiempos tardios*, edited by Miguel Rivera Dorado and Andrés Ciudad Ruiz, pp. 63–81. Publicaciones de la SEEM 1. Madrid: Sociedad Española de Estudios Mayas, 1986.

Ciudad Ruiz et al. 2011. Andrés Ciudad Ruiz, Jesús Adánez Pavón, Alfonso Lacadena García-Gallo, and María Josefa Iglesias Ponce de León. "Excavaciones arqueológicas en Machaquilá, Petén, Guatemala." *Revista española de antropología americana* 41, no. 1 (2011), pp. 143–73.

Clark, Nelson, and Titmus 2012. John E. Clark, Fred W. Nelson, and Gene L. Titmus. "Flint Effigy Eccentrics." In Pillsbury et al. 2012, pp. 273–81.

Coe 1973. Michael D. Coe. *The Maya Scribe and His World*. Exh. cat. New York: Grolier Club, 1973.

Coe 1977. Michael D. Coe. "Supernatural Patrons of Maya Scribes and Artists." In *Social Process in Maya Prehistory: Studies in Honour of Sir Eric Thompson*, edited by Norman Hammond, pp. 327–47. London: Academic Press, 1977.

Coe 1978. Michael D. Coe. *Lords of the Underworld: Masterpieces of Classic Maya Ceramics*. With photographs by Justin Kerr. Exh. cat. Princeton, N.J.: Art Museum, Princeton University, 1978.

Coe 1982. Michael D. Coe. *Old Gods and Young Heroes: The Pearlman Collection of Maya Ceramics*. Exh. cat. Jerusalem: Israel Museum, Maremont Pavilion of Ethnic Arts, 1982.

Coe 1989. Michael D. Coe. "The Hero Twins: Myth and Image." In *The Maya Vase Book: A Corpus of Rollout Photographs of Maya Vases*, vol. 1, edited by Justin Kerr, pp. 161–84. New York: Kerr Associates, 1989.

Coe 1992. Michael D. Coe. *Breaking the Maya Code*. New York: Thames and Hudson, 1992.

Coe and Houston 2015. Michael D. Coe and Stephen D. Houston. *The Maya*. 9th ed. New York: Thames and Hudson, 2015.

Coe and Kerr 1997. Michael D. Coe and Justin Kerr. *The Art of the Maya Scribe*. London: Thames and Hudson, 1997.

Coggins 1984. Clemency C. Coggins. "The Late Phase of Sacred Cenote Ritual." In *Cenote of Sacrifice: Maya Treasure from the Sacred Well at Chichén Itzá*, edited by Clemency C. Coggins and Orrin C. Shane III, pp. 111–55. Austin: University of Texas Press, 1984.

Cojtí Cuxil 1996. Demetrio Cojtí Cuxil. "The Politics of Maya Revindication." In *Maya Cultural Activism in Guatemala*, edited by Edward F. Fischer and Robert McKenna Brown, pp. 19–50. Critical Reflections on Latin America. Austin: University of Texas Press, Institute of Latin American Studies, 1996.

Cojtí Ren 2020. Iyaxel Cojtí Ren. "The Emergence of the Ancient Maya Kaqchikel Polity as Explained through the Dawn Tradition in the Guatemalan Highlands." *Mayanist* 2, no. 1 (Fall 2020), pp. 21–38.

Cojtí Ren 2021. Iyaxel Cojtí Ren. "The *Saqirik* (Dawn) and Foundation Rituals among the Ancient K'iche'an Peoples." In Moyes, Christenson, and Sachse 2021, pp. 77–90.

Colas 2004. Pierre Robert Colas. *Sinn und Bedeutung klassischer Maya-Personennamen: Typologische Analyse von Anthroponymphrasen in den Hieroglypheninschriften der klassischen Maya-Kultur als Beitrag zur allgemeinen Onomastik; Inaugural-Dissertation zur Erlangung der Doktorwürde der Philosophischen Fakultät der Rheinischen Friedrich-Wilhelms-Universität zu Bonn*. Acta Mesoamericana 15. Markt Schwaben, Germany: Saurwein, 2004.

Cook 2000. Garrett W. Cook. *Renewing the Maya World: Expressive Culture in a Highland Town*. 1st ed. Austin: University of Texas Press, 2000.

Dean 2010. Carolyn Dean. *A Culture of Stone: Inka Perspectives on Rock*. Durham, N.C.: Duke University Press, 2010.

de Coto 1983. Thomás de Coto. *[Thesaurus verboruṽ]: Vocabulario de la lengua cakchiquel u[el] guatemalteca: Nuevamente hecho y recopilado con summo estudio, travajo y erudición*. Edited by René Acuña. Mexico City: Universidad Nacional Autónoma de México, 1983.

de la Fuente and Fahmel Beyer 2005. Beatriz de la Fuente and Bernd Fahmel Beyer, eds. *La pintura mural prehispánica en México*. Vol. 3, *Oaxaca*, pt. 2, *Catálogo*. Mexico City: Universidad Nacional Autónoma de México, Instituto de Investigaciones Estéticas, 2005.

Demarest 2004. Arthur A. Demarest. *Ancient Maya: The Rise and Fall of a Rainforest Civilization*. Case Studies in Early Socicties 3. New York: Cambridge University Press, 2004.

Doménech et al. 2009. Antonio Doménech, María Teresa Doménech-Carbó, Manuel Sánchez del Río, María Luisa Vázquez de Agredos Pascual, and Enrique Limad. "Maya Blue as a Nanostructured Polyfunctional Hybrid Organic-Inorganic Material: The Need to Change Paradigms." *New Journal of Chemistry* 33, no. 12 (December 2009), pp. 2371–79.

Douglas et al. 2016. Peter M. J. Douglas, Arthur A. Demarest, Mark Brenner, and Marcello A. Canuto. "Impacts of Climate Change on the Collapse of Lowland Maya Civilization." *Annual Review of Earth and Planetary Sciences* 44 (2016), pp. 613–45.

Doyle 2016. James A. Doyle. "Creation Narratives on Ancient Maya Codex-Style Ceramics in the Metropolitan Museum." *Metropolitan Museum Journal* 51 (2016), pp. 42–64.

Doyle 2017. James A. Doyle. *Architecture and the Origins of Preclassic Maya Politics*. Cambridge, U.K.: Cambridge University Press, 2017.

Doyle 2020. James A. Doyle. "Arte del Mar: Art of the Early Caribbean." *The*

Metropolitan Museum of Art Bulletin 77, no. 3 (Winter 2020).

Doyle and Houston 2012. James A. Doyle and Stephen D. Houston. "A Watery Tableau at El Mirador, Guatemala." *Maya Decipherment: Ideas on Ancient Maya Writing and Iconography, Boundary End Archaeological Research Center*, April 9, 2012. https://mayadecipherment.com /2012/04/09/a-watery-tableau-at-el -mirador-guatemala.

Doyle and Houston 2017. James A. Doyle and Stephen D. Houston. "The Universe in a Maya Plate." *Maya Decipherment: Ideas on Ancient Maya Writing and Iconography, Boundary End Archaeological Research Center*, March 4, 2017. https://mayadecipherment.com/2017/03 /04/the-universe-in-a-maya-plate.

Earle 1986. Duncan M. Earle. "The Metaphor of the Day in Quiche: Notes on the Nature of Everyday Life." In *Symbol and Meaning beyond the Closed Community: Essays in Mesoamerican Ideas*, edited by Gary H. Gossen, pp. 155–72. Studies on Culture and Society 1. Albany: Institute for Mesoamerican Studies, University at Albany, State University of New York, 1986.

Eberl and Graña-Behrens 2004. Markus Eberl and Daniel Graña-Behrens. "Proper Names and Throne Names: On the Naming Practice of Classic Maya." In Graña-Behrens et al. 2004, pp. 101–20.

Eliade 2004. Mircea Eliade. *Shamanism: Archaic Techniques of Ecstacy*. Translated by Willard R. Trask with foreword by Wendy Doniger. 2nd ed. Princeton, N.J.: Princeton University Press, 2004.

Eller 2015. Jack David Eller. *Introducing Anthropology of Religion*. 2nd ed. New York: Routledge, 2015.

England 2001. Nora C. England. *Introducción a la gramática de los idiomas mayas*. 1st ed. Guatemala: Cholsamaj, 2001.

Fahsen 1988. Federico Fahsen. *A New Early Classic Text from Tikal*. Research Reports on Ancient Maya Writing 17. Washington D.C.: Center for Maya Research, 1988.

Farriss 1984. Nancy M. Farriss. *Maya Society under Colonial Rule: The Collective Enterprise of Survival*. Princeton, N.J.: Princeton University Press, 1984.

B. Fash 2011. Barbara W. Fash. *The Copan Sculpture Museum: Ancient Maya Artistry in Stucco and Stone*. Cambridge, Mass.: Peabody Museum of Archaeology and Ethnology, Harvard University; David Rockefeller Center for Latin American Studies, Harvard University; Tegucigalpa, Honduras: Instituto Hondureño de Antropología e Historia, 2011.

W. Fash 1991. William L. Fash. "Lineage Patrons and Ancestor Worship among the Classic Maya Nobility: The Case of Copán Structure 9N-82." In *Sixth Palenque Round Table, 1986*, edited by Merle Greene Robertson and Virginia M. Fields, pp. 68–80. Palenque Round Table 8. Norman: University of Oklahoma Press, 1991.

W. Fash and B. Fash 2000. William L. Fash and Barbara W. Fash. "Teotihuacan and the Maya: A Classic Heritage." In D. Carrasco, L. Jones, and Sessions 2000, pp. 433–63.

Finamore and Houston 2010. Daniel Finamore and Stephen D. Houston, eds. *Fiery Pool: The Maya and the Mythic Sea*. Exh. cat. Salem, Mass.: Peabody Essex Museum; New Haven: Yale University Press, 2010.

Fox 1987. John W. Fox. *Maya Postclassic State Formation: Segmentary Lineage Migration in Advancing Frontiers*. New Studies in Archaeology. Cambridge, U.K.: Cambridge University Press, 1987.

Freidel and Schele 1988. David A. Freidel and Linda Schele. "Symbol and Power: A History of the Lowland Maya Cosmogram." In Benson and Griffin 1988, pp. 44–93.

Freidel, Schele, and Parker 1993. David A. Freidel, Linda Schele, and Joy Parker. *Maya Cosmos: Three Thousand Years on the Shaman's Path*. New York: Perennial, 1993.

Freidel et al. 2017. David A. Freidel, Arlen F. Chase, Anne S. Dowd, and Jerry Murdock, eds. *Maya E Groups: Calendars, Astronomy, and Urbanism in the Early Lowlands*. With foreword by David A. Freidel and Jerry Murdock.

Maya Studies. Gainesville: University Press of Florida, 2017.

Fuentes y Guzmán 1932. Francisco A. de Fuentes y Guzmán. *Recordación florida: Discurso historial y demostración natural, material, militar y política del reyno de Guatemala*. Vol. 1. Biblioteca "Goathemala" 6. Guatemala City: Sociedad de Geografía e História, 1932.

Galinier 1984. Jacques Galinier. "L'homme sans pied: Métaphores de la castration et imaginaire en Mésoamérique." *L'homme* 24, no. 2 (April–June 1984), pp. 41–58.

García 2020. María Luz García. "Mayan Languages in the United States." In *Handbook of the Changing World Language Map*, edited by Stanley D. Brunn and Roland Kehrein, pp. 791–804. 1st ed. Cham, Switzerland: Springer, 2020.

García Barrios 2008a. Ana García Barrios. "Chaahk, el dios de la lluvia, en el período clásico maya: Aspectos religiosos y políticos." PhD diss., Universidad Complutense, Madrid, 2008.

García Barrios 2008b. Ana García Barrios. "El aspecto bélico de Chaahk, el dios de la lluvia, en el periodo clásico maya." *Revista española de antropología americana* 39, no. 1 (2008), pp. 7–29.

García Barrios 2011. Ana García Barrios. "Análisis iconográfico preliminar de fragmentos de las vasijas estilo códice procedentes de Calakmul." *Estudios de cultura maya* 37 (2011), pp. 65–97.

García Barrios and Valencia Rivera 2011. Ana García Barrios and Rogelio Valencia Rivera. "Relaciones de parentesco en el mito del dios viejo y la señora dragón en las cerámicas de estilo códice." In *Texto, imagen e identidad en la pintura maya prehispánica*, edited by Merideth Paxton and Manuel A. Hermann Lejarazu, pp. 63–87. Cuaderno 36. Mexico City: Universidad Nacional Autónoma de México, 2011.

García Barrios and Velásquez García 2018. Ana García Barrios and Erik Velásquez García. *El arte de los reyes mayas*. Puebla, Mexico: Museo Amparo, 2018.

García Escobar 2005. Carlos René García Escobar. *La danza de Ma'muun o de las guacamayas: Una versión prehispánica*

pocomchí del rapto de la doncella. La Tradición Popular 153. Guatemala City: Centro de Estudios Folklóricos, Universidad de San Carlos de Guatemala, 2005.

Geib 2018. Phil R. Geib. "Mesoamerican Flat Curved Sticks: Innovative 'Toltec' Short Sword, Fending Stick, or Other Purpose?" *Ancient Mesoamerica* 29, no. 1 (Spring 2018), pp. 45–62.

Girard 1962. Rafael Girard. *Los mayas eternos.* Mexico City: Antigua Librería Robredo, 1962.

Gonlin and Lohse 2007. Nancy Gonlin and Jon C. Lohse, eds. *Commoner Ritual and Ideology in Ancient Mesoamerica.* Mesoamerican Worlds. Boulder: University Press of Colorado, 2007.

González González et al. 2008. Arturo H. González González, Carmen Rojas Sandoval, Alejandro Terrazas Mata, Martha Benavente Sanvicente, Wolfgang Stinnesbeck, Jerónimo Avilés, Magdalena de los Ríos, and Eugenio Acevez. "The Arrival of Humans on the Yucatan Peninsula: Evidence from Submerged Caves in the State of Quintana Roo, Mexico." *Current Research on the Pleistocene* 25 (2008), pp. 1–24.

Gossen 1992. Gary H. Gossen. "Las variaciones del mal en una fiesta tzotzil." In *De palabra y obra en el Nuevo Mundo,* edited by Miguel León-Portilla, Manuel Gutiérrez Estévez, Gary H. Gossen, and J. Jorge Klor de Alva, pt. 1, pp. 195–235. Madrid: Siglo XXI, 1992.

G. Graham 2018. Gordon Graham. *Philosophy, Art, and Religion: Understanding Faith and Creativity.* Cambridge Studies in Religion, Philosophy, and Society. Cambridge, U.K.: Cambridge University Press, 2018.

I. Graham 1967. Ian Graham. *Archaeological Explorations in El Petén, Guatemala.* Middle American Research Institute. Publication 33. New Orleans: Tulane University, 1967.

I. Graham et al. 2006. Ian Graham, Lucia R. Henderson, Peter Mathews, and David Stuart. *Corpus of Maya Hieroglyphic Inscriptions.* Vol. 9, pt. 2, *Tonina.* Cambridge, Mass.: Peabody Museum of Archaeology and Ethnology, Harvard University, 2006.

Graña-Behrens et al. 2004. Daniel Graña-Behrens, Nikolai Grube, Christian M. Prager, Frauke Sachse, Stephanie Teufel, and Elisabeth Wagner, eds. *Continuity and Change: Maya Religious Practices in Temporal Perspective; 5th European Maya Conference, University of Bonn, December 2000.* Acta Mesoamericana 14. Markt Schwaben, Germany: Saurwein, 2004.

Grandin 2000. Greg Grandin. *The Blood of Guatemala: A History of Race and Nation.* Latin America Otherwise. Durham, N.C.: Duke University Press, 2000.

Graulich 1983. Michel Graulich. "Myths of Paradise Lost in Pre-Hispanic Central Mexico." *Current Anthropology* 24, no. 5 (December 1983), pp. 575–88.

Graulich 1997. Michel Graulich. *Myths of Ancient Mexico.* Translated by Bernard R. Ortiz de Montellano and Thelma Ortiz de Montellano. Civilization of the American Indian 222. Norman: University of Oklahoma Press, 1997.

Grube 2002. Nikolai Grube. "Onomástica de los gobernantes mayas." In *La organización social entre los mayas: Memoria de la tercera mesa redonda de Palenque,* edited by Vera Tiesler Blos, Rafael Cobos, and Merle Greene Robertson, vol. 2, pp. 323–53. Mexico City: Instituto Nacional de Antropología e Historia; Mérida, Mexico: Universidad Autónoma de Yucatan, 2002.

Grube 2004. Nikolai Grube. "Akan: The God of Drinking, Disease and Death." In Graña-Behrens et al. 2004, pp. 59–76.

Grube 2018. Nikolai Grube. "The Last Day of Yaxk'in." In Kettunen et al. 2018, pp. 305–15.

Grube and Delvendahl 2015. Nikolai Grube and Kai Delvendahl. "El proyecto arqueológico uxul: Siete años de investigación científica en el sur de Campeche, México." Special issue, *Glifos: Revista trimestral del Centro INAH Campeche 2,* no. 5 (October 2015).

Grube and Gaida 2006. Nikolai Grube and Maria Gaida. *Die Maya: Schrift und Kunst.* Edited by Claus Pelling and Marie Luise Zarnitz. Veröffentlichungen des Ethnologischen Museums Berlin, Neue Folge 77, Fachreferat Amerikanische Archäologie 11. Cologne: DuMont Literatur und Kunst, 2006.

Grube and Nahm 1994. Nikolai Grube and Werner Nahm. "A Census of Xibalba: A Complete Inventory of *Way* Characters on Maya Ceramics." In *The Maya Vase Book: A Corpus of Rollout Photographs of Maya Vases,* vol. 4, edited by Barbara Kerr and Justin Kerr, pp. 686–715. New York: Kerr Associates, 1994.

Guernsey 2006. Julia Guernsey. *Ritual and Power in Stone: The Performance of Rulership in Mesoamerican Izapan Style Art.* 1st ed. Austin: University of Texas Press, 2006.

Guernsey 2021. Julia Guernsey. "Beyond the 'Myth or Politics' Debate: Reconsidering Late Preclassic Sculpture, the Principal Bird Deity, and the *Popol Vuh.*" In Moyes, Christenson, and Sachse 2021, pp. 268–94.

Guernsey and Reilly 2006. Julia Guernsey and F. Kent Reilly III, eds. *Sacred Bundles: Ritual Acts of Wrapping and Binding in Mesoamerica.* Ancient America Special Publication 1. Barnardsville, N.C.: Boundary End Archaeology Research Center, 2006.

Guernsey-Kappelman 2002. Julia Guernsey-Kappelman. "Carved in Stone: The Cosmological Narratives of Late Preclassic Izapan-Style Monuments from the Pacific Slope." In *Heart of Creation: The Mesoamerican World and the Legacy of Linda Schele,* edited by Andrea J. Stone, pp. 66–82. Tuscaloosa: University of Alabama Press, 2002.

Guiteras Holmes 1961. Calixta Guiteras Holmes. *Perils of the Soul: The World View of a Tzotzil Indian.* With afterword by Sol Tax. New York: Free Press of Glencoe, 1961.

Guiteras Holmes 1986. Calixta Guiteras Holmes. *Los peligros del alma: Visión del mundo de un tzotzil.* Translated by Carlo Antonio Castro with afterword by Sol Tax. 2nd ed. Sección de Obras de Antropología. Mexico City: Fondo de Cultura Económica, 1986.

Guthrie 1995. Stewart Guthrie. *Faces in the Clouds: A New Theory of Religion.* Oxford: Oxford University Press, 1995.

Gutiérrez González 2018. María Eugenia Gutiérrez González. "Yopaat, un dios maya de la tormenta asociado al jaguar." *KinKaban* 5 (July–December 2018), pp. 1–14.

Guy 2014. John Guy. *Lost Kingdoms: Hindu-Buddhist Sculpture of Early Southeast Asia.* Exh. cat. New York: The Metropolitan Museum of Art, 2014.

Guzmán and Polaco 2000. Ana Fabiola Guzmán and Oscar J. Polaco. *Los peces arqueológicos de la ofrenda 23 del Templo Mayor de Tenochtitlan.* 1st ed. Colección Científica, Arqueología 418. Mexico City: Instituto Nacional de Antropología e Historia, 2000.

***Hacia el respeto de los derechos religiosos del pueblo maya* 1996.** Oficina de Derechos Humanos del Arzobispado de Guatemala (ODHAG). *Hacia el respeto de los derechos religiosos del pueblo maya: Informe sobre libertad de religión maya.* Guatemala City: Diakonia, 1996.

Hellmuth 1987. Nicholas M. Hellmuth. *Monster und Menschen in der Maya-Kunst: Eine Ikonographie der alten Religionen Mexikos und Guatemalas.* Graz, Austria: Akademische Druck und Verlagsanstalt, 1987.

Helmke 2012. Christophe Helmke. "Mythological Emblem Glyphs of Ancient Maya Kings." *Contributions in New World Archaeology* 3 (2012), pp. 91–126.

Helmke and Kupprat 2016. Christophe Helmke and Felix A. Kupprat. "Where Snakes Abound: Supernatural Places of Origin and Founding Myths in the Titles of Classic Maya Kings." In *Places of Power and Memory in Mesoamerica's Past and Present: How Sites, Toponyms, and Landscapes Shape History and Remembrance,* edited by Daniel Graña-Behrens, pp. 33–83. Estudios Indiana 9. Berlin: Ibero-Amerikanisches Institut; Mann, 2016.

Helmke and Kupprat 2017. Christophe Helmke and Felix A. Kupprat. "Los glifos emblema y los lugares sobrenaturales: El caso de Kanu'l y sus implicaciones." *Estudios de cultura maya* 50 (2017), pp. 95–135.

Helmke and Nielsen 2009. Christophe Helmke and Jesper Nielsen. "Hidden Identity and Power in Ancient Mesoamerica: Supernatural Alter Egos as Personified Diseases." *Acta americana* 17, no. 2 (2009), pp. 49–98.

Hemingway and R. Stone 2017. Seán Hemingway and Richard Stone. "The New York Sleeping Eros: A Hellenistic Statue and Its Ancient Restoration / L'Eros endormi de New York: Une statue hellénistique et sa restauration antique." In "Bronzes grecs et romains: Etudes récentes sur la statuaire antique," edited by Sophie Descamps-Lequime and Benoît Mille. Special issue, *Techné* 45 (2017), pp. 46–63.

Highley 2016. Christopher Highley. "Failed Commemoration: A Royal Tomb and Its Afterlife." *Huntington Library Quarterly* 79, no. 1 (Spring 2016), pp. 93–118.

M. Hill 2007. Marsha Hill, ed. *Gifts for the Gods: Images from Egyptian Temples.* Exh. cat. New York: The Metropolitan Museum of Art, 2007.

R. Hill 1996. Robert M. Hill II. "Eastern Chajoma (Cakchiquel) Political Geography: Ethnohistorical and Archaeological Contributions to the Study of a Late Postclassic Highland Maya Polity." *Ancient Mesoamerica* 7, no. 1 (Spring 1996), pp. 63–87.

Houston 1998a. Stephen D. Houston. "Classic Maya Depictions of the Built Environment." In Houston 1998b, pp. 333–72.

Houston 1998b. Stephen D. Houston, ed. *Function and Meaning in Classic Maya Architecture: A Symposium at Dumbarton Oaks, 7th and 8th October 1994.* Washington, D.C.: Dumbarton Oaks Research Library and Collection, 1998.

Houston 2006. Stephen D. Houston. "Impersonation, Dance, and the Problem of Spectacle among the Classic Maya." In *Archaeology of Performance: Theaters of Power, Community, and Politics,* edited by Takeshi Inomata and Lawrence S. Coben, pp. 135–55. Archaeology in Society. Lanham, Md.: Altamira, 2006.

Houston 2014a. Stephen D. Houston. "A Game with a Throne." *Maya Decipherment: Ideas on Ancient Maya Writing and Iconography, Boundary End Archaeological Research Center,* January 24, 2014. https://mayadecipherment.com/2014/01/24/a-game-with-a-throne.

Houston 2014b. Stephen D. Houston. *The Life Within: Classic Maya and the Matter of Permanence.* New Haven: Yale University Press, 2014.

Houston 2016. Stephen D. Houston. "Crafting Credit: Authorship among Classic Maya Painters and Sculptors." In *Making Value, Making Meaning: Techné in the Pre-Columbian World,* edited by Cathy Lynne Costin, pp. 391–431. Washington, D.C.: Dumbarton Oaks Research Library and Collection, 2016.

Houston 2018. Stephen D. Houston. *The Gifted Passage: Young Men in Classic Maya Art and Text.* New Haven: Yale University Press, 2018.

Houston 2021. Stephen D. Houston, ed. *A Maya Universe in Stone.* Los Angeles: Getty Research Institute, 2021.

Houston and Inomata 2009. Stephen D. Houston and Takeshi Inomata. *The Classic Maya.* New York: Cambridge University Press, 2009.

Houston and D. Stuart 1989. Stephen D. Houston and David Stuart. *The Way Glyph: Evidence for "Co-Essences" among the Classic Maya.* Research Reports on Ancient Maya Writing 30. Washington, D.C.: Center for Maya Research, 1989.

Houston and D. Stuart 1996. Stephen D. Houston and David Stuart. "Of Gods, Glyphs and Kings: Divinity and Rulership among the Classic Maya." *Antiquity* 70, no. 268 (June 1996), pp. 289–312.

Houston and D. Stuart 1998. Stephen D. Houston and David Stuart. "The Ancient Maya Self: Personhood and Portraiture in the Classic Period." In "Pre-Columbian States of Being." Special issue, *RES: Anthropology and Aesthetics* 33 (Spring 1998), pp. 73–101.

Houston and K. Taube 2000. Stephen D. Houston and Karl A. Taube. "An Archaeology of the Senses: Perception and Cultural Expression in Ancient Mesoamerica." *Cambridge Archaeological Journal* 10, no. 2 (April 2000), pp. 261–94.

Houston, Chinchilla Mazariegos, and D. Stuart 2001. Stephen D. Houston, Oswaldo Chinchilla Mazariegos, and

David Stuart, eds. *The Decipherment of Ancient Maya Writing*. Norman: University of Oklahoma Press, 2001.

Houston, D. Stuart, and K. Taube 2006. Stephen D. Houston, David Stuart, and Karl A. Taube. *The Memory of Bones: Body, Being, and Experience among the Classic Maya*. Austin: University of Texas Press, 2006.

Houston, D. Stuart, and K. Taube 2021. Stephen D. Houston, David Stuart, and Karl A. Taube. "Seasonal Gods and Cosmic Rulers." In Houston 2021, pp. 92–151.

Houston et al. 2015. Stephen D. Houston, Sarah Newman, Edwin Román, and Thomas Garrison. *Temple of the Night Sun: A Royal Tomb at El Diablo, Guatemala*. With contributions by Nicholas Carter, Alyce de Carteret, Andrew K. Scherer, and Karl A. Taube. San Francisco: Precolumbia Mesoweb Press, 2015.

Houston et al. 2021. Stephen D. Houston, Edwin Román Ramírez, Thomas G. Garrison, David Stuart, Héctor Escobedo Ayala, and Pamela Rosales. "A Teotihuacan Complex at the Classic Maya City of Tikal, Guatemala." *Antiquity* 95, no. 384 (December 2021). doi:10.15184/aqy.2021.140.

Hull 2011. Kerry Hull. "Ritual and Cosmological Landscapes of the Ch'orti' Maya." In *Ecology, Power, and Religion in Maya Landscapes: 11th European Maya Conference, Malmö University, December 2006*, edited by Bodil Lijefors and Christian Isendahl, pp. 159–66. Acta Mesoamericana 23. Markt Schwaben, Germany: Saurwein, 2011.

Hutson and Ardren 2020. Scott R. Hutson and Traci Ardren, eds. *The Maya World*. New York: Routledge, 2020.

Hvidtfeldt 1958. Arild Hvidtfeldt. *Teotl and 'Ixiptlatli: Some Central Conceptions in Ancient Mexican Religion; With a General Introduction on Cult and Myth*. Copenhagen: Munksgaard, 1958.

Ichikawa 2021. Akira Ichikawa. "Human Responses to the Ilopango Tierra Blanca Joven Eruption: Excavations at San Andrés, El Salvador." *Antiquity: First View* (2021), pp. 1–15. doi:10.15184/aqy.2021.21.

Ichon 1977. Alain Ichon. *Les sculptures de La Lagunita, El Quiché, Guatemala*. Paris: Centre National de la Recherche Scientifique, Institut d'Ethnologie, 1977.

Iniciativa de ley de lugares sagrados 2012. *Iniciativa de ley de lugares sagrados de los pueblos indígenas, no. 3835: En el marco del nuevo ciclo maya oxlajuj b'aqtun*. Guatemala City: Conferencia Nacional Oxlajuj Ajpop; Ministerio de Cultura y Deporte; Maya' N'aoj, 2012.

Inomata et al. 2021. Takeshi Inomata, Juan Carlos Fernandez-Diaz, Daniela Triadan, Miguel García Mollinedo, Flory Pinzón, Melina García Hernández, Atasta Flores, Ashley Sharpe, Timothy Beach, Gregory W. L. Hodgins, Juan Javier Durón Díaz, Antonio Guerra Luna, Luis Guerrero Chávez, María de Lourdes Hernández Jiménez, and Manuel Moreno Díaz. "Origins and Spread of Formal Ceremonial Complexes in the Olmec and Maya Regions Revealed by Airborne Lidar." *Nature Human Behaviour* 5 (2021), pp. 1487–1501.

Ishihara, K. Taube, and Awe 2006. Reiko Ishihara, Karl A. Taube, and Jaime J. Awe. "The Water Lily Serpent Stucco Masks at Caracol, Belize." In *Archaeological Investigations in the Eastern Maya Lowlands: Papers of the 2005 Belize Archaeology Symposium*, edited by John Morris, Sherilyne Jones, Jaime J. Awe, and Christophe Helmke, pp. 213–23. Research Reports in Belizean Archaeology 3. Belmopan, Belize: Institute of Archaeology, National Institute of Culture and History, 2006.

Ishihara-Brito and K. Taube 2012. Reiko Ishihara-Brito and Karl A. Taube. "Mosaic Mask." In Pillsbury et al. 2012, pp. 464–74.

Jensen and Caine 2021. Cody H. Jensen and Nancy G. Caine. "Preferential Snake Detection in a Simulated Ecological Experiment." *American Journal of Physical Anthropology* 175, no. 4 (August 2021), pp. 895–904.

G. Jones 1998. Grant D. Jones. *The Conquest of the Last Maya Kingdom*. Stanford, Calif.: Stanford University Press, 1998.

Joyce 1932. Thomas A. Joyce. "Presidential Address: The 'Eccentric Flints' of Central America." *Journal of the Royal Anthropological Institute of Great Britain and Ireland* 62 (January–June 1932), pp. xvii–xxvi.

Just 2012. Bryan Just. *Dancing into Dreams: Maya Vase Painting of the Ik' Kingdom*. With contributions by Christina T. Halperin, Antonia E. Foias, and Sarah Nunberg. Exh. cat. Princeton, N.J.: Princeton University Art Museum, 2012.

Kamen 2010. Henry Kamen. *The Escorial: Art and Power in the Renaissance*. New Haven: Yale University Press, 2010.

Kaufman and Norman 1984. Terrence S. Kaufman and William M. Norman. "An Outline of Proto-Cholan Phonology, Morphology, and Vocabulary." In *Phoneticism in Mayan Hieroglyphic Writing*, edited by John S. Justeson and Lyle Campbell, pp. 77–166. Publication 9. Albany: Institute for Mesoamerican Studies, State University of New York at Albany, 1984.

Kettunen 2019. Harri Kettunen. "On Men, Animals, and Supernatural Beings in Ancient Maya Iconography." In *Animals and Their Relation to Gods, Humans and Things in the Ancient World*, edited by Raija Mattila, Sanae Ito, and Sebastian Fink, pp. 249–300. Studies in Universal and Cultural History / Universal- und Kulturhistorische Studien. Wiesbaden: Springer Fachmedien, 2019.

Kettunen et al. 2018. Harri Kettunen, Verónica Amellali Vázquez López, Felix A. Kupprat, Cristina Vidal Lorenzo, Gaspar Muñoz Cosme, and María Josefa Iglesias Ponce de León, eds. *Tiempo detenido, tiempo suficiente: Ensayos y narraciones mesoamericanistas en homenaje a Alfonso Lacadena García-Gallo*. Wayeb Publication 1. Couvin, Belgium: European Association of Mayanists Wayeb, 2018.

Kidder 1947. Alfred V. Kidder. *The Artifacts of Uaxactun, Guatemala*. Publication 576. Washington, D.C.: Carnegie Institution of Washington, 1947.

Kidder, Jennings, and Shook 1946. Alfred V. Kidder, Jesse D. Jennings, and Edwin M. Shook. *Excavations at*

Kaminaljuyu, Guatemala. Publication 561. Washington, D.C.: Carnegie Institution of Washington, 1946.

Kieran 2005. Mathew Kieran, ed. *Contemporary Debates in Aesthetics and the Philosophy of Art.* Contemporary Debates in Philosophy. Malden, Mass.: Blackwell, 2005.

Knowlton 2010. Timothy W. Knowlton. *Maya Creation Myths: Words and Worlds of the Chilam Balam.* Mesoamerican Worlds. Boulder: University Press of Colorado, 2010.

Knub, Thune, and Helmke 2009. Julie Nehammer Knub, Simone Thune, and Christophe Helmke. "The Divine Right of Kings: An Analysis of Classic Maya Impersonation Statements." In Le Fort et al. 2009, pp. 177–95.

Kotz 1997. Suzanne Kotz, ed. *Dallas Museum of Art: A Guide to the Collection.* Dallas: Dallas Museum of Art, 1997.

Kupprat forthcoming. Felix A. Kupprat. "Las expresiones implícitas de la personificación de dioses en textos e imágenes mayas del periodo clásico." In Salazar Lama and Valencia Rivera forthcoming.

Kuznar 2001. Lawrence A. Kuznar. "An Introduction to Andean Religious Ethnoarchaeology: Preliminary Results and Future Directions." In *Ethnoarchaeology of Andean South America: Contributions to Archaeological Method and Theory*, edited by Lawrence A. Kuznar, pp. 38–66. Ethnoarchaeological Series 4. Ann Arbor, Mich.: International Monographs in Prehistory, 2001.

Lacadena 2010. Alfonso Lacadena. "Historical Implications of the Presence of Non-Mayan Linguistic Features in the Maya Script." In *The Maya and Their Neighbours: Internal and External Contacts through Time; Proceedings of the 10th European Maya Conference, Leiden, December 9–10, 2005*, edited by Laura van Broekhoven, Rogelio Valencia Rivera, Benjamin Vis, and Frauke Sachse, pp. 29–39. Acta Mesoamericana 22. Markt Schwaben, Germany: Saurwein, 2010.

LaGamma 2002. Alisa LaGamma. *Genesis: Ideas of Origins in African Sculpture.* Exh. cat. New York: The

Metropolitan Museum of Art; New Haven: Yale University Press, 2002.

Landa 1941. Diego de Landa. *Landa's Relación de las Cosas de Yucatan: A Translation.* Edited and with notes by Alfred M. Tozzer. Papers of the Peabody Museum of American Archaeology and Ethnology 18. Cambridge, Mass.: Peabody Museum of American Archaeology and Ethnology, Harvard University, 1941.

Landa 1982. Diego de Landa. *Relación de las cosas de Yucatan.* With introduction by Angel María Garibay K. Mexico City: Porrúa, 1982.

Lavy 2003. Paul A. Lavy. "As in Heaven, So on Earth: The Politics of Visnu, Śiva, and Harihara Images in Preangkorian Khmer Civilisation." *Journal of Southeast Asian Studies* 34, no. 1 (February 2003), pp. 21–39.

Le Fort et al. 2009. Geneviève Le Fort, Raphaël Gardiol, Sebastian Matteo, and Christophe Helmke, eds. *The Maya and Their Sacred Narratives: Text and Context in Maya Mythologies; Proceedings of the 12th European Maya Conference, Geneva, December 7–8, 2007.* Acta Mesoamericana 20. Markt Schwaben, Germany: Saurwein, 2009.

Linné 2003. Sigvald Linné. *Mexican Highland Cultures: Archaeological Researches at Teotihuacan, Calpulalpan, and Chalchicomula in 1934–35.* With foreword by Staffan Brunius and introduction by George L. Cowgill. Tuscaloosa: University of Alabama Press, 2003.

Looper 1999. Matthew G. Looper. "New Perspectives on the Late Classic Political History of Quirigua, Guatemala." *Ancient Mesoamerica* 10, no. 2 (July 1999), pp. 263–80.

Looper 2003. Matthew G. Looper. *Lightning Warrior: Maya Art and Kingship at Quirigua.* 1st ed. Linda Schele Series in Maya and Pre-Columbian Studies. Austin: University of Texas Press, 2003.

Looper 2009. Matthew G. Looper. *To Be Like Gods: Dance in Ancient Maya Civilization.* Linda Schele Series in Maya and Pre-Columbian Studies. Austin: University of Texas Press, 2009.

Looper 2019. Matthew G. Looper. *The Beast Between: Deer in Maya Art and*

Culture. Linda Schele Series in Maya and Pre-Columbian Studies. Austin: University of Texas Press, 2019.

López Austin 1993. Alfredo López Austin. *Myths of the Opossum: Pathways of Mesoamerican Mythology.* Translated by Bernard R. Ortiz de Montellano and Thelma Ortiz de Montellano. Albuquerque: University of New Mexico Press, 1993.

López Austin 1994. Alfredo López Austin. *Tamoanchan y Tlalocan.* 1st ed. Sección de Obras de Antropología. Mexico City: Fondo de Cultura Económica, 1994. English ed., *Tamoanchan, Tlalocan: Places of Mist*, University Press of Colorado, Niwot, 1997.

López Austin 1997. Alfredo López Austin. "Cuando Cristo andaba de milagros: La innovación de un mito colonial." In Noguez and López Austin 1997, pp. 231–54.

López Austin 2014. Alfredo López Austin. *Calendario, astronomía y cosmovisión: El conocimiento mesoamericano.* Vol. 1. Antologías de la Revista Ciencias 3. Mexico City: Universidad Nacional Autónoma de México; Siglo Veintiuno, 2014.

López Austin and López Luján 1999. Alfredo López Austin and Leonardo López Luján. *Mito y realidad de Zuyuá: Serpiente emplumada y las transformaciones mesoamericanas del clásico al posclásico.* Sección de Obras de Historia, Serie Ensayos. Mexico City: Colegio de México, Fideicomiso Historia de las Américas; Fondo de Cultura Económica, 1999.

López Austin and López Luján 2009. Alfredo López Austin and Leonardo López Luján. *Monte sagrado: Templo Mayor.* Mexico City: Instituto Nacional de Antropología e Historia; Universidad Nacional Autónoma de México, Instituto de Investigaciones Antropológicas, 2009.

López Luján 1993. Leonardo López Luján. *Las ofrendas del Templo Mayor de Tenochtitlan.* Mexico City: Instituto Nacional de Antropología e Historia, 1993.

López Luján 2005. Leonardo López Luján. *The Offerings of the Templo Mayor of*

Tenochtitlan. Translated by Bernard R. Ortiz de Montellano and Thelma Ortiz de Montellano. Albuquerque: University of New Mexico Press, 2005.

López Oliva 2015. Macarena S. López Oliva. "Las personificaciones de dioses y seres sobrenaturales de Yaxchilán." In "Dossier: Cerros e iglesias; Estudios sobre religiosidad popular en los Andes." Special issue, *Revista española de antropología americana* 45, no. 2 (December 2015), pp. 313–34.

Lothrop 1952. Samuel K. Lothrop. *Metals from the Cenote of Sacrifice, Chichen Itza, Yucatan*. Memoirs of the Peabody Museum of Archaeology and Ethnology 10, no. 2. Cambridge, Mass.: Peabody Museum of Archaeology and Ethnology, Harvard University, 1952.

Loughmiller-Cardinal and Eppich 2019. Jennifer A. Loughmiller-Cardinal and Keith Eppich, eds. *Breath and Smoke: Tobacco Use among the Maya*. With foreword by John E. Staller. Albuquerque: University of New Mexico Press, 2019.

Lounsbury 1980. Floyd G. Lounsbury. "Some Problems in the Interpretation of the Mythological Portion of the Hieroglyphic Text of the Temple of the Cross at Palenque." In *Third Palenque Round Table, 1978; Part 2: Proceedings of the Tercera Mesa Redonda de Palenque, June 11–18, 1978*, edited by Merle Greene Robertson, pp. 99–115. Palenque Round Table 5. Austin: University of Texas Press, 1980.

Lovell and Lutz 2013. W. George Lovell and Christopher H. Lutz, with Wendy Kramer and William R. Swezey. *"Strange Lands and Different Peoples": Spaniards and Indians in Colonial Guatemala*. Civilization of the American Indian 271. Norman: University of Oklahoma Press, 2013.

Lowe 1982. Gareth W. Lowe. "Izapa Religion, Cosmology, and Ritual." In Gareth W. Lowe, Thomas A. Lee Jr., and Eduardo Martinez Espinosa, *Izapa: An Introduction to the Ruins and Monuments*, pp. 269–306. Papers of the New World Archaeological Foundation 31. Provo, Utah: New World Archaeological Foundation, Brigham Young University, 1982.

Maler 1903. Teobert Maler. *Researches in the Central Portion of the Usumatsintla Valley: Report of Explorations for the Museum, 1898–1900*. Part 2. Memoirs of the Peabody Museum of American Archaeology and Ethnology 2, no. 2. Cambridge, Mass.: Peabody Museum of American Archaeology and Ethnology, Harvard University, 1903.

S. Martin 1996. Simon Martin. "Tikal's 'Star War' against Naranjo." In *Eighth Palenque Round Table, 1993*, edited by Merle Greene Robertson, Martha Macri, and Jan McHargue, pp. 223–36. Palenque Round Table 10. San Francisco: Pre-Columbian Art Research Institute, 1996.

S. Martin 2000. Simon Martin. "Nuevos datos epigráficos sobre la guerra maya del clásico." In *La guerra entre los antiguos mayas: Memoria de la primera mesa redonda de Palenque*, edited by Silvia Trejo, pp. 105–24. Mexico City: Consejo Nacional para la Cultura y las Artes (CONACULTA); Instituto Nacional de Antropología e Historia, 2000.

S. Martin 2002. Simon Martin. "The Baby Jaguar: An Exploration of Its Identity and Origins in Maya Art and Writing." In *La organización social entre los mayas: Memoria de la tercera mesa redonda de Palenque*, edited by Vera Tiesler Blos, Rafael Cobos, and Merle Greene Robertson, vol. 1, pp. 49–78. Mexico City: Instituto Nacional de Antropología e Historia; Mérida, Mexico: Universidad Autónoma de Yucatán, 2002.

S. Martin 2006. Simon Martin. "Cacao in Ancient Maya Religion: First Fruit from the Maize Tree and Other Tales from the Underworld." In *Chocolate in Mesoamerica: A Cultural History of Cacao*, edited by Cameron L. McNeil, pp. 154–83. Gainesville: University Press of Florida, 2006.

S. Martin 2015. Simon Martin. "The Old Man of the Maya Universe: A Unitary Dimension to Ancient Maya Religion." In *Maya Archaeology*, edited by Charles Golden, Stephen D. Houston, and Joel Skidmore, vol. 3, pp. 186–227. San Francisco: Precolumbia Mesoweb Press, 2015.

S. Martin 2020. Simon Martin. *Ancient Maya Politics: A Political Anthropology of the Classic Period, 150–900 CE*. Cambridge, U.K.: Cambridge University Press, 2020.

S. Martin 2021. Simon Martin. "The Long Twilight of the Tikal Dynasty: What Ninth-Century Tikal, Zacpeten, Ixlu, and Jimbal Tell Us about the Classic Maya Collapse." Unpublished manuscript, 2021.

S. Martin and Grube 2002. Simon Martin and Nikolai Grube. *Crónica de los reyes y reinas mayas: La primera historia de las dinastías mayas*. Barcelona: Crítica, 2002.

S. Martin and Grube 2008. Simon Martin and Nikolai Grube. *Chronicle of the Maya Kings and Queens: Deciphering the Dynasties of the Ancient Maya*. 2nd ed. London: Thames and Hudson, 2008.

S. Martin, Houston, and Zender 2015. Simon Martin, Stephen D. Houston, and Marc Zender. "Sculptors and Subjects: Notes on the Incised Text of Calakmul Stela 51." *Maya Decipherment: Ideas on Ancient Maya Writing and Iconography, Boundary End Archaeological Research Center*, January 7, 2015. https://mayadecipherment.com/2015/01/07/sculptors-and-subjects-notes-on-the-incised-text-of-calakmul-stela-51.

Mathews 2001. Peter Mathews. "Notes on the Inscriptions on the Back of Dos Pilas Stela 8." In Houston, Chinchilla Mazariegos, and D. Stuart 2001, pp. 394–415.

Mathews and Justeson 1984. Peter Mathews and John S. Justeson. "Patterns of Sign Substitution in Maya Hieroglyphic Writing: 'The Affix Cluster.'" In *Phoneticism in Mayan Hieroglyphic Writing*, edited by John S. Justeson and Lyle Campbell, pp. 185–231. Publication 9. Albany: Institute for Mesoamerican Studies, State University of New York at Albany, 1984.

Mathiowetz and Turner 2021. Michael D. Mathiowetz and Andrew D. Turner, eds. *Flower Worlds: Religion, Aesthetics, and Ideology in Mesoamerica and the American Southwest*. Tucson: University of Arizona Press, 2021.

Matos Moctezuma and Ochoa Peralta 2017. Eduardo Matos Moctezuma and Angela Ochoa Peralta, eds. *Del saber ha hecho su razón de ser: Homenaje a Alfredo López Austin.* 2 vols. Mexico City: Secretaría de Cultura; Instituto Nacional de Antropología e Historia; Universidad Nacional Autónoma de México, Coordinación de Humanidades, Instituto de Investigaciones Antropológicas, 2017.

Matsumoto 2013. Mallory E. Matsumoto. "Reflection as Transformation: Mirror-Image Structure on Maya Monumental Texts as a Visual Metaphor for Ritual Participation." *Estudios de cultura maya* 41, no. 1 (2013), pp. 93–128.

Matsumoto et al. 2021. Mallory E. Matsumoto, Andrew K. Scherer, Charles Golden, and Stephen D. Houston. "Sculptural Traditionalism and Innovation in the Classic Maya Kingdom of Sak Tz'i', Mexico." *Ancient Mesoamerica* (September 2021), pp. 1–24. doi:10.1017/S0956536121000316.

Mauricio, Hansen, and Guenter 2016. Douglas Mauricio, Richard Hansen, and Stanley Guenter. "Las cabezas de estuco recuperadas en el grupo Casa del Coral, El Mirador, Petén, Guatemala." In *XXIX simposio de investigaciones arqueológicas en Guatemala, Museo nacional de arqueología y etnología, 20 al 24 de julio de 2015*, edited by Bárbara Arroyo, Luis Méndez Salinas, and Gloria Ajú Álvarez, vol. 2, pp. 761–70. Guatemala City: Museo Nacional de Arqueología y Etnología, 2016.

Maxwell and R. Hill 2006. Judith M. Maxwell and Robert M. Hill II, eds. and trans. *Kaqchikel Chronicles: The Definitive Edition.* 1st ed. Austin: University of Texas Press, 2006.

McAnany 2014. Patricia A. McAnany. *Living with the Ancestors: Kinship and Kingship in Ancient Maya Society.* 2nd ed. New York: Cambridge University Press, 2014.

McAnany and Plank 2001. Patricia A. McAnany and Shannon E. Plank. "Perspectives on Actors, Gender Roles, and Architecture at Classic Maya Courts and Households." In *Royal Courts of the Ancient Maya*, edited by Takeshi Inomata and Stephen D. Houston, vol. 1, pp. 84–129. Boulder, Colo.: Westview, 2001.

McGee 1990. R. Jon McGee. *Life, Ritual, and Religion among the Lacandon Maya.* Belmont, Calif.: Wadsworth, 1990.

McKillop 2004. Heather McKillop. *The Ancient Maya: New Perspectives.* Understanding Ancient Civilizations. Santa Barbara, Calif.: ABC-CLIO, 2004.

McMahon 2016. Keith McMahon. *Celestial Women: Imperial Wives and Concubines in China from Song to Qing.* Lanham, Md.: Rowman and Littlefield, 2016.

Mendelson 1965. E. Michael Mendelson. *Los escándalos de Maximón: Un estudio sobre la religión y la visión del mundo en Santiago Atitlán.* Translated by Julio Vielman. Seminario de Integración Social Guatemalteca Publicación 19. Guatemala City: Tipografía Nacional, 1965.

Milbrath 1999. Susan Milbrath. *Star Gods of the Maya: Astronomy in Art, Folklore, and Calendars.* Linda Schele Series in Maya and Pre-Columbian Studies. Austin: University of Texas Press, 1999.

Miles 1957. Susanna W. Miles. "The Sixteenth-Century Pokom-Maya: A Documentary Analysis of Social Structure and Archaeological Setting." *Transactions of the American Philosophical Society*, n.s., 47, no. 4 (November 1957), pp. 733–81.

Miller 2019. Mary Ellen Miller. "Molding Maya Practice: Standardization and Innovation in the Making of Jaina Figurines." *RES: Anthropology and Aesthetics* 71–72 (Spring–Autumn 2019), pp. 40–51.

Miller and Brittenham 2013. Mary Ellen Miller and Claudia Brittenham. *The Spectacle of the Late Maya Court: Reflections on the Murals of Bonampak.* With new reconstruction paintings by Heather Hurst and Leonard Ashby for the Bonampak Documentation Project. William and Bettye Nowlin Series in Art, History, and Culture of the Western Hemisphere. Austin: University of Texas Press, 2013.

Miller and S. Martin 2004. Mary Ellen Miller and Simon Martin. *Courtly Art of the Ancient Maya.* Exh. cat. San Francisco: Fine Arts Museums of San Francisco; New York: Thames and Hudson, 2004.

Miller and K. Taube 1993. Mary Ellen Miller and Karl A. Taube. *The Gods and Symbols of Ancient Mexico and the Maya: An Illustrated Dictionary of Mesoamerican Religion.* London: Thames and Hudson, 1993.

Moholy-Nagy 2008. Hattula Moholy-Nagy with William R. Coe. *The Artifacts of Tikal: Ornamental and Ceremonial Artifacts and Unworked Material.* University Museum Monograph 127; Tikal Report 27, pt. A. Philadelphia: University of Pennsylvania Museum of Archaeology and Anthropology, 2008.

Moyes, Christenson, and Sachse 2021. Holly Moyes, Allen J. Christenson, and Frauke Sachse, eds. *The Myths of the Popol Vuh in Cosmology, Art, and Ritual.* Boulder: University Press of Colorado, 2021.

Navarrete 2011. Federico Navarrete. "Writing, Images, and Time-Space in Aztec Monuments and Books." In *Their Way of Writing: Scripts, Signs, and Pictographies in Pre-Columbian America*, edited by Elizabeth Hill Boone and Gary Urton, pp. 175–95. Dumbarton Oaks Pre-Columbian Symposia and Colloquia. Washington, D.C.: Dumbarton Oaks Research Library and Collection, 2011.

Nichols and Pool 2012. Deborah L. Nichols and Christopher A. Pool. *The Oxford Handbook of Mesoamerican Archaeology.* Oxford: Oxford University Press, 2012.

Nicholson 1971. Henry B. Nicholson. "Religion in Pre-Hispanic Mexico." In *The Archaeology of Northern Mesoamerica*, edited by Gordon F. Ekkholm and Ignacio Bernal, pt. 1, pp. 395–446. Handbook of Middle American Indians 10. Austin: University of Texas Press, 1971.

Nielsen et al. 2019. Jesper Nielsen, Christophe Helmke, David Stuart, and Angel A. Sánchez Gamboa. "'Off With His Head!': A Heretofore Unknown Monument of Tonina, Chiapas." *PARI Journal* 20, no. 1 (Summer 2019), pp. 1–16.

Nielsen et al. 2021. Jesper Nielsen, Karl A. Taube, Christophe Helmke, and Héctor Escobedo. "Blowgunners and the Great

Bird at Teotihuacan: Mesoamerican Myths in a Comparative Perspective." In Moyes, Christenson, and Sachse 2021, pp. 295–314.

Noguez and López Austin 1997. Xavier Noguez and Alfredo López Austin, eds. *De hombres y dioses.* Zamora de Hidalgo, Mexico: El Colegio de Michoacán; Zinacantepec, Mexico: El Colegio Mexiquense, 1997.

Nuku 2019. Maia Nuku. "Atea: Nature and Divinity in Polynesia." *The Metropolitan Museum of Art Bulletin* 76, no. 3 (Winter 2019).

Ochoa Cabrera, C. Cortés Hernández, and N. Cortés Hernández 1998. José Antonio Ochoa Cabrera, Claudia Linda Cortés Hernández, and Nancy Cortés Hernández. *Los oficios de K'ayom: Música hach winik (lacandona).* 1st ed. Mexico City: Grupo Luvina; FONCA, 1998.

Oliver 2009. José R. Oliver. *Caciques and Cemí Idols: The Web Spun by Taíno Rulers between Hispaniola and Puerto Rico.* Caribbean Archaeology and Ethnohistory. Tuscaloosa: University of Alabama Press, 2009.

Olivier 2003. Guilhem Olivier. *Mockeries and Metamorphoses of an Aztec God: Tezcatlipoca, "Lord of the Smoking Mirror."* Translated by Michel Besson. Mesoamerican Worlds. Boulder: University Press of Colorado, 2003.

Olivier 2019. Guilhem Olivier. "*Teotl* and *Diablo*: Indigenous and Christian Conceptions of Gods and Devils in the Florentine Codex." In *The Florentine Codex: An Encyclopedia of the Nahua World in Sixteenth-Century Mexico,* edited by Jeanette Favrot Peterson and Kevin Terraciano, pp. 110–24. Austin: University of Texas Press, 2019.

Olivier 2020. Guilhem Olivier. "'Jesucristo murió porque se le pasaron las copas': Apuntes sobre la influencia cristiana en los mitos mesoamericanos y sobre el método comparativo para su estudio; Respuesta a Michel Oudijk / 'Jesus Christ Died because He Was Intoxicated': Notes on Christian Influence in Mesoamerican Myths and on the Comparative Method for Its Study; Response to Michel Oudijk." *Estudios de cultura náhuatl* 60 (July–December 2020), pp. 77–119.

O'Neil 2012. Megan E. O'Neil. *Engaging Ancient Maya Sculpture at Piedras Negras, Guatemala.* Norman: University of Oklahoma Press, 2012.

O'Neil 2019. Megan E. O'Neil. "The Painter's Line on Paper and Clay: Maya Codices and Codex-Style Vessels from the Seventh to the Sixteenth Centuries." In *Toward a Global Middle Ages: Encountering the World through Illuminated Manuscripts,* edited by Bryan C. Keene, pp. 125–36. Los Angeles: J. Paul Getty Museum, 2019.

Pallán Goyol 2009. Carlos Pallán Goyol. "The Many Faces of Chaahk: Exploring the Role of a Complex and Fluid Entity within Myth, Religion and Politics." In Le Fort et al. 2009, pp. 17–40.

Pastor and Cherofsky 2020. Diana Pastor and Jess Cherofsky. "Celebrating the Life of Tata Domingo Choc Che and Demanding Justice for His Assassination." *Cultural Survival,* June 23, 2020, www.culturalsurvival.org/news /celebrating-life-tata-domingo-choc -che-and-demanding-justice-his -assassination.

Pasztory 1973. Esther Pasztory. "The Gods of Teotihuacan: A Synthetic Approach in Teotihuacan Iconography." In *Atti del XL congresso internazionale degli americanisti: Roma–Genova, 3–10 settembre 1972,* edited by Ernesta Cerulli, vol. 1, pp. 147–59. Genoa: Tilgher, 1973.

Patch 2011. Diana Craig Patch. *Dawn of Egyptian Art.* With essays by Marianne Eaton-Krauss, Renée Friedman, Ann Macy Roth, and David P. Silverman and contributions from Susan J. Allen, Emilia Cortes, Catherine H. Roehrig, and Anna Serotta. Exh. cat. New York: The Metropolitan Museum of Art, 2011.

Pereira 2014. Grégory Pereira. "La mort et les rites: Mises en scène funéraries dans les basses terres mayas." In *Mayas: Révélation d'un temps sans fin,* edited by Dominique Michelet, pp. 77–81. Exh. cat. Paris: Musée du Quai Branly; Réunion des Musées Nationaux, Grand Palais, 2014.

Pérez de Arce 2006. José Pérez de Arce. "Whistling Bottles: Sound, Mind and Water." In *Music Archaeology in Context: Archaeological Semantics, Historical Implications, Socio-Cultural Connotations; Papers from the 4th Symposium of the International Study Group on Music Archaeology at Monastery Michaelstein, 19–26 September, 2004 / Musikarchäologie im Kontext: Archäologische Befunde, historische Zusammenhänge, soziokulturelle Beziehungen; Vorträge des 4. Symposiums der internationalen Studiengruppe Musikarchäologie im Kloster Michaelstein, 19.–26. September 2004,* edited by Ellen Hickmann, Arnd Adje Both, and Ricardo Eichmann, pp. 1–22. Studien zur Musikarchäologie 5. Rahden, Germany: Marie Leidorf, 2006.

Pérez Suárez 1997. Tomás Pérez Suárez. "Los olmecas y los dioses del maíz en Mesoamérica." In Noguez and López Austin 1997, pp. 17–58.

Pillsbury, Potts, and Richter 2017. Joanne Pillsbury, Tim Potts, and Kim N. Richter, eds. *Golden Kingdoms: Luxury Arts in the Ancient Americas.* Exh. cat. Los Angeles: J. Paul Getty Museum; Getty Research Institute, 2017.

Pillsbury et al. 2012. Joanne Pillsbury, Miriam Doutriaux, Reiko Ishihara-Brito, and Alexandre Tokovinine, eds. *Ancient Maya Art at Dumbarton Oaks.* Pre-Columbian Art at Dumbarton Oaks 4. Washington, D.C.: Dumbarton Oaks Research Library and Collection, 2012.

Pitarch Ramón 1996. Pedro Pitarch Ramón. *Ch'ulel: Una etnografía de las almas tzeltales.* 1st ed. Mexico City: Fondo de Cultura Económica, 1996.

Platt 2011. Verity Platt. *Facing the Gods: Epiphany and Representation in Graeco-Roman Art, Literature, and Religion.* Greek Culture in the Roman World. Cambridge, U.K.: Cambridge University Press, 2011.

Plunket and Uruñuela 1998. Patricia Plunket and Gabriela Uruñuela. "Preclassic Household Patterns Preserved under Volcanic Ash at Tetimpa, Puebla, Mexico." *Latin American Antiquity* 9, no. 4 (December 1998), pp. 287–309.

J. Pohl and Lyons 2010. John M. D. Pohl and Claire L. Lyons. *The Aztec Pantheon and the Art of Empire.* Exh. cat. Los Angeles: J. Paul Getty Museum, 2010.

M. Pohl, Pope, and Von Nagy 2002. Mary E. D. Pohl, Kevin O. Pope, and Christopher von Nagy. "Olmec Origins of Mesoamerican Writing." *Science* 298, no. 5600 (December 6, 2002), pp. 1984–87.

Porter 2000. Barbara Nevling Porter, ed. *One God or Many? Concepts of Divinity in the Ancient World.* Transactions of the Casco Bay Assyriological Institute 1. Chebeague, Maine: Casco Bay Assyriological Institute, 2000.

Prager 2013. Christian M. Prager. "Übernatürliche Akteure in der klassischen Maya-Religion: Eine Untersuchung zu intrakultureller Variation und Stabilität am Beispiel des *k'uh* 'Götter'-Konzepts in den religiösen Vorstellungen und Überzeugungen klassischer Maya-Eliten (250–900 n.Chr.)." PhD diss., University of Bonn, 2013.

Prager 2018. Christian M. Prager. "A Study of the Classic Maya *k'uh* Concept." In Kettunen et al. 2018, pp. 547–611.

Prufer, Robinson, and Kennett 2021. Keith M. Prufer, Mark Robinson, and Douglas J. Kennett. "Terminal Pleistocene through Middle Holocene Occupations in Southeastern Mesoamerica: Linking Ecology and Culture in the Context of Neotropical Foragers and Early Farmers." *Ancient Mesoamerica* 32, no. 3 (Fall 2021), pp. 439–60.

Quenon and Le Fort 1997. Michel Quenon and Geneviève Le Fort. "Rebirth and Resurrection in Maize God Iconography." In *The Maya Vase Book: A Corpus of Rollout Photographs of Maya Vases,* vol. 5, edited by Justin Kerr, pp. 884–902. New York: Kerr Associates, 1997.

Quiñones Keber 1988. Eloise Quiñones Keber. "Deity Images and Texts in the Primeros Memoriales and Florentine Codex." In *The Work of Bernardino de Sahagún: Pioneer Ethnographer of Sixteenth-Century Aztec Mexico,* edited by J. Jorge Klor de Alva, Henry B. Nicholson, and Eloise Quiñones Keber, pp. 255–72. Studies on Culture and

Society 2. Albany: Institute for Mesoamerican Studies, University at Albany, State University of New York, 1988.

Quirke 2015. Stephen Quirke. *Exploring Religion in Ancient Egypt.* Blackwell Ancient Religions. Chichester, U.K.: John Wiley and Sons, 2015.

Recinos 2001. Adrián Recinos. *Crónicas indígenas de Guatemala.* Publicación Especial 38. Guatemala City: Academia de Geografía e Historia, 2001.

Reents-Budet 1991. Dorie Reents-Budet. "The 'Holmul Dancer' Theme in Maya Art." In *Sixth Palenque Round Table, 1986,* edited by Merle Greene Robertson and Virginia M. Fields, pp. 217–22. Palenque Round Table 8. Norman: University of Oklahoma Press, 1991.

Reinhard 1985. Johan Reinhard. "Sacred Mountains: An Ethno-Archaeological Study of High Andean Ruins." *Mountain Research and Development* 5, no. 4 (1985), pp. 299–317.

Restall 1999. Matthew Restall. *The Maya World: Yucatec Culture and Society, 1550–1850.* Stanford, Calif.: Stanford University Press, 1999.

P. Rice and D. Rice 2009. Prudence M. Rice and Don S. Rice, eds. *The Kowoj: Identity, Migration, and Geopolitics in Late Postclassic Petén, Guatemala.* Mesoamerican Worlds: From the Olmecs to the Danzantes. Boulder: University Press of Colorado, 2009.

Ringle 1988. William M. Ringle. *Of Mice and Monkeys: The Value and Meaning of T1016, the God C Hieroglyph.* Research Reports on Maya Writing 18. Washington, D.C.: Center for Maya Research, 1988.

Robb 2017. Matthew Robb, ed. *Teotihuacan: City of Water, City of Fire.* Exh. cat. San Francisco: Fine Arts Museums of San Francisco; Berkeley: University of California Press, 2017.

M. Robertson 2011. Merle Greene Robertson. "The Celestial God of Number 13." *PARI Journal* 12, no. 1 (Summer 2011), pp. 1–6.

Robicsek 1978. Francis Robicsek. *The Smoking Gods: Tobacco in Maya Art, History, and Religion.* With foreword by Michael D. Coe and Barbara A.

Goodnight. Norman: University of Oklahoma Press, 1978.

Rodríguez Alvarez 2008. Angel Rodríguez Alvarez, ed. *Mitología taína o eyeri: Ramón Pané y la relación sobre las antigüedades de los indios; El primer tratado etnográfico hecho en América.* San Juan, Puerto Rico: Nuevo Mundo, 2008.

Roys 1967. Ralph L. Roys. *The Book of Chilam Balam of Chumayel.* With introduction by J. Eric S. Thompson. Norman: University of Oklahoma Press, 1967.

Sachse 2008. Frauke Sachse. "Over Distant Waters: Places of Origin and Creation in Colonial K'iche'an Sources." In *Pre-Columbian Landscapes of Creation and Origin,* edited by John E. Staller, pp. 123–60. New York: Springer, 2008.

Sahagún, Bernardino de. See **Bernardino**.

Salazar Lama 2019. Daniel Salazar Lama. "Escultura integrada en la arquitectura maya: Tradición y retórica en la representación de los gobernantes (400 A.E.C.–600 E.C.)." PhD diss., Universidad Nacional Autónoma de México, Mexico City, 2019.

Salazar Lama forthcoming a. Daniel Salazar Lama. *El renacer de los reyes: Imagen, contexto y significado del friso de Balamku, Campeche.* Paris Monographs in American Archaeology. Oxford: Archaeopress, forthcoming.

Salazar Lama forthcoming b. Daniel Salazar Lama. "Los ojos como un lugar para el significado: Signos y textos oculares en la iconografía maya." In Salazar Lama and Valencia Rivera forthcoming.

Salazar Lama and Valencia Rivera forthcoming. Daniel Salazar Lama and Rogelio Valencia Rivera. *En torno a los códigos mesoamericanos de comunicación visual: La relación entre texto e imagen.* Mexico City: Centro de Estudios Mexicanos y Centroamericanos, forthcoming.

Sam Colop 2008. Luis Enrique Sam Colop, ed. and trans. *Popol Wuj.* Guatemala City: Cholsamaj, 2008.

Sánchez Gamboa, Sheseña, and Yadeun Angulo 2018. Angel A. Sánchez Gamboa, Alejandro Sheseña, and Juan Yadeun Angulo. "Recreando la

inmolación del Dios Jaguar del Inframundo: Tres cautivos de K'ihnich Baaknal Chaahk de Toniná." *Mexicon* 40, no. 1 (February 2018), pp. 8–16.

Sánchez Santiago 2021. Gonzalo Sánchez Santiago. "Las vasijas silbadoras del preclásico en Oaxaca." *Ancient Mesoamerica* 32, no. 2 (Summer 2021), pp. 187–203.

Saturno, D. Stuart, and Beltrán 2006. William A. Saturno, David Stuart, and Boris Beltrán. "Early Maya Writing at San Bartolo, Guatemala." *Science* 311, no. 5765 (2006), pp. 1281–83.

Saturno, K. Taube, and D. Stuart 2005. William Saturno, Karl A. Taube, and David Stuart. *The Murals of San Bartolo, El Petén, Guatemala, Part 1: The North Wall.* With mural drawings by Heather Hurst. Ancient America 7. Barnardsville, N.C.: Center for Ancient American Studies, 2005.

Schele and Freidel 1990. Linda Schele and David A. Freidel. *A Forest of Kings: The Untold Story of the Ancient Maya.* 1st ed. New York: Morrow, 1990.

Schele and Grube 1994. Linda Schele and Nikolai Grube. "Tlaloc-Venus Warfare: The Peten Wars 8.17.0.0.0–9.15.13.0.0." In *Notebook for the XVIIIth Maya Hieroglyphic Workshop at Texas, March 12–13, 1994,* edited by Timothy Albright, pp. 79–165. Austin: University of Texas Press, 1994.

Schele and Miller 1986. Linda Schele and Mary Ellen Miller. *The Blood of Kings: Dynasty and Ritual in Maya Art.* With photographs by Justin Kerr. Fort Worth: Kimbell Art Museum, 1986.

Schellhas 1892. Paul Schellhas. "Die Göttergestalten der Maya-Handschriften." *Zeitschrift für Ethnologie* 24 (1892), pp. 101–21.

Schellhas 1904. Paul Schellhas. *Representations of Deities of the Maya Manuscripts.* Papers of the Peabody Museum of American Archaeology and Ethnology 4, no. 1. Cambridge, Mass.: Peabody Museum of American Archaeology and Ethnology, Harvard University, 1904.

Scherer and Houston 2018. Andrew K. Scherer and Stephen D. Houston. "Blood,

Fire, Death: Covenants and Crises among the Classic Maya." In *Smoke, Flames, and the Human Body in Mesoamerican Ritual Practice,* edited by Vera Tiesler and Andrew K. Scherer, pp. 109–50. Dumbarton Oaks Pre-Columbian Symposia and Colloquia. Washington, D.C.: Dumbarton Oaks Research Library and Collection, 2018.

Schmidt, D. Stuart, and Love 2008. Peter Schmidt, David Stuart, and Bruce Love. "Inscriptions and Iconography of Castillo Viejo, Chichen Itza." *PARI Journal* 9 no. 2 (Fall 2008), pp. 1–17.

Schultze Jena 1954. Leonhard Schultze Jena. *La vida y las creencias de los indígenas quichés de Guatemala.* Translated by Antonio Goubad Carrera and Herbert D. Sapper. Biblioteca de Cultura Popular 49. Guatemala City: Ministerio de Educación Pública, 1954.

Seler 1996. Eduard Seler. *Collected Works in Mesoamerican Linguistics and Archaeology.* Edited by Frank Comparato, J. Eric S. Thompson, and Francis B. Richardson. 6 vols. 2nd ed. Lancaster, Calif.: Labyrinthos, 1996.

Sloane 1974. Florence P. Sloane. "Ideology and the Frontier: A Hypothesis of a Quiché Innovation in Religion." Paper presented at Society for American Archaeology, Washington, D.C., 1974.

Small 1999. Jocelyn Penny Small. "Time in Space: Narrative in Classical Art." *Art Bulletin* 81, no. 4 (December 1999), pp. 562–75.

Smith 1992. Carol A. Smith, ed., with Marilyn M. Moors. *Guatemalan Indians and the State, 1540 to 1988.* Symposia on Latin America. Austin: University of Texas Press, 1992.

Spaeth 2013. Barbette Stanley Spaeth, ed. *The Cambridge Companion to Ancient Mediterranean Religions.* Cambridge Companions to Religion. New York: Cambridge University Press, 2013.

Sparks 2020. Garry G. Sparks. *Rewriting Maya Religion: Domingo de Vico, K'iche' Maya Intellectuals, and the* Theologia Indorum. Louisville: University Press of Colorado, 2020.

Spinden 1975. Herbert J. Spinden. *A Study of Maya Art: Its Subject Matter and*

Historical Development. New York: Dover, 1975. First pub. Peabody Museum of American Archaeology and Ethnology, Harvard University, Cambridge, Mass., 1913.

Staller and Stross 2013. John E. Staller and Brian Stross. *Lightning in the Andes and Mesoamerica: Pre-Columbian, Colonial, and Contemporary Perspectives.* Oxford: Oxford University Press, 2013.

A. Stone 1989. Andrea J. Stone. "Disconnection, Foreign Insignia, and Political Expansion: Teotihuacan and the Warrior Stelae of Piedras Negras." In *Mesoamerica after the Decline of Teotihuacan, AD 700–900,* edited by Richard A. Diehl and Janet Catherine Berlo, pp. 153–72. Washington, D.C.: Dumbarton Oaks Research Library and Collection, 1989.

A. Stone 1995. Andrea J. Stone. *Images from the Underworld: Naj Tunich and the Tradition of Maya Cave Painting.* Austin: University of Texas Press, 1995.

A. Stone and Zender 2011. Andrea J. Stone and Marc Zender. *Reading Maya Art: A Hieroglyphic Guide to Ancient Maya Painting and Sculpture.* New York: Thames and Hudson, 2011.

D. Stuart 1987. David Stuart. *Ten Phonetic Syllables.* Research Reports on Ancient Maya Writing 14. Washington, D.C.: Center for Maya Research, 1987.

D. Stuart 1988. David Stuart. "Blood Symbolism in Maya Iconography." In Benson and Griffin 1988, pp. 175–221.

D. Stuart 1996. David Stuart. "Kings of Stone: A Consideration of Stelae in Ancient Maya Ritual and Representation." *RES: Anthropology and Aesthetics* 29–30 (Spring–Autumn 1996), pp. 148–71.

D. Stuart 1998. David Stuart. "'The Fire Enters His House': Architecture and Ritual in Classic Maya Texts." In Houston 1998b, pp. 373–425.

D. Stuart 2000. David Stuart. "'The Arrival of Strangers': Teotihuacan and Tollan in Classic Maya History." In D. Carrasco, L. Jones, and Sessions 2000, pp. 465–513.

D. Stuart 2003. David Stuart. "On the Paired Variants of *Tz'ak.*" Mesoweb,

2003. www.mesoweb.com/stuart/notes /tzak.pdf.

D. Stuart 2004. David Stuart. "History, Mythology, and Royal Legitimization at Palenque's Temple 19." In Miller and S. Martin 2004, pp. 261–64.

D. Stuart 2005. David Stuart. *The Inscriptions from Temple XIX at Palenque: A Commentary.* San Francisco: Pre-Columbian Art Research Institute, 2005.

D. Stuart 2006. David Stuart. *Sourcebook for the 30th Maya Meetings, March 14–19, 2006.* Austin: Mesoamerica Center, Department of Art and Art History, University of Texas, 2006.

D. Stuart 2007a. David Stuart. "Reading the Water Serpent as *Witz'.*" *Maya Decipherment: Ideas on Ancient Maya Writing and Iconography, Boundary End Archaeological Research Center*, April 13, 2007. https://decipherment.wordpress .com/2007/04/13/reading-the-water -serpent.

D. Stuart 2007b. David Stuart. "The Captives on Piedras Negras, Panel 12." *Maya Decipherment: Ideas on Ancient Maya Writing and Iconography, Boundary End Archaeological Research Center*, August 18, 2007. https://mayadecipherment.com /2007/08/18/the-captives-on-piedras -negras-panel-12.

D. Stuart 2010. David Stuart. "Shining Stones: Observations on the Ritual Meaning of Early Maya Stelae." In *The Place of Stone Monuments: Context, Use, and Meaning in Mesoamerica's Preclassic Transition*, edited by Julia Guernsey, John E. Clark, and Bárbara Arroyo, pp. 283–98. Dumbarton Oaks Pre-Columbian Symposia and Colloquia. Washington, D.C.: Dumbarton Oaks Research Library and Collection, 2010.

D. Stuart 2013. David Stuart. *The Order of Days: The Maya World and the Truth about 2012.* Unabridged ed. New York: Crown, 2013.

D. Stuart 2017. David Stuart. "The Gods of Heaven and Earth: Evidence of Ancient Maya Categories of Deities." In Matos Moctezuma and Ochoa Peralta 2017, vol. 1, pp. 247–67.

D. Stuart 2021. David Stuart. "The *Wahys* of Witchcraft: Sorcery and Political Power among the Classic Maya." In *Sorcery in Mesoamerica*, edited by Jeremy D. Coltman and John M. D. Pohl, pp. 179–205. Louisville: University Press of Colorado, 2021.

D. Stuart and G. Stuart 2008. David Stuart and George Stuart. *Palenque: Eternal City of the Maya.* London: Thames and Hudson, 2008.

D. Stuart, Houston, and J. Robertson 1999. David Stuart, Stephen D. Houston, and John Robertson. *The Proceedings of the Maya Hieroglyphic Workshop: Classic Mayan Language and Classic Maya Gods, March 13–14, 1999, University of Texas at Austin.* Transcribed and edited by Phil Wanyerka. Austin: University of Texas Press, 1999.

D. Stuart, Strauss, and Lopez-Finn 2017. David Stuart, Stephanie Strauss, and Elliot Lopez-Finn. "Art and Writing from the Ancient East: Echoes of the Classic Maya in Aztec-Period Aesthetics." Paper presented at Mesoamerica Meetings, University of Texas at Austin, 2017.

Tarn 1997. Nathaniel Tarn with Martín Prechtel. *Scandals in the House of Birds: Shamans and Priests on Lake Atitlán.* New York: Marsilio, 1997.

Tate 1992. Carolyn E. Tate. *Yaxchilan: The Design of a Maya Ceremonial City.* Austin: University of Texas Press, 1992.

K. Taube 1992. Karl A. Taube. *The Major Gods of Ancient Yucatan.* Studies in Pre-Columbian Art and Archaeology 32. Washington, D.C.: Dumbarton Oaks Research Library and Collection, 1992.

K. Taube 1996. Karl A. Taube. "The Olmec Maize God: The Face of Corn in Formative Mesoamerica." In "The Pre-Columbian." Special issue, *RES: Anthropology and Aesthetics* 29–30 (Spring–Autumn 1996), pp. 39–81.

K. Taube 2004a. Karl A. Taube. "Flower Mountain: Concepts of Life, Beauty, and Paradise among the Classic Maya." *RES: Anthropology and Aesthetics* 45 (Spring 2004), pp. 69–98.

K. Taube 2004b. Karl A. Taube. *Olmec Art at Dumbarton Oaks.* Pre-Columbian Art at Dumbarton Oaks 2. Washington, D.C.: Dumbarton Oaks Research Library and Collection, 2004.

K. Taube 2005. Karl A. Taube. "The Symbolism of Jade in Classic Maya Religion." *Ancient Mesoamerica* 16, no. 1 (Spring 2005), pp. 23–50.

K. Taube 2010. Karl A. Taube. "Where Earth and Sky Meet: The Sea in Ancient and Contemporary Maya Cosmology." In Finamore and Houston 2010, pp. 202–19.

K. Taube 2017. Karl A. Taube. "Pillars of the World: Cosmic Trees in Ancient Maya Thought." In Matos Moctezuma and Ochoa Peralta 2017, vol. 1, pp. 269–302.

K. Taube and Ishihara-Brito 2012. Karl A. Taube and Reiko Ishihara-Brito. "Anthropomorphic Whistle." In Pillsbury et al. 2012, pp. 426–30.

K. Taube and Saturno 2008. Karl A. Taube and William A. Saturno. "Los murales de San Bartolo: Desarrollo temprano del simbolismo y del mito del maíz en la antigua Mesoamérica." In *Olmeca: Balance y perspectivas; Memorias de la primera mesa redonda*, edited by María Teresa Uriarte and Rebecca B. González Lauck, vol. 1, pp. 287–318. Mexico City: Universidad Nacional Autónoma de México, Instituto de Investigaciones Estéticas, Dirección General de Publicaciones y Fomento Editorial; Instituto Nacional de Antropología e Historia, Consejo Nacional para la Cultura y las Artes; Provo, Utah: New World Archaeological Foundation, Brigham Young University, 2008.

K. Taube and Zender 2009. Karl A. Taube and Marc Zender. "American Gladiators: Ritual Boxing in Ancient Mesoamerica." In *Blood and Beauty: Organized Violence in the Art and Archaeology of Mesoamerica and Central America*, edited by Heather Orr and Rex Koontz, pp. 161–220. Los Angeles: Cotsen Institute of Archaeology Press, 2009.

K. Taube, Pérez de Lara Elías, and Coltman 2021. Karl A. Taube, Jorge Pérez de Lara Elías, and Jeremy D. Coltman. "The Tula Vase: Interactions between Central Mexico and Yucatan during the Early Postclassic." Unpublished manuscript, 2021.

K. Taube, Saturno, and D. Stuart 2004. Karl A. Taube, William A. Saturno, and

David Stuart. "Identificación mitológica de los personajes en el muro norte de la pirámide de las pinturas sub-1, San Bartolo, Petén." In *XVII simposio de investigaciones arqueológicas en Guatemala, 2003, Museo nacional de arqueología y etnología*, edited by Juan Pedro Laporte, Bárbara Arroyo, Héctor Escobedo, and Hector Mejía, vol. 2, pp. 852–61. Guatemala City: Ministerio de Cultura y Deportes, Instituto de Antropología e Historia, Asociación Tikal, 2004.

K. Taube et al. 2010. Karl A. Taube, William A. Saturno, David Stuart, and Heather Hurst. *The Murals of San Bartolo, El Petén, Guatemala, Part 2: The West Wall.* Ancient America 10. Barnardsville, N.C.: Boundary End Archaeology Research Center, 2010. Spanish ed., *Los murales de San Bartolo, El Petén, Guatemala, parte 2: El mural poniente.*

K. Taube et al. 2020. Karl A. Taube, Travis W. Stanton, José Francisco Osorio León, Francisco Pérez Ruíz, María Rocío González de la Mata, and Jeremy D. Coltman. *The Initial Series Group at Chichen Itza, Yucatan: Archaeological Investigations and Iconographic Interpretations.* San Francisco: Precolumbia Mesoweb Press, 2020.

R. Taube and K. Taube 2009. Rhonda Taube and Karl A. Taube. "The Beautiful, the Bad, and the Ugly: Aesthetics and Morality in Maya Figurines." In *Mesoamerican Figurines: Small Indices of Large-Scale Social Phenomena*, edited by Christina T. Halperin, Katherine T. Faust, Rhonda Taube, and Aurora Giguet, pp. 236–58. Gainesville: University Press of Florida, 2009.

B. Tedlock 1992. Barbara Tedlock. *Time and the Highland Maya.* Rev. ed. Albuquerque: University of New Mexico Press, 1992.

B. Tedlock 2002. Barbara Tedlock. *El tiempo y los mayas del Altiplano.* Guatemala City: Fundación Yax Te', 2002.

D. Tedlock 1996. Dennis Tedlock, ed. and trans. *Popol Vuh: The Mayan Book of the Dawn of Life.* New York: Touchstone Books, 1996.

Thompson 1930. J. Eric S. Thompson. *Ethnology of the Mayas of Southern and Central British Honduras.* Field Museum of Natural History Publications, Anthropological Series 17, no. 2. Chicago: Field Museum of Natural History, 1930.

Thompson 1970. J. Eric S. Thompson. *Maya History and Religion.* Civilization of the American Indian 99. Norman: University of Oklahoma Press, 1970.

Thompson 1971. J. Eric S. Thompson. *Maya Hieroglyphic Writing: An Introduction.* 3rd ed. Civilization of the American Indian 56. Norman: University of Oklahoma Press, 1971.

Tokovinine 2003. Alexandre Tokovinine. "A Classic Maya Term for Public Performance." *Mesoweb*, 2003. www.mesoweb.com/features/tokovinine/Performance.pdf.

Tokovinine 2008. Alexandre Tokovinine. "The Power of Place: Political Landscape and Identity in Classic Maya Inscriptions, Imagery, and Architecture." PhD diss., Harvard University, Cambridge, Mass., 2008.

Tokovinine 2020. Alexandre Tokovinine. "Distance and Power in Classic Maya Texts." In *Reshaping the World: Debates on Mesoamerican Colonial Cosmologies*, edited by Ana Díaz, pp. 251–81. Boulder: University Press of Colorado, 2020.

Townsend 1979. Richard Fraser Townsend. *State and Cosmos in the Art of Tenochtitlan.* Studies in Pre-Columbian Art and Archaeology 20. Washington, D.C.: Dumbarton Oaks Research Library and Collection, 1979.

Tozzer 1907. Alfred M. Tozzer. *A Comparative Study of the Mayas and the Lacandones.* Report of the Fellow in American Archaeology 1902–5. New York: Archaeological Institute of America, 1907.

Turner 2021. Andrew D. Turner. "Beauty in Troubled Times: The Flower World in Epiclassic Central Mexico, A.D. 600–900." In Mathiowetz and Turner 2021, pp. 149–73.

Umberger 2008. Emily G. Umberger. "Ethnicity and Other Identities in the Sculptures of Tenochtitlan." In Frances Berdan, John K. Chance, James M. Taggart, Alan R. Sandstrom, and Barbara L. Stark, *Ethnic Identity in Nahua Mesoamerica: The View from Archaeology, Art History, Ethnohistory, and Contemporary Ethnography*, pp. 64–104. Salt Lake City: University of Utah Press, 2008.

Umberger 2015. Emily G. Umberger. "Tezcatlipoca and Huitzilopochtli: Political Dimensions of Aztec Deities." In *Tezcatlipoca: Trickster and Supreme Deity*, edited by Elizabeth Baquedano, pp. 83–112. Boulder: University Press of Colorado, 2015.

Vail 2020. Gabrielle Vail. "The Colonial Encounter: Transformations of Indigenous Yucatec Conceptions of *K'uh*." In *Reshaping the World: Debates on Mesoamerican Colonial Cosmologies*, edited by Ana Díaz, pp. 141–79. Boulder: University Press of Colorado, 2020.

Vail and Hernández 2013. Gabrielle Vail and Christine Hernández. *Re-Creating Primordial Time: Foundation Rituals and Mythology in the Postclassic Maya Codices.* Boulder: University Press of Colorado, 2013.

Valencia Rivera 2011. Rogelio Valencia Rivera. "La abundancia y el poder real: El dios K'awiil en el posclásico." In *De dioses y hombres: Creencias y rituales mesoamericanos y sus supervivencias*, edited by Katarzyna Mikulska Dabrowska and José Contel, pp. 67–96. Encuentros 2010. Warsaw: Instituto de Estudios Ibéricos e Iberoamericanos, Universidad de Varsovia; Asociación Polaca de Hispanistas, 2011.

Velásquez García 2006. Erik Velásquez García. "The Maya Flood Myth and the Decapitation of the Cosmic Caiman." *PARI Journal* 7, no. 1 (Summer 2006), pp. 1–10.

Velásquez García 2009a. Erik Velásquez García. "Los vasos de la entidad política de 'Ik': Una aproximación histórico artística; Estudio sobre las entidades

anímicas y el lenguaje gestual y corporal en el arte maya clásico." PhD diss., Universidad Nacional Autónoma de México, Mexico City, 2009.

Velásquez García 2009b. Erik Velásquez García. "Reflections on the Codex Style and the Princeton Vessel." *PARI Journal* 10, no. 1 (Summer 2009), pp. 1–16.

Velásquez García 2017. Erik Velásquez García. "Algunas reflexiones sobre la representación del tiempo en la imaginería maya antigua." Special issue, *Journal de la société des américanistes* (2017), pp. 361–96.

Vidal-Lorenzo and Horcajada-Campos 2020. Cristina Vidal-Lorenzo and Patricia Horcajada-Campos. "Water Rituals and Offerings to the Maya Rain Divinities." *European Journal of Science and Theology* 16, no. 2 (April 2020), pp. 111–23.

Villa Rojas 1987. Alfonso Villa Rojas. *Los elegidos de dios: Etnografía de los mayas de Quintana Roo*. Mexico City: Instituto Nacional Indigenista, 1987.

Vogt 1969. Evon Z. Vogt. *Zinacantán: A Maya Community in the Highlands of Chiapas*. Cambridge, Mass.: Belknap Press of Harvard University Press, 1969.

Vogt 1976. Evon Z. Vogt. *Tortillas for the Gods: A Symbolic Analysis of Zinacanteco Rituals*. Cambridge, Mass.: Harvard University Press, 1976.

Vogt and D. Stuart 2005. Evon Z. Vogt and David Stuart. "Some Notes on Ritual Caves among the Ancient and Modern Maya." In *In the Maw of the Earth Monster: Mesoamerican Ritual Cave Use*, edited by James E. Brady and Keith M. Prufer, pp. 155–86. Austin: University of Texas Press, 2005.

Von Schwerin 2011. Jennifer von Schwerin. "The Sacred Mountain in Social Context: Symbolism and History in Maya Architecture; Temple 22 at Copan, Honduras." *Ancient Mesoamerica* 22, no. 2 (September 2011), pp. 271–300.

Wahl et al. 2019. David Wahl, Lysanna Anderson, Francisco Estrada-Belli, and Alexandre Tokovinine. "Palaeoenvironmental, Epigraphic and Archaeological Evidence of Total Warfare among the Classic Maya." *Nature Human Behaviour* 3, no. 10 (2019), pp. 1049–54.

Wauchope 1975. Robert Wauchope. *Zacualpa, El Quiche, Guatemala: An Ancient Provincial Center of the Highland Maya*. Publication 39. New Orleans: Middle American Research Institute, Tulane University, 1975.

Webster 2002. David Webster. *The Fall of the Ancient Maya: Solving the Mystery of the Maya Collapse*. London: Thames and Hudson, 2002.

Webster et al. 1998. David Webster, Barbara Fash, Randolph Widmer, and Scott Zeleznik. "The Skyband Group: Investigation of a Classic Maya Elite Residential Complex at Copán, Honduras." *Journal of Field Archaeology* 25, no. 3 (1998), pp. 319–43.

Wichmann 2004. Søren Wichmann, ed. *The Linguistics of Maya Writing*. Salt Lake City: University of Utah Press, 2004.

Wichmann and Nielsen 2016. Søren Wichmann and Jesper Nielsen. "Sequential Text-Image Pairing among the Classic Maya." In *The Visual Narrative Reader*, edited by Neil Cohn, pp. 283–314. London: Bloomsbury Academic, 2016.

Wilkinson and D'Altroy 2018. Darryl Wilkinson and Terence D'Altroy. "The Past as Kin: Materiality and Time in Inka Landscapes." In *Constructions of Time and History in the Pre-Columbian Andes*, edited by Edward Swenson and Andrew P. Roddick, pp. 107–32. Boulder: University Press of Colorado, 2018.

Wilson 1995. Richard Wilson. *Maya Resurgence in Guatemala: Q'eqchi' Experiences*. Norman: University of Oklahoma Press, 1995.

Zender 1999. Marc Zender. "Diacritical Marks and Underspelling in the Classic Maya Script: Implications for Decipherment." MA thesis, University of Calgary, 1999.

Zender 2004. Marc Zender. "A Study of Classic Maya Priesthood." PhD diss., University of Calgary, 2004.

Zender 2005. Marc Zender. "The Raccoon Glyph in Classic Maya Writing." *PARI Journal* 5, no. 4 (Spring 2005), pp. 6–16.

Zender 2006. Marc Zender. "Teasing the Turtle from Its Shell: *Ahk* and *Mahk* in Maya Writing." *PARI Journal* 4, no. 3 (2006), pp. 1–14.

Zender 2020. Marc Zender. "Disaster, Deluge, and Destruction on the Star War Vase." *Mayanist* 2, no. 1 (Fall 2020), pp. 57–76.

Zender and Skidmore 2012. Marc Zender and Joel Skidmore. "Unearthing the Heavens: Classic Maya Murals and Astronomical Tables at Xultun, Guatemala." *Mesoweb*, 2012. www.mesoweb.com/reports/Xultun.pdf.

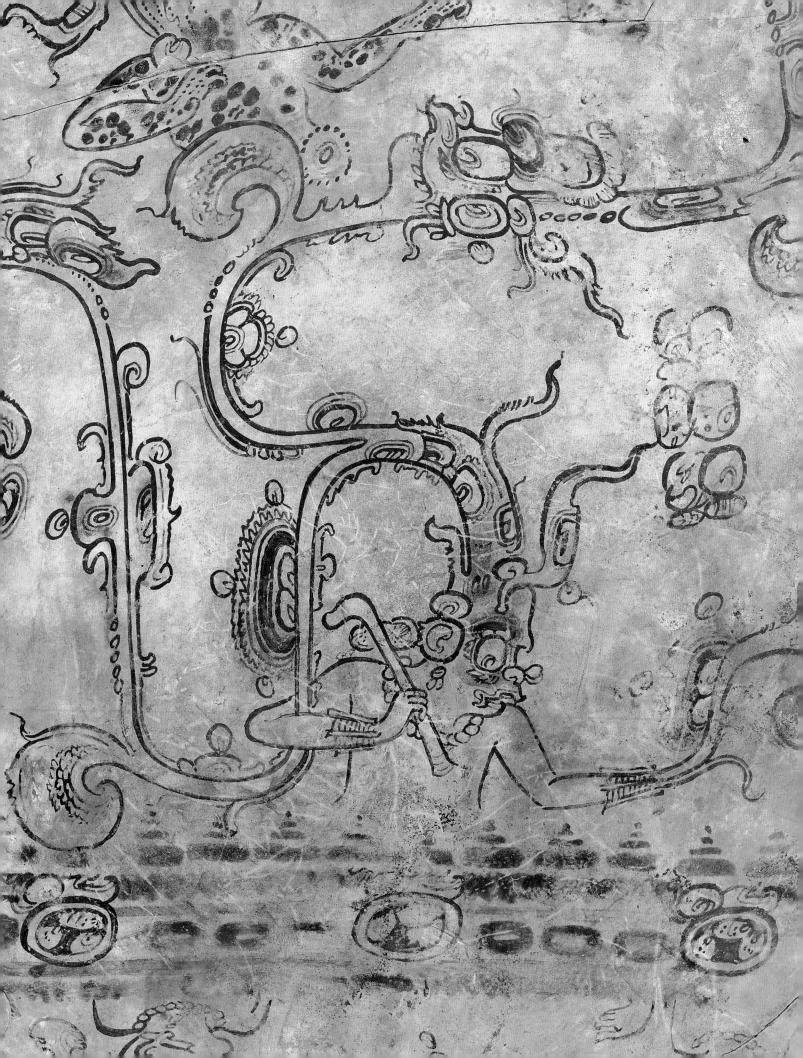

Acknowledgments

An exhibition of this scope and complexity, involving loans from many institutions and the synthesis of decades of scholarship, would not be possible without the assistance of colleagues and friends in Latin America, Europe, and the United States. We are particularly indebted to Laura Filloy Nadal, who joined us as a cocurator in February 2022, and whose contributions — both scholarly and practical — helped bring this project to fruition. We thank the co-organizer of *Lives of the Gods*, the Kimbell Art Museum, especially Eric M. Lee, Director; George T. M. Shackelford, Deputy Director; and Jennifer Casler Price, Curator of Asian, African, and Ancient American Art. Additional thanks go to their colleagues Patty James Decoster and Susan Drake.

We are particularly grateful to our international partners in Guatemala, Honduras, and Mexico and extend our appreciation to their representatives. For Guatemala, Alfonso Quiñónez, Ambassador to the United States; José Rodolfo Contreras Carrión, Cultural Attaché; and Luis Lam Padilla, Ambassador to the United Nations. For Honduras, Luis Fernando Suazo Barahona, Ambassador to the United States, and Mary Elizabeth Flores Flake, Ambassador to the United Nations. For Mexico, Esteban Moctezuma Barragán, Ambassador to the United States, and Juan Ramón de la Fuente Ramírez, Ambassador to the United Nations. Additional thanks to the New York–area consular staffs, including Rosemary Arauz, María José Buerba, Jessica Canahuati, and Jorge Islas López.

In Guatemala, we thank President Alejandro Giammattei; Felipe Amado Aguilar Marroquín, Minister of Culture and Sports; Mario Maldonado, Vice Minister of Cultural Patrimony; Jenny Ivette Barrios Vital, Director of Cultural and Natural Patrimony; and Daniel Aquino Lara, Director of the Museo Nacional de Arqueología y Etnología. We extend special thanks to Daniel Pedro Alberto Guillén Flores, Miguel Orrego Corzo, Claudia Pérez Arévalo, and Mónica Claudina Urquizú Sánchez for their thoughtful help and friendship. We are also grateful to Omar Alcover, Ricardo Alejos, Rosa María Bolaños, Mellyn García Castellanos, Marcus Catsam, Aura Rosa González, Jorge Granados, Marianne Hernández, Luis Pedro Leonardo Coronado, Enrique Marín Pellecer, Petrona Mejía Chutá de Lara, Lisbeth Mirella Mendoza López, Edwin Pérez Robles, Griselda Pérez Robles, Juan Carlos Pérez, Daniel Villatoro García, and Nando Yax.

We are indebted to the community of Santa Cruz Verapaz, Guatemala, which welcomed us as we prepared a short film in connection with the exhibition. In particular, we thank the Cofradía Santa Cruz, Ana María Cho de Rax, Alejandro Rax, and Humberto Caal Gonzales. Additionally, we are grateful to filmmaker Ricky López Bruni and his team.

In Honduras, we thank President Xiomara Castro and Presidential Minister Rodolfo Pastor de María y Campos, as well as Anarella Vélez, Minister for the Secretaría de Cultura, Artes y Deportes, and Rolando de Jesús Canizales Vijil, General Manager of the Instituto Hondureño de Antropología e Historia (IHAH). We are also grateful to Omar Alexis Talavera of IHAH and to Hector Eliud Guerra Aldana and Norman Danilo Martínez Dominguez, both of the Sitio Maya de Copán.

In Mexico, we thank Diego Prieto Hernández, Director General of the Instituto Nacional de Antropología e Historia (INAH), and Juan Manuel Garibay López, INAH's Coordinator of Museums and Exhibitions. We are grateful to Alejandra Barajas Moreno and her staff at INAH, including Itzia Naidee Villicaña Gerónimo, Priscila Medina, and Andrés Josimar Fuentes Zuno. At the Museo Amparo, we owe special thanks to Director Ramiro Martínez Estrada, Lucía Alonso, and Carolina Rojas. At the Museo Nacional de Antropología, we are grateful to Director Antonio Saborit and his staff, including Laura del Olmo, Daniel Juárez, and Sergio González. In Tabasco, thanks go to José Rafael Giorgana Pedrero, Director of the Museo Regional de Antropología Carlos Pellicer Cámara, and César Patricio Mellado Castro of the Secretaría de Cultura del Estado de Tabasco.

We are also grateful to our lenders in Switzerland and the United Kingdom. At the Museum der Kulturen Basel, we thank Director Anna Schmid, Alexander Brust, and Aila Özvegyi. At the British Museum, we thank Director Hartwig Fischer, Lissant Bolton, Jill Holmen, Laura Osorio Sunnucks, Ian Taylor, and Danny Zborover.

Domestic lenders have been equally generous, and we are grateful to the following individuals: Director Anne Pasternak and Curator Nancy Rosoff, Brooklyn Museum; Director William M. Griswold and Curator Susan Bergh, Cleveland Museum of Art; Director Agustín Arteaga and Curator Michelle Rich, Dallas Museum of Art; Director Salvador Salort-Pons, Deputy Director Judith Dolkart, and Curators Nii O. Quarcoopome and Denene De Quintal, Detroit Institute of Arts; Director Tom Cummins, Curator Juan Antonio Murro, and Registrar Carla Galfano, Dumbarton Oaks Research Library and Collection; Director Michael Govan and the curatorial team led by Diana Magaloni, including Julia Burtenshaw, Alyce de Carteret, and Aurora van Zoelen, Los Angeles County Museum of Art; John Hessler, Curator, Library of Congress; Director Matthew Teitelbaum, Ethan Lasser, and Ann Walt Stallings Tagliamonte, the Museum of Fine Arts, Boston; Director Gary Tinterow, Rex Koontz, Chelsea Dacus, and Deborah Roldán, Museum of Fine Arts, Houston; Director Alex Nyerges, Johanna Minich,

and Nancy T. Nichols, Virginia Museum of Fine Arts; Director Stephanie Wiles and Curator Susan Matheson, Yale University Art Gallery.

We thank Iyaxel Cojtí Ren, Caitlin C. Earley, Stephen D. Houston, and Daniel Salazar Lama for their scholarly contributions to this volume; their essays broaden and deepen our understanding of Classic-period Maya art and divinity. Special thanks go to Bárbara Arroyo, Fellow at Dumbarton Oaks, who served as an adviser to this project. Additional scholarly input and advice was provided by Barbara Fash, Charles Golden, Gerardo Gutiérrez, Takeshi Inomata, John Justeson, Simon Martin, Mary Miller, Mary Pye, Patricia Sarro, Frauke Sachse, Andrew Scherer, David Stuart, Karl Taube, Lisa Trever, Mark Van Stone, and Francisca Zalaquett. Howard and Jane Barnet, Eduardo Escalante Carrillo, Martha Cuevas, Edward Harwood, Patricia Ledesma, Leonardo López Luján, Eva Martínez, Roberto López Bravo, Alessandro Pezzati, Pablo Suárez Becerra, Romelia Mo Isem, and Ji Mary Seo all offered crucial assistance and support.

At The Met, our gratitude goes to Daniel H. Weiss, President and Chief Executive Officer; Max Hollein, Marina Kellen French Director; Andrea Bayer, Deputy Director for Collections and Administration; and most especially Quincy Houghton, Deputy Director for Exhibitions, and her outstanding team. Christine D. McDermott, Exhibitions Project Manager, skillfully and cheerfully kept a complex show on track, and Marci King assisted with loan letters, as did Elizabeth Doorly in the Director's Office. We thank Alicia Cheng and her team in the Design Department, especially the talented exhibition designer Patrick Herron and graphic designers Mortimer Lebigre and Kamomi Solidum, who beautifully developed the exhibition's visual identity. Thanks are due as well to Maanik Singh Chauhan, Clint Ross Coller, Jourdan Ferguson, Grace Mennell, Amy Nelson, and Sarah M. Parke.

We are grateful to Amy Lamberti and Kimberly Nastro in the Counsel's Office for their patient and thoughtful assistance with international loans and agreements.

We thank Chief Registrar Meryl Cohen and her team for organizing the complicated transportation of works, with special acknowledgment of Allison Barone, Mary F. Allen, Elsie Alonso, and Aislinn Hyde. Jason Herrick, Chief Engagement Officer, Tom Capelonga, and Caterina Toscano assisted with institutional advancement. In External Affairs, we thank Kenneth Weine, Meryl Cates, and Egle Zygas. We also thank editors Jennifer Bantz and Elizabeth Benjamin for their help with in-gallery texts. A special thank-you goes to the Digital Department — including Paul Caro, Peter Berson, Skyla Choi, and Isabella Garces — for so creatively engaging with the exhibition design and interpretation. We are particularly grateful for the vision of Kate Farrell and Melissa Bell, whose skill is evident in the exhibition's time-based media.

In the Department of Objects Conservation, our appreciation goes to Lisa Pilosi, Sherman Fairchild Conservator in Charge, Carolyn Riccardelli, and Dawn Kriss. We are especially thankful for their yearlong project to conserve two monuments from Piedras Negras, Panel 3 and Throne 1, with colleagues from Guatemala, including Luis Manuel Muñoz Lemus. The talented mount-making team included Fred Sager, Matthew Cumbie, Warren Bennett, Jacob Goble, and Andrew Estep. Additional conservation help was provided by Amanda Chau, Kate Fugett, Sara Levin, and Chantal Stein. Taylor Miller, Building Manager for Exhibitions, oversaw the complicated installation of heavy works, with the assistance of Matthew Lytle, Maria Nicolino, and Michael Doscher.

We are grateful to the entire staff of the Michael C. Rockefeller Wing at The Met, whose help throughout the project, from concept to installation, was invaluable. Particular acknowledgment goes to Alisa LaGamma, Ceil and Michael E. Pulitzer Curator in Charge; Lisa Altshuler; Christine Giuntini; Hugo Ikehara Tsukayama, Andrew W. Mellon Curatorial Fellow; Damien Marzocchi; Matthew Noiseux; Maia Nuku, Evelyn A. J. Hall and John A. Friede Curator for Oceanic Art; Raychelle Osnato; Lauren Posada; David Rhoads; and Jackie Zanca. Natalie DeJesus, Research Assistant for *Lives of the Gods*, was an invaluable member of our team, and

one who improved results at every turn. The exhibition benefited from the help of several interns, including Brandon Agosto, Arianna Martínez, Sofia Ortega Guerrero, and Sebastian Plascencia. We thank Elizabeth Perkins for her careful stewardship of the internship program, and Marianna Siciliano for educational programming during the run of the exhibition.

We have been fortunate to work with Mark Polizzotti, Publisher and Editor in Chief of the Publications and Editorial Department, and his excellent team, including Michael Sittenfeld, Peter Antony, Elizabeth De Mase, Lauren Knighton, and Josephine Rodriguez. We owe particular thanks to Anne Blood Mann and Nancy E. Cohen, our talented editors, for strengthening and clarifying the fundamental ideas presented in this volume. Additional thanks go to Amelia Kutschbach, bibliographer, and Amanda Sparrow, proofreader. We thank Susan Marsh for the elegant design of this catalogue, and Adrian Kitzinger for the fine maps.

Special thanks are due Jorge Pérez de Lara for his photographs of works and sites in Mexico and Central America. Scott Geffert and his team in the Imaging Department, including Paul Lachenauer, Juan Trujillo, and Peter Zeray, revealed the exquisite details of The Met objects in new ways.

This exhibition would not have been possible without our donors, whose support is gratefully acknowledged. In New York, thanks are due to the William Randolph Hearst Foundation, the Placido Arango Fund, the Diane W. and James E. Burke Fund, the Gail and Parker Gilbert Fund, the Mellon Foundation, and The International Council of The Metropolitan Museum of Art, and to Stephanie Bernheim for additional support. In Fort Worth, we thank the Kimbell Art Foundation and its president, Kimbell Wynne. This catalogue benefited from the generosity of the Samuel I. Newhouse Foundation, Inc., the Mellon Foundation, and the Doris Duke Fund for Publications.

OSWALDO CHINCHILLA MAZARIEGOS,
JAMES A. DOYLE,
AND JOANNE PILLSBURY

Index

(fig. 131), 165, *165*; jewel, funerary (fig. 115), 147, *147*; Maize God's association with, 82, 154; masks (figs. 6, 127), 20, *21*, *157*, 159; Motagua River valley as source of, 19; pectoral, 171; Sun God effigy, 212n31

Jaguar Bird Tapir (Bahlam Yaxuun Tihl), ruler of Tonina, *184*, 185, 215n62

jaguars: Baby Jaguar, 112, 114, 120, 122; codex bound in jaguar skin, 46; and darkness, 86, 94, 99; deities with jaguar attributes, 27, 49, 73, 78, 82, 114, 144; effigies of, 165; Hummingbird Jaguar, 175; Jaguar God of the Underworld, 99, *100*, 103, 175, 185; Jaguar Paddlers, 117; and regnal names, 162; thrones, 171, 172; water-lily jaguar, 120–22; and *way* spirits, 89, *92*

Jaina Island (Mexico), *17*, 76, 151

Janaab Pakal I, ruler of Palenque, 147, *158*, 159, 165, 179–80

Jasaw Chan K'awiil I, ruler of Tikal, 117, 167–68, *168*, 171

Juun Ajaw (God S, One Lord), 65, 142, 144–46

Juun Pu'w (One Pus), 65–66, 69, 79–82

K'abal Xook, Lady (Yaxchilan queen), 162–64, *163*, 203–4

k'ab'awil (patron deities), 189–207; and dawn's importance, 189–92; effigies of, 191, 192–94, *193*, 205–7; foundation shrines or temples, 190–91, 199, 200, *200*, 201, *202*, 205; of the Kaqchikel, 200–203; of the K'iche', 195–200, 205–7; modern practices, 204–7, *206*, *207*; and sociopolitical organization of the highlands, 194–95

K'ahk' Tiliw Chan Chahk, ruler of Naranjo, 172–75, *173*

Ka'koch (primordial god), 60

Kaminaljuyu (Guatemala), 69, 211n2, 212n31

Kan Bahlam II, ruler of Palenque, 179–80

K'an Joy Chitam II, ruler of Palenque, 119–20, *120*

Kaqchikel Maya: Chwa Nima' Ab'äj (Mixco Viejo) temples, 201, *202*; colonial dictionaries, 192, 215n3; *k'ab'awil* (patron deities), 200–203; and K'iche' alliances, 195, 199, 200–201; and Latin script, 191; sociopolitical organization of, 194–95; Xajil Chronicle, 201

K'awiil (lightning god), 125–34; attributes of, 77, 111, 126, 129, 135; Chichen Itza temple scene of, 101; Dresden Codex depiction of (fig. 101), 135, *135*; effigies of, 126–28, 165; fertility associations, 73; impersonation

of, 184; infant form of, 120, 179; obsidian incised with image of (fig. 69), 133, *133*; and regnal names, 119, 162; and rulership or scepters, 111, 128–29, *130–32*, 132–34, 170, 171, 175, 180; and smoking elements, 111, 114, 125–26, *126–27*, 129, 132

K'iche' Maya: and Dance of the Macaws, 71–72; history of, in *Popol Wuj*, 24, 61–62, 194, 196–200; *k'ab'awil* (patron deities), 195–200, 205–7; Kaqchikel as dependents of, 195, 200–203; language, 24, 199, 215n27; and Latin script, 191; modern practices, *197*, 205–7, *206*, *207*; Q'umarkaj temples, 199, *200*; sociopolitical organization of, 194–95. See also *Popol Wuj*

K'in Lakam Chahk and Jun Nat Omootz, relief with royal woman (fig. 94), 128–29, *128*

K'in Lakam Chahk and Patlajte K'awiil mo[. . .], Piedras Negras Throne 1 (fig. 142), 177–78, *178*

K'iq'ab', K'iche' ruler of Q'umarkaj, 199–201

Kisin (death god), 73–75

Lacandon Maya, 25–27, 60, 62, 73–75

Landa, Diego de, 23, 52

Las Pacayas (Guatemala), 65, *66*

lidded vessels: with bird (fig. 82), 116, *117*; with monkeys (figs. 72–75), 102–3, *102–4*; with peccary (fig. 7), *22*, 23; with turtle (fig. 8), 23, *23*

Lightning God, 51, 111, 114, 125–34, 165. *See also* K'awiil

lintels: Chicozapote, with ancestral sun and moon, 106–7; Tikal, at Temples I and IV (figs. 133–35, 139), 165, 166–68, *168–70*, 171, *174*, 175; Usumacinta River region (fig. 53), 79, *80–81*; Yaxchilan, at Structure 23 (figs. 129, 158), 162–64, *163*, 203–4, *204*, 214n11

Lo' Took' Akan(?) Xok, squared vessel (fig. 57), 87–89, *88*, 105, 211n7

Lunar Series (inscriptions), 77–78, 212n38

macaws, 62–67, *65*, *66*, 69–72, *71*

Machaquila (Guatemala), gnomon-stela, 99

Madrid Codex, 60

maize cultivation, 19, 29, 42, 46–47, 123, 133–34

Maize God, 137–59; acrobats (inverted figures), 156, *156*; apotheosis of deceased kings as, 154–59, 184; attributes of, 25, 43, 49, 69, 114, 145, 154; breath of, 50, 114; ceramic plates depicting (figs. 114, 117, 118), 146–50, *146*, *148*, *149*; ceramic vessels depicting

(figs. 109, 112, 113, 123), 106, 114, 142, *142*, 144–45, *144*, *145*, 152–54, *153*; and Chahk (rain god), 114, 115, 117, 119, 122, 142–43, 147, 213n39; Chicomecoatl (Aztec maize deity), 45; and divisions of the day, 103; early depictions of, 62, 138–43; ear ornaments with head of (figs. 104, 105), 138, *139*; Jaina-style figurine of (fig. 121), 151, *151*; and K'awiil (lightning god), 132–33; lunar aspect of, 78–79, 82, 105; Olmec jade celt incised with (fig. 24), 42–43, *43*; stone architectural busts of (figs. 106, 107), 139, *140*, *141*, 151; stone bowl with, as cacao tree (fig. 124), 139, 154–56, *155*; whistles depicting (figs. 1, 2), 15–17, *16*, 25

masks: architectural masks, 69, 138, *138*, 150–51; and impersonation of gods, 52, 162, 164; jade funerary masks (figs. 6, 127), 20, *21*, *157*, 159; stucco deity mask (fig. 67), 97, *97*

Matwiil (mythical place), 112–14, 179

Maximon (deity), 55

Maya civilization, historical overview of, 17–22. *See also* modern Maya peoples

Maya Highlands, map of, *192*

Metropolitan Painter, vessels with mythological scenes (figs. 17, 77), 31–33, *32*, *33*, 110, 111–12, 114, 120–22, 213n39

Mexica people, 43–45, *45*, 134–35

modern Maya peoples: blending of Christianity and Indigenous practices, 23, 55; cosmogonic beliefs, 60, 62; Dance of the Macaws (fig. 47), 71–72, *71*, 75; geographic spread of, 17; *k'ab'awil* (patron deities; figs. 159, 160), 204–7, *206*, *207*; myth of old god's daughter, 73–75; procession of Saint Thomas the Apostle (fig. 153), 196, *197*; survival of Maya culture, 22, 55, 60, 83, 135, 207

monkeys, 45, *45*, 51, 63, *63*, 85, 102–3, *102–4*, 194

Moon God/Goddess: ceramic vessels depicting (figs. 48, 52), *72*, 73, 77–79, *78*, *79*, 83; Coyolxauhqui (Mexica moon goddess, fig. 26), 44–45, *45*; deceased royal parents as sun and moon, 79, 106–7; gender of lunar deities, 105; impersonation of, 154; lunar Maize God, 78–79, 82, 105; obsidian incised with image of (fig. 69), 97, *99*; and rabbits, 82–83, 94, 105, 107

Mopan Maya, 62, 133–34

mountains: and divine landscape, 41–42; geographic overview of Maya Highlands, 19; human-made structures as, 43–44, 48, 150–51; Maize God's emergence from, *142*, 150–53, *151*; and mortuary spaces,

159; mural depictions of, 34, *44*; as places of primordial origin, 42, 45, 46–49, 196; sustenance mountain, 147, *147*, 150–51, 156, *156*. See also *witz*

murals: Bonampak, 92–93, 105, 215n64; Santa Rita, 99; Teotihuacan (fig. 25), 43, *44*. *See also* San Bartolo murals

Nahua peoples, 45, 71, 191, 199
Nahuatl language, 43, 45, 50, 86, 102
Nakbe (Guatemala), 46, *47*, 69
Naranjo (Guatemala), 87–89, *88*, *91*, 92, 105, 172–75, *173*, 185
Noh Peten (Guatemala), 22

obsidian: and Aqajal people, 201; and Chahk, 114; and darkness, 86; incised flakes with deity images (figs. 55, 69, 99), 82, *82*, 97, *99*, 133, *133*; and K'awiil, 129, 133; mirrors, 126–28; trade of, 19; wavy objects, 101
Olmec civilization, 23, 42–43, *43*, 138

Paddler Gods, 117, 143, 146
Palenque (Mexico): censer stands, 26–27, *26*, *27*, 99, *100*; Cross Group (three temples), 179–80, *179*; drought, 134; glyph blocks, *24*, *25*; glyph for *k'uh*, 50; jade figurine (deity effigy), 165, *165*; maize-mountain depiction, 147, *147*; panels, 60–61, *61*, 97, *98*, 119–20, *120*; patron gods, 61, 119–20, 165, 178–80; sarcophagus lid, *158*, 159, 180; stucco deity mask, 97, *97*; stucco relief with Maize God, 143, *143*; tablets, 165, 166, 179–80, *179*; throne leg, 120, *121*; Tonina's defeat of, 185
panels: Palenque (figs. 38, 68, 87), 60–61, *61*, 97, *98*, 119–20, *120*; Piedras Negras (figs. 140, 141, 152), 72, 175–77, *176*, *177*, *194*, 195; Usumacinta River region (fig. 94), 128–29, *128*; Xupa (fig. 130), *164*, 165
patron gods, 161–86; of Calakmul, 165, 170–72; characteristics and role of, 51–52, 162, 164–65, 185–86; of Copan, 180–84; effigies of, 52, 165–67, *165*, 171, 175, 183, 184; houses (*wayib*) for, 92, 166, *166*; of Mexica people, 44, 135; of Naranjo, 172–75; of Palenque, 61, 119–20, 165, 178–80; of Piedras Negras, 175–78; of Quirigua, 125; of Tikal, 119, 167–68; of Tonina, 184–85. See also *k'ab'awil*
peccaries, *22*, 23, 75
Piedras Negras (Guatemala): panels, 72, 128–29, *128*, 175–77, *176*, *177*, *194*, 195; patron gods, 175–78; stelae, 69, 96, 129; throne, 177–78, *178*

plates: Blom Plate (fig. 43), 66–67, *67*; with macaw biting off hand (fig. 42), 65, *66*; with Maize God, codex-style (figs. 114, 117), 146–49, *146*, *148*; with Maize God as ball-player (fig. 118), 149–50, *149*; tripod plate with Chahk (fig. 79), 112–14, *113*, 147
Popol Wuj (K'iche' text): on abduction of Xk'ik, 73; authorship of, 24, 55; and Copan ruler's accession, 183; on creation of the world, 61, 161; and current studies of Maya religion, 25; on heroes' defeat of the false sun (Seven Macaw), 62–67, 69–71; on heroes' rise to become sun and moon, 77; on heroes' shooting of a falcon, 69; humor in, 75; on *k'ab'awil* (patron deities), 191, 194, 196–200; and modern Maya identity, 55; passages quoted from, 31, 189, 198; Rivera's illustrations for (fig. 157), 203, *203*; tempest deities in, 125
Postclassic period: codices, 22, *54*, 83, 92, *93*, *95*, *134*, 135, *135*, 210n5; flower reliefs, 26; historical overview of, 20–22; *k'ab'awil* (patron deities), 190, 194, 203; Maize God depictions, 139; Nahuatl language, 45, 102; Rain and Lightning God depictions, 134–35, *134*, *135*; sky bands as symbols of sacred books, 211n18; Sun God depictions, 97, 99–101
Preclassic period: Chahk depictions, 115, 122; development of shared myths and deities, 33, 35, 83; El Mirador pyramids, 28; historical overview of, 20; Maize God depictions, 62, 138, 159; and *Popol Wuj*'s source material, 24; Principal Bird Deity depictions, 67, 68, 71; stela with avian being, 63–65, *64*; Sun God depictions, 101
Principal Bird Deity, 63, 65–71, 168, 176, 180, 213n24
pyramids, 20, 28, 44, 48, 87, 92, 102, 214n31

Quetzalcoatl (Nahua wind god), 71
Quirigua (Guatemala), 103, 125, *125*, 183–84, 213n17
Q'umarkaj (Guatemala), 196, 199–200, *200*

rabbits, 50, 82–83, *83*, 94, 105–7
Rab'inal (Guatemala), 71, 199, 215n27
Rain God, 44, 51, 111–25, *116*, 126, 134–35. *See also* Chahk
Rivera, Diego, *Human Sacrifice before Tohil* (fig. 157), 203, *203*
Rosalila Temple, Copan, 129, *130–31*

rulership: apotheosis of deceased rulers, 79, 106–7, 154–59, 184; development of royal iconography, 33–34; development of stone monuments, 20, 167; funerary rites, 87, 176; and impersonation of gods, 52, 69, 105, 119–20, 123–25, 162, 175, 180, 183, 185–86; K'awiil's association with, 111, 128–29, 134, 170, 175; mirrors used by rulers, 126–28; and patron gods, 51–52, 61, 119, 164–86, 203–4; and Principal Bird Deity, 69–71, 176, 180; royal names or titles, 52, 112, 119, 162, 175, 178, 180; and solar cycles, 47; sorcerer-kings, 91; and summoning of gods, 52, 128, 162–64, 176; and throne iconography, 177–78, 189–90, 196; and tobacco, 114

sacrifices: bloodletting or blood offerings, 35, 60, 71–72, 86, 105, 107, 162, 172, 199; bowls, sacrificial, 172, 180; of humans or animals, 60, 72, 107, 203, *203*; of jaguar deity, 185
Sahagún. *See* Bernardino de Sahagún
San Bartolo murals (figs. 18, 19), *34–37*; avian beings depicted on, 35, 65; birth scene with exploding gourd, 34, 152; Chahk and Maize God scene, 115, 119, 142–43; and development of religious iconography, 33–35, 42, 83; divine breath depicted on, 50
Santa Cruz Verapaz (Guatemala), 71–72, *71*
Santiago Atitlán (Guatemala), 133, 196
sarcophagus lid (fig. 128), *158*, 159, 180
Schellhas, Paul, 22, 24, 29
Seven Macaw (avian being), 62–67, 69–71
shell: Chahk's spondylus earflares, 111, 115, 119, 120, 122, 125; conch shells, 73–75, 79–82, *81*, 125; ear ornaments depicting Chahk (fig. 86), 119, *119*; ear ornaments depicting Maize God (figs. 104, 105), 138, *139*; mask, jade-and-shell (fig. 6), 20, *21*; rabbit pendant (fig. 56), 82, *83*
Shield Jaguar III (Itzam Kokaaj Bahlam III), ruler of Yaxchilan, 107, 162–64, *163*, 203–4, 214n12
sky bands, 67–69, 93–97, *94–95*, 101, 105
Spanish Empire: alphabetic script introduced to Maya, 60, 191; cultural consequences of colonization, 22, 24, 52, 204, 205; texts by friars, 24, 45, 52
spider monkey with Wind God regalia (fig. 27), 45, *45*
spondylus shells, 111, 115, 119, *119*, 120, 122, 125, 145, 172
squared vessel (fig. 57), 87–89, *88*, 105, 211n7

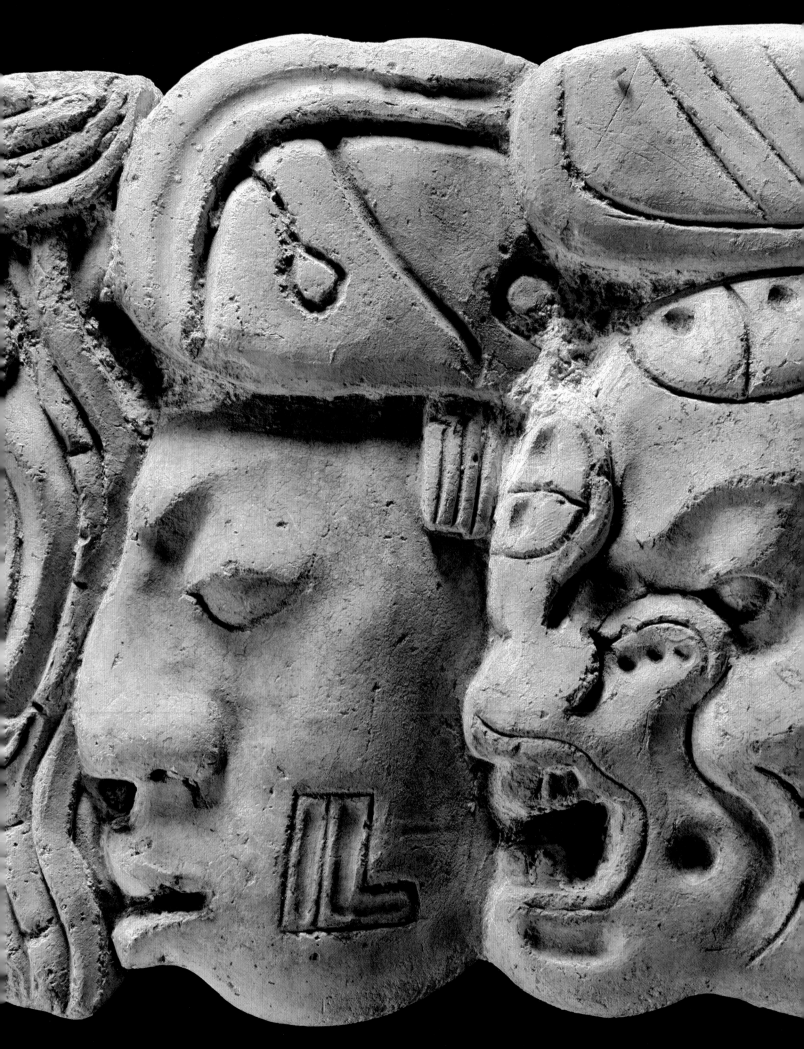

Accession Numbers

Below are the accession numbers of works in the exhibition that are illustrated in this publication.

Fig. 1: 1979.206.728
Fig. 2: 70.31
Fig. 3: PC.B.559
Fig. 4: 10-78182; Public Registry 1AMA00037537
Fig. 7: Registry 17.7.88.72 ab
Fig. 8: Registry 17.7.88.67 ab
Fig. 9: 1050 PJ7/A-0066; Public Registry 1AMA00368769
Fig. 10: 1650 PJ131/ A-0067; Public Registry 1AMA00368768
Fig. 11: 10-117746; Public Registry 1AMA00366991
Fig. 12: AP 2013.01
Fig. 13: AP 2013.02
Fig. 14: MUNAE 23489; Registry 17.7.58.219
Fig. 15: MUNAE 23481; Registry 17.7.58.213
Fig. 16: MUNAE 23481; Registry 17.7.210
Figs. 17a, b: 1978.412.206
Fig. 28: AP 2004.04
Fig. 29: MUNAE 23224; Registry 17.7.1.084
Fig. 30: CPN-28327
Fig. 35: CPN-993
Fig. 37a: 1978.412.90a, b
Fig. 40: 10-457462; Registry 1AMA00082298/1
Fig. 43: 10-425136; Public Registry 1AMA00369228
Fig. 44: 10-607617; Public Registry 1AMA00282933
Fig. 46: 1988.129
Figs. 48a, b: 77.98
Figs. 49a, b: 2014.83
Figs. 50a, b: AP 2004.02
Fig. 51: 77.49
Figs. 52a, b: M.2010.115.628
Fig. 53: AC1992.76.1
Fig. 54: 86.457
Fig. 55a: MUNAE 20613; Registry 1.1.1.4777
Fig. 55b: MUNAE 545; Registry 1.1.1.8203
Fig. 55c: MUNAE 20600; Registry 1.1.1.4771
Fig. 56: 2012.249
Fig. 57: M.2010.115.14
Fig. 58: 2017.111.3
Fig. 61: 2006.233 (not in exhibition)
Fig. 67: 1650 PJ 73 A-0006; Public Registry 1AMA00368771
Fig. 68: 10-604761; Public Registry 1AMA00366992
Fig. 70: 10-479189; Public Registry 1AMA00159375
Fig. 72: 1988.82.A-B
Fig. 73: Registry 17.788.64 ab
Fig. 74: Registry 17.7.88.44 ab
Fig. 75: Registry 17.7.88.68 ab
Figs. 77a, b: 1980.213
Fig. 78: M.2010.115.3
Figs. 79a, b: 2021.320
Fig. 81: Rain God: CPN-28560; cascades: (left) CPN-28560A; (right) CPN-25560B
Fig. 82: 64.217a-b

Fig. 86: (left) MUNAE 11489; Registry 1.1.1.8862; (right) MUNAE 11573; Registry 1.1.1.8861
Fig. 88: 10-79299; Public Registry 1AMA00033226
Figs. 89a, b: 2014.632.1
Fig. 91: 66.181
Figs. 95a–f: CPN-P-2706
Figs. 96a–c: (a) CPN-P-2704; (b) CPN-P-2703; (c) CPN-P-2705
Fig. 97: 91.332
Figs. 98a–c: CPN-00060
Fig. 99: MUNAE 10114g; Registry 1.1.1.758g
Figs. 104a, b: PC.B.567
Figs. 105a, b: 1995.489a, b
Fig. 106: Am1923, Maud.8
Fig. 107: CPN-635
Fig. 108: 10-566398; Public Registry 1AMA00028855
Fig. 111: 1983.45.McD
Figs. 113a, b: 1989.016.00.0001
Fig. 114: 1993.565
Fig. 117: M.2010.115.5
Fig. 118: MUNAE 352; Registry 1.1.1.504
Fig. 119: CPN-6536, CPN-6531, CPN-6533
Fig. 121: 2015.27
Figs. 124a, b: PC.B.208
Fig. 129: Am1923, Maud.5
Fig. 131: 10-001293; Public Registry 1AMA00361849
Fig. 136: 10-80365; Public Registry 1AMA00361848
Fig. 139: IVb 52.02a, IVb 52.02b1, IVb 52.02b2, IVb 52.02c, IVb 52.02d, IVb 52.02e, IVb 52.02f
Fig. 141: MUNAE 613; Registry 1.1.1.146
Fig. 142: MUNAE 614; Registry 1.1.1.709 ab
Fig. 147: 10-607537; Public Registry 1AMA00366989
Fig. 148: 10-588895; Public Registry 1AMA00366979
Fig. 149: 10-607560; Public Registry 1AMA00366990
Fig. 150: CPN 248-D1, D2, D3, D4, D5-67
Fig. 151: CPN-3446
Fig. 152: MUNAE 613; Registry 1.1.1.146
Fig. 154: 52 22 MA FA 57PJ 1372; Public Registry 1AMA00368663

Photography Credits

Numerals refer to figure numbers.

© 2022 Banco de México Diego Rivera Frida Kahlo Museums Trust, Mexico, D.F. / Artists Rights Society (ARS), New York. Library of Congress, Jay I. Kislak Collection: 157
© The Trustees of the British Museum: 106, 129
Photo by Brooklyn Museum: 2, 82
Courtesy of Amanda Chau, Dawn Kriss: 37b
Chrysler Museum of Art, Norfolk, Va.: 54; photo © Justin Kerr, 1982: 60; photo by Ed Pollard: 93a
Cleveland Museum of Art: 94
Image courtesy of Dallas Museum of Art: 46, 72, 111
Design Pics Inc. / Alamy Stock Photo: 153
© Detroit Institute of Arts / Founders Society

Purchase, Katherine Margaret Kay Bequest / Bridgeman Images: 51
© Dumbarton Oaks, Pre-Columbian Collection, Washington, D.C.: 3, 87, 104a, 104b, 113b, 124a, 124b
Dumbarton Oaks, Trustees for Harvard University, Washington, D.C., Justin Kerr Maya Archive, photo by Justin Kerr: 50b, 61, 93b, 114, 123a, 123b
Photo by Oscar Espinosa: 146
Image courtesy of Fine Arts Museums of San Francisco: 130
Courtesy of Kate Fugett, Dawn Kriss, Sara Levin: 5a, 5b
© President and Fellows of Harvard College, Peabody Museum of Archaeology and Ethnology: 76, 90, 132a–c
© Heather Hurst, 2004: 18, 19
Kimbell Art Museum, Fort Worth, Texas: 12, 13, 28, 50a
Courtesy of Matthew Looper: 92
Image © The Metropolitan Museum of Art: 17a, 17b, 20–23, 27, 77a, 77b, 79a, 79b, 89a, 89b, 91, 105a, 105b; photo by Juan Trujillo: 1, 24, 37a
© Authorized reproduction Ministerio de Cultura y Deportes de Guatemala, Museo Nacional de Arqueología y Etnología: photo by Jorge Pérez de Lara: 6–8, 14–16, 29, 42, 55a–c, 59, 66, 73–75, 86, 99, 118, 127, 138, 140–42, 152; image © The Metropolitan Museum of Art: 137
Photo © Museum Associates / LACMA: 52a, 53, 57, 62, 117
Photo © Museum Associates / LACMA Conservation Center, photo by Yosi Pozeilov: 52b, 78
Photo © 2022 Museum of Fine Arts, Boston: 31, 32, 45; photo by Justin Kerr: 84, 85
Museum of Fine Arts, Houston: 49a, 56, 97, 121; photo by Justin Kerr: 49b
© Museum der Kulturen Basel: photo by Peter Horner, 1997: 135; photo by Omar Lemke, 2020: 134; photo by Omar Lemke, 2022: 139
Sächsische Landesbibliothek–Staats- und Universitätsbibliothek, Dresden: 36, 63, 65, 100, 101
Secretaría de Cultura–Instituto Nacional de Antropología e Historia (INAH), Mexico, reproduction authorized by INAH: 154, 158; © Gliserio Castañeda: 26, 39; photo by Jorge Pérez de Lara: 4, 9–11, 25, 38, 40, 43, 44, 67, 68, 70, 80, 88, 109, 131, 136, 148, 149
Courtesy of Sitio Maya de Copán, Instituto Hondureño de Antropología e Historia: image courtesy of Barbara Fash: 98a–c; © Kenneth Garrett: 95 a–f; photo by Jorge Pérez de Lara: 30, 35, 41, 64, 81, 96a–c, 107, 119, 145a–e, 150, 151
Courtesy of the University of Pennsylvania Museum of Archaeology and Anthropology: 69, 83, 133
© Virginia Museum of Fine Arts, photo by Travis Fullerton: 48a, 48b
Yale University Art Gallery, photo by Justin Kerr: 58
Photo by Michel Zabé: 147

This catalogue is published in conjunction with *Lives of the Gods: Divinity in Maya Art*, on view at The Metropolitan Museum of Art, New York, from November 21, 2022, through April 2, 2023, and at the Kimbell Art Museum, Fort Worth, Texas, from May 7 through September 3, 2023.

The exhibition is made possible by the William Randolph Hearst Foundation, the Placido Arango Fund, the Diane W. and James E. Burke Fund, the Gail and Parker Gilbert Fund, the Mellon Foundation, and The International Council of The Metropolitan Museum of Art.

It is organized by The Metropolitan Museum of Art and the Kimbell Art Museum.

This publication is made possible by the Samuel I. Newhouse Foundation, Inc., the Mellon Foundation, and the Doris Duke Fund for Publications.

Published by The Metropolitan Museum of Art, New York
Mark Polizzotti, Publisher
 and Editor in Chief
Peter Antony, Associate Publisher
 for Production
Michael Sittenfeld, Associate Publisher
 for Editorial

Edited by Nancy E. Cohen
 and Anne Blood Mann
Designed by Susan Marsh
Production by Lauren Knighton
Bibliographic editing by Amelia Kutschbach
Image acquisitions and permissions
 by Josephine Rodriguez
Translations from Spanish by Philip Sutton
Maps by Adrian Kitzinger

Photographs of works in The Met collection are by Juan Trujillo, Imaging Department, The Metropolitan Museum of Art, unless otherwise noted.

Additional photography credits appear on page 243.

Typeset in Archer and Sentinel
 by Matt Mayerchak
Printed on 150 gsm Perigord
Separations by Professional Graphics, Inc.,
 Rockford, Illinois
Printed by Brizzolis, Madrid, and bound by
 Encuadernación Méndez, Madrid
Printing and binding coordinated by
 Ediciones El Viso, Madrid

Cover illustrations: front, censer stand, Palenque, Chiapas, Mexico (fig. 70); back, Panel 3, Piedras Negras, Petén, Guatemala (detail, fig. 141)

Endpapers: front, cylinder vessel with Moon Goddess and other celestial beings, Mexico or Guatemala (figs. 52a, b); back, vessel with mythological scene, Guatemala or Mexico (figs. 17a, b)

Page 1: Monument 155, Tonina, Chiapas, Mexico (fig. 148)
Pages 2–3: Throne 1, Piedras Negras, Petén, Guatemala (fig. 142)
Pages 4–5: Panel with royal woman, Usumacinta River region, Mexico or Guatemala (fig. 94)
Page 6: Squared vessel, northern Petén, Guatemala (fig. 57)
Page 8: Monument 168, Tonina, Chiapas, Mexico (fig. 147)
Pages 12–13: Guatemalan Highlands, photograph by Ricky López Bruni and Haniel López
Pages 14–15: Whistle with an old man emerging from a flower, Mexico (fig. 3)
Pages 30–31: Watercolor illustration of north wall mural, San Bartolo, Guatemala (detail, fig. 18)
Pages 56–57: Whistle figurine, Mexico (fig. 51)
Pages 84–85: Panel fragment, Chiapas, Mexico (fig. 68)
Pages 108–9: Rain God, Copan, Honduras (fig. 81)
Pages 136–37: Eccentric flint depicting a canoe with passengers, Guatemala (fig. 111)

Pages 160–61: Monument 180, Tonina, Chiapas, Mexico (fig. 149)
Pages 188–89: Throne back, Usumacinta River region, Guatemala or Mexico (detail, fig. 154)
Page 208: Lidded vessel with howler monkey, El Zotz, Guatemala (fig. 75)
Page 216: Lintel 25, Yaxchilan, Chiapas, Mexico (detail, fig. 129)
Page 234: Tripod plate with mythological scene, Guatemala or Mexico (detail, fig. 79a)
Page 242: Glyph block, Palenque, Chiapas, Mexico (detail, fig. 11)

The Metropolitan Museum of Art
1000 Fifth Avenue
New York, New York 10028
metmuseum.org

Distributed by
Yale University Press, New Haven
and London
yalebooks.com/art
yalebooks.co.uk

Cataloguing-in-Publication Data is available from the Library of Congress.

ISBN 978-1-58839-731-7

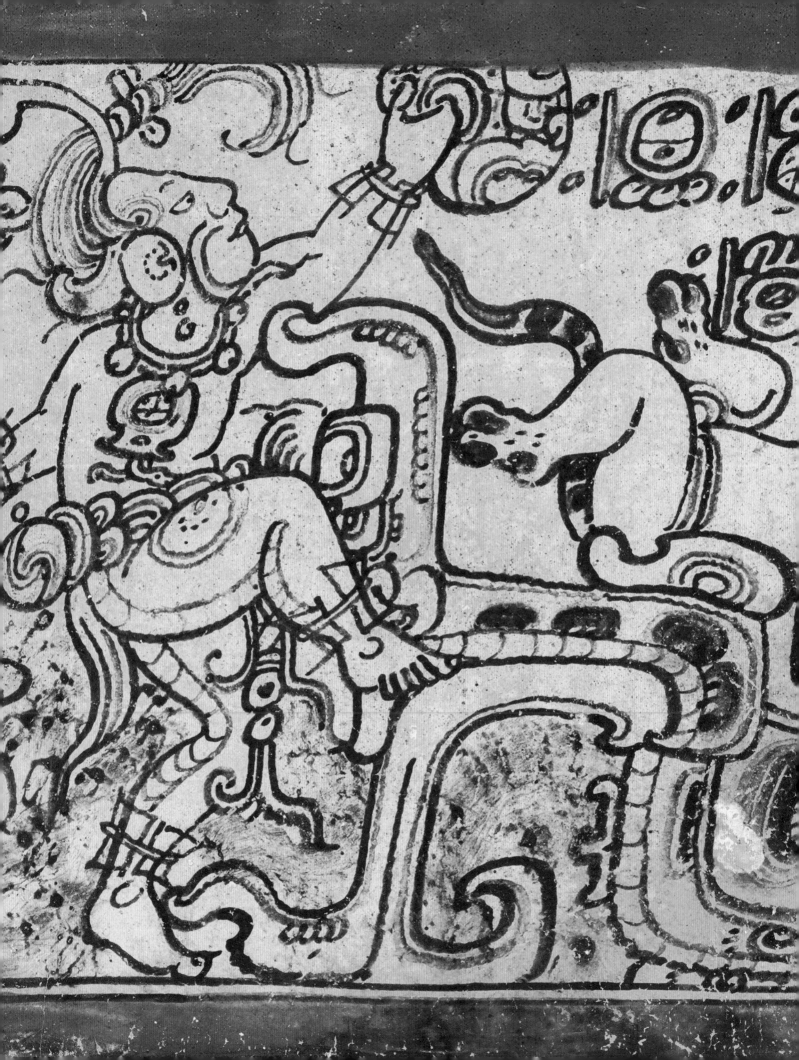